"Now that design skills have become a commodity, you need business skills to focus them. Shel Perkins has written a cracker-jack book that will be on the shelf of every ambitious designer."
Marty Neumeier
President, Neutron LLC, author of *Zag* and *The Brand Gap*

"This is the best left-brain business book I've ever read for right-brain designers. And, having two right brains, I know what I'm talking about. I'm recommending Shel's book to every student of mine and buying a copy for each designer on my staff."
Brian Collins
Chief Creative Officer, Brand Integration Group,
Ogilvy & Mather Worldwide

"Damn good advice! This is a fantastic business handbook for designers. It's loaded with the specific, usable, real-world business knowledge that designers need. Shel has done a masterful job of making the information simple, clear, and easy to follow. This is a must-have book for any designer who wants to succeed in business."
Billy Pittard
President, Pittard Inc.

"This is the most concise and brilliantly informative guide I have ever wished I'd read before establishing three studios for ATTIK. Shel has managed to capture a vast array of learning that most of us only gather after many years of trial and error — a guide that every independent designer or agency owner should have within arm's reach."
Will Travis
President, U.S. Operations, ATTIK

"Many design firms and designers have benefited from Shel's sound business perspectives and advice. Now he has written a valuable guide that continues that process. The lucky readers of Talent Is Not Enough: Business Secrets For Designers *will absorb many important messages that are essential to success. Shel deserves a 'thank-you' for rendering this service to all designers."*
Roz Goldfarb
President, Roz Goldfarb Associates,
author of *Careers by Design*

"Destined to become a dog-eared reference for all those parts of running a design firm that they never taught in college."
Mitchell Mauk
Principal, Mauk Design

"Although designers are highly skilled at applying their creativity toward solving design-related problems, most lack the fundamental business knowledge that would enable them to start or optimally run a firm. Whether you're a student, design contractor, or design firm owner, Shel Perkins' new book, Talent Is Not Enough: Business Secrets For Designers, *is a comprehensive source of information on the professional practice of design."*
Gerard Furbershaw
Co-founder and COO, Lunar Design

"A confident and perceptive mentor, Perkins creates a painless navigation through a range of strategies and issues."
Communication Arts Magazine

"This is a fantastic book; everyone should have a (well-worn) copy. In Shel's typical style, the information is delivered in clear, concise language. Required and highly valuable reading for us all."
Rob Bynder
Principal, Robert Bynder Design

"A great overview of all of the issues that designers need to know to be in business."
Nathan Shedroff
Author of *Making Meaning* and *Experience Design*

"Shel Perkins has brought together the key insights and techniques every designer needs, whether they work from a spare room or a Madison Avenue cubicle. Use this book religiously: you'll have more energy for what matters most — creativity."
Bill Camarda
Read Only

Talent is not enough:
business secrets for designers

Shel Perkins

Talent Is Not Enough: Business Secrets For Designers, Second Edition
Shel Perkins

New Riders
1249 Eighth Street
Berkeley, California
94710 USA
+1.510.524.2178
+1.800.283.9444
+1.510.524.2221 fax

Find us on the Web at: www.newriders.com
To report errors, please send a note to errata@peachpit.com

New Riders is an imprint of Peachpit, a division of Pearson Education

Acquisitions Editor: Michael J. Nolan
Project Editor: Valerie Witte
Copy Editor: Kim Wimpsett
Proofreader: Kim Wimpsett
Production Editor: Hilal Sala
Indexer: Rebecca Plunkett
Cover design: Shel Perkins
Interior design: Shel Perkins

ISBN-13: 978-0-321-70202-9
ISBN-10: 0-321-70202-6

9 8 7 6 5 4 3 2 1

Printed and bound in the United States of America

Disclaimer

This book provides information about the law to help designers safely cope with their own legal needs. However, legal information is not the same as legal advice — the application of law to an individual's specific circumstances. Although care has been taken to make sure that this information is accurate and useful, it is recommend that you consult a lawyer if you want professional assurance that this information, and your interpretation of it, is appropriate to your particular situation.

Trademarks

Many of the designations used by manufacturers and sellers to distinguish their products are claimed as trademarks. Where those designations appear in this book, and Peachpit was aware of a trademark claim, the designations appear as requested by the owner of the trademark. All other product names and services identified throughout this book are used in editorial fashion only and for the benefit of such companies with no intention of infringement of the trademark. No such use, or the use of any trade name, is intended to convey endorsement or other affiliation with this book.

Table of contents

Preface to second edition

Let me start by saying how extremely gratified I am at the very warm reception that the first edition of this book received. It garnered positive reviews in the design press and enthusiastic word-of-mouth within the creative community. It has been adopted as required reading in many design schools across the country, and it now sits on the reference shelf in many studios.

I've had many phone conversations and e-mail exchanges with readers. I've also had opportunities to give conference presentations based on topics addressed in the book and engage in lively Q&A sessions with audiences. I've enjoyed all of these interactions, and the great feedback I've received has guided me in the preparation of new content. In this expanded second edition, you'll find fresh information on managing cash flow, planning your facilities, hiring student interns, managing large projects, and forecasting your firm's workload and finances. In addition, I've revisited all of the original chapters and added updated information wherever needed.

As everyone knows, a lot has changed in the overall economy during the four years since the first edition of this book was published. The global recession has caused many clients to cut back on budgets. Competition for good projects has increased. Employment opportunities for creative professionals have been harder to find. All of this has placed even more emphasis on the vital importance of solid business skills for designers. With that in mind, my goal in preparing this revised and expanded second edition has been to make the book even more useful to you as you move forward in your career. Please let me know whether I have succeeded!

Introduction

The work that we produce as designers has always been well documented. Every museum shop is stocked with glossy magazines and coffee table books that showcase innovative design. All of these show just one side of the profession. They focus on external, client-facing issues — the creative challenges that we take on and the solutions we deliver. In contrast, little information is available about the internal, operational issues sometimes referred to as "professional practices."

The design community needs more information on internal business issues, particularly for people who are just starting their careers. The majority of young designers now enter the profession as graduates of design degree programs. Most colleges do a good job of nurturing talent, teaching technical skills, and guiding the development of portfolios. However, many degree programs do not teach professional practices. The unfortunate result is that many graduates hit the streets each year with good portfolios and lots of enthusiasm but absolutely no idea how to determine pricing, negotiate fair contracts, and avoid common tax problems. It takes more than talent to sustain a design career. Long-term success requires both creative ability and business acumen.

In the working world, it has been traditional for designers to acquire business skills the hard way — by making mistakes. Many new design firms go out of business after just a few years, not because anything is wrong with the quality of the creative work being produced but because of inadequate business practices. Sometimes it's hard for design entrepreneurs to know where to turn for reliable advice. Professional practice insights are not often shared directly between competitive firms, and small companies often can't afford the services of outside business advisors. Because of this, creative firms tend to re-invent the wheel when it comes to daily business practices. This can lead to serious problems for innocent designers who inadvertently re-invent some key aspect of labor law or tax accounting. Not only is this trial-and-error approach wasteful and unnecessary for individual companies, but, in a larger sense, it holds the entire profession back.

This book addresses a broad range of vital business issues for designers. It draws upon my own experiences as a working designer and creative manager, and those of the established creative firms with whom I collaborate. I will continue to explore these important issues in my consulting work and teaching, and I'll continue to write about them — in fact, watch for free bonus chapters to be posted from time to time on the site: www.talentisnotenough.com.

The structure of this book

In assembling this book, one of the biggest challenges has been to sort out many topics that are largely inter-woven and place them into one logical sequence. In arranging the chapters, I've chosen to cover topics in the order in which they arise over the course of a designer's career. This means that each new chapter builds in some way on the chapters that precede it, and a number of important topics (such as pricing) come up more than once. Each time a topic reappears, a different aspect of it is explored. This iterative structure will be clear to those who read the book from cover to cover. However, the book is also designed to serve as a quick reference for readers who are pressed for time. A detailed index is included to help you find specific information very quickly. In addition, many chapters list Web sites, industry associations, and publications that will be useful to you if you want to do further research.

As the table of contents indicates, the chapters have been grouped into four general sections. Here's a sneak preview of what you'll find in each section:

Career options
If you haven't yet selected your career path, this section will help you understand the many options available to you. It describes different ways to make a living as a creative professional, and it examines the key differences between a career as a designer and one as a fine artist.

Within the field of design, there are a number of different creative disciplines and work environments. If your plan is to become an employee — either in a consultancy (such as a design studio or an advertising agency) or in an in-house design department — you'll find lots of useful job hunting advice here.

On the other hand, you might decide that you don't want to be on anyone's payroll. Many people choose to remain independent and work on projects as freelancers. Most often, this involves assignments received on a subcontract basis from established design firms. To help you understand this type of relationship, a sample independent contractor

agreement is included. It clarifies many issues related
to independent contractor status and ownership of
the work being produced.

This first section ends with a review of personal income
tax requirements for independent contractors and
a recommended process for calculating a freelance
billing rate.

Small business
Many designers who start their careers as freelancers
discover that they really like being their own boss. They
start thinking about moving away from subcontracting,
going after corporate clients directly, and perhaps hiring
a friend or two to help with the increased workload.

If you decide to grow a freelance practice into a small
design company, you'll go through a series of growing
pains. This section of the book covers the essentials of
establishing and sustaining a successful firm. It will help
you choose the right legal format for your company,
register a business name, become an employer, and stay
on the right side of the law when it comes to business
licenses and taxes.

To stay afloat, your company will need a constant stream
of appropriate new assignments. To accomplish this, time
and money must continually be put into new business
development. This section includes tips for effective
marketing and self-promotional activities. Chances are
that most of your client work will be done on a fixed-fee
basis, so you'll find detailed instructions here for calculating
a fixed fee and preparing a compelling proposal document.
You'll also find information about other revenue models
for creative services, including such things as licensing
fees and royalties.

Each time you land a client assignment, you must strive
to keep the work on schedule and on budget. As every
design professional knows, this can be difficult. To help
you succeed, the essential elements of smart project
management are discussed in detail.

To round out this section on small business basics, you'll find a guide to bookkeeping fundamentals and an introduction to the various types of business insurance that your company will need.

Legal issues

Unfortunately, designers are often naïve or ill-informed when it comes to legal issues. In the working world, no one else is going to look out for our interests — we have to do it for ourselves. This section covers many important legal issues that apply to creative services. It includes an explanation of intellectual property rights (including copyrights, trademarks, and patents) plus a discussion of defamation and the rights of privacy and publicity (which are particularly important if you're working in advertising or publishing).

These and other legal issues come into play when you're negotiating contracts with clients. You can set yourself up for serious problems if you sign a contract without completely understanding the fine print. To help you avoid the most common pitfalls, this section includes the full text of the latest AIGA Standard Form of Agreement for Design Services. AIGA (formerly the American Institute of Graphic Arts) is the leading professional association for designers in the United States. This important reference document consists of recommended contract language, definitions of key terms, and suggestions for successful contract negotiations with clients.

This section closes with a few thoughts about the important ethical challenges and social responsibilities facing the design profession today.

Large firms

Over time, each successful small business will have opportunities to grow into a large business. You don't have to expand your operations if you don't want to. However, if you decide to become a larger firm, be prepared to face an entirely new series of growing pains. You'll be working with larger client organizations. Projects will

become larger and more complex, requiring you to develop a broader range of resources. You'll face the challenge of building and guiding larger and more diverse design teams.

With more people on board and more money at stake, you'll need to develop additional expertise in business planning and financial management. It will become more important to establish long-range targets and benchmark your financial performance against key indicators for your type of firm. All of these issues are discussed here.

As the firm grows, you'll be getting other people involved in new business development, and eventually you'll hire at least one full-time salesperson to represent your company in the broader business community. This will raise many issues about the evolving role of the founder and the need to develop a second generation of management. Effective long-range business planning includes thinking about ownership transition. Eventually, the founder of the company needs to create and implement a smart exit strategy — a way to extract some of the value that has built up in the firm over the years. This will provide cash for retirement or for launching other ventures. You'll find detailed information here about the process of valuing and selling a creative business, along with some tips for making a successful transition to the proud new owner.

Last but not least, this section on large firms comes to a close with a discussion of the challenges faced by design managers who are working inside large client organizations as leaders of in-house departments. In many respects, this closing chapter is a summation of all that has preceded it.

A resource for your career
In writing this book, my goal has been to provide an essential resource to the design community on professional practice topics. No matter what stage of your career you're at, I hope you find this book to be one of your most important tools for success.

Chapter 01:
Making a living as a
creative professional

Every year, thousands of hopefuls seek to enter the design profession without quite knowing what it's all about and without having a clear understanding of how a design career is different from that of, say, a fine artist or an illustrator. If you're getting ready to write a big tuition check to enter a design degree program or if you've just graduated and are wondering what to expect in the working world, read on!

Creative careers

If you're a creative person, there are many possible outlets for that creativity — ranging from music to fashion, from architecture to filmmaking. More specifically, if you're interested in visual communication, you may be attracted to a career in fine art, photography, illustration, or design. However, it's important to understand that each of these visual career options fits a different personal temperament. All of them involve the creation and use of images, but they are not the same in terms of psychology and work process. It's important to choose the one that's right for you.

Fine art

Fine artists tend to work alone, selecting their own themes and setting their own standards. The work is all about personal exploration and self-expression. If you choose a career in fine art, you'll be able to set your own schedule, and you'll have sole control over your output. Once you are satisfied with a piece, such as a painting or a sculpture, it's finished and will not change after it leaves your hands. To build a successful career, you must enjoy working independently and be good at motivating yourself to get work done. Your income will be generated through the sale of individual items, so you must produce a sufficient quantity of pieces and do a good job of calculating unit prices. Most sales of fine art are made through galleries on a consignment basis. The gallery takes a large commission on each transaction. Some fine artists also pursue grants to support personal projects. The money, which usually comes from non-profit foundations or government agencies, is a subsidy — it does not have to be repaid. Understandably, there is intense competition for fine art grants.

Photography and illustration

The careers of some photographers and illustrators are centered on fine art as well — particularly those individuals who create personal images to sell through galleries or who generate personal projects like limited-edition books. However, many more photographers and illustrators accept commercial assignments from business clients. Producing work that meets the needs of a client is very different from producing work just for you. Commercial clients specify the imagery, size, and media, and you must meet whatever technical specifications are required for the use or reproduction

of the work. You must be comfortable in accepting feedback and making any requested revisions. Budgets and schedules must be respected, and, all along the way, you must communicate effectively with the client and keep them happy.

To get assistance in lining up commercial assignments, you may want to establish a relationship with an agent (sometimes called an "artist's rep") who will promote your services and then negotiate the price and terms of each project on your behalf. In exchange, he or she will take a commission. You might also have opportunities to generate licensing income if you have retained ownership of your commercial images and they can later be used in additional ways.

Design
Unlike fine art, the focus of design is not on self-expression or the exploration of personal issues. Being a professional designer means solving business and communication problems. You are providing expert advice and strategic services to clients to help them succeed in a competitive environment. The impact and results of your work will be measured by multiple sets of criteria — both yours and the client's. Each project must meet high aesthetic standards, but it must also meet specific business objectives. Most professional design assignments span several different media such as print, online, or broadcast. This means that most assignments require a multi-disciplinary team. Projects evolve through an iterative process of multiple design directions and refinements, so you need to be very comfortable with the give-and-take of close collaboration.

There are different ways of structuring teams and different ways of charging for design services. If you are a freelancer who is subcontracting with an established creative firm, meaning that you've been brought in on a short-term basis to help with someone else's project, you'll be paid a freelance rate. If you accept a staff position as part of a creative team, you will negotiate a payroll rate. However, when you're selling services directly to a business client, it's common for design projects to be negotiated on a fixed-fee basis. Some designers are also able to generate income from licensing. Again, this assumes that you have developed and retained ownership of intellectual property, such as product designs or software applications, for which there is additional demand.

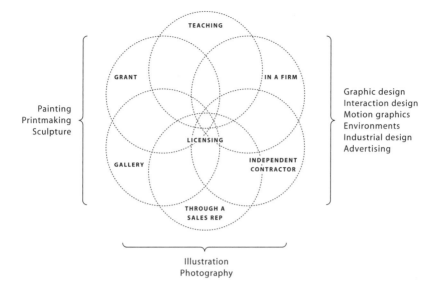

TEACHING

GRANT IN A FIRM

Painting
Printmaking
Sculpture

LICENSING

GALLERY INDEPENDENT
CONTRACTOR

Graphic design
Interaction design
Motion graphics
Environments
Industrial design
Advertising

THROUGH A
SALES REP

Illustration
Photography

Teaching

For some individuals, teaching might also be a career option, but chances are that it will not be full-time. Most schools of art and design bring in working professionals to teach specialized courses on a part-time basis. This approach has several benefits. It gives students access to the latest information and techniques. It also gives them opportunities to develop their personal networks, perhaps learn about internships or freelance gigs, and maybe even meet a potential employer. For these reasons, it's common for instructors of art or design to teach in addition to their client-related activities. Figure 01.01 shows an overview of possible income sources.

Figure 01.01. There are several ways for creative professionals to generate income. Each source of income tends to relate most closely to certain career paths. However, teaching and licensing opportunities could be available to all.

Design skill sets

If you're interested in becoming a professional designer, you must possess five essential skill sets:

Talent

The first requisite is talent. You must have an instinctive ability to exercise good judgment in manipulating the formal elements of visual communication such as contrast, scale, color, pacing, and typography. You must be able to use them effectively to develop new and appropriate visual solutions to complex communications problems. If you don't

possess this creative ability, or the potential to develop
it over the course of your education, then you are not cut
out to be a designer.

Methodology
The second requirement is to become familiar with the
current methodology in your creative discipline — the steps
and processes that support the production of good work.

Technical skills
The third requisite for a successful career is technical exper-
tise — mastery of the current tools that are necessary to pro-
duce and implement your solutions. Technical skills
are a moving target because design tools are constantly
changing. For example, twenty years ago, the tools of
graphic design included T-squares, stat cameras, waxers,
and Rapidograph pens. Eventually all of those went out
with the trash. Today's basic tools are primarily digital,
including such things as QuarkXPress, Adobe InDesign,
Illustrator, Photoshop, and Acrobat, as well as Dreamweaver
and Flash. However, twenty years from now these in turn
will be gone — replaced by even newer tools. This means
that each of us must constantly work to expand our technical
skills and stay on top of new developments.

People skills
The fourth requisite is a solid set of interpersonal skills. This
means being a good listener and a good verbal communica-
tor who is able to build and sustain positive and productive
relationships with others. It means being able to establish
and maintain mutual respect. It means having a positive
outlook and exhibiting grace under pressure. These positive
qualities will motivate others to seek you out. Co-workers
will want to have you on their teams, and clients will want
you on their accounts. Career opportunities will be severely
limited for any designer who is perceived to be a lone
wolf — defensive, territorial, uncooperative, or difficult
to understand.

Business skills
The final essential skill set for a designer is business savvy.
In order to advise our clients, we need to clearly understand

their business challenges, trends, and options. On each new account, we have to come up to speed very quickly. We also need to be just as smart when it comes to our own marketing, financial, and management issues. Business savvy is what makes our careers sustainable over the long haul.

Range of design disciplines
The field of design is quite large, spanning many different disciplines. This creates a bit of a paradox. A good designer must be enough of a generalist to see the big picture and develop strategies that are comprehensive, but at the same time he or she must be a specialist in one particular design discipline in order to execute strategy successfully at a tactical level. Each individual component of a system must be delivered in well-crafted detail. Ultimately, of course, it's not possible for one person to know and do everything. You must choose an area of concentration based on your talent and interests and then keep sight of how that piece fits into the larger strategic puzzle. For freelancers and sole proprietors, this means developing personal expertise in a specific area and developing a network of peers in complementary disciplines with whom you can collaborate on an as-needed basis. Larger design firms are able to hire individuals in a range of creative specialties, putting them together in multi-disciplinary teams. Together, they are able to plan and execute comprehensive systems with components that span as many different environments and media types as necessary. Depending on the firm and the nature of the client work being done, the following disciplines may be represented:

- Design planning and research
- Corporate identity design
- Communications and collateral design
- Publication and editorial design
- Brand identity and packaging design
- Advertising and promotion design
- Information design
- Interaction design
- Motion graphics design
- Environmental design
- Industrial design

Different team roles

In addition to bringing your specialized design skills to the group, you will also be functioning in a particular team role. Depending upon the project challenges, teams might include individuals in the following roles:

- Strategists
- Designers
- Implementation specialists
- Programmers
- Project managers

There are other possible roles as well, and some people wear more than one hat. In a small firm, it's likely that you will switch back and forth between roles from one project to the next. In a large firm, however, your role may be less flexible.

Potential employers

The next step in planning your design career is to decide whether you want to be part of an in-house creative department, join an outside consultancy, or remain independent. You need to choose the environment where you'll be most comfortable and will be able to do your best work.

In-house department
Many designers accept staff positions within client organizations. If your goal is to become part of an in-house creative team, there are many large businesses that hire design employees on a regular basis, including:

- Publishing houses
- Entertainment companies
- Broadcasting companies
- Online businesses
- Major corporations

Staff designers are often responsible for maintaining an existing identity system and making sure that there is creative consistency in all materials produced. In-house teams tend to work on recurring projects. Key assignments often come back on an annual cycle that reflects seasonal promotions and major industry events. One of the biggest

advantages of working inside a large organization is the opportunity for ongoing collaboration with product managers and marketing executives. For a young designer, this is an incredible chance to participate in long-term strategy development and to see creative challenges from the client's side of the table. Another advantage that should not be overlooked is that, because of its size, a large company is often able to offer a more extensive benefits package as well as some degree of job security. One negative aspect is that you may have to deal with corporate politics. In a large company, there's always a certain amount of tension between departments over resources, budgets, and decision-making authority.

Outside consultancy
Working in a design firm or an advertising agency is a great option for a young designer because it involves a wide variety of creative assignments from clients in different industries. It's also a great way to learn the ropes. You'll have a design mentor plus you'll learn about business practices and pricing. Corporate clients buy a range of creative services from outside consultancies. Most creative firms position themselves as specialists in a particular discipline, such as corporate and brand identity, marketing and communication systems, public relations, advertising, technology services, interactive design, or industrial design. Many advertising agencies belong to large holding companies that are publicly traded. In contrast, most design firms are small and privately owned. In fact, it's estimated that half of the design firms in the U.S. have five employees or less. Even larger design firms rarely have more than fifty employees.

Your own company
Finally, you may decide that you don't want to be on anyone else's payroll. You can choose to remain independent. In the U.S., the Bureau of Labor Statistics keeps track of employment trends in a wide range of occupations. Their information indicates that three out of ten designers are self-employed, compared to one out of ten in the overall workforce. Anyone who chooses to be self-employed must come up to speed on a range of important small business issues, including financial management and the basics of

business law. In addition to producing great design, you're also responsible for all of your own marketing and sales. Your long-term success will be very dependent upon the amount of personal networking and self-promotion that you do.

Staying flexible

At the start of your career, it's important to get yourself onto the path that is the best match for your interests, talents, and temperament — one that will give you opportunities for personal growth and satisfaction. Once you're on that path, though, it's also important to stay flexible and remain open to new opportunities. The design profession has changed significantly in recent years, and it is continuing to evolve. Larger economic shifts are taking place as well. The U.S. economy is moving from being manufacturing-based to knowledge-based, and employment is shifting from permanent staffing to short-term projects that use independent contractors or temporary workers. This places a growing emphasis on expertise, peer networking, collaboration, and technology. Designers are at the cutting edge of all this. Success requires brainpower, entrepreneurship, and flexibility. As you advance in your career, always look ahead and keep a broad view.

Chapter 02:
Job hunting

If you're looking for a staff position with a creative firm, the information in this chapter can help you move toward that goal. It includes tips on preparing your job search materials, researching job opportunities, and developing a network of personal contacts in the profession. It also includes real-world advice on interviewing well and making a successful transition from school to professional life.

What are you looking for?

To be happy in your career, you need to seek work that closely matches your interests and abilities. Think about the kind of firm that you would like to join. Each firm is focused on specific creative services and will tend to have clients that are clustered in certain industries. These have to be of interest to you. Within that firm, what kind of position do you want to hold? Chances are that you want to be doing hands-on graphic design, interaction design, industrial design, or a similar creative activity. You might be a bit flexible on the exact responsibilities of the positions that you apply for, but they must still be on your chosen career path. Be careful about taking a position that's not related closely enough, because it can easily redirect your career. You also don't want to join a firm under false pretenses. If you jump at the first position that opens up in one of your target firms with the assumption that you can somehow shift your job responsibilities after being hired, you're setting yourself up for failure. Whatever position you're hired for, that is in fact the work that you must perform.

Getting your career off to a successful start requires making an honest assessment of your own strengths and weaknesses. To move forward, you need to possess the necessary qualifications for the type of position that you want. It may be that you're not currently prepared for your dream job. You might need to develop additional skills or learn new tools before you'll be viewed as a strong candidate. If you decide that you need further academic training, be careful to choose an educational program that has a great reputation. When you apply for positions, potential employers will review your portfolio and evaluate your abilities. However, you may find that additional doors will open if you're a graduate of one of the leading degree programs. It will speak well of your abilities, and it will allow you to tap into an alumni network.

You should also be aware that some firms hire generalists while others hire only specialists. A generalist is a jack-of-all-trades who knows the basics of several disciplines (for example, print, interactive, and three-dimensional design)

Figure 02.01. Most designers are educated as generalists and then go on to become specialists over the course of their working careers.

Generalist

Know the basics of several disciplines

Print	Web	3-D	Other

Specialist

Deep expertise in a single discipline

Print	Web	3-D	Other

without necessarily having extensive experience in any of them. In contrast, a specialist has much deeper expertise in just one area (see Figure 02.01).

New graduates from design degree programs tend to be generalists — it's the natural result of completing degree requirements. A wide variety of courses with instructors from different fields will lead to a student portfolio that's broad but not deep. This broad training can be good preparation for working in small firms that sometimes need to be flexible in what they provide to clients. You might have clients in different industries facing very different business challenges. Occasionally, one of them will request a service that you haven't provided before (such as motion graphics or a trade show booth). You'll be expected to pitch in and do what you can.

However, if a large firm hires you, it's more likely that you'll be part of a team that is very focused on just one type of work. The creative director of that team will serve as a mentor, helping you to gain deeper expertise in that one area. Within a couple of years, you'll be a specialist. Keep this in mind when selecting firms that you would like to join.

Preparing for your search

If you're currently in a design degree program, you have access to your school's computer lab. Once you graduate, however, that access will end. Plan ahead by buying your own computer and printer and establishing your own Internet access and e-mail account. Next, start preparing the materials that you need for your job search. Each

potential employer will see a number of different items from you. All of the materials you provide must work together as an integrated system and project the right professional image — what management consultant Tom Peters calls "the brand you."

Stationery system
You need a personal stationery system. The components must be consistent in terms of design and in terms of paper stock. The complete system should include the following items:

- Business card
 You'll be handing out lots of these. Your card should be distinctive, but, at the same time, it's a good idea to stay close to standard sizes and materials. Odd sizes (above 3½ x 2 inches in the U.S.) won't fit well into wallets or Rolodexes. Unusual materials such as plastic or metal can make it very difficult for the recipient to turn the card over to write a note about you on the back. These are important issues for job hunters.
- Letterhead
 This will be preprinted with your name and full contact information. When finalizing your design, remember that it must scan and fax clearly, so you'll want to avoid hairline rules and the use of pale ink colors for important text.
- Second sheet
 This must be the same paper stock as your letterhead, but usually nothing is preprinted on it. You need these blank sheets for correspondence of two or more pages. In long documents, only the first page will be on letterhead.
- Business envelope
 The most common business envelope fits a sheet of letterhead that has been folded into equal thirds. (In the U.S. it measures 9½ x 4⅛ inches and is referred to as a "number ten" commercial envelope.)
- Mailing label
 You need an adhesive label that can be applied to large packages or mailing tubes.

Traditionally, stationery systems have been professionally printed in large batches using offset lithography. Now, however, you also have the less expensive option of printing out small batches on your own color printer, provided that no part of the image needs to bleed off the edge of the

sheet (and that your desktop printer is of sufficient quality).
If you're using paper that has a slight texture on one
side, you should feed it through the printer so that your
information is applied to the smooth side (otherwise,
small type may become hard to read).

As soon as your stationery system is ready, put it to use
by drafting a résumé, a cover letter, and a thank-you letter.

Résumé
This is a one-page summary of your background and
qualifications. It must include your name, full contact
information, work experience, skills, and education. If you
print it on your letterhead, your name and contact informa-
tion will already be on the sheet. If you have a Web site,
include the URL. You don't have to use the word "résumé"
at the top, but if you do, it's correct to include both accents
(unless you set the word in all caps).

There are several different ways to organize the content
of a résumé, but many employers prefer a chronological
format because it tends to be the easiest to read. List your
most recent position first, and then work your way back in
time. Give employment dates, company names and locations,
job titles, key responsibilities, and major accomplishments.
Near the bottom, list your software skills and any awards
that you've won.

Be completely honest. Don't exaggerate any aspect of
your training or experience because these facts will be
checked during the hiring process. In describing your
background and abilities, be sure to use action verbs
(like "planned," "implemented," "developed," "created,"
and "produced"). They indicate in a subtle way that you're
a proactive person with energy, ideas, and initiative.
Candidates who are perceived as passive or dependent
will be at a definite disadvantage.

Use a clean, easy-to-read layout. For the sake of brevity,
it's OK to use lists with bullet points. Good résumés are
essentially typographic. There's no need to incorporate
images. Don't include anything that's not relevant to the
job, such as family activities, obscure hobbies, or pets.

And, for legal reasons, do not include your age, gender, race, national origin, religion, a physical description, or a photo of yourself — these might expose you to illegal discrimination in the hiring process. Also, don't add the names of personal references — wait until they're requested later in the hiring process.

If you list work experience outside of the design field (such as a summer job that you had as a student), you need to explain how it's relevant. What did you learn that would carry over to this creative position? For example, was the work team-based or deadline-driven? Did you gain skills in client management? If you're a recent grad with no work experience at all, add more details about your education. Highlight particular courses, well-known instructors, or academic achievements that are relevant in some way to the work that you're seeking.

In addition to the printed version of your résumé, prepare an e-mail version to use when responding to online listings. Put all of your information into the body of the e-mail itself. There's no way of knowing exactly what e-mail system each recipient might have. For your message to display properly, it should be text only. This poses a creative challenge. You have to make it look good while using only basic type formatting and paragraph breaks. Be sure to include keywords that match the vocabulary used in the online job listing. This is important because many large firms now use software to filter messages received from job applicants. For example, if the job listing mentioned "press checks" or "XML coding," the software will screen out any responses that do not include those keywords.

Don't attach any files to your e-mail unless the company states that attachments are acceptable. To avoid viruses, many corporations have a strict policy against opening files sent to them by strangers. If it's OK to send an attachment, be sure that the title of the file includes your name (for example, Mary_Brown_resume.pdf).

Lastly, before sending out your résumé, whether it's printed or electronic, take time to proofread it very carefully. It helps to have a friend look at it as well.

Cover letter

You should never send out your résumé without a cover letter. If you're sending the e-mail version, add a block of introductory text. Whenever possible, address the letter to one particular individual at the hiring company. This requires identifying who's responsible for the search, learning that person's job title, and verifying the correct spelling of his or her name.

Your cover letter should be no more than one page in length. The purpose is to make clear the connection between the job requirements and your qualifications. State which position you're applying for, and then briefly explain why you're right for the job. Customize the text as much as you can by referring to specific elements in the job listing. Let them know how your experience and skills will benefit their company. Refer to any enclosures that you're sending, and state how you'll follow up (for example, with a phone call or an e-mail on a specific day or by dropping off your portfolio). Close your letter by expressing gratitude to the prospective employer in advance for his or her courtesy in reviewing your qualifications.

Thank-you letter

The next use of your stationery will be for sending a thank-you letter. You need to have a basic format prepared in advance so that it's easy to update and send quickly. Do this whenever you've had a personal interaction with someone, such as a telephone conversation or an interview. It's polite and professional to follow up promptly. In the text of this letter, express your appreciation for the time and personal attention given to you by the individual. If the interaction was a job interview, briefly reiterate why you believe you're a good fit for the position, and clearly restate your interest in joining the team. If you met with more than one person, send a letter to each one. The letters should not be identical. Also, if you're sending this as an e-mail message, be sure to include a signature block at the end with your full name and contact information.

Portfolio

To land a hands-on creative job, you must have an outstanding portfolio that demonstrates the quality of your thinking

as well as your form-giving abilities. The specific contents and formats of design portfolios vary quite a bit from one creative discipline to another. Regardless of your field, though, you should tailor the contents to fit the needs of each prospective employer. This means that you must carefully research each firm in advance to determine what kind of editing might be necessary.

Keep in mind that most studios and agencies have a drop-off policy. They may require you to leave your portfolio at the reception desk and then return to claim it a day or two later. You won't be there to explain any of the projects, so be sure that everything is self-explanatory. Because of this, there has been a trend away from box-type portfolios filled with loose samples. Most designers now use a case study format. This usually resembles a book, with spreads about each project. The portfolio itself becomes an exercise in publication design, with selected images or tabletop photos of completed projects, along with captions and explanatory text. For each project, you should:

- Identify the client
- Explain the business or communication challenge that they were facing
- Describe the solution you developed
- Explain how well it succeeded — quantify the results of the project by describing the impact that the finished work had on the client's business

Organize your portfolio content in such a way that it's easy for the viewer to navigate back and forth at will. Usually, this involves grouping the work into categories, adding some sort of pagination or tabs, and developing a table of contents. For projects that were produced by a team, identify the key members, and explain your role within that group.

When you drop off your portfolio, be sure to include a cover letter printed on your stationery and an extra copy or two of your résumé. Some job seekers also include a small leave-behind item that can be added to the company's files. It might be a postcard or a small booklet with selected images from the portfolio. However, be cautious about wacky self-promo items. It's best to let the quality of your portfolio

speak for itself. Any correspondence or other items that you drop off with it should be business-like. Novelty items or personal gifts (such as T-shirts or food) are not professional.

Web site
You also need to set up an online version of your portfolio. Creating a Web site will take time, but it doesn't have to be expensive. Many Internet service providers offer package deals for hosting small sites, including the ability to send and receive e-mail using your Web address. When placing files on your site, remember that search engines cannot read text that's integrated into graphic files or Flash animations. To make it easy for people to find you, be sure your contact information is somewhere on your site in a searchable text format.

If you've developed Web sites for clients, don't just list the URLs. Your portfolio should include images of those projects with captions. Again, sort the work into categories, and make it easy for the viewer to navigate back and forth. Your goal is to keep prospective employers on your own site for as long as possible. If they follow a hyperlink to a client site that you designed some time ago, they may encounter something that no longer resembles what you delivered. The quality of the site may have slipped under the direction of other people. If prospective employers see a bad site, they'll assume that you were responsible. They'll quickly move on to another candidate instead of returning to see more of your work.

When developing your online portfolio, be aware of download times. Keep them as short as possible. Before making the site available to the public, test it thoroughly to make sure everything displays exactly the way you want it to and that visitors won't receive any error messages. You should also use META tags on your pages (keywords included in the HTML source code for the header sections — these are indexed by some, but not all, search engines). One final bit of advice: this is a career-related site, so keep it professional. Don't mix in family photos or vacation stories. They're irrelevant to your job search and could easily alienate potential employers.

Conducting your search

Think of your search as a full-time job in and of itself.
Establish good daily habits to make sure that you're
spending the time and effort necessary for success.
You need to pursue more than one lead at a time. You
should also be open to the idea of relocation to another
city for the right job. Your search may take several weeks
or months, so it's important to keep track of all the leads
that you've pursued. Set up a simple tracking system
for yourself that includes:

- How you became aware of the opportunity
- The job title and description
- Anything you know about the compensation
 and benefits
- The name of the primary contact for the
 selection process
- Dates and descriptions of each interaction with
 the company (e-mails, phone calls, et cetera)
- A record of any materials that need to be returned
 to you, such as portfolio items

Your tracking system should include a simple calendar for
follow-ups. Be persistent about pursuing each opportunity
(but, of course, not to the point of having companies
regard you as a pest).

Overview

So, how do you find out about jobs that are currently open?
There are a number of different ways, but some are more
effective than others are.

In the design community, the best way to learn about
opportunities is through personal networking. It's said
that more than half of the positions at agencies and design
studios are filled in this way. Most designers hear about job
opportunities through friends before the position has been
advertised anywhere.

Second in effectiveness is to respond to direct recruitment
ads on company sites. This is a good way to find out about
in-house positions because corporate HR (human resources)
policies often dictate that job openings be advertised.

Simultaneously, these notices may be placed as classified ads in industry publications. To stay on top of these job listings, haunt the sites of the companies you're interested in, and watch the newsstand for the latest issues of key publications.

A smaller number of people find positions through headhunters. Entry-level staff positions are rarely listed with recruiters because design firms have plenty of recent grads approaching them directly. However, companies often seek help in filling senior positions because headhunters maintain extensive professional networks. They are often aware of strong potential candidates who aren't actively looking to make a change but who might be interested in switching jobs if approached discretely.

The least effective way to find a design job is through one of the huge general online job boards. These have lots of listings, but many are not current and very few are for creative positions. Even when an appropriate listing does come along, the competition will be overwhelming — you'll be one of several hundred people responding.

Now that we've done a very quick overview, let's go back to discuss some of these job search strategies in greater detail.

Personal networking
If the most effective way to find a design job is through personal networking, how do you go about developing contacts within the profession? The best way to do this is through professional associations. Do some research to identify the leading organizations in your own creative discipline. Many of them have local chapters, making it very easy for you to get involved. As a reference, here are some of the most prominent membership organizations for creative professionals in the U.S.:

- AIGA, the professional association for design (formerly the American Institute of Graphic Arts) *www.aiga.org*
- Industrial Designers Society of America *www.idsa.org*

- Graphic Artists Guild
 www.graphicartistsguild.org
- Society of Illustrators
 www.societyillustrators.org
- Society of Publication Designers
 www.spd.org
- Society for News Design
 www.snd.org
- Type Directors Club
 http://tdc.org
- Art Directors Club
 www.adcglobal.org
- American Association of Advertising Agencies
 www2.aaaa.org
- American Advertising Federation
 www.aaf.org
- Society for Environmental Graphic Design
 www.segd.org
- Broadcast Designers' Association
 www.promaxbda.org
- ACM SIGGRAPH
 (Association for Computing Machinery,
 Special Interest Group on Computer Graphics)
 www.siggraph.org
- ACM SIGCHI
 (Association for Computing Machinery,
 Special Interest Group on Computer-Human Interaction)
 www.sigchi.org
- Information Architecture Institute
 http://iainstitute.org
- Usability Professionals' Association
 www.upassoc.org
- National Art Education Association
 www.naea-reston.org
- College Art Association
 www.collegeart.org
- University and College Designers Association
 http://ucda.com
- American Society of Media Photographers
 http://asmp.org
- Professional Photographers of America
 www.ppa.com

When you find the right organization, become a member. This will get you onto their mailing list for newsletters and events. It's important to attend as many of their events as possible because each one is a great networking opportunity. Don't be shy. Arrive early, and socialize with as many people as possible. Marketing people call this "working the room." As you meet new people, keep the conversations fairly short. Let them know who you are and what you do. Whenever it feels comfortable, present your business card. With luck, they'll make a note on the back about how they met you (and perhaps your creative specialty) and then place it in their Rolodex.

In your conversation, if it turns out that there is some useful news or information that you can send to them afterward (such as a recent article about one of their clients or updated contact information for a mutual friend), follow up promptly by e-mail. When you do, be sure to add a signature block with your full contact information so that it can be easily added to their electronic address book.

Attending events is just the start. You can meet more people by becoming a volunteer and helping the organization to produce their events and publications. This will take you behind the scenes and allow others to see your creative and collaborative skills in action. Show them just how bright, talented, hardworking, and dependable you are.

To build your personal network, you need to have the mind-set that everyone you meet is important. There's no way of knowing what role each new person might play in your career. Make a good first impression. You want to be perceived as smart, friendly, professional, and upbeat. Each time that you meet someone in your field, look for opportunities to stay in touch in a non-obtrusive way. Share news that's relevant to his or her activities. Watch for occasions to send congratulations about awards and major accomplishments. To build genuine relationships, remember that it's not just about you. Help others with their careers whenever you're in a position to do so. If a project or a job

opening comes along that's not quite right for you, pass
the information along to others who might be a better
match. They will appreciate it.

Online listings
In addition to personal networking and reading ads in
industry publications, you'll be looking for work online.
Spending time on job boards can be frustrating because
many of them are cluttered with out-of-date listings for
positions that have already been filled.

When a new listing appears, you need to respond promptly.
Send your information within one week of the posting
date. If more time than that has passed, the employer will
have moved on in their hiring process. The typical cycle for
employers looks like this: a week or two of advertising, then
a week or two spent screening applicants and conducting
telephone interviews, followed by a couple of weeks of
in-person interviews and negotiations, after which the
hire is completed.

When you submit applications online, often you won't
receive any acknowledgment that your information was
received. Many large sites use software to screen candidates,
so it's very important for each application to incorporate
the keywords used in the job listing itself. Most online job
boards are free, but they require candidates to go through
a registration process. Instead of allowing you to simply post
your résumé, many require you to complete a questionnaire.
This allows them to standardize all candidate information
in a searchable database. Be cautious about the personal
information that you provide. To protect yourself against
hackers and the possibility of identity theft, do not provide
your Social Security number, date of birth, or any personal
financial data. After registering with job sites, you may begin
to receive marketing messages and spam. To minimize this,
you may want to give job sites an e-mail address that you
can later cancel after you've landed a job. Also, some sites
have a limited posting period for candidate information.
If you're still on the job market after several months, you'll
need to re-register if your original listing has expired.

Some job sites are general, while others are industry-specific. For creative positions, it's best to start with sites that are specific to design. Here are several that are hosted by industry publications and professional organizations:

- Creative Hotlist
 www.creativehotlist.com
 (This site is hosted by Communication Arts magazine. You can search design jobs by region, category, and industry. You can also post portfolio files.)
- AIGA Design Jobs
 www.aiga.org
 (AIGA members can search this national job bank by state and category, and post portfolio files.)
- IDSA Employment
 www.idsa.org
 (This site features many industrial design job listings.)
- SEGD Job Bank
 www.segd.org
 (The listings here focus on environmental graphic design.)
- Adweek Classifieds
 www.adweek.com
 (This is a searchable database of jobs in design, advertising, and public relations.)
- HOW Job Bank
 www.howdesign.com
 (HOW magazine hosts this searchable database of national listings.)
- Coroflot Jobs
 www.coroflot.com
 (This is a searchable database of U.S. and international job listings, primarily for industrial designers. You can also post portfolio files.)
- Graphic Artists Guild JobLine
 www.graphicartistsguild.org
 (Members of the Guild can sign up for a weekly e-mail listing of staff positions and freelance opportunities.)
- Ad Age Career Center
 http://adage.com
 (This publication has classified listings, mostly for advertising and public relations jobs.)

- American Advertising Federation
 www.aaf.org
 (The AAF maintains an online job bank.)
- Talent Zoo
 www.talentzoo.com
 (This site features advertising jobs and industry news.)

If you're specifically interested in corporate in-house positions, look for job listings directly on individual company sites. Many Fortune 500 companies also have links to this shared employment directory:

- JobCentral
 www.jobcentral.com
 (The Direct Employers Association is a consortium of employers. This search engine links directly to listings on individual corporate sites.)

At this point in your job search, if you haven't found any listings that interest you, the next step might be to begin visiting large, general job sites. If you do, keep in mind the drawbacks mentioned above. General sites include the following:

- Monster Jobs
 www.monster.com
 (This site promotes itself as having more than one million job postings and tens of thousands of résumés. You can set up automatic notification of new listings that meet criteria you define.)
- CareerBuilder
 www.careerbuilder.com
 (This site has some listings for advertising and graphics. You can block particular companies from seeing your résumé. This is a great feature if you don't want your current employer to know that you're thinking of leaving.)
- Craigslist
 www.craigslist.org
 (This is more of an online community, with lots of people looking for apartments and romance. It does include chronological job listings by area and category, but few are design-related.)

- Yahoo! HotJobs

 http://hotjobs.yahoo.com

 (This site has national job listings by category. You can set up automatic notification of new listings that meet your criteria, and you can block particular companies from seeing your résumé.)

In addition to the paid listings that it receives directly from employers, Yahoo! HotJobs has developed a search feature that checks for listings on other sites. A similar service is available from these companies:

- Simply Hired

 www.simplyhired.com

 (This specialized search engine indexes help-wanted listings from hundreds of sources. You can filter the results using many different criteria.)
- Indeed

 www.indeed.com

 (This is another specialized search engine that checks for listings on other sites.)

When you spot a job listing that interests you, your next step should be to research that employer. Visit their Web site for background information including their size, services, and clients. Do a search on Google for recent news stories about them. Many design firms also have profiles in online business directories such as the following:

- Core77 / BusinessWeek Design Firm Directory

 www.designdirectory.com

 (Profiles can be searched by name, location, or design specialty.)
- The Firm List

 www.firmlist.com

 (This is an international directory of Web design and development firms.)
- Agency Compile

 www.agencycompile.com

 (You can search marketing and advertising agencies by type, location, size, or client industries.)

- Adweek Directory
 www.adweek.com
 (Limited information is available for free. Payment
 is required for the full directory, which contains
 detailed profiles of more than 6,000 agencies,
 PR firms, and media buying services.)

Headhunters

Companies with senior positions to fill often contact
creative recruiters. When a recruitment firm is managing
a search, the employer pays the fee for their services.
Although the amount is usually calculated as a percentage
of the first-year base salary for the position being filled,
there is no charge to candidates or new hires. There
are two different financial models for headhunters:
"contingency" recruiters get paid only if they successfully
make a placement, whereas "retained" recruiters get part
of their fee up front. This retainer compensates them
for going through the search process, even if a hire
is never made. For a creative manager with a very heavy
workload, it can be a godsend to have a professional
recruiter take over the search process. However, when
creative firms are not busy, there's more than enough time
for them to conduct searches on their own. For this reason,
the use of headhunters tends to decline whenever there's
a downturn in the economy. Less hiring is done overall,
and when positions do open up, companies find candidates
without assistance.

Recruiters function as matchmakers. They take care of all
screening and testing, which can be very labor-intensive.
They also maintain their own databases of qualified
candidates. If a position needs to be filled quickly, an
initial group of qualified individuals can sometimes be
produced within a matter of days. In general, headhunters
are not looking to add recent grads to their databases.
They prefer to represent individuals who are further along
in their careers. This is because filling senior positions
generates larger fees. If a headhunting firm does take
you on as a candidate, they will provide you with expert
feedback and guidance regarding your portfolio, résumé,
interviewing skills, and career strategy. They will also
handle all negotiations for salary and benefits.

Each search is covered by a written agreement between the employer and the recruitment firm. Usually, the contract stipulates that the headhunter's fee must be paid if the employer hires a referred candidate for any position at all within an extended period of time, usually one year. It also includes a guarantee that additional candidates will be provided for no additional fee if a new hire is fired or quits within the first few months of employment.

Recruitment firms tend to specialize in filling permanent staff positions. However, some also function as temp agencies or brokers for freelancers. A temp agency sends individuals out on short-term assignments. The individual hands in timesheets and is paid directly by the agency at an agreed-upon hourly rate.

To learn more about recruitment firms, do some research online. You'll find that some headhunter sites only provide a description of services, but others include detailed listings of all positions currently available. To help you with your research, here are several of the best-known recruitment firms in the design community:

- Roz Goldfarb Associates
 www.rgarecruiting.com
- RitaSue Siegel Resources
 www.ritasue.com
- Aquent
 http://aquent.us
- Janou Pakter Inc.
 www.pakter.com
- Wert & Company
 www.wertco.com
- iCreatives
 www.icreatives.com
- Filter Talent
 www.filtertalent.com
- The Creative Group
 www.creativegroup.com
- Syndicate Bleu Creative Talent
 www.syndicatebleu.com

Next steps

OK, now you've identified an open position that interests you, made initial contact with the company, and given them a chance to review your portfolio. If they're interested in you, they'll ask you to come in for an interview. The next steps in the process look like this:

First interview

You will not be the only candidate interviewing for the position. To beat out the competition, you need to practice your interviewing skills. Your portfolio has already shown the quality of your work, and your résumé and cover letter have shown your writing abilities. Interviewers are looking for an open, positive personality; good interpersonal dynamics; and the right kind of chemistry for their company. They will be wondering how well you work under pressure and how well you'll fit into the team.

Chances are you'll be nervous. The best way to overcome nerves is to be well prepared. Do some additional research on the company. Find out more about their history. You want to ask informed questions about their business, not make a bad impression asking about things that you should already be familiar with.

You can also prepare for the standard job interview questions they will have for you. Expect classic questions like "What didn't you like about your last job?" and "What was the biggest mistake you ever made on a job and how did you fix it?" You should also be prepared for the trick question "What do you want to be doing five years from now?" When you explain your career goals, be careful to focus on objectives that relate in some way to the position you're interviewing for. Employers will be reluctant to hire you if they believe that your real goals lie elsewhere.

Think about the clothing that you'll wear to the interview. It's important to dress appropriately for each firm. Styles of dress vary quite a bit from firm to firm. You may want to speak to friends who are familiar with the company, or perhaps do some discrete surveillance the day before to determine whether the staff wears blue jeans or Prada.

On the day of the interview, bring extra copies of your résumé. Arrange your schedule so that you will arrive early. Never be late — you don't want them to cancel your appointment and move on to the next candidate. Before you enter the building, turn off your mobile phone (and throw away your chewing gum). Be nice to everyone you encounter — the woman walking through the parking lot might be the founder, or the guy standing in the lobby might be the human resources director. When you check in with the receptionist, you may find that there's a little bit of paperwork for you to do before the meeting. Some creative firms ask candidates to fill out a standardized job application form (it's a requirement of most employment practices' insurance policies).

In the interview itself, even though you're nervous, don't let yourself dominate the conversation. Try to spend as much time listening as you do speaking. When answering questions, be concise, honest, and upbeat. Don't rehash any old gripes about past employers or clients. Make it clear that you are a positive and productive person. Emphasize how your skills can benefit the company and contribute to their continued success.

In many instances, your first interview will be with an individual, either a team leader or an HR director. At some point, you will also meet with your potential co-workers. In large firms, this is usually reserved for the second interview because it's expensive for the company to pull several people away from billable client projects.

Be aware of your body language. Make eye contact, shake hands confidently, and smile. You want to be perceived as comfortable, open, and responsive. Don't send negative signals by physically closing in on yourself. Even though you may be shy, don't cross your arms over your chest, hang your head, or stare at the floor.

It's best to avoid negotiating compensation in the first interview. If asked, share information about your salary history, but don't go on to haggle over starting salary or benefits at this firm. Wait for the second interview to discuss compensation. If you concentrate on money too soon, it can give the wrong impression. The first priority

for you and for the firm should be to find a good fit in terms of skills and personality. Money is important, but it's not at the top of the list.

At the end of the interview, close with enthusiasm. State again how excited you are about the position. As soon as you get home, follow up promptly with a thank-you letter or e-mail. It's proper business etiquette, and it's an opportunity to provide any additional information that the employer may have requested.

Basic background check
If a company is interested in you as a candidate, they will verify the information that you gave to them on your résumé and in your interview. This fact checking will include your employment and salary history and your education and degrees. At this point in the process, they will also ask you to provide personal references.

Personal references
The hiring firm will want to speak with professionals who are familiar with your abilities and attitude and who can describe how well you function under pressure. When asked for references, it's acceptable to provide a list of names, but it's much better to provide letters. If possible, provide three letters that are no more than one year old. A good letter could be from a past supervisor, a co-worker, or an assistant (if you're interviewing for a leadership role). You might also have a letter from a vendor or a client who knows you well. When you provide contact information to the potential employer, give all of the references a quick call to let them know that they might be contacted.

Second interview
If you're called back for a second interview, be prepared to discuss compensation. The job listing itself may have stated a salary range, but it's helpful to have some outside points of reference. In the course of your job search, you will have collected some classified listings that stated what the starting salary would be. However, this information is a bit random, which means that it may not be representative. Do some additional research into current salary levels and standard benefits so that your expectations will be realistic.

You don't want to ask for a salary so high that it will kill your chances of getting the job. At the same time, if you lowball your request, it may lock you into a salary that will be very difficult to adjust upward in any significant way over the course of your employment.

Salary surveys
The best way to research compensation is to find salary surveys. Start with data that's available for free from the U.S. government. Annual income for a wide range of occupations can be found on this site:

- U.S. Department of Labor, Bureau of Labor Statistics
 www.bls.gov/oco
 (The BLS maintains the Occupational Outlook Handbook, which is a searchable database of information about hundreds of careers.)

Government information is not always the most current, however. For the latest data, you'll have to turn to industry sources such as professional associations and trade publications. For example, salary and benefits surveys are conducted by the following groups:

- AIGA / Aquent
 www.aiga.org
- HOW magazine / The Creative Group
 www.howdesign.com
- Industrial Designers Society of America
 www.idsa.org
- Association of Professional Design Firms
 www.apdf.org
- Association of Registered Graphic Designers of Ontario / Aquent
 www.rgdontario.com

Salary information for many creative disciplines can also be found online by using search engines. Type in the name of your design discipline plus "salary survey" or "wage survey"

or "median earnings." Be careful, though, when you read the results. All salary surveys are not created equal. In general, you should have these concerns:

- How large was the sample?
 (The larger the better so that the results can be broken out by region, job title, and level of experience.)
- How current is the information?
 (Data complied within the last twelve months is best so that you don't have to guess at how things have changed.)
- How reliable is the source?
 (Some Web sites use salary data to attract traffic, but they're very vague about where the information came from. If you can't determine the date or sample size, there's a good chance that the numbers are not representative and cannot be relied upon.)

Mean versus median

Look for surveys that calculate a median instead of a mean. The difference between the two is something that you probably learned in high school but may have forgotten since graduation. Here's a quick description of each to jog your memory.

"Mean" is another word for average. Let's say that you have the following set of numbers: 1, 2, 3, 4, and 500. To calculate the mean, you add them together to get a total of 510 and then divide by 5, which is the number of items in the set. The result is 102. It's important to note that, in a salary survey, the mean can be distorted if an individual response is significantly higher or lower than the rest.

You can avoid this kind of distortion by looking at the median instead. A "median" is the midpoint in a series of values. At the median, half of the values are higher and half are lower. If we return to our example of 1, 2, 3, 4, and 500, we see that 3 is the midpoint. The median is a much more realistic number to use as a basis for salary negotiations.

Other compensation issues
In the past, most design firms paid their employees base salaries only. More recently, many have added incentive programs. In these firms, base salary levels are high enough to be competitive and attract strong candidates, but no higher. This is to save room for variable pay — extra earnings that will be paid only if specific business targets are hit. Incentive bonuses may be tied to particular projects, specific client accounts, or the overall performance of the firm. A well-thought-out incentive plan can be a powerful motivator for employees. It can also allow the firm to flex payroll expenses in a way that is tied to profitability.

In your discussions with the hiring firm, you might also want to ask about their system for performance reviews and salary adjustments. Many large firms follow a strict annual cycle based on the date of hire. Often, annual adjustments are calculated in two parts — one portion reflects the quality of your job performance, and the other portion is a cost of living adjustment. A cost of living adjustment (often abbreviated as COLA) is necessary for your earnings to keep pace with the inflation rate in the overall economy. Without it, you'd be losing ground in terms of purchasing power. Cost of living adjustments are usually based on the twelve-month consumer price index (CPI) that is tracked by the federal government. Again, this type of economic data can be found on the BLS site:

• U.S. Department of Labor, Bureau of Labor Statistics
 www.bls.gov/cpi

A more extensive background check
If a company is negotiating a starting salary, it's clear that they're pretty serious about you as a candidate. At this point in the process, it may be their policy to do a more extensive background check. The results would include your credit history, any bankruptcy filings, and any type of criminal record. This practice is less common in small studios, but it's standard procedure for many large agencies and corporate in-house departments. When companies seek this type of information about accounting candidates and security guards, they often seek it for all positions so that the process is not seen as discriminatory. However, a company can only

conduct a more extensive background check if they have received the candidate's consent. You may already have signed a form authorizing additional information gathering. Many employers include this request for consent in their standard application paperwork.

Legal guidelines have been established for such background checks. For example, the federal limit on retention of consumer credit information is seven years, so any financial information that's reported will not be older than that. Standards for employment screening are included in the Fair Credit Reporting Act, which is administered by the Federal Trade Commission (FTC). For more information about this, visit their site:

- Federal Trade Commission
 www.ftc.gov/credit

Most employers do not have the time or experience necessary to conduct an extensive search on their own. Instead, they use a paid service to gather the information. One of the largest background-checking companies is:

- ChoicePoint / LexisNexis Employment Screening
 www.lexisnexis.com/risk/screening.aspx

If a decision not to hire you results from negative information found through a background check, the employer is required by law to provide you with the results and give you an opportunity to dispute them. Incorrect information might be due to such things as confusion over similar names, data entry errors like transposed digits in your Social Security number, or outright identity theft. At any rate, you have the right to set the record straight.

Extensive background checks raise a number of important concerns about the intrusion of Big Brother into our private lives. More information about these issues is available from nonprofit consumer rights organizations such as:

- Privacy Rights Clearinghouse
 www.privacyrights.org

Final hurdles

It's not common in design consultancies, but prior to hiring, some corporate employers may require a urine sample for drug testing. Many design firms and advertising agencies will, however, test your production skills if you're being hired for a position that requires mastery of certain software applications. Finally, don't be surprised if the first offer to you is in the form of a paid freelance assignment. The company may want to collaborate with you on one project as a kind of test-drive.

You're hired

To complete the hiring process, you'll be given a written job description and some form of employment agreement. In small firms, the agreement may be rather short. In larger firms, it will be a more detailed document.

It should include clarification of your employment status (temporary or regular, part-time or full-time, and exempt or non-exempt from overtime). Unless the company is unionized, your agreement will not be for a fixed period of time. Instead, it will include a statement of "employment at will." This means that you can be fired at any time and for any reason, as long as the reason is not illegal. Similarly, you have the right to resign at any time for any reason. You will also be asked to acknowledge that all original work produced within the scope of your employment will be considered "work made for hire" under U.S. copyright law (for more information about intellectual property, see Chapter 17). Your employment agreement will also include a nondisclosure section to protect confidential information that you will learn about your employer's company and about your clients' businesses.

Figure 02.02. Creative risk taking is encouraged in education but often avoided in the world of business.

Other general employee guidelines and policies may be provided to you in the form of a printed employee handbook or made available on a company intranet site. After hiring,

INNOVATION ○ ○ ○ ○ ○ ○ ○ ○ ○ ○ CONVENTION

Schools

Corporations

you will have a certain amount of time to come up to speed and become a productive team member. Usually, this initial orientation period lasts three months. If you don't catch on quickly enough and the employer is unhappy with your performance, you could find yourself job hunting all over again!

The transition from school to the professional world
One of the challenges that recent grads face when entering the working world is the fact that client assignments are very different from academic assignments. In general, professional projects involve many more constraints, including some that are related to the type of design language or visual vocabulary that can be used. Creative activity can be regarded as a continuum, with innovation at one end and convention at the other (see Figure 02.02). Innovation includes wild, crazy, risky stuff that has never been seen before. Convention includes various types of visual communication that have been around for a while. We know how they work and in what situations they are most effective.

Most design schools are clustered at the innovation end of the spectrum. Schools often pride themselves on being a protected place for experimentation, a laboratory where entirely new and volatile things can be developed without pressure from commercial interests.

When you're hired by a company that sells creative services — whether it's a design firm, an advertising agency, or another type of studio — you'll learn quickly that they do not work in that kind of isolation. Business clients tend to be positioned closer to the conventional end of the spectrum — particularly large, publicly traded companies. They avoid taking big risks on unconventional communications because failure would not be taken lightly by their shareholders. For example, most banks come to designers

Figure 02.03. Design competitions give students a lopsided view of what is being produced.

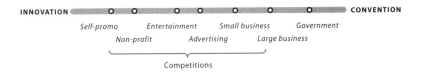

INNOVATION | CONVENTION

Self-promo Entertainment Small business Government
 Non-profit Advertising Large business

Competitions

asking for Times Roman, navy blue, and pinstripes. They know that a buttoned-down image works well in their industry because it communicates tradition and security.

Within the design profession, the most experimental work tends to be produced by small creative firms working with small client companies that are privately owned. Unexpected things can happen when both client and designer are risk-seeking and are not afraid of an occasional misstep. Large organizations, however, tend to be risk-avoiding. Global clients prefer to hire big international agencies for the security of large creative teams using extensive market testing to validate every concept. Such clients feel that too much is at stake to do otherwise.

Within each design studio, however, there may be individual projects that fall at different places along the continuum. Self-promotional pieces for the studio can be quite experimental because the design team is serving as its own client. Projects for non-profit clients often have some creative freedom built in as the trade-off for little or no payment. Entertainment clients often support innovation, such as the exciting work being done for computer game companies. Advertising clients are usually selling mainstream products, but they often commission edgy campaigns to appeal to young consumers. Small businesses are sometimes more willing to try new things than large businesses. The government tends to be the most conservative client of all.

This is not to say that one kind of work is good while the other kind is bad — it's a matter of finding the visual style most appropriate to the challenge at hand. It's OK for a skateboard magazine to be laid out in a radical way, but not a prescription drug label or a freeway sign. New types of visual communication are being developed all the time. When an innovation comes along that is really useful, it will gradually be absorbed into the mainstream. Over time, it becomes conventional.

As a recent grad, you may not be aware of how much conventional work is done by the profession. Your own personal aesthetic may have been shaped by the most recent design annuals. You need to know that competitions

are pretty heavily weighted toward innovation (see Figure 02.03). Studios do not enter the conventional work that they do for conservative clients. They enter the wilder stuff done for non-profits and for self-promotion. Edgier work wins awards because it appeals to juries of design insiders who, quite honestly, can be a bit jaded. For most design studios, the business reality is that award-winning projects are subsidized by profits from more conventional assignments, the bread-and-butter work that makes up the bulk of the workload. As a new hire, don't be surprised if you're asked to work on a navy blue pinstripe type of account.

Chapter 03:
Independent contractor issues

Freelancing for design firms and agencies is a great way to gain experience, expand your professional network, and grow your portfolio. That's the good news. The bad news is that it's not unusual for a freelancer to get into legal and financial trouble as a one-person business. This chapter explains the IRS definition of an independent contractor, reviews the benefits that self-employed people have (and do not have), and gives useful advice about the essential documents that define freelance relationships.

Many designers seek full-time staff positions, but it's also possible to build a very successful career as a freelancer. In fact, the U.S. Department of Labor reports that three out of ten designers are self-employed. Some independent designers work directly with business clients, submitting fixed-fee proposals for specific projects. Others prefer to work behind the scenes as an additional resource for established creative firms. Most design firms and agencies cope with temporary increases in their workload by bringing in outside designers on a subcontractor basis (see Figure 03.01). A freelancer with very specific skills is brought in to help with a particular phase or aspect of a project, and the freelancer is usually paid a negotiated hourly rate.

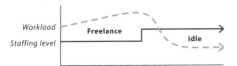

Figure 03.01. Design firms bring in freelancers when workload exceeds staffing levels. If the volume of work continues to be steady, it might trigger a hiring decision. However, there is always concern that a subsequent dip in workload could leave some employees idle.

If you are doing freelance work, remember that you are a one-person business. Design firms and agencies will make gross payments to you — that is to say that no taxes or other amounts will be withheld. You are responsible for all of your own taxes, insurance, and other business issues. Without a clear understanding of this, it's easy to get into trouble — particularly with the Internal Revenue Service (IRS).

The IRS pays special attention to independent contractor relationships. Unfortunately, it's not unusual for hiring companies to deliberately misclassify workers as freelancers rather than employees in order to avoid paying employer taxes. To determine whether an independent contractor really should have been put on the payroll, the IRS looks at twenty factors relating to behavioral control, financial control, and the overall nature of the relationship between the parties. A general overview of these issues can be found in IRS publication 1779, "Independent Contractor or Employee," which can be downloaded from www.irs.gov as a PDF file.

I will list the factors themselves below (along with some notes about how they might be applied to design):

IRS 20 common law factors

1. No instructions.
 You are being brought in as an expert who will quickly understand what needs to be done.
2. No training.
 You are already fully trained.
3. Services don't have to be rendered personally.
 If you have your own staff, they might work on the project instead of you.
4. Work not essential to the hiring firm.
 Your clients should already have core resources appropriate to the business they are in.
5. Set own work hours.
 As a business owner, you should have some flexibility in determining your schedule.
6. Not a continuing relationship.
 Your work is project-based rather than open-ended, so there may be gaps between assignments from any given client.
7. Control your own assistants.
 If you have staff, they report to you rather than to your clients.
8. Time to pursue other work.
 You need to balance your involvement in active projects with the ongoing marketing activities necessary for your business.
9. Decide on job location.
 When not in meetings or presentations at the client's office, you should be able to work on client assignments in your own studio or home office if you choose to do so.
10. Order of work set.
 You should have some control over the specific sequence of actions that you will perform.
11. No interim reports.
 Your work should be measured in terms of specific milestones and deadlines, rather than blow-by-blow accounts of your activities.
12. Paid by job.
 Your assignments should be individual projects, and you may be compensated on a fixed-fee basis.

13. Work for multiple firms.

You should have more than one client at any given time.

14. Pay business expenses.

As a business owner, you pay for your own insurance, taxes, and other expenses.

15. Have your own tools.

You should already own whatever equipment and supplies are necessary for you to do your work.

16. Significant investment in your business.

For designers, the purchase of computer equipment and software is a significant investment.

17. Offer services to general public.

If a stranger needed the kind of services that you provide, would they be able to find you?

18. Can make an entrepreneurial profit or loss.

If you have not priced or managed projects correctly, your business might not be profitable.

19. Can't be fired at will.

This is in contrast to staff members who have signed at-will employment agreements — their positions can be eliminated at any time for any reason or no reason at all. Your work should be project-based with some agreed-upon method for giving notice of cancellation and calculating any final payments that may be due.

20. No compensation for non-completion.

Client payments tend to be contingent upon your successful completion of specific tasks.

When you use these factors to analyze your own situation, you may find that your answers are a bit contradictory. Some things might point toward an employer/employee relationship, while others support your independence. It's important to understand that no single factor will determine your status. All of the factors need to be weighed against each other as if on a scale. The IRS will look to the majority of evidence. With this in mind, you need to be prepared by structuring and documenting your activities in such a way that the weight comes down on the side where you want it to be.

Your small business

It's a good practice to separate your business income and expenses from your personal finances. Opening a business bank account makes this easier. Like any small business,

you will also need to consult with a CPA for tax advice and the preparation of your tax returns. Since you are not on anyone else's payroll, be aware of these issues related to taxes and benefits:

Benefits you have
You will be covered by Social Security for the self-employed because it is required by law. You must pay both the employer and employee portions. Your CPA will help you calculate the amounts and meet the deadlines.

Benefits you don't have unless you provide them
- Vacation and sick time
- Unemployment insurance
- Workers compensation insurance
 The requirements for workers comp vary by state, but it is usually not required until you hire another person to work with you.
- Disability insurance
- Health insurance
- Life insurance
- Retirement plan

Independent contractor agreement
When you perform freelance services for a design firm, a number of different documents will be generated over the course of the relationship. Your relationship will start with a general document called an independent contractor agreement. All large design firms and agencies will have one that they ask you to sign before any services are performed (for a sample, see Chapter 04). Typically, this agreement needs to be discussed and signed only once because its purpose is to describe the underlying nature of the relationship, rather than to describe any single project.

The wording of the agreement will vary a bit from firm to firm. The essential contents will include the following: a reiteration of your status as an independent contractor (including the fact that you are responsible for your own taxes and business expenses), a commitment on your part to maintain the confidentiality of all information shared with you, a guarantee from you that the work you deliver

will be original and will not infringe on the rights of any
third parties, and an assignment by you of intellectual
property rights. An assignment means that you are granting
all rights to the design firm.

Intellectual property rights are negotiated differently when
you provide services directly to business clients. There's a
good reason for this. Design firms need to acquire all rights
from their team members — whether employees or free-
lancers — because they in turn will be selling some or all
of those rights to their business clients. Obviously, design
firms cannot sell that which they do not own.

Work-for-hire
Instead of asking you to assign all rights, the design firm
may seek to acquire them through the use of work-for-hire
language in the written agreement. Work-for-hire (also
referred to as "work made for hire") is part of U.S. copyright
law. The standard definition of work-for-hire is a work
created by an employee as part of his or her job. Copyright
belongs to the employer, who is recognized as the legal
author. (One implication of this is that a departing employee
should always ask before taking anything that might be
considered intellectual property. Even though you have
created something, you need your employer's permission
before you can add it to your portfolio.)

There is a second definition that is important to freelancers.
Work-for-hire can also include a work specially ordered or
commissioned, if the parties agree in writing that it will be
considered a work-for-hire and if it falls within one of nine
categories (for more information about intellectual property,
see Chapter 17). Work-for-hire language might show up
once, in the independent contractor agreement signed at the
beginning of the relationship, or it may be stated separately
on each project purchase order that is issued to you.

Some firms might also attach an addendum or exhibit to
the basic independent contractor agreement to describe
the type of services that you will be providing and how you
will be compensated. It's more common for that information
to appear later, in project purchase orders.

Form W-9

The last of the new relationship documents that you need to complete and sign is a form W-9. Each design firm and agency that subcontracts work to you will provide you with a blank one (it can also be downloaded from www.irs.gov). Your completed W-9 officially notifies the design firm what name and federal tax identification number (usually a personal Social Security number) should be used for you in their records.

Purchase orders

Now that you've been set up as a resource, assignments can be given to you. Design firms plan out project budgets very carefully. When a portion of a project is assigned to you, the details will be spelled out in a purchase order. The purchase order confirms specific information about the project, its schedule and deadlines, and your individual budget — probably stated in hours as well as dollars. In most design firms and agencies, the purchase order will be issued to you by a project manager or producer.

Invoices

As you perform services, you will periodically request pay-ment by submitting invoices. On large projects, you should negotiate to submit bills every week or two (for your own cash flow purposes it should never be less than monthly). You will appear as a vendor on the records of the design firm. All payments to you will be made through their accounts payable system, which means that there will usually be a delay of fifteen to thirty days. Individual invoices should reference the relevant project purchase orders, and can include whatever additional detail the design firm requests. However, you should not be asked to fill out the design firm's internal timesheets — it is only appropriate for their employees to do so.

Form 1099

At the end of each year, the design firms that you have worked with will add up the amounts paid to you (not the total of your billings to them, but the total of their actual checks to you). If they have paid you $600 or more during the calendar year, they must send you a completed form 1099-MISC by January 31. If you've worked on projects for

lots of different firms, you'll accumulate a big stack of
1099 forms. These forms are needed for tax preparation
and should always be kept with your tax documentation.
The IRS has already received duplicate copies, and that
information will be compared to what you file.

A few states have additional filing requirements related
to independent contractor relationships. You'll need to
check with your own state government to learn about these.
For example, California requires the company purchasing
freelance services to give the state advance notification
(by filing form DE-542) of individuals who will receive
more than $600.

Chapter 04:
Sample independent contractor agreement

Use an agreement like this when subcontracting with design firms and ad agencies. However, it should not be used when selling services directly to a business client. Instead, you should prepare a fixed-fee proposal that includes appropriate terms and conditions, as discussed in Chapter 11 and Chapter 19.

This services agreement ("Agreement") is made and entered into as of ... by and between ... ("Design Firm") and ... ("Contractor").

Design Firm desires to retain Contractor as an independent contractor to perform consulting services for Design Firm, and Contractor is willing to perform such services, on terms set forth more fully below. In consideration of the mutual promises contained herein, the parties agree as follows:

1. Services.

A. Contractor agrees to perform for Design Firm those services described in Exhibit A incorporated herein by reference (the "Services"). The parties may delete, add or substitute Services, extend the Term, or alter the terms of compensation by amending Exhibit A, provided that such amendment shall be signed by an authorized representative of both parties and shall indicate whether it is to replace or alter the then existing Exhibit A.

B. Contractor is authorized to perform the Services under this Agreement only upon the request or at the direction of, and shall report solely to, a Principal of Design Firm and/or his or her designee.

2. Compensation.

A. Design Firm agrees to pay Contractor the compensation set forth in Exhibit A for the performance of the Services ("Fixed Compensation"). Such Fixed Compensation shall be payable on the schedule set forth in Exhibit A.

B. Design Firm shall reimburse Contractor for reasonable pre-approved travel, living, and other expenses incurred by Contractor in connection with the performance of Services hereunder. All equipment and tangible materials purchased by Contractor and reimbursed by Design Firm under this provision shall be the property of Design Firm, and, upon request by Design Firm, Contractor shall assign ownership in, and deliver, any such equipment to Design Firm.

3. Intellectual property ownership.

A. To the extent that the work performed by the Contractor under this Agreement ("Contractor's Work") includes any work of authorship entitled to protection under copyright laws, the parties agree to the following provisions.

1. Contractor's Work has been specially ordered and commissioned by Design Firm as a contribution to a collective work, a supplementary work, or other category of work eligible to be treated as a work made for hire under the U.S. Copyright Act.

2. Contractor's Work shall be deemed a commissioned work and a work made for hire to the greatest extent permitted by law.

3. Design Firm shall be the sole author of Contractor's Work and any work embodying the Contractor's Work according to the U.S. Copyright Act.

B. To the extent that Contractor's Work is not properly characterized as a work made for hire, Contractor grants to Design Firm all right, title, and interest in Contractor's Work, including all copyright rights, in perpetuity and throughout the world.

C. Contractor shall help prepare any papers Design Firm considers necessary to secure any copyrights, patents, trademarks, or intellectual property rights at no charge to Design Firm. However, Design Firm shall reimburse Contractor for reasonable out-of-pocket expenses incurred.

D. Contractor agrees to require any employees or contract personnel Contractor uses to perform services under this Agreement to assign in writing to Contractor all copyright and other intellectual property rights they may have in their work product. Contractor shall provide Design Firm with a signed copy of each such assignment.

E. Contractor hereby waives any and all moral rights, including the right to identification of authorship or limitation on subsequent modification that Contractor has or may have in any materials or other deliverables assigned to Design Firm hereunder.

F. All of the provisions of this Section 3 shall be effective only upon full payment of all Fixed Compensation due pursuant to Section 2 and Exhibit A.

4. Originality and Noninfringement.

Contractor represents and warrants that the Work Product and all materials and Services provided by Contractor hereunder will be original with Contractor or its employees or contract personnel, or shall be in the public domain and that the use thereof by Design Firm or its customers, representatives, distributors, or dealers will not knowingly infringe any patent, copyright, trade secret or other intellectual property right of any third party. Contractor agrees to indemnify and hold Design Firm harmless against any liability, loss, cost, damage, claims, demands, or expenses (including reasonable outside attorney's fees) of Design Firm or its customers, representatives, distributors, or dealers arising out of any breach of this paragraph.

5. Confidentiality.

A. "Confidential Information" means the Work Product and any Design Firm proprietary information, technical data, trade secrets or know-how, including, but not limited to, research, product plans, products, services, customers, customer lists, markets, software, developments, inventions, processes, formulas, technology, designs, drawings, engineering, hardware configuration information, marketing, finances, or other business information disclosed by Design Firm either directly or indirectly in writing, orally or by drawings or inspection of parts or equipment.

B. Contractor and its employees and consultants shall hold all Confidential Information in the strictest confidence and shall not, during or subsequent to the term of this Agreement, use Design Firm's Confidential Information for any purpose whatsoever other than the performance of the Services on behalf of Design Firm. Confidential Information does not include information that (i) is known to Contractor at the time of disclosure to Contractor by Design Firm as evidenced by written records of Contractor, (ii) has become publicly known and made generally available through no wrongful act of Contractor, or (iii) has been rightfully received by Contractor from a third party who is authorized to make such disclosure. Without Design Firm's prior written approval, Contractor shall not directly or indirectly disclose to anyone the terms and conditions of this Agreement. Contractor may disclose

that it is "working with" Design Firm, but shall not otherwise characterize the nature or scope of the Services.

C. Contractor agrees that it will not, during the term of this Agreement, improperly use or disclose any trade secrets of any former or current employer or other person or entity with which Contractor has an agreement or duty to keep in confidence information acquired by Contractor in confidence, if any, and that Contractor shall not bring onto the premises of Design Firm any unpublished document or proprietary information belonging to such employer, person, or entity unless consented to in writing by such employer, person, or entity.

D. Contractor recognizes that Design Firm has received and in the future will receive from third parties their confidential or proprietary information subject to a duty on Design Firm's part to maintain the confidentiality of such information and to use it only for certain limited purposes. Contractor agrees that Contractor owes Design Firm and such third parties, during the term of this Agreement and thereafter, a duty to hold all such confidential or proprietary information in the strictest confidence and not to disclose it to any person, firm, or corporation or to use it except as necessary in carrying out the Services for Design Firm consistent with Design Firm's agreement with such third party.

E. Upon the termination of this Agreement, or upon Design Firm's earlier request, Contractor shall deliver to Design Firm all of Design Firm's property and Confidential Information in tangible form that Contractor may have in Contractor's possession or control.

6. Conflicting obligations.

Contractor certifies that Contractor has no outstanding agreement or obligation that is in conflict with any of the provisions of this Agreement, or that would preclude Contractor from complying with the provisions hereof, and further certifies that Contractor will not enter into any such conflicting agreement during the term of this Agreement.

7. Term and termination.

A. This Agreement shall be effective as of the date Contractor first performed the Services. This Agreement shall continue until the date specified in Exhibit A or termination as provided below ("Term").

B. Either party may terminate this Agreement without cause upon ten (10) days prior written notice to the other party.

C. If Design Firm terminates (except for Contractor's uncured material breach of this Agreement) Design Firm will pay Contractor for all services or expenses actually incurred up to the date of termination.

D. Sections 3 and 4 shall survive termination of this Agreement.

8. Assignment.

Contractor acknowledges that the consulting services to be performed hereunder are of a special and unique nature. Neither this Agreement nor any right hereunder or interest herein may be assigned or delegated by Contractor without the express written consent of Design Firm. Any such attempted assignment shall be void.

9. Independent contractor.

Contractor shall perform the Services hereunder as an independent consultant. Nothing in this Agreement shall in any way be construed to constitute Contractor as an agent, employee, or representative of Design Firm. Since Contractor is not an employee of Design Firm, it is understood that neither Contractor nor any of its employees is entitled to any employee benefits during the Term. Contractor shall pay all necessary local, state, or federal taxes, including but not limited to withholding taxes, workers' compensation, FICA, and unemployment taxes for Contractor and its employees. Contractor acknowledges and agrees that Contractor is obligated to report as income all compensation received by Contractor pursuant to this Agreement, and Contractor agrees to indemnify Design Firm and hold it harmless to the extent of any obligation imposed on Design Firm (i) to pay withholding taxes or similar items or (ii) resulting from Contractor's being determined not to be an independent contractor.

In the performance of all Services hereunder, Contractor shall comply with all applicable laws and regulations.

10. Equitable relief.

Contractor agrees that it would be impossible or inadequate to measure and calculate Design Firm's damages from any breach of the covenants set forth in Sections 3, 5, or 6 herein. Accordingly, Contractor agrees that in the event of such breach, Design Firm will have, in addition to any other right or remedy available, the right to seek to obtain from any court of competent jurisdiction an injunction restraining such breach or threatened breach and specific performance of any such provision.

11. Miscellaneous.

This is the entire agreement between the parties relating to the subject matter hereof and no waiver or modification of the Agreement shall be valid unless in writing signed by each party. The waiver of a breach of any term hereof shall in no way be construed as a waiver of any other term or breach hereof. If any provision of this Agreement shall be held by a court of competent jurisdiction to be contrary to law, the remaining provisions of this Agreement shall remain in full force and effect. Neither party shall have any liability for its failure to perform its obligations hereunder when due to circumstances beyond its reasonable control. This Agreement shall inure to the benefit of and be binding upon each party's successors and assigns. This Agreement is governed by the laws of the State of .. without reference to conflict of laws principles. All disputes arising out of this Agreement shall be subject to the exclusive jurisdiction of the state and federal courts located in County, .. , and the parties agree and submit to the personal and exclusive jurisdiction and venue of these courts.

In witness whereof, the parties hereto have executed this Agreement as of the day and year first written above.

For Design Firm:

Authorized signature..

Print name and title ..

Date ..

Address...

For Contractor:

Authorized signature..

Print name and title ..

Social Security or Federal Tax ID Number

Date ..

Address...

Exhibit A

Services to be performed by Contractor.
Contractor shall perform and Design Firm shall pay for the
following services: ...
...
...
...
...
...
...
...
...
...
...
...
...
...
...
...
...
...

Term.
The Term shall commence on the date hereof and
terminate on: ..

Fixed Compensation.
Design Firm shall pay the Contractor as follows (select one):
o Project rate of $.....................
o Day rate of $..................... / day
o Hourly rate of $..................... / hour
o Other $.....................

Invoice schedule.
Contractor shall invoice Design Firm as follows (select one):
o At the end of each week
o At the end of each month
o Upon completion of the project

Payment schedule.
Payment shall be made within thirty (30) days of Design
Firm's receipt of Contractor's invoice.

Accepted.
I have read and understand the above terms.

For Design Firm:

Authorized signature ..

Print name and title ..

Date ..

Address ..

For Contractor:

Authorized signature ..

Print name and title ..

Social Security or Federal Tax ID Number

Date ..

Address ..

Chapter 05:
Income taxes for freelancers

If you're new to freelancing, chances are that you have some questions about how to calculate and report your income taxes. This chapter covers the basics of income taxes for freelancers — from tracking typical business expenses and making quarterly estimated tax payments through filing your completed annual return. It also includes important information about the tax issues that are raised if your freelance business is not profitable.

Previously in your career, you may have been on someone's payroll. As you recall, they withheld estimated tax amounts from each of your paychecks and forwarded those amounts to the government on your behalf. Now that you are an independent businessperson, you are required to do that for yourself.

To start off on the right foot, visit the tax information site www.irs.gov and download the PDF file for publication 583, "Starting a business and keeping records." It's a good overview of tax issues for entrepreneurs.

Estimated tax payments

So, how does it work? As you go through the year, you'll be receiving payments from various clients for services performed. Consult with your CPA to determine the amount of state and federal tax that you owe on that income. Then, on a quarterly basis, you are required to make estimated tax payments. For federal income tax and self-employment tax (Social Security and Medicare), you must use form 1040-ES ("Estimated Tax for Individuals"). State income tax must be reported on the appropriate form for the state in which you live. Personal tax rates change every year. Individual income tax tables and tax rate schedules are published each year in the federal 1040 and state tax booklets. Be sure to check the booklets for the current rates.

Business expenses

The tax that you owe will be based on income minus "ordinary and necessary" expenses for the type of business that you're operating. For most freelancers, those expenses will include amounts related to the business use of your home. If you're reporting a home office to the IRS, your use of that space must be "exclusive and regular." That is to say that the space used for your business cannot serve any other purpose, and you must actually conduct your business there on an ongoing basis. Direct expenses that relate only to the business part of your home can be deducted in full. Indirect expenses for maintaining and operating the entire home can be deducted in a proportionate amount. Rent expense (or depreciation if you own your home) is determined by the percentage of your home's total area that is used for business. Unrelated expenses such as lawn care are not deductible.

Be aware that there are some limits to the amounts that you can deduct. In general, the IRS does not want you to show a loss resulting solely from the cost of the business use of your home. More detailed information can be found in IRS publication 587, "Business Use of Your Home," which can be downloaded as a PDF.

Most freelancers also report expenses that relate to business use of their personal car. There are two ways to calculate the value of this. This first method is to use the "standard rate" published by the IRS. The standard rate changes at least once a year (for example, the published rate at the start of 2010 was 50 cents per mile). You must keep a diary of business mileage, including the date, destination, and purpose of each trip. At the end of the year, you simply add up that business mileage and multiply it by the appropriate rate.

The second option is to value the business use of your car on an actual cost basis. This involves a bit more paperwork. On the first day of January, record the beginning odometer reading for the year. Then keep a diary of business mileage, with the date, destination, and purpose of each trip. On the last day of December, record the ending odometer reading for the year. From these numbers, you will calculate what percentage of the total miles driven during the year related to your business. Meanwhile, you must keep detailed records of all actual costs incurred during the year (insurance premiums, gas and oil expenses, repairs and maintenance, et cetera). On the last day of December, add up the dollar total of all expenses, and then apply the business mileage percentage to determine the deductible cost.

Additional information about both options can be found in IRS publication 463, "Travel, Entertainment, Gift and Car Expenses."

Deadlines
Your quarterly estimated tax deposits are due on April 15, June 15, September 15, and January 15. In most cases, they must add up to at least 90% of this year's liability or 100% of last year's liability, whichever is lower (see Figure 05.01). The IRS does charge fines for under-estimating, as well as interest on any late payments. If this

Actual amounts **Estimated amounts**

Total of prepayments must equal at least 90% of this year's liability *100% of last year's liability divided into four equal payments*

Figure 05.01. There are two options for determining the amounts of your quarterly prepayments of estimated income tax.

is your first year of freelancing, you'll have to work with your CPA to calculate the proper amount each quarter. After your first year, the process becomes much easier because you can simply divide the previous year's total by four (provided that this year's overall level of business activity is not significantly different).

By the end of January, all clients that have paid you $600 or more during the year just ended must provide you with an IRS form 1099-MISC ("Miscellaneous Income") that shows the actual total.

Your final, completed tax return for the year is due on April 15. It will show your total tax liability minus the four prepayments that you have already made. If it turns out that you owe a small additional amount, that must be paid when you file the return. (If for some reason you have overpaid, you can request a refund or carry the extra amount forward to be applied to next year's tax liability.) As a self-employed businessperson, you need to use the federal long form 1040 (and the state long form as well) and include the following attachments:

- Schedule C, "Profit or Loss from Business or Profession," including car expenses
- Schedule SE, "Computation of Social Security Self-Employment Tax"
- Form 8829, "Expenses for Business Use of Your Home"
- Form 4562, "Depreciation and Amortization," if you are reporting car depreciation

Be sure you have the cash
In order to make all the various tax payments on time, you'll need to keep enough cash in your business bank account.

A good rule of thumb is to set aside one third of each client payment that you receive during the year. In this way, you'll accumulate a tax reserve so that you won't have to scramble when you're on deadline to make tax payments. Paying the proper amounts at the correct times is essential for staying out of trouble!

Business versus hobby
What happens if your freelance business is not profitable? The IRS expects you to report a net profit in at least three out of five consecutive years. This is often called "the hobby test." If you're not able to meet this requirement, they will attempt to re-classify your creative activities as a hobby rather than a business. This is important because, if you are not recognized as a business, you will no longer be able to deduct business expenses from your taxable income.

If you have not been profitable in three out of five consecutive years, you will need to prove to the IRS that you are indeed actively engaged in business with a clear profit motive. In order to evaluate your situation, the IRS will look at nine profit motive factors. Here is a list of those factors (along with some notes about how they might be applied to design):

1. The manner in which the taxpayer carries on the activity.
 Are you diligent and business-like in seeking and completing projects?
2. The expertise of the taxpayer and his or her advisors.
 Do you and your collaborators have the design and implementation skills necessary?
3. The time and effort expended by the taxpayer in carrying out the activity.
 Is the majority of your time dedicated to making your design business successful?
4. Expectation that assets used in the activity may appreciate in value.
 You should be selling your projects for more than they cost you to produce them.
5. The success of the taxpayer in carrying on other similar or dissimilar activities.
 Have you been more profitable in some other line of work in the past?

6. The taxpayer's history of income or losses with respect to the activity.
 Could it be that your design business is only experiencing temporary losses due to relocation or repositioning?
7. The amount of occasional profits, if any, which are earned.
 Is it possible that a few good projects are profitable enough to offset the bad ones?
8. The financial status of the taxpayer.
 Are you wealthy enough that you do not need profits from your design work?
9. Elements of personal pleasure or recreation.
 Designers are passionate about their work and experience significant personal growth by taking on tough challenges. We are not Sunday painters — design is a problem-solving process and a highly customized professional service.

Chapter 06:
Calculating a freelance rate

Many designers spend part of their careers as freelancers — it's a great way to gain experience, build relationships, and develop a diverse portfolio. Some independent designers work directly with business clients, submitting fixed-fee proposals for specific projects. However, others prefer to work behind the scenes as an additional resource for established creative firms. If you are working behind the scenes, how should you go about calculating a fair price for your services?

Most design firms and agencies cope with temporary increases in their workload by bringing in outside designers on a subcontractor basis. A freelancer with very specific skills is brought in to help with a particular phase or aspect of a project, and the freelancer is usually paid a negotiated hourly rate (and reimbursed for any necessary project materials). The rate that you receive will be a gross amount — that is to say that no taxes will be withheld. As a self-employed worker, you are responsible for all of your own taxes and business expenses. For that reason, it's important to calculate an hourly rate that is based on your own situation. The process is not complicated — just follow these simple steps:

Add up your expenses
Start by adding up all of your annual business expenses (see Figure 06.01 for an overview). If you've been freelancing for a couple of years, this is easy — just look at Schedule C from the federal income tax return that you filed last year. However, if you're new to freelancing, you'll need to prepare a worksheet with estimated amounts. Do some research to make the estimates as realistic as possible, and be sure to include a reasonable salary for yourself — one that honestly reflects your skills and your level of experience. (As a reference, look at the annual survey of design salaries published by AIGA, the professional association for design.) A complete list of your annual business expenses will look something like this:

General expenses
- Office rent and utilities
 (If you work from a home office, these will be prorated amounts.)
- Office telephone and Internet access
- Office supplies
- Liability insurance
- Advertising and marketing expenses
- Business travel and client entertainment
- Legal and accounting services
- Business taxes and licenses
- Depreciation
 (If you purchased any furniture, fixtures, or equipment during the year, add just one year's worth of depreciation to the list, rather than the full purchase price.)

Labor expenses

- Salary

 (This must be a competitive wage that is adequate to cover your personal expenses such as home rent or mortgage — the portion that does not relate to your home office — food and clothing, personal travel, and recreation.)

- Health insurance
- Other employee benefits
- Employer taxes

This calculation includes all of your general business expenses — it does not include the purchase of outside services or materials that relate to just one project. If you buy printing, photography, or special materials for a specific project, those expenses would not be factored into your hourly rate. Instead, the costs would be marked up and then billed to the client separately.

Figure 06.01. Start to think of the business as being larger than yourself as an individual. It will have many expenses in addition to the living wage paid to you as an employee.

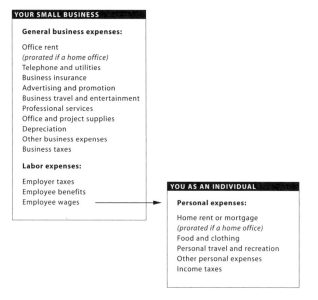

YOUR SMALL BUSINESS

General business expenses:

Office rent
(prorated if a home office)
Telephone and utilities
Business insurance
Advertising and promotion
Business travel and entertainment
Professional services
Office and project supplies
Depreciation
Other business expenses
Business taxes

Labor expenses:

Employer taxes
Employee benefits
Employee wages

YOU AS AN INDIVIDUAL

Personal expenses:

Home rent or mortgage
(prorated if a home office)
Food and clothing
Personal travel and recreation
Other personal expenses
Income taxes

Estimate your billable hours

The next step involves estimating how many billable hours you might be able to produce during the year. No matter how diligent you are, you can't be billable every waking moment. Out of a full-time work schedule, most designers

Estimate of billable hours available

Freelancer		Hours	Percentage
Full-time schedule	52 wks x 40 hrs	2,080	100%
Less:			
Vacation	3 wks x 40 hrs	120	6%
Sick time	8 days x 8 hrs	64	3%
Public holidays	10 days x 8 hrs	80	4%
Marketing	50 wks x 14 hrs	700	34%
Total		**1,116**	**53%**

Figure 06.02. Be conservative in estimating the number of billable hours that you will be able to produce during the year.

range between 50% and 80% billable. Figure 06.02 shows a format for estimating your potential for billable hours. Why is this example on the low end of the scale? In a large firm, staff designers have the potential to produce lots of billable hours because other employees are there to take care of non-billable tasks such as marketing. As an entrepreneur, however, you'll be doing everything yourself. New business development activities may take up a significant portion of your time, particularly when you are first starting out.

Know your break-even rate

At this point in the process, you know how much money is needed each year to keep your business afloat, and you know how many hours are available to produce that money. The next step is simply to divide the total expenses by the total billable hours available. This gives you a break-even rate, meaning that you have to charge at least that much per hour in order to keep the doors open.

Bump it up to a billing rate

However, you want your business to do more than just break even — you want it to produce a profit. To make sure that happens, you must decide on a target profit margin and build that margin into your billing rate. This is an important management decision for you. The typical profit margin varies by design discipline, but it is usually somewhere between 10% and 20%.

Look for industry comparisons

Now that you've calculated your personal billing rate, it would be very helpful to compare it to the rates that other freelancers use for similar work. Ask around within your community and check for recent surveys. A junior

production specialist may bill for as little as $35 an hour while a creative director may bill for $75 or more per hour, so it's important to find comparative information that is a close match to your own skills. Most advertising agencies and design firms use lots of different freelancers. This means that they know what the typical rates are, although in conversations with you they may be tempted to understate them a bit as a negotiating strategy. If you are asking to be paid more than the going rate, you will have to be able to explain why that is appropriate.

Stay competitive

You may want to adjust your own billing rate in response to the industry comparisons that you have found, but you should never sell your services at less than your break-even rate. If you are a freelancer with modest expenses but a high number of billable hours, then you may have the luxury of adjusting your billing rate upward. However, if you find that you need to adjust your rate downward in order to be competitive, then you need to go back over your calculations very carefully. As a businessperson, you must find ways to cut costs and/or increase your billable hours. You might also consider lowering your target profit margin, but you should never eliminate it altogether.

Finally, you should keep in mind that calculating an hourly rate is not a one-time process. You need to update your hourly rate periodically because costs change, your skills change, and overall client demand changes as well. Because of this, it's a good idea to recalculate your standard rate once or twice each year to make sure that it remains as current and competitive as possible.

Chapter 07:
Becoming a business

The transition from being a freelancer to being a design firm involves a number of important steps. This chapter is an overview of the various start-up requirements for small businesses: choosing an ownership structure, choosing a name, dealing with local business issues, and, lastly, becoming an employer. As you go through this transition, you'll encounter a variety of challenges for the first time. The process will be much easier for you if you seek out and use expert advisors.

If you've been successful as a freelancer and you enjoy independence, you may want to establish your own small design firm. Usually this does not happen suddenly — it involves a gradual shift away from subcontracting and toward direct business relationships. If you currently hold a full-time staff position in someone else's studio, you may want to negotiate a gradual cutback in scheduled hours, and you'll want to be careful about issues of competition and conflict of interest. It may take a while for you to establish the legal structure of your new company, create an identity for it, print up your first batch of stationery, and land your first paying client. The transition can happen much more quickly, of course, if you're lucky enough to have an actual client already waiting to work with you.

Advisors

As you make the transition from being an independent contractor to being a company, it's important to seek out good advice. The process of launching a small business will be new to you, and you'll be faced with a series of first-time challenges. You don't want to reinvent the wheel. Good advice can help you avoid problems. Start by talking with designers who've been through this process before. Discuss your plans with peers who've started their own companies, and ask for their honest feedback. Then, seek guidance from the following professional advisors:

- An attorney to help you set up the company and provide you with ongoing guidance on intellectual property questions
- A certified public accountant (CPA) who has other design firms as clients to help you set up your financial systems and provide you with ongoing guidance on tax issues
- A banker with a focus on small business clients to provide advice and assistance with a range of banking and financing needs
- A business insurance agent who is an independent broker to make sure that your business is adequately protected against common risks
- An industry consultant with particular expertise in your creative discipline to serve as a strategic advisor

Figure 07.01. Each business format has advantages and disadvantages that you must weigh carefully.

Legal format of business	Setup complexity	Limit on liability	Taxation
Sole proprietor	Low	No	Single
General partnership	Low	No	Single
Limited partnership	Medium	Some	Single
"C" corporation	High	Yes	Double
"S" corporation	High	Yes	Single
LLC	Medium	Yes	Single

CHOOSING A LEGAL STRUCTURE

Every business has a legal format that defines its ownership structure and how its profits will be taxed. Here's a brief comparison of the formats typically used by creative firms. In order to choose the most appropriate format for your business, you'll have to carefully weigh a number of important trade-offs: the ease or difficulty of setup, the level of business taxation, and the extent of your personal liability for business debts and obligations (see Figure 07.01).

Sole proprietor

When you first start working on your own, your business is, by default, a sole proprietorship. You don't need to do anything special to set up an unincorporated business that's owned and managed by one person. No legal formation documents need be filed with any governmental agency (although some local registration and permit requirements may apply — more about this in a moment). For tax purposes, the Internal Revenue Service (IRS) considers a sole proprietor and his or her business to be one entity. Business profits are not taxed separately. They are reported and taxed on your personal tax return, using your Social Security number. (As you already know from your freelance career, you need to estimate the amount of tax you owe and make quarterly prepayments to the IRS.) This single level of taxation is the major benefit of a sole proprietorship. The major disadvantage is that you have unlimited personal liability for all business debts and obligations. If something goes wrong, you're on the hook, and you could lose personal assets such as your savings, house, or car.

General partnership

A partnership can be easy to establish as well. A partnership is defined as a voluntary association of two or more people to carry on a business as co-owners for profit. They don't

TALENT IS NOT ENOUGH: BUSINESS SECRETS FOR DESIGNERS

necessarily need to file any formal paperwork to do this. There are two basic types of partnerships — general partnerships (also known as ordinary partnerships) and limited partnerships. If you don't file any paperwork, you've automatically formed a general partnership. Over the years, these have been quite common among creative professionals. It's a logical move to launch a business that you co-own with a friend or fellow grad who has a complementary skill set. This is especially true in advertising, where many agencies are co-founded by an art director and a copywriter. In a general partnership, all partners participate to some extent in the day-to-day management of the business. All partners also have a duty of loyalty — a legal obligation not to act adversely to the interests of the partnership, such as usurping opportunities.

For taxation purposes, the company is not considered separate from its general partners. This means that the business itself does not pay taxes on profits. Instead, the partnership "passes through" the profits or losses to each partner (based on percentage of ownership), who then reports his or her share on an individual tax return. (Again, you'll need to make quarterly estimated tax prepayments to the IRS.) At the end of the year, the partnership must file an informational tax return with the IRS (form 1065) and distribute a schedule to the business owners (Schedule K-1) that lists each owner's share of the business income or loss. This single taxation is one of the benefits of selecting a general partnership as your legal format.

General partnerships have a downside, however. Because a general partnership is inseparable from its owners from a legal standpoint, the partners are jointly liable for the entire amount of any business-related contracts, debts, or other obligations. This means that you are legally bound to any business transactions made by any of your partners. If one of them takes out a loan on behalf of the partnership, you can be held personally responsible for the debt. Creditors can come after your personal assets to make sure that partnership debts get paid. Because a general partner's actions can legally bind the entire business, you need to be cautious when considering potential partners. They must be people you respect and trust. You should also negotiate a detailed partnership agreement before launching the

company. A formal partnership agreement is not required by law (if you don't create a written agreement, the partnership laws of your state will govern the relationships), but it's a very good idea to prepare one. The drafting process gives you and your partners a chance to discuss your expectations of each other and to define how each of you will participate in the business. It will help you work out any issues that could lead to disagreements or problems later on, including such things as capital contributions, division of profits and losses, salaries, management duties, limitations (if any) on authority, and an agreed-upon process for the admission or withdrawal of partners from the firm.

It's important to consider what will happen to the company if one partner wants to leave, reaches retirement age, or dies. Your agreement should include a buyout provision (sometimes called a "buy-sell" provision) to spell out in advance how you will handle the sale or buyback of an ownership interest. The agreement can control who can buy the departing partner's share of the business. For example, it may limit the purchase to existing partners. You might not want to share control of the company with an outsider you have not selected. Without a buyout provision, if one partner decides to leave, the partnership might be dissolved by law. This would force you to divide all assets and profits among the partners and then start the business over.

Limited partnership
The other basic type of partnership is a limited partnership. It's a bit more complex and expensive to set up than a general partnership because a limited partnership becomes a separate legal entity from the partners themselves. It's comprised of one or more general partners and one or more limited partners. The general partners control the company's day-to-day operations and are personally liable for the partnership's debts and obligations. This is in contrast to the limited partners, who are passive investors. They contribute capital and they share in profits, but they cannot be involved in the management of the company. They have no right to bind the partnership to contracts or other obligations. Because of this, the personal liability of a limited partner is capped at the amount of his or her investment.

Limited partnerships enjoy single taxation. At the end of the year, the company files an informational return with the IRS, but the income and expenses are reported on the personal income tax returns of the partners. Limited partnerships are not common in the design profession. It's a format that's used more often by companies making investments in other firms or in real estate. Federal and state securities laws often apply to the sale of limited partnership interests, so if you're interested in creating this type of business, you need to consult an attorney who has experience setting them up in your state.

"C" corporation

For businesses, forming a corporation is the next step up the evolutionary ladder. There are several different types of corporations. The most common is a "C" corporation, meaning that it meets the requirements of Subchapter C of the Internal Revenue Code. A corporation is legally defined as having a separate existence from that of its founders or owners. As a separate legal entity, the corporation can conduct business, open bank accounts, and own property under its own name. Each corporation is formed under the laws of a specific state. Because the details of state laws vary, large corporations generally choose to incorporate in the state with laws most favorable to their internal operations. One popular state for large corporations is Delaware. However, for the sake of convenience, smaller corporations tend to choose the state where they will be doing most of their business. The owners of a corporation are referred to as "shareholders." If just one shareholder or a very small group of shareholders owns the company, it's called a close (or closely held) corporation. Corporations are complex to set up and maintain, so it's best to use an attorney. Your incorporation papers will identify the initial shareholders and specify the number and type of shares being issued ("C" corporations can issue different classes of stock). Once you receive a certificate of incorporation, you must comply with a wide variety of rules.

On an annual basis, the shareholders elect directors who are responsible for making major business decisions, particularly those that legally bind the corporation (such as borrowing money, leasing an office, or buying real estate). Corporate

resolutions must be prepared in connection with important decisions, and all board decisions must be entered in a book of corporate minutes (usually maintained by your attorney).

The corporate directors appoint officers to run the day-to-day operations of the company. In a small design firm, though, it's common for the owners to be directors, officers, and employees simultaneously. Because the corporation has an independent existence, it's possible for it to remain in operation perpetually. The purchase, sale, and gifting of stock make it possible for individual shareholders to come and go without causing major disruptions in the corporation's ability to conduct business.

The main advantage of a forming a corporation is that its shareholders are not personally liable for the company's debts and obligations. This protection is sometimes referred to as the "corporate shield" or "corporate veil." If the corporation cannot pay its debts and is forced into bankruptcy, the assets of the company will be liquidated, but the stockholders, directors, or officers will not be required to pay any shortfall with their own money. Because of this, when a lender is approached by a small corporation (particularly one that is newly formed), the lender may require personal guarantees from the corporate officers as a condition of supplying credit. Obviously, signing a personal guarantee negates the limitation of liability. In certain instances, a court might also impose personal liability on officers and directors for damages caused by the corporation under their control. This is referred to as "piercing the veil" and can happen if the individuals have intentionally acted in an illegal way or if their actions have exceeded the authority given to them by the company's articles of incorporation.

The biggest disadvantage of a "C" corporation is that it's subject to what is often called "double taxation." Business profits are taxed first at the company level and then again at the individual level if they are distributed to shareholders. Profits distributed as dividends become taxable personal income to those who receive them.

"S" corporation

To avoid this double taxation, corporations can make a special election to be taxed as a "pass-through" entity under Subchapter S of the Internal Revenue Code. "S" corporations are most appropriate for small business owners and entrepreneurs who want to be taxed as if they were sole proprietors or partners. The corporate profits pass through to the owners, who then pay taxes on the profits at their individual tax rates. At the end of the year, the company files an informational tax return to show each shareholder's portion of the corporate income.

To qualify as an "S" corporation, a number of IRS rules must be met. The company must be a profit-making enterprise and can only issue a single class of stock. The company must have no more than 75 stockholders, all of them natural persons (or estates or certain trusts) residing in the U.S. Partnerships and other corporations cannot be shareholders. Once Subchapter S status has been granted, it's possible to lose it if the company receives a large percentage of its income from passive sources (such as royalties, rents, and investments) for several consecutive years.

Limited liability company

The limited liability company, or LLC, is the most recent business format to be offered, and there are different versions in different states. Its popularity has grown very quickly because it represents a great combination of benefits: it's less complicated to set up than a corporation, it offers protection from personal liability for business debts and claims, and business profits are taxed only at the personal level. For these reasons, it's now the preferred business structure for design entrepreneurs. The owners of an LLC are called "members," and typically there must be two or more. In general, to form an LLC you must file formal articles of organization with your state's LLC filing office (usually the secretary of state or department of corporations). Depending on your location, you may need to comply with additional filing requirements. For example, some states require you to publish a notice of your intention to form an LLC in a local newspaper. In some states there's a separate version of the LLC that can be used only for licensed professionals such as lawyers, doctors, accountants, and architects.

You should also prepare a detailed operating agreement. It's not required in all states, but it's very important to clarify the rights and responsibilities of the members. In a design firm, it's common for all members to work in the company and play an active role in managing it. It's important to note that if you plan to sell memberships to passive members, the setup process will become more complicated. If you're sharing ownership with people who will not be actively working in the business, you may be subject to federal and state securities laws.

Cooperatives and collectives

Occasionally, a group of designers will describe themselves to potential clients as a cooperative or a collective. Casual use of these two terms can create confusion because one is, in fact, a formal legal structure while the other is not.

Cooperative
In some states, a cooperative (also "co-operative" or "co-op") is a distinct business format, usually as a type of corporation. In a co-op, several individuals (or businesses) voluntarily join together to provide services to members. As a legal entity, it's owned and democratically controlled by its members. To qualify as a co-op, it's usually required that there be no passive shareholders, no political activities, and a limited return on any invested capital. For this last reason, many are established as non-profits. In those that are organized as for-profit enterprises, profits are often shared based upon the production, capital, or effort of each individual member. The members of a co-op are protected from personal liability for business debts and claims.

It's not likely that your creative firm will be structured as a co-op, but many design firms and advertising agencies work with clients who are. They can be organized with several different objectives in mind. There are producer co-ops where farmers, ranchers, or manufacturers work together in promoting and distributing specific commodities, occasionally under a single brand name such as Land O'Lakes, Ocean Spray, or Sunkist. There are retailer co-ops that use economies of scale to get discounts from manufacturers or to conduct joint marketing activities. This is common for locally owned grocery stores, hardware

stores, and pharmacies. This kind of shared marketing is often done by franchisees of major chains (such as fast-food restaurants) in order to produce regional advertising. The co-op collects dues from its members (usually calculated as a percentage of gross sales) and hires a regional advertising agency. The regional agency must then coordinate its campaigns with the national franchisor's agency of record in order to ensure uniformity. There are also consumer co-ops such as food-buying co-ops or credit unions, where individuals join together to obtain price advantages from volume purchasing. Members get discounts compared with non-member customers. A well-known example of this in the U.S. is the REI (Recreational Equipment Incorporated) chain.

Collective
A collective is not a type of legal entity. Your business must be organized in one of the formats discussed earlier in order to identify its tax status and to be capable of suing (and being sued) in a court of law. In contrast, the term "collective" describes an overall philosophy of interaction and decision making. It can be used to describe any group of like-minded individuals brought together in an organized manner to accomplish a shared goal. Members of a collective tend to have an egalitarian or non-hierarchical way of relating to each other. Decisions are reached using a consensus process.

In the design world, when several creative professionals describe themselves to a potential client as a collective, most often the reality is that they collaborate on projects but each is a separate business entity. One of them signs a formal contract with the client and then brings the others in as independent contractors. The client might not be aware that the various team members are not part of a single company. Disagreements can crop up between collaborators, so it's important to negotiate and document the terms of the project very carefully with all of the various subcontractors. You need to have signed agreements in place to spell out how each will be compensated, to explain how any final profit or loss will be shared, and to clarify the ownership of any intellectual property that is created.

State tax issues

We've been discussing the process of selecting a legal structure for your company, but there are other challenges for new businesses as well, including two different types of state tax that you should be aware of.

State business income tax

In most states, companies are required to file an annual informational return with the state government. Depending on your legal structure, you may have to pay a state business income tax.

State sales tax

In many states, you may need to register for a sales tax license (also called a "seller's permit"). This usually applies to businesses involved in selling or leasing tangible property. However, in some states it applies to services as well. The license lets you collect any applicable sales tax from your customers and pass it on to the state. Currently, five states do not impose a general sales tax: Alaska, Delaware, Montana, New Hampshire, and Oregon. However, individual cities and counties in those states may have the authority to impose local sales taxes, so you'll have to check with your local government.

Name of firm

Choosing a name for your company is a very important part of the setup process and a key component in developing an overall brand identity for your firm. Your business may already have a legal name by default. If you're a sole proprietor, then the legal name of the company is the same as your personal name. The legal name of a general partnership usually consists of the last names of the owners. However, for limited partnerships, LLCs, and corporations, the legal name of the business will be whatever name you registered with the state filing office. When selecting a name, follow the advice that you give to your clients — the name should be short, distinctive, easy to remember, and easy to find on the Internet. Start the process by brainstorming a list of potential names. The next step is to carefully check each one for state, national, Web, and local availability. Your business name should not be the same as any existing entity — particularly within the same category of services — and it

cannot include a term such as "Inc." or "LLC" unless that is in fact your legal structure. If you find that your preferred name (or a very similar one) is already taken at any of the following levels, you'll have to think of another.

State
If you're establishing a limited partnership, corporation, or LLC, check for name availability with your state government.

National
On a national level, you'll want to check whether the name is available as a trademark. This means conducting a name and trademark search with the U.S. Patent and Trademark Office to make sure that no one else is using the name you want (or something very close to it) to identify their services in the marketplace. (For more information about trademark searches, see Chapter 17.)

Internet
You'll want the name of your company to be the name of your Web site as well, so you need to check for Internet domain name availability. To conduct a search of top-level domain (TLD) names, go to the site of a domain name registrar. Registrars are accredited internationally by the nonprofit Internet Corporation for Assigned Names and Numbers (ICANN). For a full listing, visit the accredited registrar directory at www.internic.net/regist.html. As you'll see, there are a lot of them. Register.com and Network Solutions are among the largest. Finding an available name can be a frustrating process because millions of names are already taken (more than 83 million have been registered with the .com extension alone).

Local
Finally, you need to register your business with your local government. If you're a sole proprietor or a partnership, you may want your company to operate under a name that's different from its legal name (such as Mary Smith wanting to conduct business as Impact Design). The registration process will include filing a fictitious business name state-ment. A fictitious business name (FBN) is also referred to as an "assumed business name" or a DBA ("doing business as"). You'll check the name's availability by searching the local

government database, which is usually maintained by the county clerk's office. The registration process will include publishing an FBN notice in the local paper.

Other local licenses and permits

Your company may also need to receive local business licenses or permits in order to operate. You'll have to do some research to make sure that you understand city and county rules. Often the requirements and fees vary based on the nature of the business, and the paperwork must be completed before you actually start conducting business. Start by asking city and county officials about license and permit requirements. The office of the assessor or treasurer can tell you about any local taxes on property, fixtures and equipment, or gross receipts.

Zoning

When you register your business with the local government, your address will be checked to determine whether it's zoned for your type of business. This also applies to businesses operating from a residence. Be sure that you look into this before you sign any lease. Zoning is public regulation of the use of land. It involves the adoption of ordinances that divide a community into various zones or districts. Each district allows certain uses of land, such as residential, commercial, industrial, or mixed. Your local government is concerned about how business activities might impact the neighborhood (for example, by creating traffic or noise). In some communities, you must have a zoning compliance permit before you can start your business in a given location. Local ordinances control such construction issues as neighborhood density, building height, bulk, setbacks, and parking. Zoning laws often regulate the size, construction, and placement of signs as well.

Many design firms seek to occupy space in historic buildings. Often these structures are centrally located and have interesting architectural details. Historic district locations may have additional restrictions, such as the need for city approval before a building's exterior can be modified or painted a different color.

Becoming an employer

If your newly established design firm is going to hire employees, you'll need to apply for a Federal Employer Identification Number (EIN) from the IRS and a State Employer Identification Number from your state government. Both of these are necessary for payroll processing. (They're not needed if you're a sole proprietor with no employees, because you'll be using your own Social Security number.) For more information about payroll, please see Chapter 13. Lastly, your business may also be subject to state requirements for workers' compensation insurance. Much more information about workers' comp can be found in Chapter 15.

As you can see, new businesses need to jump through a lot of hoops. If you've never launched a company before, you won't be familiar with the process and requirements. That's why it's so important to seek out expert advisors. In particular, you'll need guidance on legal and tax issues from an attorney and a CPA. Discuss the details of your own particular situation with them. You'll be very glad that you did.

Chapter 08:
Pricing models

When figuring out how to charge a client for creative services, designers have several different pricing models to choose from. How do you select the most appropriate one? This chapter explains each category of pricing and defines some of the key terminology that often comes up during the negotiating process.

When design firms sell work, there are several very different ways to structure the compensation. The most common pricing formats are:

- Time and materials
- Fixed fee
- Licensing: use-based
- Licensing: royalty
- Hybrid
- Free

Time and materials

This is the simplest approach, although it's not the best. When working on a project, you track the actual hours and bill them to the client at agreed-upon hourly rates. In addition, you track out-of-pocket expenses and bill the client for reimbursement. Travel-related expenses are usually reimbursed at cost, but all other expenses should be subject to a standard markup of 20%. Why is that? It's to compensate you for the administrative time involved in making those purchases and paying those vendors, plus the fact that your own cash has been used, which otherwise would be invested and earning interest.

A time-and-materials relationship involves a certain amount of trust. The client must have confidence that you won't leave the meter running needlessly. To explain how the time has been used, you must provide a detailed recap of all activity on a regular basis, usually at the end of each month.

A time-and-materials relationship is the easiest to understand and document, but the big drawback is that your billings to the client will not reflect the ultimate value or impact of your creative services.

Fixed fee

A fixed-fee contract is usually a much better approach for design firms, but it does come with some risk. Before starting work on a project, you agree on a flat amount that will be charged for services. This creates the opportunity for you to make an entrepreneurial profit or loss, depending on how well you estimate and manage the work. The goal is for your total price to reflect the real value of the work to the client,

as measured by the positive impact that it will have on their business. At the same time, your total price must be competitive within the marketplace for design services.

It's important for your fixed-fee proposal to be very specific about the exact scope of work — what is included and what is not included. This is because clients will almost always make additional requests after the project has started. You can only identify those requests as being outside of the original scope if indeed that scope was well defined in the first place. When an additional request is made, you'll have to decide whether you have the time and resources to take it on. If so, estimate the additional time and expenses involved, and send a change order document to the client. A change order is in fact a small additional proposal that must be approved and invoiced separately. It is outside of the original contract. Because of this, many change orders are shot down. This is fine. It means that the process is working and the profit margin that you built into your original proposal has been protected.

Fixed-fee proposals typically include an assignment of all intellectual property rights from the designer to the client. The total price that you charge must be high enough to cover the value of the intellectual property involved. (For more information, see Chapter 11 and Chapter 17.)

Licensing: use-based
Use-based pricing is common for photographers, copywriters, and illustrators, particularly if their work is being used for advertising or marketing purposes. The price is determined by the ways in which the finished work will be used or reproduced. Talk with your client about the usage rights that they need, and then sign an agreement that specifies such things as:

- The category of media to be used
 For example, a magazine cover or a billboard.
- The total number of items that will be produced
 For example, if your work is being used on printed materials, the agreement may specify the size of the print run.
- The geographic area of distribution
 Such as North America only or Europe only.

- The time period of use
 For example, a campaign that will last six months.

If the client later decides that additional usage rights are needed, they will have to come back to you and negotiate additional payments. In legal terms, the permission that you give for the use of your work is a type of license.

Licensing: royalty

This is another important category of compensation. Separate from the usage negotiations that we have just discussed, licensing is common for industrial designers and others whose work can be applied to manufactured items. In a product licensing relationship, the creative professional is the licensor, providing an original design. The product company is the licensee — they provide everything else, including manufacturing, marketing, inventory control, distribution, and customer service.

Compensation to the designer is in the form of a royalty, which is a percentage of the money received from net sales of the product (gross sales adjusted for any returns or discounts). In most product categories, royalties are based on the wholesale price. In publishing, however, royalties are usually based on the retail price. Standard royalty rates can vary quite a bit based on the product category (furniture, gift items, stationery, and so on). They may be as low as 3% or as high as 15%. Sometimes the percentage paid will increase when the product exceeds a certain sales target (for example, when a book sells out and needs to be reprinted). Licensors with successful past products are in a good position to negotiate higher royalty rates on future projects. Some agreements guarantee a minimum total that will be paid to the licensee over the term of the agreement. A portion of your royalty may be paid up front as a non-refundable advance (this is often the case in publishing, for example).

Hybrid

On a large project, a hybrid approach to compensation sometimes makes the most sense. It's not unusual to see several different types of compensation included in one deal. For example, an industrial design firm might be paid a fixed fee for the initial phases of a project, followed by a royalty to be paid after the new product goes into mass production.

Free

Finally, you also have the option of giving your work away. Just be aware that there is "good" free and "bad" free. An example of "bad" free is speculative work. Spec work is when a client asks you to generate a few sample ideas without actually hiring you. It's a kind of test-drive — they want to see the visual approach that you would take. For designers, this short-circuits the normal creative process because it requires you to jump right to form-giving without first completing adequate research, analysis, and strategy development. This means that even if the client does later hire you, it's highly likely that you will need to discard the sample work and start again in the proper way.

Spec work can cost you quite a bit in payroll and out-of-pocket expenses. It's important to weigh these ramp-up costs against the potential gain of later landing the account. For a graphic design firm, that potential gain might be zero. Clients in the U.S. do not usually sign long-term contracts for graphic design services — the relationships tend to be on a project-by-project basis. In addition, labor billings on a typical print project are often less than $10K. If you do several thousand dollars worth of spec work, it's unlikely that you'll be able to recoup that from the first paid project, and there is no guarantee that the client will ever give you a second project. (In the advertising world, spec work makes a bit more sense because the relationship potential is so much higher. An advertising agency might spend $100K or more on a major pitch because it could lead to a one- or two-year contract to manage a significant amount of media billings.)

A "bake-off" is a variation of spec work where the client approaches several firms and offers each of them a very small amount of money to produce sample creative work. Again, this short-circuits the design process and burdens you with expenses that are difficult to recoup.

In contrast, "good" free is doing pro bono work. *Pro bono publico* is a Latin phrase that means "for the public good." It refers to services that are donated to political, social, or religious organizations. Many designers generously provide their creative services in support of causes that they are

passionate about. In the U.S., there is a tax aspect to this that you should be aware of. In order to report this type of contribution on your tax return, the client organization must have federal non-profit status, and you can only deduct actual out-of-pocket expenses. You cannot deduct the value of your labor. (Congress has debated the possibility of changing this law. A recently proposed bill would allow living artists, writers, musicians, and scholars to donate work to charitable causes and receive a tax deduction based on full market value. This would be a very welcome change.)

Figure 08.01. The essential pricing trade-offs that you'll probably want to keep in mind but not describe to the client.

Trade-offs

When negotiating compensation issues with clients, many designers keep a simple formula in mind: "fast, cheap, good — pick two" (see Figure 08.01). You won't want to describe the situation to your client in such a blunt way, but these are in fact the essential trade-offs on creative projects. For example, you won't be paid on a pro bono project, yet you'll want the finished work to be as good as it can possibly be. The trade-off is that the project will probably take a little longer to complete. Paid clients will always be given scheduling priority — after all, it's their projects that pay the rent. Because of this, pro bono projects often move to the back burner. In contrast, let's say that a large corporate client comes to you with a fast-track project that is of great importance to their business. It has to be fast, and it has to be good. Chances are that it won't be cheap.

Terminology

When discussing potential projects with clients, be careful about terminology. When you use a term, it's important to know that both you and the client understand it to mean exactly the same thing. As a reference, here are standard definitions for some of the terms that frequently come up during negotiations.

Estimate

An estimate is tentative and non-binding. It is a projection of the approximate costs that you anticipate on a project. The total is usually described as a rough "ballpark" figure or presented as a high/low range.

Quote
A quote is much more precise. It is a firm offer to perform specified services for a fixed price. For example, printing companies submit quotes based on the exact specifications provided to them by clients.

Bid
This term is normally used when a client is seeking competitive prices from several different suppliers. Many corporations have strict guidelines for the competitive bidding process.

Letter of agreement
This is a written recap of items that have already been agreed to orally. It's a bad idea for any creative firm to begin a project solely on the basis of an oral agreement — always protect yourself by having a signed document. A letter of agreement is better than nothing, but it's smarter to submit a complete proposal.

Proposal
A proposal is a detailed project document that defines the scope of work, the process, the schedule, and the total price (usually in the form of a fixed fee). It normally includes legal terms and conditions as well. It is a discussion document where the designer puts forward a recommended course of action for the client to consider. Many proposals go through several rounds of changes and negotiations before they are finalized. (For more information about proposals, see Chapter 11.)

Not to exceed
Watch for this term on documents that come to you from the client — particularly on corporate purchase orders. It indicates the maximum amount that the client will pay for a project, including any taxes, shipping, or other last-minute charges. You will not be able to bill for anything beyond this total without going through a lengthy re-authorization process.

Chapter 09:
Setting rates for a firm

Calculating a standard billing rate for a design firm is a bit different from calculating an hourly rate for a freelancer (a process that we discussed in Chapter 06). However, the essential business challenge is the same — you need a rate that will cover your costs and produce a profit.

Freelancers tend to work on projects that are subcontracted to them by design firms and agencies. Because of this, most freelancers have a single rate, and their services are billed on a simple time-and-materials basis. In contrast, design firms tend to work for clients on a fixed-fee basis. This puts pressure on firms to use a very logical process for planning and pricing each project.

To calculate a fixed fee, design firms must first estimate the number of hours that will be involved and then apply a standard hourly rate to get a potential price for the project. Some firms call this standard hourly rate their "default" or "base" rate. When it comes to calculating rates to use for internal planning purposes, there are several different approaches. Some studios have one rate that they use for everything. Others have multiple rates. The most common approaches include:

- One rate for the entire firm
- A different rate for each staff member
- A different rate for each role on the team
- A different rate for each task
- A multiplier that is applied to base salaries

Here's some information about each of these methods:

One rate for the entire firm
This calculation starts with an analysis of total payroll and overhead expenses and then moves on to an analysis of chargeable staff hours. Next, a target profit percentage must be determined. Finally, all of these components are put together to determine an hourly rate. It's often called a "blended" rate because the calculation is based on company-wide financial data. It represents a blend of all employee hours, all payroll costs, and all overhead expenses.

In calculating this labor rate, you don't need to worry about project materials — that is to say, special items or outside services that are purchased only for specific client assign-ments. Instead, these one-time costs should be budgeted project by project. The amount you're charged by the vendor will simply be marked up and invoiced to your client. The hourly rate that you use for labor needs to cover everything else, including your company's full payroll and all of your

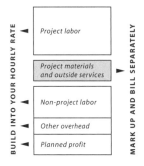

BUILD INTO YOUR HOURLY RATE

- ◄ Project labor
- Project materials and outside services ►
- ◄ Non-project labor
- ◄ Other overhead
- ◄ Planned profit

MARK UP AND BILL SEPARATELY

Figure 09.01. Your pricing must take into account each expense category on your profit and loss statement, as well as the net profit desired.

overhead expenses (see Figure 09.01). These recurring costs must be covered if you're going to stay in business. The challenge is that they don't match up neatly to any single project. That's why they must be built into your hourly rate. This allows you to spread them proportionately across all client work.

Covering your business costs isn't the entire picture, though. If you charge just enough to cover costs, you'll only break even. As a businessperson, you want to do better than just break even — you want to produce a profit. To do this, a base profit margin also needs to be built into your hourly rate. (If you think carefully about profits, you'll realize that some of your annual profits also come from markups on project materials. However, in contrast to advertising agencies, most design firms do not broker large amounts of outside expenses. For the most part, design income is based on staff labor. Your business model is to generate fee billings for the creative services produced by you and your team.)

To calculate a blended rate for a design firm, follow these four steps:

1. Add up all of the expenses that need to be covered for you to stay in business.

 Total payroll (both project labor and non-project labor)
 + all overhead expenses
 = total costs to be covered

2. Out of the total amount of time covered by salaries, determine how many staff hours are actually available for client projects. For example, the annual salary for a full-time employee covers 2,080 hours (52 weeks x 40 hours). Salaries for five full-time employees would cover a total of 10,400 hours. However, once you've subtracted all non-billable time from the total, chances are that only 60 to 65% of the annual schedule is available for client projects. (Billable and non-billable hours for design firms are discussed in greater detail in Chapter 26.)

Total staff hours (number of employees x annual schedule)
- *vacation*
- *sick time*
- *holidays*
- *staff meetings*
- *administrative activities*
- *new business development*
= *total chargeable hours*

3. Determine a target profit percentage to be built into your hourly rate. For most design firms, the net profit each year (before bonuses and taxes on business income) is in the neighborhood of 10%. This is the pre-incentive margin that appears near the end of the company's profit and loss statement. However, for planning purposes, you should not hesitate to be more aggressive about your target profit. Some creative firms are able to achieve a net profit as high as 15 or 20%, depending on the type of services being sold and the strength of the firm's reputation.

4. Put all of these components together to determine your hourly rate:

 Total costs to be covered
 ÷ *by total chargeable hours*
 = *break-even rate*
 + *target profit percentage*
 = *hourly rate to use for project planning purposes*

Because your labor expenses and overhead expenses change over time, it's a good idea to recalculate this rate once or twice a year to make sure that it's current.

Again, this is referred to as a blended rate. In the past, most design firms used this approach. The major benefit of using a single rate is that it makes project planning very easy. There's a downside, though. When you get into pricing conversations with corporate clients, it can be very difficult to explain why the same rate is used when interns are making photocopies and when the company's founders are developing global strategies. Although clients will love paying a low rate for the founders, they'll complain bitterly about being overcharged for everyone else.

A different rate for each staff member
This leads to a different approach. It involves calculating
personal billing rates based on the salary level and
work schedule of each person involved. The rates must
also include a standard overhead factor and a target
profit percentage.

To calculate the overhead factor, look at a twelve-month
profit and loss statement. Compare total payroll expense
(both project labor and non-project labor) to overhead
expenses (refer back to Figure 09.01). For most design
firms, the overhead expenses will be equal to roughly
50 or 60% of total payroll expenses. This means that
the overhead factor for our rate calculations will be
roughly 1.5 or 1.6.

> *Individual salary*
> ÷ *by individual chargeable hours*
> = *payroll per chargeable hour*
> x *overhead factor for company*
> = *breakeven rate*
> + *target profit percentage for company*
> = *personal billing rate for project planning purposes*

A personal rate reflects the skills and experience of each
team member. The senior partner on a project will bill
at a much higher rate than the junior associate. This
approach puts pressure on the design firm to make the
most appropriate use of each resource. It also puts pressure
on senior staffers to delegate effectively. If they make
their own photocopies or mount their own presentation
materials, they'll find that they're burning through the
project budget much too quickly.

Firms that calculate personal billing rates must take care
to protect the confidential payroll information involved.
Anyone who knows a person's billing rate and the formula
that was used to calculate it can learn the underlying salary.
In a firm where salaries vary widely, this can lead to gossip
and discontent.

If you're responsible for planning a project and you know for certain which individuals will be involved, you can work up a very accurate estimate using their personal rates. However, if you work in a large firm and you're pitching a big project that won't start until next year, you can't know for certain who will be involved and who will be unavailable. Often, the best you can do is to determine the size of the team and the skill sets required. This leads to another pricing variation, which is to calculate fixed fees using hourly rates for general roles rather than individual people.

A different rate for each role on the team

The size of each project team is determined by the scope of work that must be accomplished. In general, though, most projects require the involvement of a creative director, one or more designers, one or more production specialists, and a project manager. In a large firm, there will be several staff members in each of these categories. The standard billing rate used for each role will be an average of all the individuals in that category. This approach still allows you to produce very accurate estimates for projects, and it has the added benefit of protecting the confidentiality of payroll information. For these reasons, many leading firms have adopted hourly rates based on roles. In practice, it leads to a rate structure like the following:

- Principal (for co-owners and executives)
- Senior (for all senior staff members and team leaders)
- Staff (for all mid-level team members)
- Junior (for all entry-level employees and interns)

A different rate for each task

Sometimes, design firms are tempted to set rates based on recurring tasks that are involved in all projects, such as sketching, scanning, time spent in meetings, mounting presentation materials, et cetera. Task rates only work well in small firms where all team members receive roughly the same compensation. In large firms, they become a problem. If highly compensated individuals spend lots of time on tasks that bill at low rates, it will make the project budgets look good, but it will mask a deeper problem. From a business standpoint, highly paid individuals need to generate enough revenue to cover their salaries and justify their positions.

There is an opportunity cost to the company every time that senior people stray from their highest and best use. If a high-level resource spends lots of time on low-level tasks, a billing shortfall is being created. When you compare the actual income generated to what could have been generated at senior rates, you'll see the revenue that was lost.

A multiplier that is applied to base salaries
This approach is not as common for design firms, but it's widely used in other professions such as accounting and law. It's based on the assumption that annual labor billings should be a certain multiple of annual labor expenses. For example, if an accounting firm is hiring a CPA, they might agree that he or she can receive an annual salary of $100,000 provided that he or she generates $500,000 in revenue for the firm.

The exact multiplier will vary from company to company, based on the type of service being provided. Here are some typical multipliers used by different professions:

•	Attorneys	5.0 to 7.0
•	Accountants	4.0 to 5.0
•	Business consultants	4.0 to 5.0
•	Industrial designers	3.5 to 4.0
•	Graphic designers	3.5 to 4.0
•	Architects	2.5 to 3.5
•	Interior designers	2.5 to 3.5

So, how exactly do you use a standard multiplier to calculate a billing rate? Here are two examples:

• Staff designer

Annual base salary of $50,000
÷ *by target billable hours of 1,664 (80% of 2,080)*
= *equivalent hourly rate of $30*
x *industry multiplier of 3.5*
= *suggested billing rate $105*

- Company principal

Annual base salary of $150,000
÷ *by target billable hours of 1,664 (80% of 2,080)*
= *equivalent hourly rate of $90*
x *industry multiplier of 3.5*
= *suggested billing rate $315*

As you see, this can create a wide spread between junior and senior rates. In practice, most firms sculpt things a bit so that the variation in dollar amounts is smaller, but the company itself still achieves the desired multiplier overall:

- Principal 2.50
- Senior designer 3.00
- Designer 3.50
- Production specialist 4.00
- Student intern 4.50
- Average for the team 3.50

If you decide to use this approach, be aware that there are variations on the calculation. Some design firms include base salaries plus payroll taxes and benefits. Also, the billable hours for each position are open to discussion. In any event, this is intended to be a quick rule-of-thumb calculation, so it's best to keep it as simple as possible.

Project planning
Once you've calculated a standard hourly rate, you're ready to use it to develop preliminary budgets for projects. A standard rate will allow you to work up a "suggested retail" price based on the number of hours that you believe will be required. However, before you communicate a price to the client, especially in the form of a fixed-fee contract, you need to make an important judgment call. Is this suggested price too high to be competitive on this particular project? If so, how can it be brought down? Conversely, is the suggested price too low to accurately reflect the project's importance? Always adjust your final price to reflect current market conditions and the value of the work to the client, as measured by the impact that it will have on their business.

The ultimate goal for design firms is to determine final prices based on value rather than simply the number of hours involved. However, to make smart pricing decisions, you must first go through a logical planning process. A sample worksheet for project planning is shown in Figure 09.02. Using a worksheet forces you to clarify assumptions about the size of the team required, the steps that will be involved in producing the work, and what outside purchases will be necessary.

Figure 09.02. Use an internal planning worksheet to identify how many phases, steps, and team members will be needed. The result is a "suggested retail" price based on your standard billing rates and markups. These totals can be adjusted as needed. The proposal document that you subsequently draft for the client will not include most of these behind-the-scenes details. For example, on a fixed-fee project, the client does not need to know the number of hours involved.

Methodology

One of the most important things about your internal planning worksheet is that it must accurately reflect your creative methodology. It has to be a realistic description of the way you actually work. Think about how you want projects to unfold. What phases, steps, and milestones are the most natural for you? Having a rational work process does not mean that you're ruling out the unexpected — there's still plenty of room for magic. Detailed planning is not a threat to the intuitive insights that emerge from the creative process itself. The goal here is to develop a model that will, in fact, enable you to do your very best work.

Your own creative methodology should be the framework for all planning and the outline for the proposal document that you will eventually send to the client (for additional

Process		Fees				Expenses			
		Name Rate	Steve $100	Mary $100	John $100		Net	Markup	Gross
1	Step one	Hours	8	8	8	Description	$100	20%	$120
	Step two		8	8	8	Description	$100	20%	$120
	Step three		8	8	8	Description	$100	20%	$120
	Milestone		8	8	8	Description	$100	20%	$120
	Hours	96	32	32	32		—	—	—
	Fees	$9,600	$3,200	$3,200	$3,200		—	—	—
	Expenses	$480	—	—	—		—	—	$480
2	Step one	Hours	8	8	8	Description	$100	20%	$120
	Step two		8	8	8	Description	$100	20%	$120
	Step three		8	8	8	Description	$100	20%	$120
	Milestone		8	8	8	Description	$100	20%	$120
	Hours	96	32	32	32		—	—	—
	Fees	$9,600	$3,200	$3,200	$3,200		—	—	—
	Expenses	$480	—	—	—		—	—	$480
Total	Hours	192	64	64	64		—	—	—
	Fees	$19,200	$6,400	$6,400	$6,400		—	—	—
	Expenses	$960	—	—	—		—	—	$960

discussion of the client document, see Chapter 11).
Many designers follow the example of the multidisciplinary
firm Fitch and structure their projects in four consistent
phases: Discovery, Definition, Design, and Delivery.
A general framework like this can be flexible enough for
planning and executing a wide variety of client assignments,
from identity design to Web development to the creation
of new products.

Think carefully about your own preferred phases and
steps, and then prepare a written description and a
visual overview in the form of a diagram or a flow chart.
These will be very useful in explaining to clients how
their projects will move forward. It's particularly helpful
for clients who have never purchased creative services
before and don't know what to expect. Many design firms
also develop specialized terminology for unique project
components or milestones. Presenting a compelling
description of your process is a very powerful way
to differentiate yourself from your competitors.

The underlying message of all this to a new client is that
you're an expert. By giving their project to an expert
instead of the lowest bidder, they will gain a much higher
probability of success. Your process is a distillation of years
of experience. You've been down this road before, and you
understand the critical issues. By emphasizing creative
methodology, you also make it clear that design is, first
and foremost, a problem-solving process. It's a highly
customized professional service that is idea-driven and
focused on innovation. For these reasons, pricing must
reflect the process being employed. This counters the
misconception held by some clients that design is a com-
modity buy, like placing an order with a service bureau.
Many leading creative firms work on strategic projects
that do not produce traditional types of design deliverables.
Unit pricing based on the size or quantity of output does
not match the consultative nature of the work being
done in the profession today.

Chapter 10:
Marketing

Successful marketing involves the systematic planning, implementation, and control of a wide range of business activities. For creative firms, some of the most important aspects include clear positioning on the competitive landscape, a varied promotional mix that is appropriate to your creative discipline, and a focus on long-term mutually advantageous relationships. This chapter shares expert advice on each of these vital topics.

Positioning

Positioning has to do with the way that clients view competitive firms. A successful positioning strategy involves marketing decisions and activities intended to place your services into a desired position in a particular market and in the minds of purchasers. Some companies attempt to clearly differentiate their offer from a competitor's. Other companies seek to appear similar to a competitor.

The process of positioning yourself effectively starts with preparation of a positioning statement. Keep it simple and brief — no more than two sentences. This is your "elevator speech" for communicating the essentials of your business in just a few moments. Here is a suggested format with some blanks for you to fill in: "We are a [type of firm] providing [range of services] to [categories of clients]. Our [unique selling point] provides [specific client benefits]." Don't make a potential client work too hard to figure it out. If it's too vague or too complicated, they will just move on. Here are some thoughts about filling in the blanks:

Type of firm
State the general category of business that you are in, such as graphic design, Web development, or advertising.

Description of services
State your core competencies. The initial impulse of many a designer is to describe himself or herself as a "Renaissance man" — able to take on a wide variety of creative challenges. This may in fact be true, but it does not work well as a positioning statement. In a highly competitive market, you can't be everything to everybody. The appearance that you are willing to do so could convey a certain air of desperation. What we are looking for here is a frank statement of the two or three services that actually produce the majority of your billings.

Client categories
Identify the industries of your largest clients, such as manufacturing, financial services, or entertainment. These are the businesses that you know the most about. List no more than two or three.

Unique selling point
You need to make a clear distinction between your firm and others that are serving the same market. You may want to emphasize your years of experience in a particular category, your award-winning team, your proprietary methodology, your understanding of new technologies, or something comparable.

Benefit statement
What will the client gain by hiring you instead of someone else? Describe the specific competitive advantages that you have provided to past clients. These might include benefits like reduced time to market with new products, more effective communications with a particular target demographic, increased traffic, or higher sales.

As you draft your positioning statement, spend time conducting research on your competition. List the people you tend to come up against when you are pitching new projects. Who are they, and how is your firm different from theirs? Visit their Web sites, look at their marketing materials, and talk to people who have worked with them. How many employees do they have, who are their major clients, what are their strengths and weaknesses?

Visualize the information that you have gathered about the competitive landscape by preparing a positioning map (see Figure 10.01). Start by drawing a very large plus sign (+) and assigning a key differentiator to the vertical axis. Company size (either in staff or total billings) is a good vertical measurement, with large at the top and small at the bottom. For the horizontal axis, choose a type of differentiation that is very specific to your situation. It may be a contrast of two creative disciplines such as print and interactive, or perhaps a contrast between specialist and multi-disciplinary. Another option might be a contrast of creative approaches, such as conventional and cutting edge, or perhaps a geographic difference, such as local versus national.

Now plot the locations of at least eight competitors — companies who have been or who might be hired instead of you by a client. Finally, mark the position of your own firm. This position mapping exercise will help you to analyze the nature and extent of the differences between you and your closest competitors. Keep in mind, though, that you have an

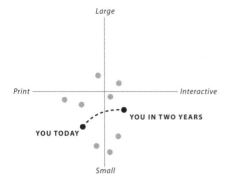

Figure 10.01. Your position-ing map can help you to analyze the competitive landscape, set future goals, and monitor your progress toward them.

insider's knowledge of the situation and the players. There may be a big disparity between your reality and your clients' perceptions. It's good to get outside verification that clients see the options in the same way that you do. This variation is called "perceptual mapping." It charts the way that individuals selected from the target market per-ceive different creative firms and their services. Future marketing efforts can then address those discrepancies.

Going through this mapping exercise is great preparation for new business pitches. You'll be able to counter informa-tion that the client may bring up about other firms and to clarify the advantages of hiring you. Mapping can also be a useful tool in your own long-range business planning. Is there some aspect of a competitor's business that you would like to emulate? If you want to resemble another firm more closely in the future, think about what would be involved in that transition. How long would it take, and what specifically would you be changing? This process is called "repositioning" — shifting your studio to occupy a distinctive position in the market and in the minds of target clients that is quite different from the one that you occupy today. Repositioning may be necessary if your sales are declining or if you want to introduce new services.

Promotions program

The next challenge for you is to choose the most appropriate mix of promotional activities (such as personal selling, adver-tising, publicity, and public relations) for communication with your target market. You should put together a promo-tions program that is as diverse as you can possibly manage. Here are some thoughts about the most common compo-nents for creative firms:

Identity system

No doubt you've already developed a great visual identity for your firm and the first application of it was on your stationery. Now you need to carry through and practice what we preach to clients about comprehensive branding. Make sure that you expand the basic elements into a flexible system that gives consistency to all the different promotional materials that you will produce.

Capabilities / case studies

The classic marketing tool for creative firms used to be a four-color, glossy capabilities brochure. It took a lot of time and money to produce. When completed, it became obsolete almost immediately because it was impossible to update. Most design firms have now moved to a modular approach, with separate sheets for each major creative category or client industry. This involves selecting only the most compelling project in each major category and presenting it as a case study with key visuals and captions. A good approach is to briefly describe the client's initial business need or communications challenge and then describe the process that you went through to develop the most appropriate solution. Then, whenever possible, quantify the results by describing the impact that your work had on the client's business. Each project is a success story with an emphasis on client benefits. Even for freelancers, there is a clear trend away from a portfolio filled with loose samples and toward a compact collection of success stories that present work in a larger context.

Web site / interactive projects

Again, it's a good idea to prepare an overview of the project using only key information and visuals. From there, a prospective client can dive into the full project if they are interested and have the time. Place success stories rather than just a list of hyperlinks on your Web site. If someone follows a link for a project that you completed some time ago, they might encounter a site that has changed considerably and no longer resembles what you delivered. The prospective client would not know that, however — they would leave your site, see bad work elsewhere, and would simply not return.

Demo reel of motion graphics

If your firm does motion graphics, you'll have no problem selecting a great assortment of clips. The challenge is to bring them together in a clean, simple framework that is a clear extension of your own identity, both in the format for the onscreen introductory graphics and in the appearance of the external packaging.

Direct mail

Many creative firms mail out promotional materials several times a year. This raises two questions: what exactly are you sending, and who is going to receive it? If you are doing large mailings, it makes sense to produce small, inexpensive materials such as postcards that feature recent projects. That way you can save any complex, expensive materials for personal selling efforts. Developing a mailing list is a challenge in and of itself — more about this in a moment.

Advertising

When design firms advertise, it tends to fall into two categories: recruitment and new business development. Recruitment is not just classified job listings but also image ads in design publications. The goal is to enhance the way in which you're perceived in the design community in order to attract the best talent to your team. If you want to develop new business, however, you must choose the publications that your clients read and run ads that clearly communicate your positioning and the client benefits of working with you.

Directories

Directories and workbooks are important for photographers and illustrators. Many directories are regional and are published once a year. They are sent to art directors in the hope that they'll be kept on a reference shelf, like a cross between a design annual and a phone book. The directories sell space to you, either as single pages or as spreads. You may want to feature just one large project, or you may want to show a variety of small images. You can purchase extra copies of those pages to use in your other marketing activities.

Trade shows and industry events

Trade shows are especially important if you are a product designer. They are chances to immerse yourself in the client's

industry, whether it's high technology, housewares, or anything else. They are great opportunities to see what's new, see what the competition is doing, and spot companies that could use your help. By spending time on the trade show floor, you can meet a lot of people and increase general awareness of your firm. You might also want to participate in conference programming, perhaps by being part of a panel discussion. If so, contact the event producers at least eight to ten months in advance to let them know about your availability and expertise.

Press releases
Each time you complete an important project, win an award, or land a major new client, you should send out a press release. Unfortunately, in most creative firms this task goes to the back burner so often that it's never actually completed. It may be a better idea for you to outsource the process to a small public relations firm or freelancer. The information itself must be newsworthy and presented in a way that makes it interesting to the reader of a trade publication, and it must be sent to the correct editors and columnists.

Press coverage and reprints
Ideally your press releases will lead to some press coverage. A positive article about you is essentially a third-party endorsement. It's a great addition to your marketing materials. However, don't use photocopies. The quality is too low to project the right image. Contact the publication to arrange for reprints. The usual method is for them to sell you duplicate film or files, which you can then take to an offset lithographer.

Publishing articles and books
You can demonstrate your knowledge and enhance your stature as an expert in a particular field by submitting articles to trade publications. Many creative firms also produce books about their work, although this can be very expensive and time-consuming, and potential clients might never see the book unless you give them a free copy.

Memberships and personal networking

Take the time to join professional organizations and actively participate in industry groups. It's a great way to expand your personal network, stay on top of trends, and learn about project opportunities.

Alliances

Depending on the nature of your firm, you might consider teaming up with companies that provide different but complementary services. For example, many identity design studios have close ties with venture capital firms.

Referrals

You may feel a bit shy about this at first, but it's good to ask for referrals from current and past clients. For example, your contact in a large corporation may have counterparts in other divisions. Someone who already knows you and trusts you is in a great position to recommend you to peers and perhaps provide you with a brief testimonial that you can use in future marketing efforts.

Mailing list

Every design firm needs to build a mailing list. Start with current and past clients and then add interesting companies in your target markets. Perhaps you've read about them in the business press or become aware of them through industry events. You can also supplement your own information by purchasing mailing lists in various categories for one-time use. If you do this, be careful of several potential pitfalls — purchased lists can sometimes be expensive and out-of-date, and they may not be targeted narrowly enough for your exact needs.

Each time you add a company to your list, do some research to identify the senior decision maker for the purchase of creative services. Be sure that you have the correct spelling, office address, and job title. You should set an initial goal of compiling 200 to 500 names, but of course the emphasis must be on quality rather than quantity. Instead of using word-processing software for your list, get a basic contact tracking application. That way you'll be able to sort the names into categories, record the date and content of each mailing, record any response that you received, and make

additional notes about other interactions or future commit-ments. The initial building of your list is only half of the work required. You need to make a serious commitment to maintain the list. Constantly update and correct it to reflect such things as employee turnover, address changes, mergers, and acquisitions.

Sales process
The overall sales process for creative firms usually looks something like this:

Identify leads
These may be companies that you've read about or become aware of through industry events.

Qualify leads
Do some research on each company to see how much potential there might be. Do they need the type of services that you provide? Search the Internet for articles about them. Visit their Web site, if they have one. If the company is publicly traded, get a copy of their annual report.

Make contact
It's fairly standard to send some initial information about your services with a personalized cover letter and then follow up a few days later with a phone call. Your goal is to make a positive first impression and learn more about their situation and needs. Try to get information that is more current and more specific than what you found in your research.

Criteria to pursue or drop
At this point, you'll know enough about the company to be able to decide whether or not you should pursue them. For example, if it's a new company, do they have sufficient funding in place? Have they just hired someone else to provide design services? If you decide to pursue the company, it means spending additional time and marketing dollars. You should do so only if you feel that there is clear potential for appropriate work.

Capabilities presentations

The next step is to schedule a personal meeting, which involves advance preparation and perhaps travel. You will explain your capabilities, show past work, and leave behind high-quality marketing materials. Your hope is that the company will be impressed, keep you in mind, and eventually ask you to submit a proposal.

Proposals

Developing and negotiating a proposal is an iterative process. Based on feedback from the client, your document may go through several revisions. At the same time, the client will no doubt be negotiating with a number of other creative firms. Not every proposal that you send will be accepted. Over time, track your acceptance rate (often called your "hit rate"). What is normal for you? Is it one in two, or one in three, or one in four? Average hit rates will vary from studio to studio based on how selective you are in pitching to new clients and how strong your relationships are with existing clients.

Active projects

Never start a project without a signed proposal. A signature means you're on your way. Do a great job!

Close the loop

When each project concludes, take time to meet with the client to assess the results of the assignment and their level of satisfaction. This creates an opportunity for you to sell add-on work and propose new projects. It also provides you with important insights for possible modifications of your offering in order to deliver more of the benefits that your clients desire. For example, your creative product may be very strong, but perhaps some simple improvements could be made in the area of customer service. The client will give you this feedback if you ask (see Figure 10.02).

Relationships

When the chemistry is right and the long-term potential is there, consciously work to convert new client projects into ongoing relationships.

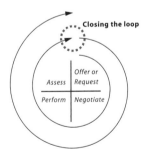

Figure 10.02. Closing the loop by assessing client satisfaction is important for turning one-off projects into ongoing relationships.

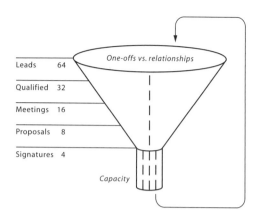

Figure 10.03. It's much easier to keep the sales funnel full if you get repeat business from satisfied clients.

One-offs vs. relationships

Leads	64
Qualified	32
Meetings	16
Proposals	8
Signatures	4

Capacity

Your own sales process is probably similar to the one just described. Take a look at the volume of activity required and how the numbers play out for you. For example, do fifteen leads result in seven meetings, of which three result in proposals, but only one is accepted? This winnowing-down process is often called the "sales funnel." If the majority of your work consists of small projects for one-time buyers, it's quite a challenge to keep the sales funnel full by putting enough new leads into the top. That business model requires continual prospecting, lots and lots of cold calls, and many capability presentations that never lead to real projects. It all becomes much easier for you as a businessperson if existing clients are so pleased that they come right back for more. If you can fill half of your firm's capacity with repeat business, that will eliminate the need for 50% of the cold calls that would have been required otherwise (see Figure 10.03).

Overall, your sales process parallels the classic decision-making process for clients: awareness (knowledge that you exist); interest (a desire to know more about what you are offering); evaluation (consideration of you as a viable option for their next purchase); trial (award of a first project to you in order to test the waters); repurchase (if they are happy with the initial results, they may come to you with add-on projects); and loyalty (an ongoing relationship in which they trust you and prefer you over other service providers).

Client loyalty is a vital success factor for creative firms. To achieve it, you must provide good design, take good care of the client in the process, and always close the loop to identify new opportunities.

Relationship management

Healthy design firms tend to have several good clients with a variety of ongoing needs. These relationships are mutually advantageous. A creative team that is already familiar with a client account can provide good work more quickly and efficiently. A standing team can also provide strategic continuity and brand stewardship, particularly when there is staff turnover on the client side. Another benefit is that an ongoing client will gradually trust you with assignments outside of the original need that brought them to you. For example, the first project might be a brochure or sales materials, but the relationship could expand into packaging or Web sites, or other categories of work. It's a great way to grow your skills and your portfolio.

However, as a businessperson, it's important to avoid becoming overly dependent on any one client. A good rule of thumb is that no single account should represent more than 25% of your total billings. In a way, this is just common sense: don't put all of your eggs into one basket. What would happen if your primary contact retired, or the firm went through a merger, or the client industry went into a slump? The health of your own business could be affected quite dramatically.

At the other extreme, you don't want to take on too many small clients. Maintaining lots of small accounts can be exhausting because of the distractions involved and the level of multitasking required. Too much "background noise" of this type makes it difficult for you to do your best work. To prevent this, you may need to rethink the filters that you use to qualify leads and assess how consistent you are in applying those criteria. Since initial marketing costs tend to be the same for every new client, many creative firms set a minimum size for the new accounts they're willing to go after (see Figure 10.04).

Figure 10.04. Pursue accounts that have strong potential for repeat business.

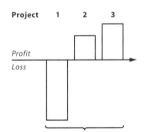

It may take several profitable projects to offset the relationship ramp-up costs.

If you find yourself working on an account that is too small or too dysfunctional, you should let it go. The opportunity cost of working with the wrong client can be high. If you are so busy taking care of an account that is not creatively satisfying or financially profitable, you may not have the bandwidth to respond to other, better opportunities.

Sadly, even good, large client accounts don't last forever. Over time you may begin to see an average life span for client accounts. It will vary based on your practice area and the rate of change in the client industries that you are serving. There are several reasons why clients leave. It could be about you: perhaps you've done ineffective work or provided inadequate service. Or it could be about them: they may be undergoing general cost-cutting initiatives or experiencing a change in senior management, perhaps because of a merger or acquisition.

Some final advice
Never stop marketing, even when your workload of active projects is high. As projects finish, you must have a constant stream of appropriate new assignments lined up to replace them. Otherwise you may find yourself on a very scary roller-coaster ride between too much work and not enough.

TALENT IS NOT ENOUGH: BUSINESS SECRETS FOR DESIGNERS

Chapter 11:
Proposals

A proposal is a detailed project document that defines the scope of work, the process, the schedule, and the total price (usually in the form of a fixed fee). It is a discussion document where the designer puts forward a recommended course of action for the client to consider.

The proposal must be accompanied by an appropriate set of terms and conditions. Together, the proposal and the terms and conditions will form your legal agreement with the client. Many agreements go through several rounds of changes and negotiations before they are finalized. Some discussions with the client may relate to the project specifications in the proposal, while other discussions might focus on the legal terms and conditions. The final goal is to have one comprehensive agreement that is signed by both parties (see Figure 11.01 for an overview of the entire process).

Initial steps for you
Start with some general preparation that is relevant to all of the work done by your firm:

Think about your creative process.
Write down the ideal sequence of activities — phases, steps, and milestones — that allows you to produce your best work. If you are active in more than one practice area, you may have several variations. Your own creative process should be the framework that you use for planning and managing projects.

Calculate a standard hourly rate.
This is an important internal tool that you need in order to sketch out initial budgets. Rates vary from firm to firm based on the amount of overhead being carried, the number of hours available to devote to client projects, and the target profit margin included in the calculation. (See Chapter 09 for more detailed information about calculating rates.)

Research industry terms and conditions.
Become familiar with standard legal language appropriate to the type of work that you are selling.

Now you can zero in on the particular client project that you are bidding on:

Gather client information.
Collect as much information as you can about the potential project. If the client has provided you with an RFP document (a request for proposal), review all of the details carefully.

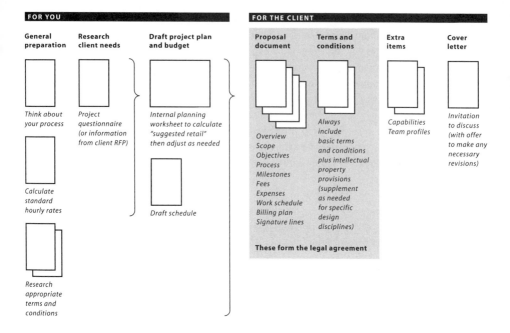

FOR YOU			FOR THE CLIENT			
General preparation	**Research client needs**	**Draft project plan and budget**	**Proposal document**	**Terms and conditions**	**Extra items**	**Cover letter**

Think about your process

Project questionnaire (or information from client RFP)

Internal planning worksheet to calculate "suggested retail" then adjust as needed

Overview
Scope
Objectives
Process
Milestones
Fees
Expenses
Work schedule
Billing plan
Signature lines

Always include basic terms and conditions plus intellectual property provisions (supplement as needed for specific design disciplines)

Capabilities
Team profiles

Invitation to discuss (with offer to make any necessary revisions)

Calculate standard hourly rates

Draft schedule

These form the legal agreement

Research appropriate terms and conditions

Figure 11.01. The agreement that you eventually sign with your client is part of a larger planning process.

Beyond this, you may want to complete your own form of project questionnaire to make sure that no important details are overlooked. This may involve additional discussions with your client contact and possibly others at the client company in order to learn more.

Now you're ready to prepare a preliminary project plan and budget. Even though you may be allergic to spreadsheets, it's important to get in the habit of using an internal planning worksheet to calculate a "suggested retail" price for the project. This ballpark number has to be based on the scope of work required, your own step-by-step design and implementation process, the size of the team that will be required, an estimated number hours for each team member (valued at your standard hourly rate), and estimated outside purchases (including a standard markup). Now you have to make a judgment call: adjust the totals as needed in order to reflect market conditions and the ultimate value of the work to the client.

You'll also need to draft a preliminary work schedule that shows the number of workdays or workweeks required (don't forget to factor in your prior commitments to other

TALENT IS NOT ENOUGH: BUSINESS SECRETS FOR DESIGNERS

clients). A good approach is to do this as a Gantt chart that shows blocks of time and indicates project activities that can happen concurrently (see Figure 11.02). Whenever possible, it's best to avoid locking in specific start dates, approval dates, or completion deadlines, because all of them are sure to change. It's better to plan the schedule in terms of the elapsed time necessary.

All of this internal preparation and planning has been just for you. The next step is to begin drafting a document that the client will see.

Proposal document

This is where we begin to draft the actual document that will be sent to the client. Written proposals include specific details that vary quite a bit based on the individual project and the creative firm. However, there is a fairly standard structure for the proposal document itself. Typical components include:

- An overview of the client situation
 This shows your understanding of their industry and competitive challenges.

- A description of the scope of work and specific objectives for this project
 Describe the immediate need that must be addressed and the specific targets that must be achieved.

- The process that you are recommending
 For each individual phase, spell out what is included and what is not. In each phase, describe the sequence of steps, the deliverables and milestones, the number of creative directions that you will be showing, the number of revisions or refinements that are included, the format for delivery, the necessary time frame, and a subtotal of fees and expenses. Along the way, be sure to clarify the client's responsibilities and explain how the client will be integrated into the process.

- A recap of the total time frame, total fees, and total expenses
 Here you're going to add up all of the subtotals, plus any applicable taxes.

- A billing plan
This is a simple list of invoice amounts and when they will occur during the project (the payment terms will be explained later in the terms and conditions).

- Appropriate terms and conditions
(See Chapter 19 for much more information about legal terms and conditions.)

- Two lines for authorized signatures
Place these at the end of the document. One should read "submitted by," and the other should read "accepted by."

You may want to include some extra items, particularly if the client's approval process involves routing the proposal to an executive who has not met you:

- Capsule bios of senior team members

- Background information on your design firm's capabilities and your credentials

When finalizing a proposal package, always include a cover letter. It will be written last. Keep it short, professional, and enthusiastic. Don't repeat any of the details that are in the proposal itself. The letter is simply an invitation for a follow-up conversation, and it should indicate your willingness to update or revise the scope of work if necessary.

Next, consider the best way of getting the proposal package to the client. Whenever possible, present it in person. This allows you to explain the contents, to address any concerns that the client might have, and to begin building a positive professional relationship.

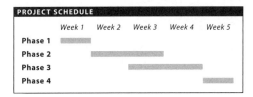

Figure 11.02. In addition to showing duration, a Gantt chart indicates whether activities must happen in sequence or whether they can be undertaken concurrently.

Chapter 12:
Project management basics

Project management is an area where the freedom of the creative process and the constraints of sound business procedures overlap. One is quite loose and visionary, while the other is more structured and driven by numbers. This chapter shares some thoughts about how to bring the two together.

Successful projects require detailed planning and advance preparation. Once a project begins, however, it's important to remain flexible. The work will never proceed exactly according to plan. In the midst of a project, decisions have to be made about a range of trade-offs, including issues of cost and quality. Smart decisions are well-informed ones, so every design firm needs a reliable system for tracking and analyzing project activity. This chapter discusses the preparation and use of progress reports and shares real-world strategies for managing client expectations and coping with project changes. Sometimes problems come up as well, so there's a discussion of the most common "red flags" and what you can do about them, along with some expert advice for keeping customer relationships on track.

Getting started

Producing good design is only half of the battle. The work that you do also has to be on schedule, be on budget, meet client expectations, and produce a profit for your design firm. A good system for planning and tracking projects can make all of this easier. However, your project-management system will only be as good as the people using it, so it's equally important to hire people with the right skill sets. If you have a small office and work primarily on small projects, the best approach is to hire for talent. Once employees are in place with the necessary design abilities, you can gradually develop their project-management skills with on-the-job guidance and training. A different approach is taken by larger offices, where big projects are completed by multidisciplinary teams. Large offices have the luxury of making separate hires for each necessary skill set, including project management. (This all-star team approach is one of the major benefits of being part of a larger firm.) The overall goal in project management, apart from supporting the development of great design, is to manage each project according to its planned budget and schedule so that it can be completed profitably. This means that each project must have a plan to begin with.

As we discussed in Chapter 11, there are several steps involved in putting a solid plan together. You should start with some general preparation that is relevant to all of the client work that you do: map out your own preferred creative process, calculate standard billing rates that you can use in

developing preliminary budgets, and research standard contract terms and conditions that are appropriate to the type of creative services that you provide.

Next, focus in on the specific project at hand: gather as much information as possible about the client and their business needs in order to clearly define the scope of work to be produced and to identify the resources that will be required. With this information in hand, you'll be ready to develop a comprehensive project schedule and budget. This internal planning should be done with a spreadsheet that will help you determine the size of the team that will be required, estimate the number of hours that will be needed for each person, and plan any outside expenses that will be necessary. Remember to build in some leeway for yourself. As any seasoned professional will tell you, it's smart to "under-promise and over-deliver." In practice this means that, even though you will define the scope of work as tightly as possible, your internal planning should also include a small contingency. It should not be more than 10%. This will give you some breathing room in case an aspect of the project turns out to be just a bit more complex than you expected. If no complications come up, the contingency will allow you to deliver just a bit more than you promised to the client in your written proposal. A small amount of extra work that the client is not expecting is not really "over delivery" if you have, in fact, allowed for it in your internal planning.

The last step in your advance preparation is to draft an agreement document to be signed by the client. For most design firms, this consists of a fixed-fee proposal with attached terms and conditions. This document locks in the scope of work and sets the client's expectations about the project's process and deliverables. (For more guidance on budget preparation, please refer back to Chapter 11.)

Keeping records

When the client approves the agreement document, work on the project begins. Your business challenges now are to track and manage that work effectively while it is being done. This requires a well-thought-out project-management system. Small firms tend to start with a manual system based on two separate files. The first is the creative file, where you will accumulate the various design elements as they

are developed. The second is the business file, which will contain the project's legal and financial documentation. Physically, these two files will be large folders or three-ring binders. While the project is active, the creative file will sit on the desk of the person responsible for design of the project and for making sure that it is in alignment with the quality standards of the studio. The business file will sit on the desk of the person primarily responsible for project-management issues, including budgets, schedules, and logistics. In a small office, the designer and the project manager may often be the same person.

Inside the cover of the business file, some firms place a checklist of the necessary contents. The first items on the list will relate to your advance preparation:

- Your internal planning worksheet and draft schedule
- A copy of the formal proposal document that the client signed
- A contact sheet for all members of the design and client team
 This should include each person's name, job title, project role, telephone number, fax number, e-mail address, and a street address for physical deliveries. The contact sheet should be distributed to all participants at a project kickoff meeting that is held after the proposal has been signed.

The other contents of the business file will be items that are generated while the project is active:

- A running tally of all time spent on the project
 In a small firm, this may be a manual summary. In a freelance business where only one project is active, it might be your actual daily timesheets. In a larger firm where everyone is working on multiple projects, this will be a weekly report from your project-tracking software. (More about work-to-date progress reports in a moment.)
- A running tally of all supplies that have been used and vendor expenses that have been incurred
- Copies of any purchase orders that you have issued
 When advance commitments are made to vendors, such as an order placed with a printing company, you'll want to lock in the results of your negotiations by issuing a written purchase order. In the project's business file and

*on any progress reports, this is a reminder that certain
portions of the budget have been committed to vendors.
If the project is later cancelled, the vendors must be notified.
In some instances, they might charge you a fee upon
cancellation, such as the restocking fee that printers must
charge for any paper that was special ordered. Be just
as professional and respectful with your vendors as you
are with your clients. Your vendors are a great source
of expert advice. It's also likely that one day you'll be
completely dependent on one of them to come through
for you in a pinch.*

- A copy of each invoice that has been sent to the client
 *Add notes for yourself to indicate which ones have
 been paid.*

Over the course of the project, signed proofs from the
design and production process will be collected as well.
These might be included in the business file, but it's more
likely that they'll be placed in the creative file for easier
access by the rest of the design team.

Staff time that is posted to projects will be coming
from daily timesheets. The layout of the timesheet will
vary based on the preferences of the design firm and the
project-tracking software that is being used, but the basic
elements will include the date of work, employee name,
client name, project name or number, task being performed,
amount of time spent (usually in fifteen-minute increments),
an indication of whether the time is billable or non-billable,
and perhaps some room for comments. Billable time will
be the norm, but some non-billable time might be posted
to client projects for such things as fixing studio mistakes
or re-creating lost files. (Staff members will also spend
non-billable time on in-house projects and activities. For
a more detailed discussion of billable and non-billable
time, please see Chapter 26.)

As work on a project moves forward, many individual
computer files will be generated. Be sure to put dates
and version numbers on everything. If you don't, things
can become very confusing. You would not want to lose
track of any edits or corrections or mistakenly release
the wrong file to a vendor. To avoid these problems, use
a simple and consistent naming convention for all files.

You'll also need a good storage and backup procedure for your digital files so that everything can be found quickly and easily. If an important file does get lost and has to be re-created, it could significantly reduce your profitability.

Keep the overall size of the business file manageable. Do this by periodically weeding the folder or binder of any duplicate or out-of-date information. Don't throw anything away — just separate "reference" information that will be accessed often (such as the proposal, budget, and schedule) from "archive" information (such as earlier versions and superseded documents) that can be stored somewhere else. When you're setting up your project-tracking system, you also need to devise a simple "tickler system" to flag anything that will require a specific future action. A missed deadline or failure to follow through on an action item can cause major problems within the project itself and can even endanger your entire relationship with the client.

Progress reports
As you work on projects, get in the habit of preparing and reviewing progress reports at least once a week. Maintaining a running comparison of the estimated amounts to the actual amounts is vital for effective project management. Again, this means that each project must have a detailed plan to begin with. Use the same overall format for your original, internal estimate and for the running tally of actual activity. This will allow you to make comparisons easily and to see at a glance whether an item is over budget or under budget. This approach is often called "management by exception" because you are watching for things that don't match your original expectations.

The running totals for actual work performed must be as current as possible. This means that time spent on client projects must be recorded on a daily basis. All invoices received from vendors must be reviewed and posted on a daily basis as well. On a fast-moving project, a delay in getting current totals can cause big problems. If too much time or money is going into a project but you don't become aware of it until long after the fact, it will be too late for you to intervene and get things back on track. You have to catch problems early while you can still correct them.

Keeping an eye on variances between estimated amounts and actual amounts will help you to...

- Become aware of any internal inefficiencies *(such as too many creative directions being pursued or too many people being assigned to the creative team, which can cause you to burn through the project budget too quickly)*
- Make sure that the services being performed stay within the agreed-upon scope of work *(this is vital when you are being compensated on a fixed-fee basis)*
- Generate change orders promptly when and if they become necessary *(more about change orders below)*

Your project-management system must allow you to report on progress at varying levels of detail, depending on who will be receiving the information. The most detailed progress reports will be the internal updates used by the creative team and by the financial manager for the design firm. These need to be side-by-side comparisons of estimated and actual amounts. Team reports will start with the name of the client, the name of the project, the job number that has been assigned for studio tracking purposes, any control number that was issued by the client, the project's start date and target completion date, and a brief note about the current status (such as the next milestone or the next action that needs to be performed).

Beyond this general information, there are many specific things that you'll want to know about the state of the project. The exact layout of a progress report varies from firm to firm, but the most common format is to include separate horizontal rows to identify the individual tasks and materials that were budgeted, followed by several columns with the amounts that you will be analyzing. (You might want to organize the tasks by phase so that you can include subtotals.) For each task, this is what you need to know:

- The original estimate amounts that were approved by the client

- Any subsequent change order amounts that were
 approved by the client
 *Together these first two columns will represent the total
 that can be billed to the client for the project.*
- Your internal studio budget
 *When listing your internal information, you can decide
 whether you want to see the amounts at gross or at net
 (with net being staff labor at payroll rates plus vendor
 expenses without markups). It's best to show staff labor
 both in hours and in dollars, while outside purchases
 will only appear as dollars.*
- Any purchase orders that you have already issued to
 your vendors
 *These outside commitments are pending costs. When vendor
 bills are received, they must be matched to the purchase
 order for approval. If vendors have submitted progress
 billings, show the net amount that is remaining (the original
 total less the amounts that have already been billed to you).*
- Running totals for the actual work that has been
 performed to date
 *Again, these must be as current as possible. Look at labor
 both in hours and in dollars, calculated at standard billing
 rates. Outside materials and services should be listed at
 marked-up amounts. This is a useful approach because it
 shows you what the project could have been billed for if
 it had been negotiated on a time-and-materials basis. On
 a fixed-fee project, you will of course be billing the amounts
 specified in your contract, but this allows you to make a
 very interesting comparison.*
- A running total of all the invoices that you have issued
 to your client to date
 *Usually this will include a deposit invoice plus a series of
 progress billings.*
- A calculation of the current variance between what has
 been worked and what has been billed to the client
 *Usually these will not be in sync — you'll see a positive
 balance if your billings have fallen behind the pace of
 the services actually performed, or a negative balance
 if progress billings have gotten slightly ahead of the
 work itself.*
- The amount remaining on the client estimate (including
 change orders)
 These numbers represent the future billings on the project.

- The amount remaining on your internal budget

 As the project moves forward, it's very important for you to keep an eye on the speed at which the budget is being used. This is often called the "burn rate." You can be less formal about this on a small project, but on a fast-moving large project, it's wise to study it closely. One way of doing this is to prepare a chart of the budget amounts that have been used, either week-by-week or on a cumulative basis. Your actual activity will take place in fits and starts, but the estimate is commonly charted as a straight line. To do this, simply divide the approved total by the number of weeks in the schedule. Related to this, you should also keep in mind that the mathematical percentage of budget used might not match the team's perception of where they are in the overall creative process. (For a more detailed discussion of these issues, please see Chapter 25.)

Any project reports that are prepared for people outside the project team will be much less detailed. For example, summaries provided to studio management will usually show totals only. If there are any questions, it's always possible to drill down into the details. For the most part, all that is needed is a note about the current status of the work, the percentage of the budget that has been used, the percentage of the approved estimate that has already been billed, and the scheduled completion date.

On some projects, you may be asked to submit summaries to the client. Just remember that only gross amounts should appear on any reports that go to a client. Some client organizations will request progress reports, and some will not. When they are requested, it may be just a formality for their accounting or purchasing department. On a fixed-fee project, it's not a good idea to go into too much detail. Send a snapshot only. Providing unnecessary detail sometimes encourages the client to start nit-picking the numbers, which is not a productive exercise — it won't change the total billings for the project, and it will shift attention away from the overall progress that is being made on the creative side. Sometimes all that is needed to meet the client's informational needs is to add a brief recap like this to the bottom of each new invoice: previous billings of $X plus this invoice of $X equals total billings to date of $XX.

Managing changes

Successful designers learn to guide client expectations and effectively manage changes. No project will ever go completely according to plan. There will always be at least minor adjustments. If the changes remain within the overall scope that was previously agreed upon, however, they will not pose a problem. Some of these changes may originate on your side of the relationship — that is to say that they will involve things that are primarily within your control. The project team will be making a number of judgment calls that involve trade-offs between schedule and budget and perhaps quality. Every designer knows that, on some projects, it takes a little longer to come up with the best creative solution. For your own internal management purposes, you might be able to shift the budget around a bit between tasks or phases to accommodate this. Savings in one area can be applied to an overage somewhere else. Usually this is not apparent to the client.

Occasionally you might also decide to put in a significant amount of additional design time. It's not unusual for a design firm to make a judgment call related to quality and consciously decide to put more labor into a project even though it will not be compensated. As a designer, you will always strive to produce the very highest quality of work possible. As a businessperson, make sure that you are making informed decisions, with a clear understanding of the costs and the impact on your company.

Changes that originate on the client side of the relationship will often involve additional work that is outside of the original scope or in addition to the original set of deliverables. Such client alterations or additions should trigger a change order from the design firm. Prompt and consistent use of change orders can have a huge impact on the long-term success and profitability of your business. However, you will only be able to trigger a change order if the original scope of a project is very clearly defined in the first place. If the proposal document sent to the client was vague, you'll be facing an uphill battle when it comes to managing changes.

This is the essential information that should be included on your change order form:

- The date of the request
- The name of the client contact who made the request
- A description of the specific change or additional work that was requested
- The reason for the change
- A description of the effects that the change will have on the project's schedule, resources, cost, or quality
- The effects that the change will have on the project's essential features or functionality
- The names of the people who should be notified of the requested change (the stakeholders who will be most affected by it)
- Two signature lines: "submitted by" and "accepted by"

You should also include these important notes:

- A statement that the additional work will not be done unless the change order form is approved within a certain number of days
- An explanation that each approved change order will be invoiced separately
- A statement that the legal terms and conditions of the original contract will also apply to the additional work

To make your life easier, the process of generating a change order must be as simple as possible. Many design firms place a pad of preprinted, multicopy change order forms near the telephone at each team member's desk. Do not perform the additional work until the client has signed the change order. On a fixed-fee project, make sure the client understands that this work will be billed in addition to the original contract total. Later, when you send a separate invoice for the change, attach a photocopy of the signed form.

In some instances, a change order will not be the right approach for you to take. If your client is making a large request for something "instead of" as opposed to something "in addition to," it may be time to re-estimate. If a client initiates major changes to the overall specifications or scope of work partway through the project, it's usually simpler

and less confusing just to close out the old paperwork. This will allow you to start fresh with new documents, including a new proposal from the design studio and a new purchase order or requisition from the client.

Starting fresh will also help you to keep your own completed projects sorted into distinct categories. If you are using project-tracking software that sorts out your business activity into job types, this re-estimated work may need to be identified as belonging to a different category. You wouldn't want to mix together jobs that actually produced different types of deliverables.

Common problems
As any professional designer can tell you, there are many things that can go wrong over the course of a project, both internally and externally. Here are some "red flags" that indicate potential business problems, along with some thoughts about what you can do to prevent them:

- An incomplete plan
 A lack of comprehensive planning can lead to oversights and unpleasant surprises. If you leave out something that is small, you might be able to absorb the additional expense. However, if you leave out something large, it will require an embarrassing renegotiation with the client.
- Poor organization of resources
 On a daily basis, make sure that there are no coordination or communication problems that could possibly lead to misunderstandings or to a resource not being ready when needed.
- Lack of role definition for team members
 If there is confusion about who is doing what or who is responsible for what, it could lead to serious overlaps or gaps. Establish individual accountability for tasks and make it clear who has the authority to make decisions on any trade-offs.
- Dependency on one person
 Make sure there is always cover in case of emergency or illness. On a daily basis, make sure that information is shared and progress is documented.

- Scope creep
 This is the most common problem of all. As work is being done, people will always want to add things. A moving goal post will make success impossible. Stick to the original specifications as much as possible. When necessary, issue change orders or re-estimate.
- Unclear objectives
 How will you know that the project is done and whether or not it has been successful? The most important things to be accomplished by the end of the project must be agreed upon in advance. Otherwise, you're setting yourself up for possible disputes in the closing days of the project. You may think that the work is complete and successful, but your client may be evaluating it in a completely different way.
- Project funding
 Don't let yourself be taken by surprise — make sure that you know who holds the purse strings and whether or not they have made an adequate commitment to the project. A number of things might cause the funding for your project to dry up before it is completed: there may be a larger shift in the client's business strategy that makes the project unnecessary; poor financial performance might trigger general cost-cutting; the project might be put on hold or cancelled because of a merger or acquisition; or executive turnover may bring new priorities and competing relationships.

Staying on track

Good project management includes providing outstanding customer service. Make sure that you maintain excellent client communication all through the process. Be proactive and professional about providing the client with updated information. Always be accessible and respond promptly to inquiries. Follow through on all commitments that you make. By providing both great design and great customer service, you will earn the confidence and respect of each of your clients. Your goal is to be regarded as a dependable ally and trusted advisor. The long-term success of your business will depend on your ability to convert one-off projects into ongoing, mutually beneficial relationships.

Chapter 13:
Bookkeeping basics

Proper bookkeeping can sometimes be a challenge for a person who has graduated with a design degree. This is because small business basics usually are not taught in design degree programs. As a result, most designers must learn the basics of bookkeeping on the job. For the most part, keeping the books for a business is an extension of the skills that you've already developed in order to manage your personal finances — that is, if you are a person who balances your checkbook every month. With those skills as a foundation, you'll go on to learn some specialized terminology and become familiar with additional business record-keeping requirements.

For your company to prosper, you must of course be producing good design. But, in addition to that, you also must have a very clear picture of where the money is coming from, where it is going, and whether or not you are producing a profit. Complete and accurate record keeping is what provides you with that clear picture. Proper bookkeeping allows you to produce reliable financial statements, file accurate tax returns, and maintain the overall health of your business. This chapter explains the essentials of bookkeeping and shares real-world tips for tracking your business activity and staying out of trouble with the tax authorities.

Bookkeeping is important, but it can seem a bit intimidating. To make it as accessible as possible for someone just getting started in business, this overview breaks the topic down into three sections. The first section explains the essential records that must be maintained by all businesses. The second section describes the basic procedures and systems that are needed for effective financial management. The third section lists key internal controls that should be put in place to keep everything on track.

As an entrepreneur, you need a system that will enable you to monitor the progress of your business, keep track of income and expenses, and prepare accurate tax returns. The financial records that you maintain must be complete, accurate, and timely. How do you accomplish all of this? Well, ultimately, you'll learn by doing, but there's absolutely no need for you to reinvent the wheel when it comes to financial matters. Here are some strategies for starting off on the right foot:

- Get advice about systems and procedures from an accounting professional (more about CPAs and bookkeepers in this chapter).
- Pick up a reference paperback or two. There are a number of good titles currently available, including *Keeping the Books* by Linda Pinson.
- Consider enrolling in a seminar. Many community colleges and university extension programs offer a financial workshop for entrepreneurs. The title is usually something along the lines of "Accounting for Non-Accountants."

- Visit the Internal Revenue Service site at www.irs.gov and download the PDF file for publication 583, "Starting a business and keeping records." It is a good overview of basic bookkeeping and tax issues for entrepreneurs, and it explains the documentation that is needed in order to resolve any tax-related questions. It's illegal to misrepresent or under-report your business activity, even if it is done accidentally. Keep in mind that much of your financial activity will involve other people — vendors, clients, banks, et cetera. At the end of the year, many of them will be reporting their side of the transactions to the government. Your returns must match those amounts. By keeping good business records, you are creating something called an "audit trail," meaning a chain of references that makes it possible to trace information about transactions back through your accounting system.

BUSINESS RECORDS

OK, so what are the basic business records that you need to maintain? They include the following:

Client invoices

Keep a copy of all invoices that you have sent to clients. A chronological listing of all the invoices that you have generated during the year is called your "sales journal." When each invoice is added to the sales journal, it is officially recorded as business income for the month in which it was issued. While you are waiting for client payments to arrive, the open items are called your "accounts receivable," which is carried on your books as a business asset. To track the due dates on the open client invoices, you should periodically prepare an aging report, which sorts the unpaid items into columns based on how long ago they were issued, such as "0 to 30" days, "30 to 60" days, and so on. When you receive payment, write the payment information on your copy of the invoice and then move it to a file marked "paid." Set up a separate paid file for each year. The contents of the file should be arranged alphabetically by client name.

Vendor invoices

When your business is new, some vendors may require you to pay for materials or services on a C.O.D. basis.

Most, however, will extend credit to you. Activity will be charged to your account, and the vendor will later send a bill to you in the mail. Be sure to go through your incoming business mail on a daily basis. Some of the bills that you receive will relate to client projects, and some will be for general operating expenses. Before you post them to your books, review all incoming bills for accuracy and match them to any packing slips that you've accumulated or any purchase orders that you've issued. A chronological listing of all the bills that came in during the month is called your "purchases journal." Each purchase that you make will be identified by expense category. Each posting should be based on an original invoice. Do not record purchases based on monthly statements (except for statements that relate to business credit cards, in which case the statement itself serves as the invoice). If you see an unidentified entry on a month-end statement from a vendor, ask them to provide you with a copy of the invoice that you are missing.

Until you pay the bills, the open items are referred to as your "accounts payable." The total will appear on your financial statements as a business liability because it represents money that you owe to creditors for services or goods already received. Keep all unpaid bills in a file that is arranged by due date. Most firms also summarize unpaid bills by periodically preparing an aging report (as described earlier). When you eventually send your payment to the vendor, be sure to indicate on the face of the check which invoice is being paid. Write your check number, date, and payment amount on the bill itself and move it to a paid file for the year, arranged alphabetically by vendor name.

Business bank account information
Even though you may be operating a one-person company, it's best to keep the financial activity of the business separate from your personal finances. At the end of every month, reconcile each business bank account statement and keep it in your files along with the cancelled checks themselves (or the digital check images on paper provided to you by the bank). Contrary to popular belief, reconciling a bank statement is not useless busywork — it's an important process. It brings your records and the bank's records into agreement at the end of each banking period. You need to make sure that each deposit went into the right account and that all checks cleared for the correct amounts. It's an

opportunity to correct any mistakes that you find and to record any month-end bank charges or service fees. At the end of the reconciliation process, you will know exactly which items have cleared the bank and which are still pending.

Disbursements journal

Just as in your personal life, much of your company's financial information will come from the checkbook. In a business it is called a "check register," and it's usually in a larger format. However, the essential purpose is the same — to maintain a running record of transactions for a specific bank account, including all checks written and all deposits made. Some businesses have multiple checking accounts, so they have multiple check registers. The payments that you make are called "disbursements." The disbursements journal for your company is a combined listing of all payments from your various accounts within a particular period of time. Most of your disbursements will be payments for vendor invoices that are sitting in your open accounts payable, but others may be for new purchases that you have decided to pay for immediately. The activity is listed chronologically, with the amount and the name of the payee. Each disbursement is also identified by type so that you can run totals for each category at the end of each month.

Receipts journal

The deposits that you make are called "receipts." Your receipts journal is a chronological listing of all money that has come to the business within a certain period of time. It's often called the "cash receipts journal," but most of the money that you receive will be in the form of checks sent by clients in payment of invoices that you have been carrying in your open accounts receivable. The receipts journal identifies each payment by date, amount, and source, along with an indication of what it was for.

Time-keeping records

For your own internal management purposes, design services being provided to clients will be measured in terms of the amount of labor involved. This means that a design business must track all project time very carefully. There are different ways of doing this. Usually, the hours worked by each person will be captured initially on a daily

timesheet and then later posted to the individual projects. A manual project-tracking system will involve folders, binders, or large envelopes called "job dockets." For each project, you need to maintain a running total of the time and materials that have gone into it.

Daily diary for recording business mileage
As we discussed in Chapter 05, any business use of your personal car must be recorded in a simple diary with the date of the trip, the purpose, and the number of miles driven. While you're at it, it's easy to record client entertainment expenses (such as meals) and travel expenses (such as tolls and gasoline) in the same diary.

Schedule of fixed assets
You must maintain a separate listing of all furniture, fixtures, equipment, and computers purchased during the year (along with any leasehold improvements or automobiles). This list must include all physical assets with a value of more than $100 and a useful life of more than one year. For tax purposes, you need to calculate depreciation for these items in order to reflect the fact that they will slowly decrease in value over time. The original purchase price will be recorded on your books as an asset. Then, each year, a small portion will be moved to expense. Your accountant will maintain a depreciation worksheet to calculate the annual depreciation amounts reported on your company's tax returns. However, if the original purchase price of an item is less than $100, it will not be depreciated. The full purchase amount will be treated as a direct operating expense in the period of its purchase. (For more information about depreciation, please see Chapter 26.)

Tax returns
You must keep copies of all tax returns filed by the business, whether they are local, state, or federal. For most businesses, this will include such things as corporate business taxes, employer payroll taxes, state sales or excise taxes, and local business taxes. If you have employees, you must also maintain detailed employee compensation records. The easiest way to take care of this is to sign up with an outside service to process your payroll. It may be an independent payroll company or a department within your bank. If your business is new, the payroll service will handle the

paperwork necessary to receive a federal EIN (employer identification number) and a state EIN. These numbers are necessary for your firm to be able to file payroll tax returns. If you sign a power of attorney form, the payroll service will not only calculate your payroll and print checks for your employees, but it will also file all necessary payroll tax returns on your behalf and prepare all required tax deposits. This is a very helpful service because it means that you won't inadvertently miss any deposit deadlines. You must of course coordinate with your payroll service so that there are adequate funds in your bank account when each payroll is processed and when each tax deposit is due. These periodic deposits will include all tax amounts that have been withheld from employee checks plus your employer payments for Social Security, Medicare, and unemployment taxes. (For a more detailed discussion of income tax requirements for independent contractors, please see Chapter 05.)

Other business records

Before you launch your business, you must do some local research in order to determine what licenses are required by the city or county where you are located. Most local licenses must be renewed annually, and you may also be required to prominently post all current licenses in your place of business. You must also keep copies of all insurance policies, leases, and signed contracts. Be sure to retain any important business correspondence as well, whether physical or electronic. Your correspondence may later be needed to answer questions that come up, to document your intentions, and to serve as evidence in any dispute or lawsuit.

Retention schedule

As you can see, quite a variety of items will be accumulated by your business. You need a good filing system to keep track of everything. From time to time you may be tempted to clean house and get rid of older items. Be very cautious about this! Legal requirements for records retention vary for different types of documents. For example, federal and state laws require that all cancelled checks be retained for at least three years. In contrast to this, it's recommended that all tax returns should be retained permanently. When you are first launching your business, you should consult with an attorney to develop a formal retention policy for your

TALENT IS NOT ENOUGH: BUSINESS SECRETS FOR DESIGNERS

company. To avoid any potential problems, you may be advised that the easiest approach for freelancers and small design firms is simply to keep everything. In a small business, your accumulated files will not take up too much space. If your desk or filing cabinet does eventually become a bit crowded, older items can always be moved to off-site storage.

BUSINESS PROCEDURES AND SYSTEMS

In addition to keeping proper records, good financial management involves setting up and following the right procedures. You must also record all activity when it happens. Procrastination will only create an intimidating backlog of paperwork, and in the meantime it's all too easy to forget important details about a transaction or lose receipts and supporting documents. Here are some recommendations for good procedures in a number of key areas:

Billing cycle and process

Make the process of issuing invoices to your clients as easy as possible, and be very consistent about the way that you do it. As a businessperson, you'll learn that it's best to send out a fairly steady stream of invoices so that, later on, client payments will come in at a steady pace as well. Don't wait until the end of the month to do one big batch of invoices. You should also avoid waiting to do just one invoice at the end of a big project. Whenever possible, get an up-front deposit and then break up the balance of a large project into a series of progress billings.

Recording client deposits

When you do receive client deposits, retainers, or advance payments, make sure that you record them correctly on your books. These up-front amounts must be shown as liabilities until your services are actually performed. It's not yet your money — you might have to refund some or all of it if the projects are cancelled. In the meantime, keep these amounts in your bank account — don't spend them on other things.

Efficient collections

When you send an invoice, you need to make it as easy as possible for the client to pay you. If your client is a large company, your invoice will probably be reviewed by several

different people. To simplify the approval process, make each invoice self-explanatory. Include the project name and number, the name of your primary client contact, and any necessary client requisition or purchase order information. You may also want to add the date of the signed contract for the work and some indication of which phase or billing milestone is covered by this particular invoice. With corporate clients, it also helps to submit each invoice in duplicate — an original for them to keep in their files and a remittance copy to return to you with payment.

After you've sent an invoice, follow up at the end of the month with a statement of account — a printed list of all open items. It's a reminder and a chance to compare records. If the client sees an invoice listed on the statement that they do not have in their system, they will ask you to provide another copy. As the due date approaches, phone the client's bookkeeper or accounts payable department to verify that the invoice has indeed been scheduled for payment. If it has not, you may need to provide additional information or ask your primary client contact to intercede to get the paperwork back on track. Be persistent but always friendly and professional — don't be difficult or threatening in any way because that could damage the ongoing relationship. Keep notes of what you are told about the status of each invoice and follow up regularly until you receive full and final payment.

At the beginning of a new client relationship, you may want to establish an initial credit limit for the account and perhaps obtain a credit report to see what their relationships have been like with other suppliers. You should also include a clause in your contract that gives you the ability to charge a penalty on any late payments (a typical rate for this is 1.5% per month; for more information, see Chapter 19). Over time, track each client's payment history so that you have a clear picture of who pays you on time and who does not. Most design firms also calculate the overall collection period for the entire business, meaning the average number of days it takes to collect accounts receivable from all clients (calculated from the point of billing to the point of collection).

Vendor relationships

Your company needs to establish a good payment history with each one of its vendors. This will require good cash management. Keep track of when payments are due and manage your cash so that you can pay them on time. If you come up a bit short, call the vendor and work out a payment schedule — perhaps a series of small checks over a longer period of time. These are important relationships for your business. Keep the lines of communication open. When preparing vendor payments, it's best to do a small batch of checks each week, rather than saving things up for the 15th or the end of the month. When you begin a relationship with a vendor who is an individual, such as a freelance designer, be sure to have him or her fill out an IRS form W-9 ("Request for Taxpayer Identification Number"). The tax ID number will usually be a personal Social Security number. At the end of each year, add up the amounts that you have paid to each freelancer and prepare a form 1099-MISC ("Miscellaneous Income") that shows the total and the tax ID that was given to you. You must provide the completed form to the individual by January 31. (As we discussed in Chapter 03, copies are sent to the government as well.)

Business banking relationship

Choose your bank carefully. You need one that specializes in providing services for small businesses. Your relationship will start with checking and money market accounts. It will gradually expand to include such things as equipment loans, a line of credit, and payroll processing. Get to know the banker assigned to your account. He or she can be a great source of business advice. Plan on having a sit-down discussion with this person at least once a year.

Rainy day reserves

One of your financial goals should be to gradually build up reserves. Think of this money as your rainy day fund — protection against unexpected events. Once it's in place, you'll sleep much better at night. For most companies, a reasonable goal is an amount equal to two or three months worth of operating expenses, including payroll and rent. (This reserve must be in addition to any client deposits that you may be holding, and it should not include any equity lines that have been extended to you by the bank.) You'll want the funds to be generating interest income, but not

tied up for long periods of time. Place your rainy day reserves in short-term investments that are easily accessible.

Master calendar

At the beginning of each year, compile a master list of all tax-filing deadlines, payroll processing days, renewal dates for leases, and insurance policies. (This is sometimes referred to as a "corporate calendar.") Depositing taxes on time is especially important because tax authorities charge penalties and interest on all late tax payments.

Payroll cycle

Your payroll processing must happen like clockwork. As you go through the year, regular payments to yourself and other team members must be absolutely dependable. This requires you to manage your cash flow in such a way that there is always enough money in the bank on payday. At the end of the year, your outside payroll service will provide you with annual totals by individual. They will prepare a printed IRS form W-2 ("Wage and Tax Statement") that shows gross earnings, itemized deductions, and net pay. Your employees need these in order to prepare their own personal income tax returns, so, by law, you must distribute them no later than January 31. (Copies are sent to the government as well.) When you add an employee to your payroll, there are some initial hiring requirements that you need to be aware of. Each new employee must fill out a form I-9 ("Employment Eligibility Verification") to prove that he or she is legally eligible to work in the U.S. This form is available for download as a PDF file from the U.S. Citizenship and Immigration Services site at http://uscis.gov. Each new employee must also fill out an IRS form W-4 ("Employee's Withholding Allowance Certificate") in order to notify you of his or her personal income tax filing status and withholding allowances. After that, employees can give you a new form W-4 any time their tax situation changes.

Financial software

You'll find that it's a lot easier to track your finances using software than it is to do everything manually. Currently, the two most commonly used financial applications in the U.S. for small, Macintosh-based creative firms are MYOB and QuickBooks. Both are quite user-friendly. Your initial use of either application will probably focus on the check register.

Over time, you'll become familiar with additional functions. These general financial applications will let you do some limited analysis of income and expense by individual client project. However, as your firm grows, you will eventually find it necessary to implement a more robust system at the project level. You'll need software that can handle detailed project estimates and schedules, provide comparisons of estimated amounts and actual amounts for individual tasks, and help you track resources and deadlines. When selecting and setting up any kind of financial software, you'll want to get advice from an accounting professional.

Accounting professionals

Accounting is not just the preparation of tax returns. For proper setup of your financial system, including procedures, files, software, and reports, you'll need guidance from a Certified Public Accountant (CPA). A CPA is a person who has been licensed by a state to practice the specialized profession of public accounting. Most creative firms work with an outside CPA. Very few are large enough to need a CPA on staff. It's important for your system to be adequate and reliable and in compliance with GAAP (generally accepted accounting principles). Accounting is the overall process by which financial information is classified, recorded, summarized, and interpreted. It has to do with business systems, rules, and methods. Bookkeeping is a subset of accounting. The focus of bookkeeping is on the recording process. On a daily basis, source documents are reviewed, coded, entered into the system, and filed. A bookkeeper is the person with primary responsibility for properly recording figures into the accounting records. This takes some experience, but it is primarily a clerical role and does not require a state license. New design firms sometimes have their bookkeeping done by an outside service. As the company grows, however, it becomes necessary to bring it in-house.

Double-entry bookkeeping

So, how exactly do bookkeepers do what they do? Your financial activity will be recorded using an approach that is called "double-entry bookkeeping." This has been the standard approach to financial management for a very long time — it was first developed in Italy during the Renaissance. The fundamental characteristic is that it's a self-balancing system based on the assumption that all transactions

consist of an exchange of one thing for another. This means that every financial transaction has two sides — at least one account must be debited and at least one account must be credited, and the totals for each side must be equal. This is what keeps the books in balance. For example, buying supplies will increase your expenses and decrease your cash. Here is how the debits and credits work for different types of transactions:

	Increase	Decrease
Assets, expenses	*Debit*	*Credit*
Liabilities, owners equity, income	*Credit*	*Debit*

Chart of accounts

The internal accounts that you use for tracking your financial activity will be assigned names and code numbers. A list of these is called your "chart of accounts." The accounts are grouped into ranges of numbers to indicate their relative positions within your company's financial statements. The standard chart of accounts varies from industry to industry. For a design firm, it usually looks like this:

Balance sheet items

1000–1999	Assets
2000–2999	Liabilities
3000–3999	Owners equity

Profit and loss activity from operations

4000–4999	Sales
5000–5999	Cost of sales
	(this includes all direct project expenses)
6000–6999	Overhead
	(all indirect costs such as general, administrative, and marketing expenses)

Profit and loss activity that is not related to operations

7000–7999	Other income/expense
	(including such things as interest income, interest expense, and taxes on business profits)
8000–8999	Incentives
	(including any staff bonuses, profit sharing payments, or 401(k) matching funds)

In setting up individual accounts, it's always best to be as specific as possible. Avoid describing anything as miscellaneous. At the end of each month, your bookkeeper will prepare a list of the ending balances in all accounts. This list of dollar amounts is called the "trial balance." It is prepared to verify that the debits and credits for the month were posted properly. If it's in balance, then financial statements can be prepared. The net profit or net loss produced by your business each month will be the amount by which total revenues exceed total expenses (or vice versa). This overall profit or loss is often referred to as the "bottom line." (For more information about the preparation and use of financial statements, please see Chapter 26.)

Cash-basis vs. accrual-basis

There is another accounting concept that you need to be familiar with. For government reporting purposes, your business has a choice of two different accounting methods: cash-basis or accrual-basis. In accrual-based accounting, all income is counted when it is earned, and all expenses are counted when they are incurred, regardless of when the actual cash is received or paid. This means that on your financial statements, you will be recognizing project activity in the month where the work itself took place. As mentioned earlier, your invoices to clients are recorded as sales and then tracked as open accounts receivable. Your purchases from vendors are recorded as expenses and then tracked as open accounts payable. This is in contrast to cash-basis accounting, where income and expenses are not counted until the actual cash changes hands. Cash payments tend to happen long after the fact, which can distort your view of monthly activity and indicate ups and downs that are quite misleading. For this reason, accrual-based financial statements present a more accurate picture. For internal management purposes, most design firms track monthly activity on an accrual basis. At the end of the year, your outside CPA will analyze whether or not there would be a tax benefit in calculating the business tax returns using the cash method. If so, the CPA will convert just the year-end balances into the alternate format.

INTERNAL CONTROLS

As your business grows, some of your employees will become involved in financial matters. This represents a very important transition for your business. You need good procedures and internal controls to prevent simple mistakes, but also to deter such things as theft, embezzlement, kickbacks, or fraud. It's much less likely that these things will ever take place if you're proactive in taking preventative measures. Smart business practices include the following:

Careful staffing

- Be cautious when hiring new employees who will have financial responsibilities. Candidates for these positions must have solid financial skills as well as honesty and integrity. Verify the professional experience of each candidate, and speak with past employers. It's important to conduct diligent background checks.
- If you are transferring or promoting a current employee into a financial position, be sure that he or she has the necessary skills and aptitude. A good receptionist or a good traffic manager will not necessarily make a good bookkeeper.
- Delegate slowly and maintain close supervision of all employees with financial responsibilities. While you are evaluating the quality and accuracy of their work, you must also strive to maintain good morale. Like all employees, those involved in financial management will be happier and more productive when paid a competitive wage and treated fairly and when their individual efforts are acknowledged and appreciated.
- You should require some cross-training among your employees so that they can fill in for each other when needed. With that as a basis, you should also require mandatory vacations for your financial employees. This will give you a chance to verify that everything is being accounted for correctly.

Setting limits

- Limit the number of people who can sign business checks, and place a dollar limit on each person's authority. Above a certain amount, transactions

should come to you for additional review and a second signature.

- You should establish dollar limits for other types of decision making as well. For example, purchase orders above a certain amount should require a second signature.

Other measures

- It's a good idea to separate purchasing authority from payment authority. The person who identifies and negotiates with vendors should not be the same person who later writes them a check.
- Each time a check is drafted, it should come to the signer with supporting information attached. For example, a large vendor invoice would typically be matched to a purchase order and a packing slip. These may be needed to answer any questions before the check is signed.
- Envelopes from the bank should be opened first by the owner of the firm, especially those containing account statements and cancelled checks. Quickly review the contents before passing them on to the bookkeeper for reconciliation. Look through statements for any unusual activity. Look at the names, amounts, and signatures on the cancelled checks to make sure that there have been no changes or forgeries.
- Avoid cash transactions in your business. Do this by using checks or charge cards for all activity so that there is a clear paper trail. Avoid writing any checks to "cash." Avoid having a petty cash fund on hand — it's much too easy to lose track of when and how the currency is spent.
- Finally, have your CPA do a periodic audit of the company's books. Many people are under the impression that audits are only conducted in connection with tax disputes, but the term "audit" refers to any professional examination of your company's financial records. The purpose of an audit is to gauge the accuracy, appropriateness, and consistency of your company's accounting practices.

Chapter 14:
Cash flow

Managing cash effectively is an important challenge for all creative firms. "Cash" includes not just currency but also checks, money orders, bank transfers, and the like. The term "cash flow" refers to the overall movement of money into and out of your business during a given span of time. If a company has positive cash flow, money will be available for such things as expanding operations or making distributions to the owners. However, if a company has negative cash flow, it may have to borrow money to continue operating. This chapter will help you get a handle on this vital business issue.

There are three standard tools used by well-managed businesses to analyze their cash activity:

- A short-term cash flow projection
- A long-term cash flow projection
- A cash flow statement

Let's discuss each of these tools individually.

Short-term cash flow projection

This is a forecast of the cash that you anticipate receiving and disbursing within the next sixty days. It's usually organized into four columns, each representing a fifteen-day span (see Figure 14.01). In order to prepare the projection, you must first print two small reports from your financial system: an updated accounts receivable aging and an updated accounts payable aging. An accounts receivable aging report is a list of unpaid client invoices, usually grouped by name. On the left, each invoice is listed in order of the date issued. On the right, there are columns to identify how long you've been waiting for payment. You can set these preferences in your financial software — for example, "current" (less than 15 days), "15 to 30," "30 to 45," and "45 or more." Unless a client has informed you to the contrary, your expectation is that the oldest invoices will be paid first. Your accounts payable information should be aged in the same way. Typically, you'll pay the oldest vendor invoices first, although priorities sometimes shift. Don't forget that you may have a few additional obligations that do not go through the accounts payable system, such as monthly rent, payroll, and loan payments. We'll list these as "direct disbursements."

To start your short-term cash flow projection, enter your beginning cash balance at the top of the first column. This should include the amount in your checking account plus cash reserves such as savings accounts or money market accounts.

Now, enter all anticipated receipts and payments (from your aging reports, plus direct disbursements) into the appropriate columns. Within each fifteen-day period, you'll see the beginning balance, the expected cash in,

the planned cash out, the net change, and the ending balance that will result. The ending balance at the bottom of the first column becomes the starting balance at the top of the next, and so on. This short-term format is very

Figure 14.01. It's important to note that this shows open receivables as of today only — future billings are not included. Similarly, it shows open payables as of today only — future purchases are not included. If you had to close your doors today, this is how cash activity would wind down. You don't want the final balance to be negative!

60-DAY CASH FLOW PROJECTION

All amounts as of: **October 1**		Oct 1 to 15	Oct 16 to 31	Nov 1 to 15	Nov16 to 30	Later dates
BEGINNING BALANCE						
Cash on hand						
Checking account	30					
Savings account	5					
Combined	35					
Total beginning balance		35	2	22	2	0
CASH IN						
Accounts receivable aging						
Over 90 days	2	2	0	0	0	0
60 to 90 days	6	3	3	0	0	0
30 to 60 days	100	0	50	50	0	0
0 to 30 days	142	0	0	0	71	71
Total accts receivable	250					
From other sources						
Line of credit		0	0	6	0	0
Loans		0	0	0	0	0
Total cash in during period		5	53	56	71	71
CASH OUT						
Accounts payable aging						
Over 90 days	0	0	0	0	0	0
60 to 90 days	12	0	6	6	0	0
30 to 60 days	60	0	0	30	30	0
0 to 30 days	20	0	0	0	10	10
Total accts payable	92					
Direct disbursements						
Rent		5	0	5	0	5
Payroll		27	27	27	27	27
Sales tax		6	0	8	0	0
Repay line of credit		0	0	0	6	0
Loan payments		0	0	0	0	0
Total cash out during period		38	33	76	73	42
NET CASH FLOW		-33	20	-20	-2	29
ENDING BALANCE		2	22	2	0	29

conservative. It shows only actual amounts that are already on your books. It doesn't factor in any potential or speculative future activity.

Update this projection every week before you make any disbursements. Most design firms try to prepare the majority of their checks in one weekly batch because it's a more efficient approach than writing checks in dribs and drabs.

If your short-term projection shows that cash will go negative during any of the upcoming fifteen-day periods, you need a plan for dealing with that temporary shortfall. Your options include the following:

- Speed up receipts
 It's difficult to get clients to pay early, but you can definitely speak with any clients who are habitually late. Negotiate with them to bring their payments up-to-date.
- Slow down payables
 Some business expenses, such as payroll, rent, and taxes, must be paid on specific dates. However, you may have more leeway in scheduling payments to vendors. If you're facing a cash shortage, it may be possible to negotiate with some vendors to slow down your payments, perhaps by breaking large invoices into a series of partial payments. On a related note, many design firms pay vendors for project-related expenses only after client money has been received. Be cautious about this, however. It's important to be fair to your suppliers. If you happen to be late in billing a client, or are in a dispute with the client over an unrelated matter, the vendor should not suffer for it.
- Borrow
 If you're facing an immediate deadline such as payroll, you might consider short-term borrowing. Many design firms have a line of credit available from the bank. If you exercise a line of credit, be sure to repay the funds promptly to minimize the total interest expense.
- Obtain additional investments from owners
 It may be possible to arrange additional cash inflow from the owners of the firm. That is to say, owners might use personal funds to increase their equity stake in the company.

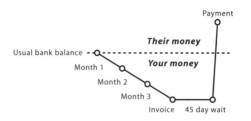

Figure 14.02. If you wait to bill the client at the end of the project, and then wait another 30 to 45 days for payment, you will have to cover labor and other expenses in the meantime. This means that your cash will be tied up in work-in-process inventory.

Maintaining healthy cash flow is crucial to the success of your design firm. You need to have enough cash available to pay creditors, employees, and others on time. Several basic business practices will make this easier for you:

- Always ask for an up-front deposit before commencing a new project, especially if it's a large one.
- On large projects, don't wait to bill everything at the very end. Instead, submit a series of progress billings (see Figures 14.02 and 14.03). Send invoices at least monthly.
- Make sure that your invoices are self-explanatory. Include complete reference information (requisition number, purchase order number, contact name, and so on) so that invoices are very easy for large client organizations to process.
- Follow up on unpaid invoices by sending each client a month-end statement of account, providing additional copies if needed, and phoning on due dates to inquire about payment status.
- Collect the full amount of each invoice. This is sometimes a challenge for recent grads and small firms. If you have a fixed-fee agreement in place with your client and you've provided everything that you promised, don't let the client get away with paying you less. The time for the client to negotiate pricing is before the work is done, not after.

Now that we have a handle on short-term needs, we're ready to take a much broader view by preparing a completely different sort of report.

Long-term cash flow projection
This is normally prepared as part of a business plan. Specific formats for business plans vary. This section

TALENT IS NOT ENOUGH: BUSINESS SECRETS FOR DESIGNERS

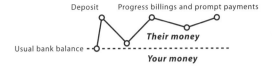

Deposit Progress billings and prompt payments

Their money

Usual bank balance

Your money

Figure 14.03. Bill frequently and work with clients to receive payments within terms. This way, the project can be completed entirely with cash from the client.

might be called the "cash plan," "cash budget," or "pro forma cash flow." Many samples can be found online and in books about business planning. Essentially, it's a prediction of the cash demands that you expect to face over the course of the next three years. It's not tied to the clients and vendors currently on your books.

Preparing it requires you to make a series of very broad assumptions about future activities. You need to give careful consideration to such things as changes in the overall size of the business, possible adjustments to staffing levels, potential changes to your mix of client categories or services offered, the timing of any major purchases, and other potential milestones such as relocation.

With each issue, you need to be as logical and objective as possible. Don't let yourself get carried away by unrealistic expectations. Your month-by-month sales projections should be based on past averages, adjusted to reflect current trends and planned changes. Monthly expense targets will be determined in a similar way.

Because this long-term projection is based on so many assumptions, it tends to become less accurate as it moves further out into the future. For this reason, you should update it on a regular basis so that it keeps pace with your evolving business. Your goal in preparing this projection is to anticipate and estimate the resources and reserves that will be needed to support your continued success. For example, some businesses (such as annual report firms) go through seasonal cycles of profits and losses. If that's your situation, it may be necessary to borrow money to maintain operations during

times of low sales or heavy expenses. The cash projection shows the amount of credit needed as well as the plan for repayment. (For more information about long-term financial projections, please see Chapter 27.)

As you go through this planning process, keep the following tips in mind:

- It may seem obvious, but for the long-term viability of your firm, your accounts payable must consistently be less than your accounts receivable. If this is not the case, see whether your prices can be raised and/or your costs lowered.
- Whenever possible, avoid draining current cash balances to buy long-term assets such as equipment. It's much better to finance big purchases so that long-term assets are paired with long-term liabilities.
- In periods where your cash balance is healthy, have arrangements in place to sweep any excess amounts into an interest-bearing account. Many banking systems will allow you to do this automatically.

Cash flow statement

In this final report, we turn from predicting the future to recapping the past. The cash flow statement can also be called a "statement of cash flows" or "sources and uses of cash." Samples can be found online and in most accounting textbooks. It's one of three standard financial statements that well-run businesses prepare at the end of each month, quarter, and year (the others are the balance sheet and the profit and loss statement).

This retrospective report shows the amount of cash that was generated and used by your company during a particular period in the past. From an accounting standpoint, it doesn't include any accrued amounts. This means that income and expenses are included only if cash was actually received or paid. It doesn't include any non-cash activity such as depreciation.

The report is divided into these standard sections:

* Operations
 This shows cash flow that was related to the sale of goods and services. It includes the majority of daily activities involving customers, suppliers, and employees.
* Investment
 This shows cash flow that was related to discretionary business activities such as the purchase or sale of property and equipment.
* Financing
 This category includes external sources and uses of cash, such as loan activity or the payment of dividends to owners.

At the end of the cash flow statement, you'll see the net change that resulted from the listed activities, broken down by account (cash in the bank as well as any cash equivalents such as marketable securities).

Using these tools

As a smart businessperson, you'll want to master each of the management tools we've discussed in this chapter. They'll help you to spot trends and anticipate future needs. Planning and managing cash effectively is vital for the overall health of your creative firm.

Chapter 15:
Insurance basics

Insurance is protection against the occurrence of unlikely events. Chances are rather small that your office will ever burn down or that one of your employees will be seriously injured while scanning slides. However, as a prudent businessperson, you must arrange for adequate protection just in case. Every design firm needs several different types of insurance. You need standard protection against fire, theft, and general liability for injury to third parties. In addition to that, you need liability coverage that relates directly to the professional services that you are selling. For you and your employees, you'll also want an excellent medical plan, life insurance, and long-term disability coverage.

This chapter shares essential information about each of these insurance categories. It also includes a few tips about insuring a home office. However, this chapter can only serve as a brief introduction to the subject matter. You will of course want to review your own particular situation with an experienced insurance agent. With that in mind, some information is also included on the different types of agents available to you.

INSURANCE BASICS

If you're just starting out in business, the whole subject of insurance can be rather confusing. To put things into context, here's an overview of the various players and what it is that they provide. Let's start with the insurance companies themselves.

Insurance companies

Insurers issue insurance policies and are often referred to as "carriers" because they carry (assume) risk for you, the policyholder. A carrier accepts responsibility for the financial consequences of loss or liability in exchange for your payment of a premium. The dollar amount of that premium will reflect the probability of the specified loss ever taking place. If a covered economic loss does take place, the insurance company has promised to pay up to a specified sum of money. In the meantime, insurance companies invest the premiums that they receive. This generates significant investment income for them.

So, what types and what levels of insurance should you buy for your business? The insurance payments that you make will be an overhead expense for your company, so of course you'll want to proceed cautiously. As a business owner, you must weigh the ongoing expense of the insurance against the potential cost of a one-time uninsured loss. Most businesses buy different kinds of coverage from several different providers. This is because there are three different types of insurance companies, and your needs span all three categories: property-casualty, life and disability, and health insurance.

In the U.S., the government closely regulates the insurance industry. Property-casualty companies and life and disability

companies are largely regulated by the fifty states. Health insurance must follow basic federal government regulations, but states can and do impose additional regulations. Every state has a Department of Insurance that monitors and regulates every insurer operating within the state's borders. In addition to licensing insurers, approving rates, and setting minimum levels of coverage for each type of policy, the state's insurance department issues operating licenses to agents based on their ability to meet requirements for conduct and knowledge about insurance issues. For a list of these state departments of insurance, visit the site of the National Association of Insurance Commissioners at www.naic.org. The site has a map of the U.S. with links to all of the state Web sites.

Since legal requirements vary, the exact policy options available to you will depend upon your location. This is why some large insurers actually consist of multiple companies. They may share an overall brand, but each business unit is separately organized in order to conform to different state insurance codes and regulations.

The financial strength of each insurance company is moni- tored closely by the investment community. As a purchaser of insurance, you'll want to be aware of this as well. If you're going to sign a policy with an insurer, their stability and long-term financial strength are very important factors for you to consider. You may need to file a claim at some point in the future, and you must have confidence that the company is going to be there. For example, if you ever become disabled, your own cash flow will be dependent on the insurance company that you selected. Several independent rating services track the financial strength of insurers, including Standard & Poor's, Moody's, and A.M. Best. Each insurance company is assigned a financial strength rating on a thirteen-step scale. The scale ranges from a high rating of A++ (superior) all the way down to the lowest rating of D (poor). More information about the rating process can be found at www.ambest.com.

Insurance agents
So how do you go about shopping for a policy? In general, insurance companies use two major marketing channels. Most insurance sales are done through outside agents. However, some companies choose to do their own direct

marketing and sales. For example, if you contact GEICO or USAA, you'll be speaking with a salaried employee. As a business customer, it's much better for you to use an outside agent who can provide you with guidance and advice. The services of an agent will be free to you. Agents receive their income in the form of commissions from the insurance companies. The commissions are calculated as a percentage of the premium for each policy that they sell. Many agents distinguish themselves from their competitors by going through professional training programs that qualify them to use professional designations on their marketing materials. Perhaps the most prestigious one is CPCU, which stands for Chartered Property Casualty Underwriter. It indicates that the agent has successfully completed a series of college-level professional courses and passed a rigorous national exam.

There are two main types of agents: captive agents and independent agents. A captive agent is a representative of a single insurer. For example, State Farm and Allstate primarily use captive agents. A captive agent is obliged to submit business only to the company that he or she works for. In exchange, the insurer provides the agent with an expense allowance that covers some of the costs of maintaining an office and may provide other benefits such as a pension. In contrast, an independent agent is a contractor who represents several different insurance companies. The typical independent agent has ongoing relationships with about eight companies. This means that he or she can obtain competing quotes. An independent agent will analyze your needs and then put together a combination of policies from the different carriers that they represent. Independent agents pay all of their own agency expenses out of the commissions that they earn from policy sales. To find an independent agent, visit the site of the Independent Insurance Agents and Brokers of America at www.trustedchoice.com. They have a searchable database of local listings.

A broker is different from an agent. A broker is not working for the insurer — he or she is working for you. Because brokers represent the buyer rather than the insurer, they can conduct a wider search of the market to identify the best sources for each of your insurance needs. They can investigate competitive alternatives from a broader range of reputable carriers. In essence, a broker is an intermediary

who can help you prepare applications for multiple insurers. However, some insurance companies will only accept applications from brokers with whom they have an ongoing relationship. When a policy is sold, the insurance company will pay the broker a commission called a "brokerage fee." You should also be aware of a legal limitation: because brokers are not formal representatives of insurers, any wrongful act of a broker is not the legal responsibility of the insurance company.

EMPLOYEE BENEFITS

OK, so what exactly are you shopping for? Let's start by discussing health-related issues. Employee benefits, even for a one-person company, should include health insurance (plus dental and vision coverage if possible), life insurance, and long-term disability coverage. The purpose here is to protect the individual worker. If you are a freelancer, you'll be shopping around for an individual health insurance policy like those available from Blue Cross. Lots of information about health insurance is available on the Internet. Commercial sites such as www.insurancetracker.com and www.insure.com are online databases of medical insurance providers. By filling in a form you can get comparative quotes. Unfortunately, premiums for individual policies are much higher than premiums for group policies. If you're a freelancer, it's smart to look around for an existing group plan that you may be eligible to join. Many university alumni associations, as well as professional membership organizations like the Graphic Artists Guild, offer their members access to group health plans on a state-by-state basis. Many local chambers of commerce offer group health plans as well. The cost of your membership is usually much smaller than the savings you enjoy on insurance purchases.

So how does a group plan work? Most insurance companies define a group as five enrolled employees or more, but the best rates are only available to very big groups. If you are an employer with a large staff, your company will serve as the policyholder for the group insurance. It will be purchased in the name of the company and offered to employees. However, a different approach is often used for small businesses. An insurer can pool several businesses together in

a multiple-employer trust. The trust itself, rather than any single employer, is the policyholder. This is the approach taken by many industry associations. It enables smaller businesses to benefit from the lower premiums and other services enjoyed by large groups. At the individual employee level, eligibility is usually limited to workers who are regularly scheduled for at least thirty hours a week. Group employee benefits typically include health coverage, life insurance, and long-term disability coverage. Let's look at each of these insurance categories individually.

Health insurance
There are several different models for health insurance, but the market in the U.S. is dominated by managed health care plans. These include health maintenance organizations (HMOs) and preferred provider organizations (PPOs). An HMO requires you to get all of your services from one specific provider, using their facilities and personnel. This is different from a PPO, which is a broad network of health care providers who have agreed to provide services to the organization at a discount. It's common for a PPO to offer several tiers of coverage with varying benefit levels. The more generous the coverage, the higher the price of the policy will be. Many variables will affect the premium:

- The ages of the group participants
 If you have a large staff, there may be different premiums for different age groups.
- The amount of the annual deductible
 A deductible is the initial part of the expense that you must pay out-of-pocket before any insurer payments can begin.
- The amount of co-pay required
 Often referred to as coinsurance, the co-pay is the percentage of the medical bills that the insured individual is responsible to pay after the annual deductible is met. For example, many policies state that the insurance company will pay 80% of the covered bills.
- The range of health services included
 The policy may or may not include such things as dental, vision, hospital stays, psychological counseling, or chiropractic care.

- How much flexibility you have in the choice
 of providers and specialists
 Oftentimes, a formal referral is required from your
 primary care giver. If you go to a provider who is
 outside of the plan, the co-pay will be different.

Many policies also place standard limitations on certain
pre-existing conditions. Federal law regulates these
limitations. If you received care within the six months
preceding your enrollment date, certain expenses may
not be covered when the policy first goes into effect. How-
ever, as soon as you pass the twelve-month anniversary of
your enrollment date, any exclusions for pre-existing
conditions should no longer be valid.

Most group health insurance premiums are billed monthly.
Essentially, you prepay for each period. Your payment
must be received for coverage to remain in effect. Some
policies provide a grace period for overdue premiums, but
you shouldn't count on that. Some employers pay the full
amount of the premium for each worker while others split
the expense with the covered employees, in which case the
employee portion of the premium is handled as a payroll
deduction. If the plan allows an employee to add depen-
dents, it's common for the additional expense to be paid
entirely by the employee.

One final note about health insurance: if you are an
employer, you need to be aware of COBRA, which is
an acronym for the Consolidated Omnibus Budget
Reconciliation Act of 1985. This is a federal law that
applies to all companies that employ twenty or more
people. When employees lose health or dental coverage
due to certain qualifying events, such as termination or
layoff, they have the legal right to continuation of their
group coverage for eighteen months if they pay the full
cost of the premium. In certain special circumstances, it
is possible to extend coverage beyond eighteen months.

Life insurance
There may be some life insurance included in your general
medical plan. If so, it's usually a small amount (like $5K or
$10K). You may want to shop separately for a larger amount.
As you probably know, life insurance is money that will be

paid to your designated beneficiary upon your death. Many financial advisors recommend that you carry an amount equal to at least five times your normal annual income. Keep in mind that there are two general categories of life insurance. With term life policies, the premiums that you pay purchase coverage just for the term of the policy. This means that you must reapply when you reach the end of the term, and higher rates will be charged as you enter older age brackets. In contrast, a whole life policy provides lifetime protection as long as regular premiums are paid.

Long-term disability
This is also called "disability income insurance." It's a form of health insurance that provides periodic payments to you if you're unable to work for a long period of time as a result of sickness or injury. It is not the same as short-term disability coverage, which is provided by some states (New York, New Jersey, and California, among others) and paid for by payroll taxes. Depending on the state, temporary disability may be covered for up to 26 weeks. Long-term disability insurance is also separate from workers' compensation, which we'll discuss in a moment.

Long-term disability insurance is a type of optional coverage designed to replace a portion of your income if you become temporarily or permanently disabled as the result of sickness, accident, or injury. Disability means a physical or mental inability to perform the major duties of your occupation. Employers are not required to provide this kind of coverage, but most creative firms do because a generous benefits package is a competitive advantage when trying to attract the best job candidates. Long-term disability coverage tends to be expensive, but there are many variables that will affect the premium, such as:

- How broadly the term "disability" is defined
 It could be an inability to reasonably perform the duties of your own specific job in the design profession, or it could be an inability to perform any job in any category of occupation.
- The length of the waiting period
 This is the amount of time that you must wait after the disability commences before you can start collecting benefits. It might range from a low of 30 days to a much

longer period such as 180 days, but it is usually set at the upper end of the range so that benefits kick in after the state limit on short-term disability has been reached. The purpose of the waiting period is to avoid claims for minor injuries and illnesses.

- The length of time that benefits are payable
The shortest term might be two years, but the longest might be until you reach the traditional retirement age of 65.
- The amount of benefits payable
Total benefits are calculated as a percentage of your net income. Sixty percent is typical.

If you do become disabled, the benefit payments that you receive from the plan will be reduced to take into account certain types of other disability benefits that you may be entitled to, such as Social Security, workers' compensation, or retirement benefits. When setting up the policy, you will also have to decide who is responsible for paying the premiums. Generally, if the employer pays the premium, any long-term disability benefits that are eventually received will be considered taxable personal income to the disabled employee. This is called a "non-contributory plan" because the employee does not contribute to the premium. In contrast, a contributory plan is one in which the employee pays the premium. If the premium is paid by the employee (usually this is set up as a payroll deduction), any eventual benefits would be tax-free for the disabled employee.

BASIC BUSINESS INSURANCE

Now that the individuals in your firm are taken care of, what about the needs of the business itself? You need to protect the company against possible loss of critical tools and property as well as potential liability to others. An unfortunate occurrence such as a fire or a lawsuit could have a huge impact on your company, causing a significant loss of income or even forcing you to close your doors. You don't want that to happen. Other companies that you deal with don't want that to happen, either. In fact, it's common for business insurance requirements to be written into office leases and important client contracts.

Depending on the type of work that you do, some business insurance may be available to you through industry organizations, where similar businesses have grouped together to qualify for broader coverage at better rates. One such organization is the Printing Industries of America (PIA). Their Web site is www.printing.org. PIA offers members access to group programs through local affiliates, state-by-state. If you don't have access to an industry group, you should meet with an independent insurance agent. He or she will discuss your business activities with you and prepare a list of the type, value, and location of all reasonably foreseeable property loss and liability events. With this assessment, you'll be ready to shop for policies that will minimize each risk to an acceptable level. The agent will offer assistance in identifying insurance options including carriers, policy types, deductible limits, coverage limits, exclusions, and policy costs. The agent will obtain all necessary application forms for you. (Sometimes specimen policies are available. A specimen policy is a sample document that allows you to see the full text of the standard policy. Not all insurers are willing to provide them.) Each completed application that you file will be reviewed carefully by the insurer. If your application is approved, a formal policy will be prepared for you to sign.

A policy is a written agreement that puts specified insurance coverage into effect. It describes the term, coverage, exclusions, premiums, and deductibles. Agreeing to the terms of an insurance policy creates a binding contract. In most instances, the process starts with a standard policy document that can then be modified to fit your particular situation. This is done with endorsements. An endorsement (sometimes called a "rider") is a written agreement attached to an insurance policy that modifies the clauses and provisions, adding or subtracting specific elements and conditions of coverage. Each business insurance policy will have a specified policy term, meaning the effective dates of coverage — the period for which premiums are paid. The term of most business policies is twelve months. This sets you up for an annual review and renewal cycle. You'll find that, over time, your rates will change to reflect shifts in the nature and scope of your business activities but also in response to any claims that you may have filed.

You can shop for each type of business coverage separately, but for your basic needs you may want a package policy. A package policy includes multiple lines or types of insurance within one policy document. Package deals are often cheaper than buying several individual policies. The most common type of package is called a "business owner's policy."

Business owner's policy

A business owner's policy (BOP) combines property coverage and general liability insurance in a single package. A BOP is usually the most economical way to protect your company against a broad range of risks, but not every business is eligible for BOP coverage. These packages are intended for small to medium-sized firms that are operating in a low-risk business category, such as professional offices. Those who operate a business in a higher-risk category such as manufacturing would need what is known as a "commercial policy." A commercial policy is more complex and more expensive. Designers should note, however, that BOP liability coverage does not protect against professional errors or negligence. These must be covered by professional liability insurance, which is discussed later in this chapter. Each BOP contains three essential components: basic business liability insurance, property insurance, and business interruption. Let's look at each of these categories individually.

Basic business liability insurance

This is often called "general liability" or "casualty insurance." It provides basic coverage for personal accidents or bodily injury to a third party or damage to their property. (The most common type of accident in this category is often referred to as a "slip-and-fall.") It covers the medical expenses of individuals other than employees (such as customers, suppliers, or business associates) injured on your premises or as a direct result of the operations of the business. It covers legal costs to defend you against claims, and it covers any damages that your business is ordered to pay.

Property insurance

Property insurance provides your company with coverage for business property that's damaged or destroyed. For insurance purposes, property is divided into two general

categories: real property and personal property. The term "real property" refers to land and attachments to the land, such as buildings. Insurance coverage for a building includes the structure itself and any permanently installed fixtures, machinery, or equipment. (If you're renting, you should ask to see your landlord's insurance policy so that your coverage can be coordinated with what's already in place.) Personal property includes furniture, any fixtures that are not permanently installed, and similar items — if they're not specifically excluded from coverage. Check to see how your policy treats computers and telephone equipment — sometimes they're considered to be special property, and they may require extra coverage. Most business property insurance will also protect you against loss or damage to the personal property of others while it's in your care, custody, or control.

Basic policies generally cover loss or damage that is caused by fire or lightning, as well as any expenses related to removing property if necessary to protect it from further damage (such as removing computers from a damaged building in order to prevent them from being stolen). Many standard policies also cover "extended perils" such as windstorm, hail, explosion, riot and civil commotion, and damage caused by aircraft, automobiles, or vandalism. Other important perils such as earthquake and flood damage are often not covered in standard policies.

For insurance purposes, your property can be valued in several different ways. The two most common approaches are the replacement cost method and the actual cash value method. The replacement cost of an item is the amount of money that you would need to replace it with new property of like kind. In contrast, actual cash value is the replacement cost minus accumulated depreciation to reflect the age and condition of the original that was damaged or destroyed. Clearly, you will want your property to be valued at full replacement cost so that if you receive an insurance settlement, it will be enough to purchase replacements at current prices. However, there is always an overall limit to the policy. The limit of insurance stated in the policy declarations is the most that the insurer will pay for loss or damage in any one occurrence.

Business interruption

This is often called "business income insurance." If your business is severely damaged or destroyed, business interruption insurance provides indemnification for ongoing fixed expenses and for loss of normal profits. For example, if a fire temporarily shuts down your business, you would be reimbursed for salaries to key employees, rents, taxes, interest, depreciation, utilities, and other expenses during the repair period plus the net profits that would have been earned. You may also be able to negotiate for broader coverage to include any extra expenses incurred during the period of restoration. Extra expense insurance would cover the costs of renting a temporary location, fitting it out for use, and moving expenses. The policy will probably establish a maximum length of time (such as one year) allowed for the recovery period. Apart from business interruption insurance, you'll also want to develop an advance plan for disaster recovery. A good disaster recovery plan can help you minimize losses and get back to normal operations much more quickly.

ADDITIONAL BUSINESS INSURANCE

In addition to the three types of basic protection that are included in your BOP, you need to consider several additional types of coverage.

Umbrella liability insurance

The purpose of this is to extend the limits of your coverage above the maximum amounts of the basic business liability insurance policy. You will receive payments under the umbrella coverage only after the basic policy limits have been exceeded.

Business automobile policy

Auto liability coverage is not included in general liability policies, but it is legally required for drivers in all but four states. As you probably know from personal automobile policies that you've purchased over the years, automobile coverage should include the following components:

- Collision insurance for loss or damage to the vehicle itself.

- Comprehensive insurance for any loss or damage from causes other than a collision.
- Liability insurance for damages that the insured might cause to third parties, including property damage and bodily injury.
- Medical payments coverage for authorized drivers and for passengers.
- You may also purchase uninsured motorist coverage for the driver and passengers if they are injured by an uninsured motorist or a hit-and-run driver.

So how is a business automobile insurance policy different from a personal policy? In addition to providing coverage to any vehicles owned by the business, it also covers hired and non-owned autos. This means that the business is protected if you or an employee rents a vehicle in the company name and an accident occurs. It also means that the company is protected if an employee has an accident in his or her own vehicle while on company business. Remember that all drivers must have a valid driver's license. Remember also that any personal property stored inside an automobile (such as project-related materials being delivered to a client) will not be covered under a standard automobile policy.

Workers' compensation

If you have employees, workers' compensation insurance is required by law in most states. It covers employees for work-related sickness and for injuries that occur within the scope of their employment. (This is different from the short-term disability coverage discussed earlier. Short-term state disability benefits are intended to cover non-job-related sickness or injury.)

Four types of benefits are included in workers' compensation: medical care, death, disability, and rehabilitation. The specific levels for coverage are defined by each state. Premiums vary widely for different types of businesses because the rates are determined by the nature of the working environment. Rates are lower for office work environments and higher for industrial work environments (such as factories or construction sites). Large companies with workers in several different categories will have multiple rates — perhaps as low as 0.1% of the payroll

for employees in safe occupations all the way up to 25% or more of the payroll for employees in very hazardous occupations.

Unemployment insurance
Unemployment insurance is not something that you will be shopping for. It's a state benefit that is paid for by payroll taxes. More information about unemployment insurance is available from your state employment office.

Valuable papers and records
If important business records are destroyed, it may take a lot of time and effort to re-create them. The standard property policy will reimburse you for lost office supplies, but it will not include coverage for the labor costs of researching, repairing, restoring, or reconstructing the information contained in valuable papers, records, and electronic data files. Specialized coverage can usually be purchased as an endorsement to a standard policy. Your valuable papers and records might include such things as personnel files, contracts, leases, archival material such as the company's original incorporating documents, or rare books and manuscripts.

Coverage can also be amended to include valuable records belonging to others, while that property is in your care, custody, and control. Even though you're carrying this specialized insurance, you will, of course, want to do everything possible to protect your valuable business records. Make duplicate copies of important documents and clearly labeled backups of important data and store them at an off-site location.

Fidelity insurance
Fidelity insurance covers loss of business property due to employee dishonesty. It also covers any suspicious loss of property that cannot be directly attributed to a particular employee. The coverage may be added as an option to your business policy. The typical fidelity policy covers losses of property due to theft, embezzlement, forgery, or similar criminal acts performed by your employees. Most design firms are small and the employees feel that they know each other quite well. However, small companies are not immune

to fidelity crimes. Losses can take a variety of forms. Many companies are victims of theft of property for the personal gain of an employee. The stolen property might include money, financial securities, computers, or other valuable equipment. Losses could also involve the destruction of property by an employee.

Most fidelity policies cover the loss of assets on your business premises as well as property in transit or temporarily in another location. First-party fidelity covers your property. Third-party fidelity extends coverage to your client's property. Be sure to read your policy carefully to understand any exclusions.

A fidelity insurance policy protects against losses due to employee dishonesty in general. As an alternative, you might consider a fidelity bond that is limited to particular individuals. The premium for a bond will generally be lower, because protection is limited to just those individuals being bonded. Usually these will be the people directly involved in finances, with access to bank accounts and accounting records. Dishonesty by financial managers can take many forms, including such things as adding fictitious employees to the payroll or issuing payments to nonexistent suppliers.

Key-person insurance

Key-person insurance is sometimes referred to as "business life and disability insurance." It provides protection against business losses that result from the death or disability of a key person. A key person is defined as an owner, a partner, or a highly skilled employee whose efforts are directly responsible for some measure of profitability to the firm. The policy is owned by the company and any benefits are payable to the company. For a design firm, loss of a key person is a very serious setback. It helps to have additional funds available to get the business back on track.

Employment practices

More and more claims against companies are filed each year by job candidates, current employees, and former employees. Their charges may include allegations of harassment, racial or gender discrimination, failure to promote, wrongful termination of employment, defamation, or

invasion of privacy. Employment practices insurance provides coverage in the event of legal actions resulting from such charges. In order to qualify for this coverage, however, you must be able to demonstrate that your firm already has good employment practices in place.

Directors' and officers' liability

If you have a large company, it's a very good idea to talk to your independent agent about directors' and officers' liability insurance. Legally, directors and officers are separate entities from the company itself. In the event of a legal action, they could face unlimited personal liability. Directors' and officers' liability insurance protects the personal assets of these individuals if they are sued over their performance of company-related duties. It covers claims related to certain "wrongful acts" such as management errors, misleading statements, or neglect. Coverage includes the costs of legal defense.

LIABILITY ISSUES THAT ARE SPECIFIC TO DESIGN FIRMS

Typical BOP coverage excludes liability related to professional services. This type of exposure must be separately insured under a policy that is particular to the services you are rendering.

Professional malpractice insurance

This type of policy can be called "malpractice insurance," "professional liability insurance," or "errors and omissions insurance." Regardless of the name, the objective is the same: to help manage the risks associated with inadvertent mistakes, oversights, or failures by you or your employees in the performance of your professional services. For insurance purposes, a professional is considered to be anyone involved in an activity that requires specialized skill and training. Malpractice insurance protects you against loss from claims of negligent acts, errors, or omissions that result in loss to a client. It may also include claims of breach of confidentiality, non-performance of a contract, fraud, or negligent oversell. The act in question must actually be an error, however, and not merely poor judgment viewed in hindsight. It's also important to note that professional malpractice insurance does not cover intentional wrongdoing, such as causing deliberate harm to a client or a client's property.

Some professions (such as architecture, engineering, medicine, law, accounting, and financial services) are required by law to carry professional liability insurance. Although claims are not filed very frequently, when they are filed, they can be expensive. The legal test of whether or not negligence, errors, or omissions have taken place is a comparison against the standard of care that would have been exercised by other competent professionals under similar circumstances practicing in the same jurisdiction.

Some professional liability policies cover attorney costs, but some do not. If you are sued, you will definitely want the policy to help defray the costs of your legal defense. As a businessperson, you can avoid many professional risks by not accepting work assignments that you are not qualified to perform and by not making any client promises that you can't keep. Even so, customers can always accuse you of doing something wrong, even if the underlying claim has no merit. Because the costs of defending even frivolous malpractice claims can be substantial, it's wise to add legal costs to your coverage if the option is available.

The term of your professional liability policy is very important. Not all errors are discovered at the time they are made. They might not become apparent until some time later. If your policy pays only for claims filed while the coverage is in effect, you'll have to maintain it for a long period of time — perhaps even after you've gone out of business. In contrast, other policies focus on the date when the alleged mistake was made. If the error occurred at a point in the past when a policy was in effect, then it would be covered. This type of coverage is often more expensive. Your policy will also state a maximum amount for the protection provided to you, on both a per-claim basis and an aggregate basis. If a significant mistake results in damages that exceed your policy limits, you would liable for the excess amount.

One final note that is important to design firms: professional malpractice insurance coverage is usually limited to the business activities of employees, meaning those who are on the company's payroll and receive a form W-2 at the end of the year. Your policy might not include any independent contractors who receive a form 1099 from your company.

If you use a lot of freelance labor on client projects, you'll want to discuss this issue carefully with your insurance agent. As entrepreneurs, freelancers should, of course, maintain independent coverage appropriate to their own business activities.

Intellectual property insurance

Creating intellectual property and negotiating its ownership and use are core activities in all design firms. The major categories of intellectual property are copyrights, trademarks, and patents. It's possible that work done by your firm could later become the subject of an infringement claim. Infringement is the unauthorized use of someone else's intellectual property. Even though the infringement is accidental, there may be legal liability, and you may be ordered to pay damages.

A growing number of disputes and lawsuits are taking place in this area. Intellectual property insurance covers the costs of legal defense and any judgments up to the policy limits. A standard business owner's policy does not provide protection from loss, damage, or liability related to intellectual property, although some limited protection may be in place if you negotiated a separate commercial liability policy. Intellectual property insurance can be bundled with other things, such as the professional liability coverage discussed earlier. Speak with your independent agent to review your own particular situation and business needs. Design firms need to be careful in this area. When finalizing a contract with a client, be sure that you understand all of the fine print. The terms and conditions section of a contract for creative services will normally describe specific obligations and liabilities that relate to intellectual property. (For more information about terms and conditions for design contracts, please see Chapter 19.)

Media liability

Media liability insurance deals primarily with risks related to privacy, publicity, and defamation. This type of policy

is sometimes called "communications liability insurance."
It protects you against claims that might arise from the
gathering and communication of information. Essentially,
it is coverage for errors and omissions in the written or
spoken word. Claims of this nature seek to impose liability
on a publisher for economic loss or personal injury allegedly
caused by some error or negligence in the content of pub-
lished material. Personal injury can be physical or emotional,
including a damaged reputation. Media liability covers:

- Libel, slander, defamation of character
- Product defamation
- Personal disparagement
- Invasion of privacy
- Unfair competition

This type of insurance is usually referred to as "media
liability" because it's purchased by companies involved
in publishing, broadcasting, and advertising. However, the
rapid expansion of digital communications means that any
company distributing information to the public via e-mail
or the Web now faces many of the risks of a traditional
publisher. (For more information about defamation,
privacy, and publicity, please see Chapter 16.)

Product liability insurance
If you are working on the development of a product that
will eventually be sold to the public, this will be an important
issue. Your client may ask for proof that you are carrying this
kind of insurance. Product liability refers to the legal respon-
sibility of product designers, manufacturers, distributors, and
sellers to deliver products to the public that are free of any
defects that could harm people. If a product is defective,
the purchaser will probably sue the seller, who may then
bring the distributor or manufacturer or product designer
into the lawsuit. Any one of the parties may be liable for
damages or may have to contribute toward a judgment.
Your product liability policy will pay defense costs,
whether or not a judgment is rendered against you.

What about a home office?

Many designers are self-employed and work from home. It's important to note that most standard homeowner's or tenant's policies exclude liability for business-related activities. You need to speak with an independent agent about putting additional coverage in place. It may be possible to add an endorsement to your existing policy. However, the coverage will be very limited. A "business pursuits" endorsement will not be enough for home-based businesses that have frequent meetings with customers or suppliers onsite or have invested in costly equipment. Loss of business property is usually reimbursed up to $2,500 in the house and up to $250 for business property damaged or lost away from the premises. For a designer, the value of your computer equipment alone will far exceed these amounts.

It is much wiser to put in place a separate policy that addresses the needs of your small business. Shop for a business owner's policy, as discussed earlier in this chapter. It will include property insurance, basic liability insurance, and business interruption coverage. To that you can add whatever endorsements are appropriate to the particular professional services that you are selling to clients. (See Figure 15.01 for a recap of the various types of coverage that are available.)

Figure 15.01. Speak to an independent agent about the full range of insurance coverage needed by your business.

BASIC BUSINESS INSURANCE

Business owner's policy:
General liability
Property insurance
Business interruption

Additional coverage:
Umbrella liability
Business automobile
Workers compensation
Valuable papers and records
Fidelity insurance
Key-person insurance
Employment practices
Directors' and officers' liability

DESIGN-SPECIFIC ISSUES

Professional malpractice
Intellectual property
Media liability
Product liability

EMPLOYEE BENEFITS

Health insurance
(plus dental and vision if possible)
Life insurance
Long-term disability

Certificate of insurance

Once you have basic insurance coverage in place, you may be asked to prove it to banks and other lenders, as well as to clients. If you are asked to provide proof of insurance, just ask your agent to send the requesting party a certificate of insurance. A certificate of insurance is written evidence of the existence and terms of your property and liability policy. It's a statement summarizing the types of coverage, amounts of coverage, and policy effective dates. Once it has been issued, the certificate holder will also be notified if a policy is cancelled.

Occasionally, a client will ask to be named as an additional insured on your property and liability policy. The client would then be covered under your policy in the event that they are sued for damages or expenses as a result of work that you do on their behalf. To do this, a policy endorsement is required, and the amount of your premium may increase. Speak to your insurance agent about this. An endorsement would extend to the named client the same protection as the insured. If a client is asking to be named as an additional insured, they will state that request in the terms and conditions section of the project contract. Whenever you are finalizing a contract to provide services, take care to read all of the fine print. Don't agree to take on any obligations or liabilities that you are not completely comfortable with. Have your attorney review any proposed contract language that comes to you from clients.

Chapter 16:
Facilities planning

It's important for all designers to have a well-planned studio that's clean, comfortable, and efficient. Space planning becomes an especially important issue when your company is expanding or relocating. A great deal of thought (and, quite often, a lot of money) will go into finding the perfect-sized space, configuring it to facilitate your work, and adding the right creature comforts to make it fun and inspiring.

If you have frequent on-site meetings with clients, your physical space is also an important part of your brand — the location and condition must reflect the high quality of your services.

Finding the right space

When selecting a location, you may be faced with a trade-off between price and proximity to your clients. It's good to be close to your most important accounts. However, if their headquarters are downtown, you might not be able to afford a large enough space in their area. Rather than squeeze your staff into an expensive space that's too small, it's usually better to find something larger in a nearby district with more reasonable rents. You might even find an appropriate space that's located midway between your clients and key suppliers such as printers or fabricators.

The amount of space you're looking for will be based on your company's head count (both full-time and part-time employees) multiplied by a certain number of square feet per person. Each industry has a standard range for this. In the design world, it's 250 to 350 square feet per employee. Design spaces tend to be large to accommodate the dynamic nature of our work. As a reference, the majority of other businesses range from 200 to 250 square feet per employee. At the lowest end of the scale, there are also businesses like call centers with just 150 to 200 square feet per employee.

Don't be confused by this rule of thumb — it does not represent the amount of personal space given to each individual employee. The calculation includes everything: individual work areas, walkways, meeting spaces, a reception area, storage, space for network servers, a packing and shipping area, space for books and reference materials, restrooms, and a kitchen. Using this rule of thumb, a 2,000 square foot space could comfortably fit a creative firm of 6 to 8 people. Carved out of that total area, each personal space would be about 100 square feet. Just as a comparison, the typical administrative cubicle in a corporation is about 64 square feet (8 feet by 8 feet), although personal space in corporations is currently on a downward trend.

If you're making these calculations because you're moving into a new space, be sure to leave yourself room to grow. If the new space seems too empty at the start, consider subletting a portion on a temporary basis to a friend. To keep this option open, you need to negotiate a master lease that allows you to bring in subtenants.

Configuring the space

The next big challenge for you is to configure the space to function well. Each design firm has to find the most appropriate mix of personal, team, and public areas. There are contrasting philosophies about how to do this. At one end of the spectrum, some firms choose to do all of their work in a single, large space. An open area that's shared by everyone is sometimes referred to as a "bullpen." The major benefit of this approach is that it encourages constant collaboration and information sharing. Employees have easy access to each other for brainstorming and feedback. It's also inexpensive to set up. The downside is that it can be very noisy with lots of distractions.

In complete contrast, you could take a more traditional approach and set up private offices. Separate, small spaces with doors that close are much quieter. This makes them well suited to tasks that require uninterrupted concentration, such as writing. The downside is that private offices can be very isolating. They're more expensive to build and can be difficult to modify once they're in place. Offices also take up more space (in the corporate world, they're often 150 square feet), which leaves less available for other uses.

Most design firms opt for a combination of open and enclosed areas. Here's what's included in the mix:

Personal space
Individual designers need large desktops to spread out work, an ergonomic arrangement of computer equipment, a way to store project files and binders, and a place to tack up reference materials. There has to be easy access to scanners and printers and a way to keep lighting and temperature at comfortable levels.

Team space

Designers also need space to collaborate. This might include a meeting table placed at the center of a shared work area, a long wall for critiques, and maybe even a separate room dedicated to one major project or client account, where reference materials can be accumulated and work in process can be displayed. (For more information about project workrooms, please see Chapter 22.) Apart from work areas, many firms also create a shared social space. This might be a lounge or, if it's large enough, the kitchen. Shared meals can be an important part of your studio's culture.

Public space

The public face of your studio begins with the reception area. When a client arrives for a meeting, it's important to make a positive first impression. There should be an adjacent meeting area or conference room. Even in an open-plan studio, this meeting area tends to be an enclosed space where lighting and sound levels can be controlled for presentations. It's helpful to have a large white board for brainstorming and a narrow ledge for showing work (sometimes called a "crit rail"). In large firms, the main conference room often has its own kitchenette and bathroom. This cuts down on foot traffic through the rest of the studio and helps protect the confidentiality of other accounts.

If you're planning to sign a lease for a space that's completely raw and unfinished, it will of course require a build-out. Even if you're moving into a space that has been occupied previously, chances are it will have to be remodeled. Both situations require careful negotiation with the owner of the building. Discuss how financial responsibility for the necessary improvements can be shared. Most landlords are willing to provide subsidies for improvements that increase the value of the property and make it more desirable to future tenants. A commercial real estate attorney can be an invaluable resource to you when negotiating these aspects of the lease agreement. The negotiation might focus on the cost of specific improvements, or it could lead to a general build-out allowance

that's calculated as an amount per square foot. Depending on the size and condition of the space, this rate can vary greatly. You'll also need to clarify who will oversee the work and what the required process will be for getting the final plans approved by the landlord before construction actually begins.

In general, leasehold improvements are structural or functional. They tend to be permanently attached or integrated into the building, such as plumbing and electrical wiring. In contrast, the term "fixtures" is used for items that could be removed and taken with you if you relocate. Your lease agreement should specify whether you are allowed (or perhaps required) to remove any fixtures at the end of the lease. If you have a long-term lease, it's fairly common for design firms to make comprehensive leasehold improvements — permanent modifications that tailor the space to your needs. With short-term leases, however, fewer changes are made. Often there's a narrower focus on the arrangement of furniture and equipment, and some of these items might even be rented from vendors rather than purchased.

As you make financial commitments, speak with your accountant about how they should be recorded on your books. For tax purposes, different items will be depreciated in different ways. In the U.S., most leasehold improvements to commercial buildings are depreciated over the course of thirty-nine years. With some leasehold improvements, however, it may be possible to shorten the depreciation schedule to match the term of your lease. Other categories such as fixtures, furniture, and equipment are depreciated more quickly. Federal tax codes change periodically and state requirements sometimes vary, so you'll want expert guidance from your CPA.

Build-outs and remodels require specialized expertise. As a designer, you may be tempted to take on projects like this entirely on your own. Think carefully before making this decision. Do you have the appropriate skills and experience, and do you have the time to spare from paid client assignments? It usually makes sense to bring in professional advisors from outside your firm.

Advice from a space planner might be free if he or she represents a company that sells contract furnishings or modular office systems (the consultation might be viewed as a marketing expense by that company). A qualified interior architect can work with you on a paid basis to analyze needs and develop plans, guide the selection of materials and fixtures, prepare blueprints and construction documents, coordinate any necessary permits, seek competitive bids from contractors such as carpenters and electricians, and monitor the quality of contracted work as it's being done. Obviously, all of this can make your life a lot easier! You'll also want advice from a computer network consultant on data and phone connections, on-site (and perhaps off-site) servers, and wireless capabilities.

The best configuration of your space depends on your particular situation and needs. Keep in mind that three of the most essential elements for creating comfortable work areas are good airflow, good lighting, and noise control. Many design firms have high ceilings but low interior walls. Private offices are few and tend to have a glass wall or glass door opening onto a larger, shared space. Open areas are not divided into boxy, corporate-style cubicles. Instead, flexible infrastructure and modular furniture systems can allow team members to be grouped into reconfigurable "pods" that place several collaborators (staff and freelancers) in close proximity to each other. Some firms put as many components as possible on wheels, making it easy to move desks, white boards, and partitions as needed.

As you go through the planning and construction process, be sure to keep your employees in the loop. Get early input from everyone who will be using the finished space. Ask what elements they would like to see. Be open to ideas, but don't let this request for input devolve into decision making by committee. It's important to have the involvement of all stakeholders, but it's also very important to maintain strong project leadership and clear decision-making authority.

A large project like this will take weeks or months to complete. During that time, provide regular updates to the staff. Uncertainty and lack of information can lead to anxiety. Reduce the stress of moving or reconfiguring by giving

employees as much information as possible. As the build-out process moves forward, take employees to see the empty space, show them blueprints, and perhaps even build models to help them visualize what the finished workplace will be like.

Many design firms also factor in some flexibility for individual employees by providing options for the final components that will go into their personal spaces. Allow workers to control what they can. Give them a chance to personalize their new workspaces by choosing from a pre-selected menu of items such as chairs, desks, tables, file drawers, bookshelves, and lamps.

When you're ready to occupy the finished space, orchestrate the actual move-in very carefully to minimize disruptions to daily activities as much as you can. There will be an adjustment period as everyone settles in, but client projects must go on!

Staying flexible
When it comes to facilities, the biggest challenge for creative firms is that needs are not static. Personal and team requirements change over time. Your firm will have turnover in staff, bringing new employees with different personal preferences. You'll also have to cope with larger adjustments as your mix of services evolves. For example, the space, lighting, and equipment needs for print design are different from those of Web development. What's ideal today may be less than ideal three years from now if the services that you provide to clients have changed. When laying out space, be sure to allow for growth and flexibility.

Chapter 17:
Intellectual property

Intellectual property is a very important topic for creative professionals. We strive to produce work of significant value, and we negotiate with clients for its use and ownership. This chapter provides an overview of the core issues for design and marketing: copyrights, trademarks and trade dress, utility patents, and design patents. It also covers the essentials of trade secrets and moral rights. It ends with some thoughts about the challenges of protecting intellectual property rights on the Internet and in global trade. All of these are complex issues, and this chapter can only serve as a brief introduction. For more detailed information, you will, of course, want to speak with an intellectual property attorney.

COPYRIGHT

"Copyright" is statutory protection granted to "original works of authorship." In the United States, copyright has been an important legal issue from the very beginning. In 1787, the U.S. Constitution empowered Congress to enact copyright protection. Three years later, the Copyright Act of 1790 laid out the administrative procedures for registration and enforcement. Since that time, U.S. law has gone through several major revisions in order to broaden the scope of copyright, to change the term of copyright protection, and to address new technologies. The current version of U.S. copyright law was passed by Congress in 1976 and became effective in 1978. From time to time, minor revisions are made as well. One recent example was the passage of the Digital Millennium Copyright Act in 1998, which addressed some of the ownership challenges posed by easy access to digital works on the Internet. Copyright registration is managed by the U.S. Copyright Office, which is part of the Library of Congress. Lots of useful information is available from their Web site, www.copyright.gov. For a handy reference, go to the "Publications" section and download the PDF file for Circular 1, "Copyright Basics."

Copyright does not cover an idea in and of itself — it covers the expression of it in a fixed or tangible form. The author has the exclusive right to reproduce or sell the work, distribute copies, display the work publicly, perform the work publicly, or prepare derivative works. Each specific use can be transferred outright (assigned) or transferred in a more targeted way (licensed). A transfer of rights can be either exclusive or nonexclusive. Any transfer may be terminated after thirty-five years (except "work-for-hire," which is discussed in this chapter). Any rights not transferred explicitly remain the property of the owner (see Figure 17.01).

It's important to note that copyright ownership is separate from ownership of the physical work. For example, an art collector may purchase a signed original photographic print, but the photographer will be careful to retain rights to the image itself.

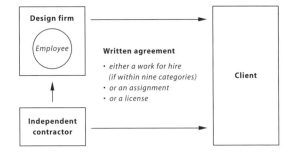

Figure 17.01. A signed agreement is needed to clarify issues related to ownership and use of copyright-protected materials.

Work-for-hire

This is also called "work made for hire." It refers to original work made by an employee, in which copyright ownership automatically belongs to the employer. It can also refer to original work made by an independent contractor or a design firm, in which copyright ownership might automatically belong to the client, but only under certain limited conditions. If your work doesn't meet all of the criteria, copyright will belong to you unless you assign it to your client. The work must be specially ordered or commissioned, a written agreement must be signed saying that it is a work made for hire, and the work must fall within one of the following nine categories:

1. A contribution to a collective work
 (such as a magazine, an anthology, or an encyclopedia)
2. A work that is part of a motion picture or other audiovisual work
 (such as a Web site or a multimedia project)
3. A translation
4. A supplement prepared as an adjunct to a work created by another author
 (such as a foreword, an appendix, or charts)
5. A compilation
 (a new arrangement of pre-existing works, such as a catalog)
6. An instructional text
 (whether it is literary, pictorial, or graphic)
7. A test
8. Answer material for a test
9. An atlas

Original works of authorship

As stated earlier, U.S. copyright law protects "original works of authorship." So what exactly is included? Here is a list of the various works that are covered:

- Published and unpublished fiction and nonfiction
- Catalogs and advertising copy
- Drawings and other designs
- Fabric designs and sketches for garments
- Photographs
- Sculpture, paintings, and other works of fine art
- Architectural plans, drawings, and models
- Musical scores and lyrics
- Musical performances captured on records, tapes, discs, et cetera
- Choreographic works that have been notated or recorded
- Dramatic works such as stage plays and screenplays
- Motion pictures captured on film, video, DVD, et cetera
- Computer programs, including source code and distinctive screen displays

As you can see, the list is quite long. Copyright protection covers a broad range of creative output. However, it's important to note that the following works are specifically excluded from protection:

- Titles, names, short phrases, and facts
- Anything that is written or created by the U.S. government
 (This includes such things as NASA photographs and government maps.)
- Utilitarian works
 (Historically, this category has included typeface designs produced by traditional methods because the alphabet itself is utilitarian. It was only possible to copyright original characters outside of the standard alphabet. However, nearly all typefaces are now designed and distributed electronically. Digital fonts are in fact software, which can be copyrighted.)

Collective works

In addition to individual works, copyright also protects collective works. Examples of this include magazines, anthologies, and encyclopedias. Copyright for the collective work is separate from the individual components. This means

that individual contributors may retain the underlying rights to their own portion of the project, even though the publisher will own the copyright to the finished compilation. The law presumes that contributors transfer nonexclusive rights only and that all other rights to components remain vested with the authors. Any exclusive or all-rights transfers to a publisher must be in the form of a written agreement signed by both parties.

Duration
Copyright protection begins automatically from the moment a work is created in fixed or tangible form. Copyright immediately becomes the property of the author who created the work. Because the law has changed over time, the exact duration of protection will depend upon when the work in question was created.

For older works that were created and published or registered before 1 January 1978, the initial term was 28 years, which could then be renewed for an additional 47 years (bringing the total to 75). However, the Copyright Term Extension Act of 1998 allowed a second renewal that added 20 more years (bringing the total to 95). This second renewal was a bit controversial because it applied to some important works of American popular culture from the 1920s, including the first version of Mickey Mouse and the early songs of Cole Porter. The Copyright Term Extension Act was subjected to a legal challenge, but it was upheld by the U.S. Supreme Court in January 2003.

The duration of copyright protection is different for older works that were not published or registered and for more recent works. Works created before 1 January 1978 but not published or registered by that date, and works created on or after 1 January 1978, have the following term: a sole author's life plus 70 years, a joint author's life plus 70 years, or, in the case of work-for-hire, 95 years from publication or 120 years from creation, whichever is shorter.

At the end of the appropriate term, a work enters the public domain. This means that copyright protection has expired and the work becomes available for anyone to use in whatever way they might like. One note of caution: if you are working on a project that involves

TALENT IS NOT ENOUGH: BUSINESS SECRETS FOR DESIGNERS

an older literary work, be careful about translations. If the text that you want to use comes from a recent translation, it will be protected by its own copyright.

Copyright notice

The use of a copyright notice on the work is beneficial but not absolutely required. The standard format is this: © (the letter "C" in a circle) + the year of first publication + the name of the owner. The letter "P" in a circle is used for "phonorecords" — a general term for cassette tapes, CDs, and LPs. If the owner licenses the work to someone else, the licensee's name can only be used on the copyright notice if the license is exclusive.

Copyright registration

Even though formal registration of copyright is not required by law, it is still beneficial because it establishes a public record of the date of creation and the original owner. This information is very important if, at a later date, it becomes necessary to take legal action against infringement. If you feel that you have created something of value that others might be tempted to appropriate, then you should register it. If your copyright was registered before the infringement occurred, you will be entitled to recover your attorneys' fees when you win the lawsuit, plus the right to an award of statutory damages (even if you cannot prove a specific monetary loss). It's recommended that you register a work within three months of its creation. The registration process is very simple. Go to www.copyright.gov and download form VA (for visual arts). Complete the form and send it to the Copyright Office with documentation of the work that you are registering (one copy if unpublished, two copies if published) plus a filing fee (currently $45, although it is lower if you follow a new online procedure). After receiving your information, it usually takes the Copyright Office from sixteen to twenty-four weeks to complete the processing of your registration.

Group registration

If you register lots of separate works, the process can become expensive. However, if you have produced a number of items that are related in some way, you may be able to save money by filing a group application.

Any number of unpublished works may be registered as a collection for a single fee if all of the following conditions are met: the elements of the collection are assembled in an orderly form, the combined elements bear a single title identifying the collection as a whole, the copyright claimants for each of the elements are the same, and all of the elements have at least one author in common.

Also, any number of published elements may be registered together if they are published as a single unit (for example, a game that consists of playing pieces, instructions, and a game board) and the copyright claimants for each of the elements are the same. Group registration can also be made for certain contributions to periodicals.

Copyright infringement

Infringement is unauthorized use of a substantial portion of a copyright-protected work. It's the opposite of seeking and receiving permission, using correct notice of ownership, and contracting for payment of a royalty or fee. Copyright infringement must be intentional — the infringer must knowingly copy the work without obtaining authorization. If you become aware that an individual or a company is infringing upon your work, you can obtain an injunction or restraining order to stop them from using it. In a lawsuit, you must prove that you own the work and prove that the defendant has copied it. You will recover attorney's fees if you win. You may also recover actual damages, statutory damages, or the profits that were generated by the infringement. The judgment that is made will be affected by the extent of infringement and how much proof there is that it was intentional.

Fair use

It is important to note, however, that there are certain uses of copyright-protected material that do not constitute infringement. These have to do with criticism, comment, news reporting, teaching, scholarship, and research. Fair use also protects parody, satire, and caricature. Usually only a small portion of the work is used, and it should not affect the potential market value of the work. Factual works tend to be less protected than creative ones, and in a dispute, the court will consider whether the use was commercial or nonprofit.

TRADEMARKS

A "trademark" is a word, name, symbol, design, picture, device, or slogan, or a combination of these elements, that is used by a business to distinguish its products or services from those of its competitors. Trademark protection can also include distinctive sounds, shapes, scents, or colors that are used in commerce. The purpose of a trademark is to identify the source of a product or service and prevent confusion in the marketplace. Some well-known trademarks are the roar of the MGM lion, the pink of the insulation made by Owens-Corning, and the "Just Do It" slogan that is used by Nike.

Trademark is a general term, but it's also possible to be more specific. A "service mark" is a mark used by a business in selling or advertising services. A "collective mark" is used to indicate that the producer of goods or services is a member of a particular organization or group such as the ILGWU (International Ladies Garment Workers Union), IGA (Independent Grocers Alliance), or FTD (Florists Transworld Delivery).

A "certification mark" is used as a seal of compliance or approval, such as the UL (Underwriters Laboratory) mark that appears on many electrical products, and the various marks that have been developed in connection with recycling. The owner of the mark permits it to be used to certify that the goods or services of others meet certain standards such as safety, quality, accuracy, morality, use of materials, mode of manufacture, or region of origin.

A "trade name" is the name by which the public knows a particular business. A domain name on the Internet can be registered as a trademark or a service mark if it identifies the source of goods or services and is not simply a digital address. In the early days of the World Wide Web, there were quite a few lawsuits over newly registered URLs that resembled existing trade names. Congress eventually stepped in to clarify the situation. Domain name pirates can be sued for trademark dilution under the Anticybersquatting Consumer Protection Act adopted in 1999.

There are some restrictions on what can be registered. You cannot register a trademark that:

- Is confusingly similar to another mark that is already registered
- Is merely descriptive, like "soft drink"
- Is immoral, deceptive, or scandalous
- Defames an institution, belief, national symbol, living or deceased person
- Contains the flag or other insignia of a country, state, or municipality
- Includes the name, portrait, or signature of a living person without his or her written permission
- Includes the name, portrait, or signature of a deceased U.S. president during his or her surviving spouse's lifetime without written permission

Trademark registration

Registration is done through the U.S. Patent and Trademark Office. The site www.uspto.gov has detailed information about the process. You can also register trademarks in some individual states, but that protection is only local. Since most businesses today are involved in some form of interstate commerce (this includes all firms that transact business on the Internet), it makes more sense to go directly to the national registration process.

You must first conduct a comprehensive trademark search to check if someone already has a conflicting mark — that is to say, a mark already on file that matches or closely resembles what you would like to register. The U.S. government database can be searched for free. The government maintains self-service Patent and Trademark Depository Libraries in many large cities across the country. Usually they are located inside the main public library. Even though the government database can be searched for free, many companies prefer to have the search conducted by a legal professional. The most commonly used private search service is Thomson Compumark (more information is available from their site at http://compumark.thomson.com). Search services are available from other companies as well, including CT Corsearch, LawMart, and 4Trademark.com.

You will need to specify whether you want a word search and/or a design search and whether you want it to be U.S. and/or international.

You must use a trademark in interstate commerce in order to qualify for U.S. registration. However, while your new business is in its ramp-up stage, you may reserve a trademark in advance by filing an "intent-to-use" application six months prior to the planned start of actual use. It's also possible to file for a series of extensions to bring the advance total to thirty-six months.

Currently, the federal registration fee is $375 (it's a bit less if you file electronically). After you have submitted your information and fee, it usually takes six months to receive a filing receipt from the Patent and Trademark Office and then at least another six months for them to complete the processing. In the meantime, many companies use a small "TM" or "SM" on their business materials to indicate that trademark or service mark status is being claimed. Those letters are later replaced with the symbol ® (an "R" in a circle) when the entire registration process is complete.

Duration

Trademark registrations completed on or after 17 November 1989 are valid for an initial period of ten years. After that, they can be renewed every ten years as long as they are still being used in business. A trademark is presumed to be abandoned if it is not used for a three-year period. Abandoned trademarks become available to anyone.

Infringement

Trademark infringement includes unauthorized use of an existing registered mark or use of a new mark that resembles one too closely. Trademark infringement is not about originality but about creating confusion in the marketplace as to the source of a product or a service. Trademark rights can be infringed unknowingly — that is, even if the new work was created independently. Even though the infringement may be accidental (you may independently create a logo for your client that looks like someone else's trademark),

there may be infringement liability, and the infringer may be responsible for paying substantial damages. Each case is, of course, judged according to its own merits.

Defending a trademark

Some clients use in-house legal resources to monitor for improper or illegal use of their trademarks. Others use a professional trademark watch service to monitor the use of their marks in publications, in advertising, and on the Internet (including domain name registrations). The service will also monitor new state and federal trademark filings. If something turns up as a result of this monitoring, the client can respond in a number of ways:

- Send a letter explaining the proper use of the mark
- Send a formal cease-and-desist letter
 (a warning that all usage of the mark be stopped)
- Make a counter-filing with the USPTO
 (objecting to the registration of a trademark or seeking its cancellation)
- Negotiate a license
- File a lawsuit claiming infringement or dilution

In litigation, the strength of a trademark can vary based on the nature of the mark itself. A mark that strongly suggests the type of product or service being sold (like "Roto-Rooter" or "Port-a-Potty") is often weak from a legal standpoint. A mark that uses an ordinary word or phrase in an arbitrary, unexpected, and surprising way is stronger (like "Yahoo!" or "Oh Henry!"). A fanciful word that did not exist before and has no literal meaning apart from its commercial usage tends to be the strongest (like the coined words "Diageo" and "Exxon").

Most companies actively promote their trademarks to the public, but they must take care that a mark remains distinctive and does not slip into general usage as a common term for describing an entire category of products or services. If a mark becomes generic, federal trademark protection will be difficult to maintain. Two examples of genericized marks that have lost their protection are cellophane (originally trademarked in 1912 by DuPont) and zipper (registered as a trademark in 1925 by B.F. Goodrich).

From a grammatical point of view, generics are generally nouns, trademarks are generally adjectives, and the generic term almost always follows the trademark. For this reason Johnson & Johnson is careful to promote "Band-Aid® brand adhesive bandages" and Kimberly-Clark advertises "Kleenex® brand tissue." Also, a protected mark should not be used in the plural, as a possessive, or as a verb.

Trademark dilution

Even when a new mark does not directly infringe on an existing one, there may be an issue of dilution. Infringement is generally focused on products or services that are directly competitive and the question of whether confusion is being created about their source. In contrast, dilution is generally focused on non-competing goods and whether a famous mark is losing its association in the public mind with one particular product or product category.

Some state laws regarding dilution have been on the books for several decades. More recent laws include the Federal Trademark Dilution Act of 1995 and the Trademark Dilution Revision Act of 2005. From a legal standpoint, dilution occurs when there is a lessening of the capacity of a famous mark or trade name to identify and distinguish goods or services — regardless of the presence or absence of competition between the parties or the likelihood of confusion, mistake, or even deception. Dilution can happen in two ways:

- Blurring
 (when a famous mark becomes identified with more than one type of good, such as "Kodak shoes")
- Tarnishment
 (when a famous mark is disparaged though association with a low-quality or unsavory product)

An example of the second category was the long-running legal dispute between Victoria's Secret (a famous national clothing company) and Victor's Little Secret (an adult boutique in Kentucky that sold, among other things, X-rated novelties). Victoria's Secret claimed that their reputation was being damaged by association with unsavory products. In 2008, a U.S. District Court in Kentucky ruled that the situation did in fact represent trademark dilution by tarnishment.

Trade dress

"Trade dress" is part of U.S. trademark law. It protects an established "look" for a particular product or service in the marketplace, including overall composition and design, size, shape, color, texture, and graphics. Trade dress is intended to protect a brand from unfair competition by imitators and copycats. For example, trade dress for a product will include the design and appearance of the product itself as well as that of its container (a famous example is the distinctive "contour" bottle shape used by Coca-Cola since 1916) and all other distinguishing non-functional elements that make up the total visual image with which the product is presented to consumers. However, a general visual "style" cannot be protected, such as art nouveau or art deco. Keep in mind that trade dress protection applies to the manufacturer or source of products, not usually to the designer — unless you are very well known and have negotiated an agreement to co-brand a product with your client (like Philippe Starck and Target).

Trade dress infringement

Just as we discussed with trademarks, trade dress rights can be infringed unknowingly — that is, even if the new work was created independently.

Unfair competition

So far, we have been discussing disputes between trademark owners. Another part of U.S. trademark law, Section 43(a) of the Lanham Act, opens up the possibility of lawsuits by consumers. The law includes the following language: "Any person who shall affix, apply, or annex, or use in connection with any goods or services, or any container...for goods, a false designation of origin, or any false description or representation, including words or other symbols tending falsely to describe or represent the same...shall be liable to a civil action...by any person who believes that he is or is likely to be damaged by the use of any such false description or representation." This means that both competitors and consumers can file suit against:

- Active misrepresentation of one product or service in relation to another
- False statements made in connection with a promotion
- False designations of origin

- Misuse of names and trademarks
- Commercial imitation of voice, image, or likeness without consent

PATENTS

The holder of a "patent" has a legal monopoly on a particular invention for a limited period of time. A patent cannot be obtained for a mere idea or suggestion — it must be for something that is complete and specific. In legal terms, the invention must be "reduced to practice," which means that the inventor is required prepare a physical manifestation of the idea. There are two ways to do this:

- Actual reduction to practice
 by building and testing the invention, such as constructing a working prototype
- Constructive reduction to practice
 by preparing a detailed document that explains how to make and use the invention

A patent gives the inventor the right to exclude other people from making, using, importing, offering, and selling the invention. By inference, this gives the inventor the opportunity to produce and market the invention, or license others to do so, and to make a profit from it. A patent can be obtained for any new, useful, nonobvious invention, including food and clothing. Nonobvious means not obvious to a person having ordinary skill in the field. Patents cannot be obtained on any of the following: the laws of nature, physical phenomena, abstract ideas, machines that are not useful, inventions that are useful solely in relation to nuclear weapons, new minerals or new plants that have been found in the wild, printed matter, or human beings. The patent itself is a type of personal property. It may be sold, assigned or licensed to others, mortgaged, bequeathed, or inherited. In a design relationship, typically it is the client who will own the patent. However, the designer must first assign rights to them.

There are several different categories of patents, but two categories are of particular interest to designers: utility patents and design patents.

Utility patents

"Utility patents" protect useful processes, machines, articles of manufacture, and compositions of matter. Examples include fiber optics, computer hardware, medications, and user interfaces. A utility patent is valid for twenty years from its filing date (if three maintenance fees are paid). This category includes so-called business process patents. Patents for business methods have generated many lawsuits over the past few years, particularly among Internet companies. For example, MercExchange sued eBay, alleging unauthorized use of a patented procedure for locking in an offer during an online auction. The court ordered eBay to pay $25M in damages. Another example is the lawsuit filed by Amazon.com against BarnesandNoble.com for using a "1-click" purchasing system. The settlement required Barnes and Noble to change their online ordering process.

Critics of these process-oriented patents claim that basic business practices are being usurped and that innovation is being jeopardized. They contend that new patent applications are not screened closely enough and that too many vague patents have been granted. In response to these concerns, a number of possible changes to the system are being explored by the Patent Office, as well as by the Federal Trade Commission, the National Academy of Sciences, and Congress.

In the meantime, an April 2007 decision by the U.S. Supreme Court set a higher standard for "nonobvious." According to the decision, incremental advances or simple combinations of pre-existing inventions should be considered "obvious" and not eligible for patent protection.

Design patents

A "design patent" is intended to protect a new, original, and nonobvious ornamental design for an article of manufacture. It protects only the appearance of an article, not its structural or functional features. For example, the outward appearance of an athletic shoe or of a bicycle helmet can be protected. A design patent is valid for fourteen years from the date it was granted, with no interim maintenance fees.

Patent registration

When applying for a patent, it's best to use the services of an experienced intellectual property attorney. The process begins with a patent search to check for "prior art." Once the application is filed with the Patent Office, it can take up to twenty-two months for processing to be completed. Application, issue, maintenance, and related fees can cost at least $4,000 over the life of a patent. The words "Patent Pending" on a product mean that a patent has been applied for. The words "U.S. Patent Number XXXXXXX" on a manufactured item mean that the processing is complete and a patent has been issued. It's illegal to use either of these phrases if you have not actually applied.

Patent infringement

Patent rights can be infringed unknowingly — that is, even if the work was created independently. Litigation to protect patents can be very time-consuming and expensive. Because of this, many product firms carry patent enforcement insurance.

TRADE SECRETS

A "trade secret" is any type of information that cannot be trademarked or patented but that you want to keep secret because it gives you an advantage over your competitors. The information must not be generally known to others, and it must have actual or potential economic value. Examples include the formula for Coca-Cola, a customer list, or an advertising plan. You must make reasonable efforts to maintain the secrecy of the information. This means controlling access to it and having signed agreements in place for confidentiality, nondisclosure, and noncompetition. If the information is in a digital format, you must protect your computer network and maintain reasonable security against hackers. Trade secrets do not have a specific duration. They can be protected indefinitely. Every state in the U.S. has enacted a law prohibiting theft or disclosure of trade secrets. Intentional theft can also be a federal crime under the Economic Espionage Act of 1996.

MORAL RIGHTS

"Moral rights" are sometimes referred to in design contracts, but they are really more relevant to the fine arts. The Visual Artists Rights Act (VARA) is an amendment to U.S. copyright law that took effect in 1991. It extends to artists in the U.S. rights that are similar to those contained in the Berne Convention, an international copyright treaty. U.S. protection lasts, in general, for the life of the artist. Protection cannot be transferred, but it can be waived. It does not apply to work-for-hire (discussed earlier). The VARA defines a work of art as:

- A painting or a drawing
- A print, sculpture, or photograph, if it is in a limited edition of 200 or fewer copies, consecutively numbered and signed by the artist.

In the U.S., VARA gives an artist these specific rights:

- The right of attribution
 To claim authorship of his or her work, and to prevent the use of his or her name on the works of others
- The right of integrity
 To prevent use of his or her name on mutilated or distorted versions of the work (if the changes would injure his or her honor or reputation), and to prevent the mutilation or distortion itself if it will damage the artist's reputation
- Plus the additional right to prevent the destruction of a work if it is of "recognized stature"

Even though these rights have been in place since 1991, only a few U.S. artists have actually filed VARA lawsuits. Most of these cases have involved public works of art or pieces affixed to buildings. This lack of claims may be because costs can be high if an artist files a federal lawsuit and then loses, especially if the case goes to appeal. The legal costs could easily exceed the value of the artwork in question.

ISSUES ON THE INTERNET AND IN GLOBAL TRADE

The rapid expansion of the Internet has created new enforcement challenges for owners of copyrights, trademarks, and patents. It's very easy to take work that is digital and use it without authorization. Sometimes it's difficult to tell who is doing the infringing and where they are located, so there are also legal risks for Web site owners and Internet service providers who may transmit or store material that infringes.

If you are a Web designer, you can avoid problems by using only content that is either completely original, verifiably in the public domain, or for which you have the signed consent of the owner. On each site, you must include patent marking, copyright notices, and trademark notices as appropriate.

Compounding the challenge is the fact that intellectual property laws are national, but the Internet is global. Global businesses often seek to register intellectual property separately in each country where they plan to do business. After registering in the U.S., many American companies also seek protection in Canada, Japan, Australia, and the European Union. However, when you are registering in different countries, the specifics of eligibility and duration can vary quite a bit. Here's one example that relates to patents: most countries in the world offer patent protection on a "first to file" basis, but the U.S. and the Philippines have a "first to invent" system.

Intellectual property laws are national, but many countries sign international treaties and trade agreements that include intellectual property protection, such as the Paris Convention for the Protection of Industrial Property (which is focused primarily on industrial design and patents) and the Berne Convention for the Protection of Literary and Artistic Works (which is focused primarily on copyright).

As trade becomes increasingly global, U.S. trade negotiators seek to defend American companies from foreign copycats and pirates in many product categories such as music, films and videos, software, and pharmaceuticals. In 1995

a major international trade agreement known as TRIPs (Trade-Related Aspects of Intellectual Property Rights) went into effect. It put in place a rule-based trade system. Upon signing, countries are given a specific amount of time (usually 1, 5, or 11 years) to bring their national laws and practices into compliance. Countries that permit intellectual property violations can be threatened with trade sanctions.

Global trade involves a very wide range of social and economic issues, but for questions specifically related to intellectual property law, you'll want to take a look at these two Web sites:

- www.wto.org
 The World Trade Organization currently has 151 member states and 31 observer governments.
- www.wipo.org
 The World Intellectual Property Organization is part of the United Nations — it includes 184 member states and administers 24 international treaties.

Chapter 18:
Defamation, privacy, and publicity

Advertising agencies, publishers, and broadcast companies produce a steady stream of messages for the general public. The content of these messages often includes information about, or images of, specific individuals — whether they are models, celebrities, employees, or people on the street. In preparing this content, publishers, broadcasters, and agencies have always been aware of potential liability for claims of defamation of character or violation of an individual's rights of privacy and publicity. However, the rapid expansion of digital communications means that any company distributing information via e-mail or the Web now faces many of the same legal risks.

Someone may file a claim against you seeking to impose liability for economic loss or personal injury allegedly caused by some error or negligence in the content of the work that you produce. Personal injury can be either physical or emotional, including a damaged reputation. This chapter explains the key legal issues that communications professionals must be aware of.

DEFAMATION

"Defamation" is intentional communication of a false statement about someone to a third party — a statement that injures the subject's good name and reputation, damages the subject's standing in the community, or deters others from associating with him or her. Defamation is a civil wrong (also referred to as a "tort"). In this context, civil means that the matter is a dispute between two private parties rather than a proceeding by the government against a party. The injured person can seek remedy by bringing a lawsuit against the person or company that made the false statement. The remedy will usually be in the form of damages (there are several types of damages — more information about this in a moment). When an injured party takes legal action, he or she is the plaintiff in the matter, and the individual or company that made the untrue statement is the defendant.

There are two different categories of defamation: slander and libel.

Slander

"Slander" is oral defamation — a spoken assertion about someone that is not true. It happens when an individual tells one or more persons something false about someone else, usually in direct conversation. Other forms of communication are covered by libel.

Libel

"Libel" includes untruthful statements expressed in a fixed or permanent medium. For example, they could be in writing, on a sign, in a picture, or broadcast on radio, television, or the Internet. This means that the statement has the potential to reach a very wide audience. The false statement must hold the subject up to ridicule, hatred,

scorn or contempt, cause the subject to be shunned or ostracized, or cause the subject to suffer mental anguish and humiliation. The individual or company responsible for printing or broadcasting the statement (for example, a newspaper, a magazine, a political organization, or a broadcaster) is open to a lawsuit by the person the statement was about.

In the U.S., most states demand a published retraction for libelous statements. A printed retraction serves as an admission of error and a public correction. Usually, the injured party does not have the right to file a lawsuit if a correction is made. Very minor mistakes in reporting, however, are not considered to be libelous. This would include such simple errors as misstating someone's age. (Incorrect information can also present someone in a false light — more about this in a moment.) In addition, it's generally the case that government bodies and public records are exempt from libel actions.

Defamation per se
Certain types of untrue statements are so serious that they will always qualify as defamation. They are grouped together under the term "defamation per se." Each of them is considered incapable of having an innocent meaning. Such accusations include:

- Imputing that the subject has committed a crime or engaged in criminal conduct
- Claiming that the subject has a feared illness or loathsome disease
- Imputing personal conduct or characteristics that render the person unable to perform his or her occupation, such as stating that the person is incompetent or unreliable as a businessperson
- Claiming that the subject has engaged in unchaste behavior or immoral acts, such as serious sexual misconduct

If spoken, such statements are "slander per se." If printed or broadcast, they are "libel per se." The statement is actionable in itself without the plaintiff introducing additional facts because the harmful intent is considered to be obvious.

Claims

When a claim of defamation is made, the following aspects will be examined very carefully:

Identification

A plaintiff must establish that the alleged defamation refers to him or her specifically. A statement is not defamation unless it identifies the person being attacked.

Publication

The statement must be shown or communicated to at least one other person before it is actionable by law.

Statement of fact

The statement must be reasonably understood by third parties to purport fact. If it is presented as a fact rather than as an opinion, it will be actionable. In general, opinions, satire and works of fiction — if they are clearly identified as such — are not defamatory.

Falsehood

The statement must be false. If it's true and can be proven, it's not defamation.

Actual injury

In a lawsuit, no one can recover damages unless he or she has suffered injury. The plaintiff will be asked to provide proof of damaged reputation, mental anguish, suffering, or economic loss.

Liability

In many instances, whether or not the person who made the statement is found to be liable will depend on whether the injured party is a public figure or a private person. If a public figure is involved, the matter may be of public concern. Although libel is defined under state law, the U.S. Supreme Court has consistently ruled that First Amendment protection of free speech applies to matters of public concern. Because of this, a public figure must prove that the libelous statement was made with malicious intent. Otherwise, the statement will be protected as a form of fair commentary. Everyone has a constitutional right to express opinions or make fair comment on public figures. To recover damages,

a well-known plaintiff (such as a politician, government official, celebrity, or other prominent person) who alleges libel (by a newspaper, a radio station, et cetera) must prove that the defendant made the statement with reckless disregard for the truth — perhaps even knowing that it was false. In contrast, there is greater protection for a private person. A private person does not need to prove malice on the part of the defendant, merely that some degree of negligence was involved in not checking for truthfulness before publishing the false statement.

Legal fees
In many instances, a defendant who is found to be liable will be ordered by the court to pay the plaintiff's attorney's fees.

Damages
If the defendant is found liable for defamation, the plaintiff will be awarded damages in the form of monetary compensation. The amount of money that the defendant is ordered to pay might be determined in several different ways.

Actual damages / special damages
Depending on the details of the case, the amount paid to the plaintiff might be limited to actual damages and special damages. Actual damages are out-of-pocket costs that resulted directly from the defamation, such as medical bills. Special damages (also called "consequential damages") are for other types of harm such as a measurable loss of business. They are awarded in an amount deemed to compensate for the specific losses named. Actual damages and special damages are not speculative or subjective. They can be easily calculated in monetary terms. They are different from general damages, which do not have evidence of a specific monetary amount.

General damages
These are subjective, both in nature and in monetary value. They include such things as pain and suffering. General damages serve as compensation for losses that will continue into the future and for which no exact value can be calculated. In most cases, malice must be proved before a plaintiff can receive general damages for harm done to his or her reputation. However, in cases

of defamation per se, there is no need to prove malice because such claims involve vicious statements that are considered to be obviously harmful.

Punitive damages
These are also referred to as "exemplary damages" because, in addition to serving as a punishment of the defendant, they set an example for the public. They may be awarded if the defendant acted in a particularly egregious way — willfully committing acts that were oppressive, violent, wanton, or fraudulent. Punitive damages are often requested by plaintiffs in lawsuits, but they are seldom awarded by the court.

Nominal damages
At the other end of the scale, the court may order the defendant to pay only a small (nominal) amount of money. Nominal damages may be awarded if a wrong occurred but the actual harm was minor. This sometimes happens in cases where the plaintiff is a public figure. A small amount of money may be awarded to acknowledge that the plaintiff was right but did not suffer any substantial injury.

PRIVACY

The next issue that communications professionals need to be aware of is the right of privacy. U.S. law recognizes each person's right to live without being subjected to unwarranted and undesired public scrutiny. Essentially, this is the right to be let alone, free from intrusion into matters of a personal nature. Violation of this right constitutes an invasion of privacy, which is a civil wrong. In general, there are four different categories of invasion:

1. Intrusion
 This refers to an aggressive and shocking intrusion on reasonably expected solitude. It sometimes occurs in newsgathering, such as when paparazzi invade someone's privacy by trespassing on private property to photograph the person, thereby unreasonably interfering with his or her seclusion. Intrusion can also include such things as wiretapping or reading someone else's mail.

2. Public disclosure of private facts

 Everyone has the right to keep personal matters to oneself and to keep others from disclosing private facts that are not of legitimate concern to the public. It is an invasion of privacy if someone causes a person embarrassment and humiliation by publicizing information about that person's private affairs that reasonable individuals would find objectionable.

3. False light

 This means publicizing information about a person that unreasonably creates an untrue or misleading portrayal. It can include such things as falsely attributed acts or beliefs. False light claims are not recognized in all states. In jurisdictions where they are recognized, the misrepresentation does not need to be defamatory, but it must be made with knowledge of its inaccuracy, and it must be offensive or objectionable in some way to a reasonable person.

4. Appropriation and exploitation

 This means the use of a person's name, likeness, voice, or other aspects of personal identity without permission for commercial purposes. Protection against this category of invasion is usually called the "right of publicity."

PUBLICITY

Each person has the exclusive legal right to control and profit from the use of his or her identity (name, image, personality, voice, et cetera) to promote and sell goods or services. Appropriation of someone's identity without consent violates that person's right of publicity. However, the extent of legal protection varies from state to state. The issue is further complicated by the fact that many cases bump up against federally protected free speech — the right to express one's thoughts and opinions in a free society. In each case, the challenge for the court is to find an appropriate balance between the plaintiff's right of publicity according to that state's laws and the defendant's right of free speech as guaranteed by the First Amendment to the U.S. Constitution (see Figure 18.01).

In order to do this, distinctions are made between three different categories of use:

1. Creative use
 If the defendant has created a work of pure fiction such as a novel, any alleged resemblance between an actual person and a character in the work will not usually be regarded as a violation. When aspects of someone's personal identity are used in fine art such as a painting, drawing, or sculpture, the use will not usually be regarded as a violation. The original artwork may be displayed and sold without a problem.

2. Matters of public interest
 If someone is a public figure or becomes involved in newsworthy events, his or her right of publicity is not violated by media coverage. The law allows exceptions to the right of publicity when someone's identity is used for educational or editorial purposes, such as in coverage of news, public affairs, sports, or political campaigns. This makes it possible to produce such things as magazine articles, books, and documentaries about individuals.

In these first two categories, free speech is the starting point. The use of someone's identity is generally allowed because prohibiting such use would be an unconstitutional restraint on free speech. However, the third general category of use is not considered to be a form of free speech because it is done primarily with the intention of producing a profit:

3. Commercial use
 Permission must be obtained before aspects of someone's identity may be used in connection with the advertising or sale of goods and services. This includes such things as a name or likeness (even a look-alike or sound-alike) in an advertisement or on a T-shirt, coffee mug, postcard, or any other merchandise. Appropriation of identity and exploitation of it for commercial gain may result in a lawsuit. The burden will be on the plaintiff to prove that there was unauthorized commercial use that violated his or her right of publicity. For example, unauthorized use of a celebrity's name in connection with a product might appear to be an endorsement, which would have the effect of increasing sales.

Figure 18.01. Many cases are not clear-cut. A judgment must be made about the precise nature of the use.

EDITORIAL USE

EDITORIAL USE COMMERCIAL USE

◄ – – – – – – – – – – – – – – – – – – ►

First Amendment *State protection*
protection of *of the right of*
free speech *publicity*

Confusion arises when a particular use doesn't fit neatly into just one category. Some uses are hybrids — for example, when a depiction from a work of fine art is subsequently applied to a commercial product. In an attempt to sort out these issues, a recent decision by the California Supreme Court applied the concept of "transformative" use. This is an idea that has been borrowed from copyright law, where it refers to fair use of material that would otherwise be protected, provided that it's used in a way or for a purpose that's different from the original to such an extent that the expression or meaning becomes essentially new.

In the context of publicity rights, a "transformative" commercial work might be interpreted as primarily an expression of the artist's or designer's own ideas rather than a mere likeness of a particular individual. By adding significant creative elements, the artist is creating a new meaning for the image. On a case-by-case basis, this exception to publicity rights might also extend to other types of stylization or distortion such as parody and caricature. From a legal standpoint, this concept is rather vague and open to interpretation. For this reason, the California precedent might not be followed by other states.

This is in contrast to products, services, and advertisements that use more conventional images, particularly of celebrities. A literal depiction is a reproduction or imitation of a person's likeness. Such an image is not protected when it's used for commercial purposes, such as a photo of a rock musician used on a poster.

Depending on the state, the exact details of the right of publicity may vary between celebrities and non-celebrities, and between living or deceased persons. For example, in the state of California, the heirs of a personality can continue to protect his or her right of publicity. California makes liable anyone who, without consent, uses a dead celebrity's name or likeness to promote products or services within seventy

years after death. (There are even legal firms and talent agencies that specialize in managing the licensing rights of dead celebrities such as James Dean and Marilyn Monroe, and they generate significant licensing income for the celebrities' estates.)

For creative professionals, the bottom line is that you must obtain permission before using aspects of anyone's personal identity for commercial purposes. The rights of privacy and publicity make it necessary to obtain signed releases when working with models, even if they are employees of your firm. Whenever you are creating and distributing content that includes references to, or images of, real people and those individuals are clearly recognizable, you must be cautious about issues of defamation, privacy, and publicity. If you have questions about a specific project that you're working on and you're wondering what risks might be involved, you should ask your attorney for guidance.

Chapter 19:
Understanding terms and conditions

This chapter is an introduction to the latest version of the AIGA Standard Form of Agreement for Design Services. If you're familiar with the previous versions, you'll notice that this one is quite different. It does not take a one-size-fits-all approach, and it is not an extensive pre-printed document where you simply fill in the blanks. Instead, it acknowledges that most design firms develop their own custom proposal document for each project and are looking for an appropriate set of terms and conditions to attach to it. When put together and signed, the custom proposal document and its attached terms and conditions comprise the binding agreement with the client.

With this in mind, the new focus of the *AIGA Standard Form of Agreement* is on those terms and conditions. AIGA members are involved in many different design disciplines. Because of this, the recommended terms and conditions have been prepared in a modular format. This also helps to keep individual agreements down to a more manageable size. The first two modules, *Basic Terms and Conditions* and *Schedule A: Intellectual Property Provisions*, should be used for all design assignments. An additional three modules are provided as supplements that can be added to the agreement as needed: *Print-Specific Terms and Conditions*, *Interactive-Specific Terms and Conditions*, and *Environmental-Specific Terms and Conditions* (see Figure 19.01).

This new format for the *AIGA Standard Form of Agreement for Design Services* was developed by a team of industry experts: Don Brunsten (intellectual property attorney, Don Brunsten & Associates), Linda Joy Kattwinkel (intellectual property attorney, Owen, Wickersham & Erickson), Frank Martinez (intellectual property attorney, The Martinez Group), and Jim Faris and Shel Perkins (past AIGA national board members). It is being provided as a reference for the design community. However, this information is not a substitute for personalized professional advice from an attorney. If you have specific legal questions, you should always seek the services of appropriate legal counsel.

How to use it
In general, the process of drafting, negotiating, and finalizing an agreement with a client will follow this sequence of activities:

- Advance preparation and information gathering about the client and the potential project
- Internal planning of budget and schedule
- Drafting a custom proposal document that the client will see
- Attaching these two AIGA modules for all design projects:
 Basic Terms and Conditions
 Schedule A: Intellectual Property Provisions

Figure 19.01. Shared concerns include basic terms and conditions plus intellectual property provisions. Other modules can be added for issues that relate only to a specific discipline.

- Adding these AIGA supplements as needed:
 Print-Specific Terms and Conditions
 Interactive-Specific Terms and Conditions
 Environmental-Specific Terms and Conditions
- Reviewing the final AIGA checklist of options in the terms and conditions
- Presenting the agreement to the client and answering any questions
- Negotiating any modifications requested by the client
- Finalizing the agreement with authorized signatures

The following pages offer practical advice on the overall process and discuss the important legal and financial issues to be addressed in the "fine print" of any agreement. To help you with the jargon involved, basic explanations of legal terms are included. However, these notes can only serve as a brief introduction to the issues involved. Depending on the type of work you do and the size of your projects, some of the contractual issues can become rather complex. When finalizing an agreement with a client, you will of course want to have it reviewed by your attorney. With that in mind, these notes end with some pointers on how to find the right attorney and make the best use of his or her time and expertise.

NOTES ON BASIC TERMS AND CONDITIONS

This first module of the AIGA system includes general terms and conditions that apply to all creative disciplines, addressing such essential issues as payment terms, client changes, and portfolio usage. These shared issues are discussed in detail in this section. Some descriptions of related concepts are included as well in order to provide additional context.

Definitions
Important terms such as "Agreement" and "Deliverables" need to be used in a consistent way in both the proposal document and the attached terms and conditions. Internal conflicts in terminology will cause confusion and weaken the agreement from a legal standpoint. After a term has been defined, it will be capitalized each time that it is used.

Proposal

The terms and conditions should not restate any of the
project specifications already included in the body of your
proposal document, but they should include an expiration
clause. This is a statement of how long the unsigned offer
will remain valid. If the client sits on the proposal for
a month or two, you may need to update the document
to reflect changes in your pricing or availability.

Fees

If you are charging for your services on a fixed-fee basis, the
total amount will be specified in the body of the proposal.

Taxes

It's a good idea to state that the client is responsible for
any applicable sales or use taxes, even if they are calculated
after the fact (for example, during a subsequent audit of
the designer's tax returns).

Expenses and additional costs

Every project will involve at least a few expenses. They may
be small like reimbursements for photocopies or taxi rides,
or they may be large like the purchase of photography. You
should spell out for the client exactly how project expenses
will be handled and whether or not estimated amounts for
those expenses have been included in your proposal. Some
clients may want to receive photocopies of receipts for
reimbursable expenses while others may simply request
the right to audit your project records if they ever feel it's
necessary to do so. It's not unusual for a client to require
pre-approval if a purchase exceeds a certain amount. If you
are requesting a mileage reimbursement for automobile use,
you may want to use the standard rate published each year
by the Internal Revenue Service (available on www.irs.gov).

In most design firms, out-of-pocket travel expenses for
projects are passed through at cost, but all other expenses
are subject to a markup. State what percentage you use for
your standard markup (20% is common). If a client wants
to avoid a markup on a large expense, consider allowing
them to purchase it directly. However, your fee for services
must cover the time that you put into vendor sourcing and

quality control. Many design firms do not want to take on the potential legal liabilities of brokering expensive third-party services. If something goes wrong with a third-party service such as printing, it's much safer for the designer if the client made the purchase directly.

Invoices

Your schedule for project billings should be stated in the body of the proposal. Progress billings can be based on phases or milestones, or they can be weekly or monthly. You might also want to specify that you will print hard copies in duplicate and send them via regular mail to the accounts payable address given to you by the client.

Payment terms

When you send an invoice to a client, full payment is due within a certain number of days, counting from the day that the invoice was issued. For example "Net 30" means that the client must get full payment to you within thirty days. Some corporate clients stretch this a bit by saying that the days should be counted from the date they receive the invoice. It's common for design firms to establish client payment terms of "Net 15" because client cash must be received in time for the design firm to pay for related project supplies purchased from vendors on terms of "Net 30." Related to this, you may want to put a limit on the amount of credit that you are willing to extend to a new client. This would be a judgment call based on the client's credit history and your own financial needs. You should state that a project may be put on credit hold if required payments are not made.

Late payment penalties

Most design firms charge clients a late fee on overdue payments. The standard rate tends to be 1.5% per month (which is the equivalent of 18% per year), but there are legal limits to the rate in some states. Separate invoices are not generated for the late fees. Instead, they appear as line items on monthly statements sent to clients to remind them of unpaid invoices. When client payments are received, the funds are applied first to the penalty charges and then to the unpaid balance on each open invoice, starting with the oldest.

Full payment
If you have agreed that you will be transferring some or all rights to your client, you should definitely make any transfer of rights contingent upon receipt of full payment from the client for your services.

Changes
It's fairly common for minor client changes to be billed on a time-and-materials basis, so your standard hourly rate(s) will be listed here. You might also want to state that your standard rates will not change without thirty days advance notice to the client. When a client requests additions or modifications, you should respond with a change order form. A change order is a document drafted by the designer to acknowledge a client request that is outside of the original scope for the project. The designer describes the amount of additional time and money required and sends the change order to the client for review and an authorized signature. It is essentially a mini-proposal. You'll want to reference the original proposal and state that the same terms and conditions will apply. Compensation for a change order can be calculated on a time-and-materials basis or as a fixed fee.

As the work involved is completed, each change order should be invoiced separately. If a client requests substantial changes, however, it's sometimes cleaner and less confusing to start all over with a new proposal for the entire project. You may want to define a substantive change as being anything that exceeds a certain percentage of the original schedule or budget (such as 10%) or a certain dollar amount (such as $1,000), whichever is greater.

Timing
It's paradoxical that the typical client will negotiate for a very tight schedule yet, in the middle of the project, that same client may cause serious delays by failing to provide necessary information, materials, or approvals. Most design firms specify that if a client causes a lengthy delay, it will result in a day-for-day extension of the project's final deadline. During that client delay, you may also have to reassign some of your resources to other projects, if you have any. You might have cleared the decks for the fast-track project by delaying or turning down other assignments. The danger

for you as a businessperson is that an unexpected delay could mean that you're temporarily unable to produce billable hours. To offset this risk, some creative firms attempt to charge a delay penalty or a restart fee. You may want to raise this issue as a negotiating point. However, most clients are not very receptive to the idea.

Testing and acceptance

All work that you deliver to the client should be considered accepted unless the client notifies you to the contrary within a specified period of time (usually five or ten days).

Cure

Related to testing and acceptance is the concept of cure. If the client notifies you that the work is not acceptable, you should have the opportunity to effect a cure. This means to repair, correct, or re-design any work that does not conform to the project specifications in order to make it acceptable to the client.

Client responsibilities

If a client has never purchased creative services before, they may not be aware of how extensive and important their own involvement in the process will be. You'll want to point out what is required of them in terms of information, content, schedules, decision making, and approvals.

Accreditation / promotions

This has to do with receiving proper credit for the work and being able to add it to your design portfolio. You should ask for a credit line to be included in the work itself. You should state that, once the project has been completed and introduced to the public, you will have the right to add the client's name to your client list and the right to enter the work into design competitions. You'll also want to be able to show and explain portions of the completed project to other companies when you are pitching new business. Sometimes clients who are in highly competitive industries have concerns about this. They may ask for the right to review and approve such promotional activity on a case-by-case basis. If you have licensed the final art to the client rather than making a full assignment of rights and the work does not fall within the category of work-for-hire (defined in a moment), you are legally entitled to show the work in your portfolio.

As a professional courtesy, however, you will want to be sensitive to client concerns. (For more information about ownership and licensing, see the notes regarding *Schedule A: Intellectual Property Provisions.*)

Confidential information
In order for these terms and conditions to be complete and comprehensive, confidentiality should be included here even if you've already signed a separate confidentiality and non-disclosure agreement (perhaps during your very first meeting with the client). Depending on the type of work that you do, you may want confidentiality and nondisclosure to be mutual so that your own proprietary information is protected as well.

Relationship of the parties
Your agreement should reiterate the fact that you are not an employee of your client and you are not forming a joint venture or partnership with them. As an outside supplier of services, you are functioning as an independent contractor. You will also want the ability to bring in your own assistants or agents as needed.

Work made for hire
Discussions with your client about independent contractor status and about ownership and use of project deliverables are sometimes complicated by confusion over the related concept of work-for-hire. This phrase comes from U.S. copyright law. It refers to original work made by an employee within the scope of his or her job, in which copyright ownership automatically belongs to the employer. However, it can also refer to original work made by an independent contractor or a design firm, in which copyright ownership might automatically belong to the client. This is only true if the work meets very specific criteria — it must be specially ordered or commissioned, and it must fall within one of nine categories:

- A contribution to a collective work
 (such as a magazine, an anthology, or an encyclopedia)
- A work that is part of a motion picture or other audiovisual work
 (such as a Web site or a multimedia project)
- A translation

- A supplement prepared as an adjunct to a work created by another author
 (such as a foreword, an appendix, or charts)
- A compilation
 (a new arrangement of pre-existing works, such as a catalog)
- An instructional text
 (whether it is literary, pictorial, or graphic)
- A test
- Answer material for a test
- An atlas

Also, a written agreement must be signed by both parties saying that it is a work made for hire. If the project doesn't meet all of these criteria, work-for-hire does not apply. Copyright will belong to you unless you assign it to your client. (More information about copyright is available in the AIGA publication *Guide to Copyright* and directly from the U.S. Copyright Office at www.copyright.gov.)

No solicitation

It doesn't happen very often, but sometimes a client is so pleased with the work of a particular member of the designer's team that they will seek to establish a direct relationship with him or her. Some people refer to this as "cherry picking." If a client recruits one of your team members away from you, you should at least be entitled to a placement fee for having made the introduction. Beyond that, you should also consider the impact on your operations. If your most experienced and productive team member is no longer available, your business may be damaged by the unexpected interruption to your activities.

No exclusivity

You may want to add that the relationship between you and the client is not an exclusive one. You sell services to a range of clients, and some of them may be competitors. If a company wants to be your only client in a particular category, your pricing will have to reflect that. An exclusive relationship would require you to turn down projects from similar firms. Higher rates are necessary in order to offset that lost business.

Warranties and representations

A warranty is a promise in a contract. It is a written guarantee that the subject of the agreement is as represented. As a designer, you might warrant that your work is free from defective workmanship or that it is original and does not infringe the intellectual property of others. If some portion of the work turns out to be defective (for example, a problem with some line of custom computer code in an interactive project), then it is your responsibility to repair or replace it.

Legal issues related to originality can be a bit more challenging. You can only infringe a copyright if you knowingly copy someone else's work. However, trademark, trade dress, and patent rights can be infringed even if you create your work independently. Thus, it's best to limit your warranty of non-infringement to "the best of your knowledge." If you are going to provide a guarantee of non-infringement without such limitation, then at some time before the end of the project a formal search should be conducted to determine whether or not your work inadvertently resembles a third party's trademark or patent ("prior art"). It's best to place responsibility for this type of prior art search on the client. If you agree to arrange for the search, then your schedule and budget for the project must include the hiring of an attorney or legal service to actually carry it out.

It's best for warranties and representations to be reciprocal. The client should make the same promises to you for any project components that they supply.

Infringement

Infringement is the unauthorized use of someone else's intellectual property. It is the opposite of seeking and receiving permission, using correct notice of ownership, and contracting for payment of a royalty or fee. Even though the infringement may be accidental (you may independently create a logo for your client that looks like someone else's trademark), there may be infringement liability, and the infringer may be responsible for paying substantial damages and stopping the use of the infringing work.

Disclaimer of warranties and use of ALL CAPS
If an agreement includes a disclaimer of any warranty, many states require by law that the disclaimer language be sufficiently "conspicuous" in the document. It needs to stand out in such a way that any reasonable consumer would notice it. This usually means that the disclaimer must be printed in all capital letters or in type that is larger or in a contrasting color. If you do not follow these guidelines, you run the risk of making the disclaimer invalid.

Indemnification
In the event that you breach any warranty that you have given, you agree to provide security against any hurt, loss, or damage that might occur. You would have to make the client "whole" by giving them something equal to what they have lost or protecting them from any judgments or damages that might have to be paid to third parties, along with attorney's fees. For example, you might be asked to provide indemnity against third-party infringement claims.

At the same time, however, you need to have the client indemnify you against any breach of warranties that they have made. Indemnification is a very important issue for designers because the scope of potential liability can be considerable.

Liability
Liability means legal responsibility for the consequences of your acts or omissions. Your accountability to the client may be enforced by civil remedies or criminal penalties. For example, a Web developer who has agreed in writing to complete an e-commerce site by a specific date will have liability to the client if the project is not completed on time.

Limitations on liability and use of ALL CAPS
Again, if an agreement includes a limitation on liability, many states require by law that the limitation language be sufficiently "conspicuous" in the document. It needs to stand out in such a way that any reasonable consumer would notice it. This usually means that the limitation must be

printed in all capital letters or in type that is larger or in a contrasting color. If you do not follow these guidelines, you run the risk of making the limitation invalid.

It's smart for a designer to ask a client to agree that they may not recover any damages from you in excess of the total amount of money agreed to in the proposal. While it's possible for you to limit the amount that each of you might owe to the other in this way, you should keep in mind that you cannot contract away the rights of any third party to make a claim.

Remedy

A "remedy" is the legal recourse available to an injured party. It may be stipulated in an agreement or a court may order it. A remedy might require that a certain act be performed or prohibited, or it might involve the payment of money.

Damages

"Damages" are financial compensation for loss or injury suffered by a plaintiff (the person suing). The amount of money awarded in a lawsuit can vary greatly. There are several different categories of damages, including the following: actual damages, such as loss of money due on a contract; general damages, which are more subjective and might relate to loss of reputation or anticipated business; and punitive damages, which may be awarded if the defendant acted in a fraudulent way.

Term and termination

The normal term of a project will begin with the signing of a written agreement and end with the client's acceptance of your completed services. If something happens in the meantime to make cancellation necessary, the agreement must describe in advance the process for doing that, from notification through calculation of your final invoice. That final billing might cover time and materials for actual services performed through the date of cancellation, or it might be a lump-sum cancellation fee, or perhaps a combination of the two. Cancellation also raises questions about ownership of the unfinished work. Typically the

designer will retain all preliminary art, including any studies and comps already rejected by the client, while the client might receive the most recent approved version of the work in process.

General items

Most of the legal issues addressed in this section of the terms and conditions are fairly self-explanatory. However, the following information may be helpful:

Force majeure

This is a French term that means "superior force." It refers to any event or effect that cannot be reasonably anticipated or controlled. If such an event occurs (for example, a war, a labor strike, extreme weather, or an earthquake), it may delay or terminate the project without putting the designer or client at fault.

Governing law

This has to do with jurisdiction. You must identify the state whose laws will govern the signed agreement. Your client will usually request the state where their main office is located.

Dispute resolution

There are three standard types of dispute resolution. Here's a brief description of each one:

- Mediation

 Mediation is a non-binding intervention between parties in an informal setting in order to promote resolution of a dispute. It involves the active participation of a third party (a mediator) who facilitates discussion in order to clarify issues, find points of agreement, and encourage cooperation. A commitment to mediation is often included in contracts. There are professional mediators and lawyers who offer mediation services.

- Arbitration

 The next step beyond mediation is arbitration, in which an impartial third party (an arbitrator) hears both sides of the dispute in an out-of-court setting. The arbitrator is an attorney who acts much like a judge, listening to both sides of the story but not actively participating in

discussion. You and your opponent will have the
opportunity to present evidence and witnesses. After
hearing the facts, the arbitrator will make a decision.

In your contract, you will specify whether the decision
of the arbitrator is binding or non-binding. Binding
arbitration imposes a legal obligation on the parties
to abide by the decision and accept it as final. Arbitration
proceedings are held in an attempt to avoid a court
trial. However, contract-required arbitration may
later be converted into a legal judgment on petition
to the court. Arbitration fees might be large (depending
on the dispute, they could easily range from $3,000
to $20,000 or more), but usually they are less than
those involved in pursuing a lawsuit. For the sake
of convenience, many contracts identify a large,
national arbitration service to be used in the event
of a dispute. However, it may be preferable for you
to replace this national name with a local name,
particularly if you can find a service that is geared
toward the arts.

- Litigation
Litigation means that you are pursuing a lawsuit through
the court system in order to resolve a dispute. The time
and expense involved may be considerable.

Attorneys' fees
When a decision has been reached concerning a dispute,
either through arbitration or litigation, the losing side may
be liable to pay the winning side's costs and attorneys' fees.
Under copyright law, a winning plaintiff is entitled to recover
his or her attorneys' fees if the copyright was registered
before the infringement occurred. For other types of liability,
the obligation to pay the prevailing party's legal expenses
must be established in your contract.

NOTES ON SCHEDULE A:
INTELLECTUAL PROPERTY PROVISIONS

Every designer produces original work that is covered
by copyright protection and additional work that could
possibly be registered under trademark or patent laws.
Because of this, every design contract needs to address

the issues of ownership and usage of intellectual property. These can be negotiated in a variety ways, based on the nature of the work and the specific needs of the client.

Preliminary art versus final art
There is an important distinction to be made between preliminary and final art. Early in each project, a designer may produce a lot of discussion materials (such as sketches, rough layouts, visualizations, or comps). These are prepared solely for the purpose of demonstrating an idea or a message to the client for acceptance. Normally the client does not receive legal title to or permanent possession of these items, so it's important for your contract to be clear on this point. Many preliminary concepts will later be modified or rejected entirely. Usually only one concept will be taken through to completion, and it is only the approved and finished final art that will be delivered to the client.

Third-party materials
If intellectual property owned by a third party is to be used in a project (for example, an illustration or a photograph), the designer should state that the client is responsible for respecting any usage limitations placed on the property. You may even want the client to negotiate usage rights with the third party and make payments directly to them.

Trademarks
Issues related to trademarks are discussed in the warranties and infringement sections earlier.

Designer tools
This deals with the issue of background technology. If any code that is proprietary to the designer is necessary to develop, run, display, or use the final deliverables, then the designer needs to retain ownership of it while granting a non-exclusive license for the client to copy and use it. This way you can use that same technology on any other clients' projects.

License
A license is a limited grant by a designer to a client of rights to use the intellectual property comprising the final art in a specified way.

Scope of license
The extent of the license that you grant will vary based on the type of work involved. The rights may be limited to use on certain products, in particular media, in a certain territory, and/or for a specified time period. Other basic limitations include whether or not you will allow the client to modify your work in any way or to turn around and license the work to a third party without your permission. If the client later decides that they need additional rights, they will have to come back to you, renegotiate, and pay additional fees.

Exclusive license
If a license is exclusive, it means that even though you have retained ownership of the work, you will not be giving permission to anyone else to use it. This means that you will not be able to generate additional licensing income from other sources. Because of this, designers need to negotiate higher prices for exclusive licenses.

Liquidation for unlicensed use
When licensing rights, you may want to consider agreeing in advance on the amount of damages that would be payable by the client upon a breach of contract. These are called "liquidated damages." At some point in the future, the client may be tempted to exceed the original scope of the license that you've granted. Instead of coming back and renegotiating with you as they should, they might just begin unlicensed usage. (This is a challenge that's faced all the time by stock photography businesses and illustrators.) Since you can't know in advance the extent of the actual damages that would be caused by the unlicensed usage, the amount of money to be paid is calculated as a multiple of the original contract price (300% is common).

An agreement on liquidated damages can help to avoid potential lawsuits and serve as an incentive for the client not to exceed the scope of the license. However, you'll want to weigh your other options carefully. If you reserve the right to sue for breach of contract or infringement, it's conceivable that the amount of money awarded to you in a lawsuit could be higher.

Assignment of rights
An assignment is a full transfer of intellectual property rights to your client. It might include copyright, patent, trademark, trade dress, or other types of intellectual property. For example, when a new corporate identity is developed and sold to a client, the sale typically includes an assignment of all rights. The client will go on to complete U.S. and international registration of copyright, trademark, patent, and other rights in its own name. Designers should charge a higher fee for any project that involves a full assignment of rights.

NOTES ON SUPPLEMENTS

Beyond the basic issues discussed earlier, additional language may be needed in the agreement to clarify issues that are specific to a particular design discipline. For example, Web developers have particular concerns that are different from those of packaging designers. Out of the many possible variations, we have focused in on three areas that we feel will be most relevant to the majority of AIGA members. Most of the items in the supplements are fairly self-explanatory. However, the following information may be helpful.

Supplement 1: Print-Specific Terms and Conditions

Samples
You will want to specify the number of printed samples to be provided to you.

Finished work
In the printing industry, it's not unusual to encounter slight variations of specifications or materials (for example, substitution of a comparable paper stock due to limited availability) as well as a variance of plus or minus 10% on the final, delivered quantity. These should be considered normal and acceptable. Much more information is available about standard trade practices in the printing industry from organizations such as the PIA (Printing Industries of America) and the Graphic Arts Technical Foundation.

Supplement 2: Interactive-Specific Terms and Conditions

Support services
If you're bidding on a Web site and the scope of services described in your proposal includes testing, hosting, and/or maintenance, you are taking on additional legal responsibilities that need to be described in the agreement. Try to limit any additional liability as much as possible. On all interactive projects, you'll want to be very specific about how much support or maintenance you will provide after delivery and whether or not those services will be billed in addition to the original contract price.

Compliance with laws
Section 508 of the Workforce Investment Act of 1998 is of particular importance to user interface designers as well as software and hardware developers. This law requires electronic and information technology purchased by the U.S. government to be accessible for people with disabilities. It sets accessibility and usability requirements for any Web sites, video equipment, kiosks, computers, copiers, fax machines, and the like that may be procured by the government, thereby essentially affecting all such products in the American market. (Australia, Brazil, Canada, Japan, Portugal, and the United Kingdom have also put accessibility guidelines into place.)

Supplement 3: Environmental-Specific Terms and Conditions

Photographs of the project
After completion of an environmental/3-D project (such as a signage system, a trade show booth, a retail interior, or an exhibit), you need the right to photograph the result. This involves being able to access it and take your photographs under optimal circumstances.

Additional client responsibilities
Environmental design projects often require various types of government approval, such as building permits or zoning reviews. Be sure to state that the client is responsible for these.

Engineering and implementation
You will be providing specifications for materials and construction details that will be interpreted by other professionals, such as architects, engineers, and contractors. Typically the client will contract and pay for such implementation services directly. Your agreement should include a disclaimer that you are not licensed in those fields and that responsibility for the quality, safety, timeliness, and cost of such work is the responsibility of the client and the architect, engineer, or contractor involved. The client should indemnify you against any claims in this regard.

Compliance with laws
Your project may be subject to the Americans with Disabilities Act of 1990 (ADA), which is a civil rights act that affects private businesses as well as governmental organizations. ADA requirements are of particular importance to industrial designers, interior designers, and architects.

Client insurance
Ask your client to provide you with proof that they have adequate insurance coverage in place for the duration of the project (one million dollars is a common minimum amount).

FINAL CHECKLIST

Before you send the draft agreement to the client, look
through it one more time for quality control purposes.
In the terms and conditions pages, there are several blanks
that need to be filled in and some very important options
need to be selected.

Basic Terms and Conditions

2.
Number of days that the unsigned proposal will remain valid.

3.2
Standard markup percentage for expenses (and perhaps
standard rate for mileage reimbursement).

3.4
Number of days allowed for payment of invoices.

4.1
Hourly billing rate to be used for general client changes.

4.2
Percentage of original project schedule or budget that
will be used to determine whether or not changes are
substantive instead of general.

12.5
Name of state identified for governing law.

12.8
Identify which supplements are attached, if any.

(Last page)
Add your name, signature, and date.

Schedule A: Intellectual Property Provisions
Choose only one of these three combinations:

IP 2.A (1) (a) and IP 2.1
A license for limited usage, client may not modify the work;
indicate whether it is for print, interactive, or environmental;
describe the category, medium, duration, territory, and
size of initial press run; indicate whether the license is
exclusive or nonexclusive.

or IP 2.A (1) (b) and IP 2.2
A license for unlimited usage, client may not modify
the work; indicate whether it is for print, interactive,
or environmental/3-D; (this license is exclusive).

or IP 2.A (1) (c) and IP 2.3
A license for unlimited usage, client may modify the
work; indicate whether it is for print, interactive, or
environmental/3-D; (this license is exclusive).

And, with any of the three options above, be sure to include
the following liquidation clause, just in case the client later
exceeds the usage rights that you have granted:

IP 2.A (2) and IP 2.4
Fill in the percentage that will be used to calculate the amount
of additional compensation.

Or skip all of the above and go directly to:

IP 2.B and 2.5
This assigns all rights to the client, with no limitations.

Supplement 1: Print-Specific Terms and Conditions
P 1.
Enter the number of printed samples that you want to receive.

Supplement 2: Interactive-Specific Terms and Conditions
I 1.1
Enter the number of months in the warranty period,
and enter the number of support hours to be provided
at no additional cost.
I 1.2
Enter the number of months in the maintenance period,
and enter the flat fee to be charged per month or the hourly
billing rate for maintenance.

Supplement 3: Environmental-Specific Terms and Conditions
3D 3.
Remove either the brackets or the text within them in
order to indicate whether you are or are not a licensed
engineer or architect.
3D 6.
Insurance requirement for the client: enter a dollar amount.

Negotiation issues

Present the draft agreement to the client in person, if possible, so that you can explain the contents and answer any questions. Don't be surprised if they ask for modifications or additional items to be included. Here are some of the issues that may come up:

Pricing

Often the initial client response will be to ask for a lower price. It's best for you to avoid getting into a discussion of standard hourly rates. Discuss the scope of work instead. Focus on the main objectives. Can portions of the project be scaled back? Are there components that can be broken out as later projects? Reducing the scope of work will reduce the overall price.

Deposits

Whenever possible, you should ask for a deposit at the beginning of a project. There are different approaches to this. Some designers apply the deposit to the first progress billing (making it essentially a pre-payment of phase 1). Others state that the deposit will be held until the end of project and applied to the final billing. If that's the case, point out that no interest will be paid while it is being held. If the project is cancelled, the deposit will be refunded less any amounts due to the designer.

Product liability

If you are working on the development of a product that will eventually be sold to the public, this will be an important issue. Your client may ask to have it included in the agreement. "Product liability" refers to the legal responsibility of product designers, manufacturers, distributors, and sellers to deliver products to the public that are free of any defects that could harm people. If a product is defective, the purchaser will probably sue the seller, who may then bring the distributor or manufacturer or product designer into the lawsuit. Any one of the parties may be liable for damages or may have to contribute toward a judgment.

Designer insurance

Large clients often specify minimum insurance levels for the designer's business. Standard business requirements include

general liability, workers comp, and automobile coverage. In addition, you may need to carry professional liability insurance to cover such things as intellectual property infringement or errors and omissions. You'll need to analyze your own needs in this area and do some research with an independent insurance agent. Certain types of professional liability coverage may be limited in scope and rather expensive. If designer insurance requirements are added to the agreement, you must provide proof of coverage in the form of a certificate of insurance that is sent from your insurance agent directly to the client.

Addendum to the agreement
There are two ways to record the changes that result from your negotiations with the client. The most direct is to go back into the body of the agreement and change the original language. This is, in fact, what you should do for all changes that relate to the scope and specifications in the proposal document at the front of the agreement. However, things can become quite confusing if you start to rewrite the attached terms and conditions. It is sometimes better to list negotiated changes to the terms and conditions on a separate sheet, called an "addendum." The addendum must clearly describe exactly what is being changed, and it must not create any contradictions or ambiguities. If you do go back into the original terms and conditions and make the changes directly, then you must be cautious when you are drafting your next client agreement. If you're in a hurry, it's all too easy to copy the modified terms by mistake. Be sure that you always go back to the standard language and not your most recent adaptation. The original text must always be your starting point — otherwise you can stray quite far from the original intent.

Negotiating just once for the entire relationship
Terms and conditions can be negotiated separately for each and every project, or they can be negotiated just once for the entire relationship. If you start with a complete set and state that it will apply to all projects, then future proposals can just refer back to it. This can save on paperwork, time, and legal expenses for both you and your client.

Finding and working with an attorney

It can be a challenge to find the right attorney and to use his or her time in an efficient way. Most attorneys specialize in a single category of law, such as real estate or labor law. As a creative professional, you need to find an attorney who specializes in issues related to intellectual property (copyrights, trademarks, patents, and trade secrets). Attorneys are licensed state by state, so you need to find one in your own area. Start your search by visiting these online directories:

- Volunteer Lawyers for the Arts
 www.vlany.org
 (A nonprofit listing of legal resources for artists in approximately 30 U.S. states plus Canada and Australia)
- Martindale-Hubbell
 www.lawyers.com
 (A commercial directory of U.S. and Canadian attorneys that you can search by specialty and location)
- FindLaw / Thomson Reuters
 www.findlaw.com
 (A searchable commercial database of attorneys, along with articles on various legal topics)

It's a good idea to look for an attorney who has other designers as clients. Speak with established members of your own design community — one of them may be able to provide you with a local recommendation. Seek out an appropriate attorney when you are first establishing your business. Getting preventative advice on basic issues is much better than waiting until you're already in some sort of legal difficulty.

Initial discounts are sometimes available through groups such as Volunteer Lawyers for the Arts, but in general legal services are not inexpensive. Attorneys may charge a flat fee for assisting with certain basic transactions such as setting up an LLC, but for the most part services are billed on a time-and-materials basis. For this reason, you need to be efficient in the way that you interact. Make the best use of your attorney's time by being very well prepared.

Bring copies of any correspondence that you have already received from or sent to the client. Gather sample documents from your industry, and become familiar with the basic legal issues relevant to the creative services that you offer. You may be able to use one of these reference documents as a draft for further discussion with your attorney. Be completely honest, and ask questions about anything that is not clear to you. Together you will then craft a final version to send to your client.

If your client is a small business, they may respond with some basic questions that you will have no trouble answering. With large clients, though, you may find that your document is routed to an in-house legal department. If questions come to you from an in-house attorney, consider having that person negotiate the fine points directly with your own lawyer. If the in-house counsel is a specialist in some other area of law, your intellectual property attorney can explain the context for the agreement language that you are requesting. Attorney-to-attorney negotiation creates additional expense, but if the resulting terms and conditions can be accepted as the basis of an ongoing relationship, then you won't have to go through the process a second time.

Chapter 20:
AIGA Standard Form of
Agreement for Design Services

BASIC TERMS AND CONDITIONS

1. Definitions.

As used herein and throughout this Agreement:

1.1 *"Agreement"* means the entire content of this Basic Terms and Conditions document, the Proposal document(s), Schedule A, together with any other Supplements designated below, together with any exhibits, schedules or attachments hereto.

1.2 *"Client Content"* means all materials, information, photography, writings and other creative content provided by Client for use in the preparation of and/or incorporation in the Deliverables.

1.3 *"Copyrights"* means the property rights in original works of authorship, expressed in a tangible medium of expression, as defined and enforceable under U.S. Copyright Law.

1.4 *"Deliverables"* means the services and work product specified in the Proposal to be delivered by Designer to Client, in the form and media specified in the Proposal.

1.5 *"Designer Tools"* means all design tools developed and/or utilized by Designer in performing the Services, including without limitation pre-existing and newly developed software including source code, Web authoring tools, type fonts, and application tools, together with any other software, or other inventions whether or not patentable, and general non-copyrightable concepts such as Web site design, architecture, layout, navigational and functional elements.

1.6 *"Final Art"* means all creative content developed or created by Designer, or commissioned by Designer, exclusively for the Project and incorporated into and delivered as part of the Final Deliverables, including and by way of example, not limitation, any and all visual designs, visual elements, graphic design, illustration, photography, animation, sounds, typographic treatments and text, modifications to Client Content, and Designer's selection, arrangement and coordination of such elements together with Client Content and/or Third Party Materials.

1.7 *"Final Deliverables"* means the final versions of Deliverables provided by Designer and accepted by Client.

1.8 *"Preliminary Works"* means all artwork including, but not limited to, concepts, sketches, visual presentations, or other alternate or preliminary designs and documents developed by Designer and which may or may not be shown and or delivered to Client for consideration but do not form part of the Final Art.

1.9 *"Project"* means the scope and purpose of the Client's identified usage of the work product as described in the Proposal.

1.10 *"Services"* means all services and the work product to be provided to Client by Designer as described and otherwise further defined in the Proposal.

1.11 *"Third Party Materials"* means proprietary third party materials which are incorporated into the Final Deliverables, including without limitation stock photography or illustration.

1.12 *"Trademarks"* means trade names, words, symbols, designs, logos or other devices or designs used in the Final Deliverables to designate the origin or source of the goods or services of Client.

2. Proposal.
The terms of the Proposal shall be effective for (........) days after presentation to Client. In the event this Agreement is not executed by Client within the time identified, the Proposal, together with any related terms and conditions and deliverables, may be subject to amendment, change or substitution.

3. Fees and Charges.

3.1 *Fees.* In consideration of the Services to be performed by Designer, Client shall pay to Designer fees in the amounts and according to the payment schedule set forth in the Proposal, and all applicable sales, use or value added taxes, even if calculated or assessed subsequent to the payment schedule.

3.2 *Expenses.* Client shall pay Designer's expenses incurred in connection with this Agreement as follows: (a) incidental and out-of-pocket expenses including but not limited to costs for telephone calls, postage, shipping, overnight courier, service bureaus, typesetting, blueprints, models, presentation materials, photocopies, computer expenses, parking fees and tolls, and taxis at cost plus Designer's standard markup of percent (........%), and, if applicable, a mileage reimbursement at per mile; and (b) travel expenses including transportation, meals, and lodging, incurred by Designer with Client's prior approval.

3.3 *Additional Costs.* The Project pricing includes Designer's fee only. Any and all outside costs including, but not limited to, equipment rental, photographer's costs and fees, photography and/or artwork licenses, prototype production costs, talent fees, music licenses, and online access or hosting fees, will be billed to Client unless specifi-cally otherwise provided for in the Proposal.

3.4 *Invoices.* All invoices are payable within (........) days of receipt. A monthly service charge of 1.5% (or the greatest amount allowed by state law) is payable on all overdue balances. Payments will be credited first to late payment charges and next to the unpaid balance. Client shall be responsible for all collection or legal fees necessitated by lateness or default in payment. Designer reserves the right to withhold delivery and any transfer of ownership of any current work if accounts are not current or overdue invoices are not paid in full. All grants of any license to use or transfer of ownership of any intel-lectual property rights under this Agreement are conditioned upon receipt of payment in full which shall be inclusive of any and all outstanding Additional Costs, Taxes, Expenses, and Fees, Charges, or the costs of Changes.

4. Changes.

4.1 General Changes. Unless otherwise provided in the Proposal, and except as otherwise provided for herein, Client shall pay additional charges for changes requested by Client which are outside the scope of the Services on a time and materials basis, at Designer's standard hourly rate of per hour. Such charges shall be in addition

to all other amounts payable under the Proposal, despite any maximum budget, contract price or final price identified therein. Designer may extend or modify any delivery schedule or deadlines in the Proposal and Deliverables as may be required by such Changes.

4.2 *Substantive Changes.* If Client requests or instructs Changes that amount to a revision in or near excess of percent (........%) of the time required to produce the Deliverables, and or the value or scope of the Services, Designer shall be entitled to submit a new and separate Proposal to Client for written approval. Work shall not begin on the revised services until a fully signed revised Proposal and, if required, any additional retainer fees are received by Designer.

4.3 *Timing.* Designer will prioritize performance of the Services as may be necessary or as identified in the Proposal, and will undertake commercially reasonable efforts to perform the Services within the time(s) identified in the Proposal. Client agrees to review Deliverables within the time identified for such reviews and to promptly either, (i) approve the Deliverables in writing or (ii) provide written comments and/or corrections sufficient to identify the Client's concerns, objections or corrections to Designer. The Designer shall be entitled to request written clarification of any concern, objection or correction. Client acknowledges and agrees that Designer's ability to meet any and all schedules is entirely dependent upon Client's prompt performance of its obligations to provide materials and written approvals and/or instructions pursuant to the Proposal and that any delays in Client's performance or Changes in the Services or Deliverables requested by Client may delay delivery of the Deliverables. Any such delay caused by Client shall not constitute a breach of any term, condition or Designer's obligations under this Agreement.

4.4 *Testing and Acceptance.* Designer will exercise commercially reasonable efforts to test Deliverables requiring testing and to make all necessary corrections prior to providing Deliverables to Client. Client, within five (5) business days of receipt of each Deliverable, shall notify Designer, in writing, of any failure of such Deliverable to

comply with the specifications set forth in the Proposal, or of any other objections, corrections, changes or amendments Client wishes made to such Deliverable. Any such written notice shall be sufficient to identify with clarity any objection, correction or change or amendment, and Designer will undertake to make the same in a commercially timely manner. Any and all objections, corrections, changes or amendments shall be subject to the terms and conditions of this Agreement. In the absence of such notice from Client, the Deliverable shall be deemed accepted.

5. Client Responsibilities.
Client acknowledges that it shall be responsible for performing the following in a reasonable and timely manner: (a) coordination of any decision-making with parties other than the Designer; (b) provision of Client Content in a form suitable for reproduction or incorporation into the Deliverables without further preparation, unless otherwise expressly provided in the Proposal; and (c) final proofreading and in the event that Client has approved Deliverables but errors, such as, by way of example, not limitation, typographic errors or misspellings, remain in the finished product, Client shall incur the cost of correcting such errors.

6. Accreditation / Promotions.
All displays or publications of the Deliverables shall bear accreditation and/or copyright notice in Designer's name in the form, size and location as incorporated by Designer in the Deliverables, or as otherwise directed by Designer. Designer retains the right to reproduce, publish and display the Deliverables in Designer's portfolios and Web sites, and in galleries, design periodicals and other media or exhibits for the purposes of recognition of creative excellence or professional advancement, and to be credited with authorship of the Deliverables in connection with such uses. Either party, subject to the other's reasonable approval, may describe its role in relation to the Project and, if applicable, the services provided to the other party on its Web site and in other promotional materials, and, if not expressly objected to, include a link to the other party's Web site.

7. Confidential Information.

Each party acknowledges that in connection with this Agreement it may receive certain confidential or proprietary technical and business information and materials of the other party, including without limitation Preliminary Works ("Confidential Information"). Each party, its agents and employees shall hold and maintain in strict confidence all Confidential Information, shall not disclose Confidential Information to any third party, and shall not use any Confidential Information except as may be necessary to perform its obligations under the Proposal except as may be required by a court or governmental authority. Notwithstanding the foregoing, Confidential Information shall not include any information that is in the public domain or becomes publicly known through no fault of the receiving party, or is otherwise properly received from a third party without an obligation of confidentiality.

8. Relationship of the Parties.

8.1 *Independent Contractor.* Designer is an independent contractor, not an employee of Client or any company affiliated with Client. Designer shall provide the Services under the general direction of Client, but Designer shall determine, in Designer's sole discretion, the manner and means by which the Services are accomplished. This Agreement does not create a partnership or joint venture and neither party is authorized to act as agent or bind the other party except as expressly stated in this Agreement. Designer and the work product or Deliverables prepared by Designer shall not be deemed a work for hire as that term is defined under Copyright Law. All rights, if any, granted to Client are contractual in nature and are wholly defined by the express written agreement of the parties and the various terms and conditions of this Agreement.

8.2 *Designer Agents.* Designer shall be permitted to engage and/or use third party designers or other service providers as independent contractors in connection with the Services ("Design Agents"). Notwithstanding, Designer shall remain fully responsible for such Design Agents' compliance with the various terms and conditions of this Agreement.

8.3 *No Solicitation.* During the term of this Agreement, and for a period of six (6) months after expiration or termination of this Agreement, Client agrees not to solicit, recruit, engage, or otherwise employ or retain, on a full-time, part-time, consulting, work-for-hire, or any other kind of basis, any Designer, employee or Design Agent of Designer, whether or not said person has been assigned to perform tasks under this Agreement. In the event such employment, consultation or work-for-hire event occurs, Client agrees that Designer shall be entitled to an agency commission to be the greater of, either (a) 25% of said person's starting salary with Client, or (b) 25% of fees paid to said person if engaged by Client as an independent contractor. In the event of (a) above, payment of the commission will be due within 30 days of the employment starting date. In the event of (b) above, payment will be due at the end of any month during which the independent contractor performed services for Client. Designer, in the event of nonpayment and in connection with this section, shall be entitled to seek all remedies under law and equity.

8.4 *No Exclusivity.* The parties expressly acknowledge that this Agreement does not create an exclusive relationship between the parties. Client is free to engage others to perform services of the same or similar nature to those provided by Designer, and Designer shall be entitled to offer and provide design services to others, solicit other clients, and otherwise advertise the services offered by Designer.

9. Warranties and Representations.

9.1 *By Client.* Client represents, warrants and covenants to Designer that (a) Client owns all right, title, and interest in, or otherwise has full right and authority to permit the use of the Client Content, (b) to the best of Client's knowledge, the Client Content does not infringe the rights of any third party, and use of the Client Content as well as any Trademarks in connection with the Project does not and will not violate the rights of any third parties, (c) Client shall comply with the terms and conditions of any licensing agreements which govern the use of Third Party Materials, and (d) Client shall comply with all laws and regulations as they relate to the Services and Deliverables.

9.2 *By Designer.*

(a) Designer hereby represents, warrants and covenants to Client that Designer will provide the Services identified in the Agreement in a professional and workmanlike manner and in accordance with all reasonable professional standards for such services.

(b) Designer further represents, warrants and covenants to Client that (i) except for Third Party Materials and Client Content, the Final Deliverables shall be the original work of Designer and/or its independent contractors, (ii) in the event that the Final Deliverables include the work of independent contractors commissioned for the Project by Designer, Designer shall have secured agreements from such contractors granting all necessary rights, title, and interest in and to the Final Deliverables sufficient for Designer to grant the intellectual property rights provided in this Agreement, and (iii) to the best of Designer's knowledge, the Final Art provided by Designer and Designer's subcontractors does not infringe the rights of any party, and use of same in connection with the Project will not violate the rights of any third parties. In the event Client or third parties modify or otherwise use the Deliverables outside of the scope or for any purpose not identified in the Proposal or this Agreement or contrary to the terms and conditions noted herein, all representations and warranties of Designer shall be void.

(c) EXCEPT FOR THE EXPRESS REPRESENTATIONS AND WARRANTIES STATED IN THIS AGREEMENT, DESIGNER MAKES NO WARRANTIES WHATSOEVER. DESIGNER EXPLICITLY DISCLAIMS ANY OTHER WARRANTIES OF ANY KIND, EITHER EXPRESS OR IMPLIED, INCLUDING BUT NOT LIMITED TO WARRANTIES OF MERCHANTABILITY OR FITNESS FOR A PARTICULAR PURPOSE OR COMPLIANCE WITH LAWS OR GOVERNMENT RULES OR REGULATIONS APPLICABLE TO THE PROJECT.

10. Indemnification/Liability.

10.1 *By Client.* Client agrees to indemnify, save and hold harmless Designer from any and all damages, liabilities, costs, losses or expenses arising out of any claim, demand, or action by a third party arising out of any breach of Client's responsibilities or obligations, representations or warranties under this Agreement. Under such circumstances Designer

shall promptly notify Client in writing of any claim or suit; (a) Client has sole control of the defense and all related settlement negotiations; and (b) Designer provides Client with commercially reasonable assistance, information and authority necessary to perform Client's obligations under this section. Client will reimburse the reasonable out-of-pocket expenses incurred by Designer in providing such assistance.

10.2 *By Designer.* Subject to the terms, conditions, express representations and warranties provided in this Agreement, Designer agrees to indemnify, save and hold harmless Client from any and all damages, liabilities, costs, losses or expenses arising out of any finding of fact which is inconsistent with Designer's representations and warranties made herein, except in the event any such claims, damages, liabilities, costs, losses or expenses arise directly as a result of gross negligence or misconduct of Client provided that (a) Client promptly notifies Designer in writing of the claim; (b) Designer shall have sole control of the defense and all related settlement negotiations; and (c) Client shall provide Designer with the assistance, information and authority necessary to perform Designer's obligations under this section. Notwithstanding the foregoing, Designer shall have no obligation to defend or otherwise indemnify Client for any claim or adverse finding of fact arising out of or due to Client Content, any unauthorized content, improper or illegal use, or the failure to update or maintain any Deliverables provided by Designer.

10.3 *Limitation of Liability.* THE SERVICES AND THE WORK PRODUCT OF DESIGNER ARE SOLD "AS IS." IN ALL CIRCUMSTANCES, THE MAXIMUM LIABILITY OF DESIGNER, ITS DIRECTORS, OFFICERS, EMPLOYEES, DESIGN AGENTS AND AFFILIATES ("DESIGNER PARTIES"), TO CLIENT FOR DAMAGES FOR ANY AND ALL CAUSES WHATSOEVER, AND CLIENT'S MAXIMUM REMEDY, REGARDLESS OF THE FORM OF ACTION, WHETHER IN CONTRACT, TORT OR OTHERWISE, SHALL BE LIMITED TO THE NET PROFIT OF DESIGNER. IN NO EVENT SHALL DESIGNER BE LIABLE FOR ANY LOST DATA OR CONTENT, LOST PROFITS, BUSINESS INTERRUPTION OR FOR ANY INDIRECT, INCIDENTAL, SPECIAL, CONSEQUENTIAL, EXEMPLARY OR PUNITIVE DAMAGES ARISING OUT OF OR RELATING TO THE MATERIALS OR THE SERVICES PROVIDED BY DESIGNER, EVEN IF DESIGNER HAS BEEN ADVISED OF

THE POSSIBILITY OF SUCH DAMAGES, AND
NOTWITHSTANDING THE FAILURE OF ESSENTIAL
PURPOSE OF ANY LIMITED REMEDY.

11. Term and Termination.

11.1 This Agreement shall commence upon the
Effective Date and shall remain effective until the Services
are completed and delivered.

11.2 This Agreement may be terminated at any time by
either party effective immediately upon notice, or the mutual
agreement of the parties, or if any party: (a) becomes insol-
vent, files a petition in bankruptcy, makes an assignment for
the benefit of its creditors; or (b) breaches any of its material
responsibilities or obligations under this Agreement, which
breach is not remedied within ten (10) days from receipt
of written notice of such breach.

11.3 In the event of termination, Designer shall be
compensated for the Services performed through the date
of termination in the amount of (a) any advance payment,
(b) a prorated portion of the fees due, or (c) hourly fees
for work performed by Designer or Designer's agents as
of the date of termination, whichever is greater; and Client
shall pay all Expenses, fees, out of pockets together with
any Additional Costs incurred through and up to, the
date of cancellation.

11.4 In the event of termination by Client and
upon full payment of compensation as provided herein,
Designer grants to Client such right and title as provided
for in Schedule A of this Agreement with respect to those
Deliverables provided to, and accepted by Client as of
the date of termination.

11.5 Upon expiration or termination of this Agreement:
(a) each party shall return or, at the disclosing party's
request, destroy the Confidential Information of the other
party, and (b) other than as provided herein, all rights and
obligations of each party under this Agreement, exclusive
of the Services, shall survive.

12.　General.

12.1　*Modification/Waiver.* This Agreement may be modi-
fied by the parties. Any modification of this Agreement must
be in writing, except that Designer's invoices may include,
and Client shall pay, expenses or costs that Client authorizes
by electronic mail in cases of extreme time sensitivity. Failure
by either party to enforce any right or seek to remedy any
breach under this Agreement shall not be construed as a
waiver of such rights nor shall a waiver by either party of
default in one or more instances be construed as constitut-
ing a continuing waiver or as a waiver of any other breach.

12.2　*Notices.* All notices to be given hereunder shall
be transmitted in writing either by facsimile or electronic
mail with return confirmation of receipt or by certified or
registered mail, return receipt requested, and shall be sent
to the to the addresses identified below, unless notification
of change of address is given in writing. Notice shall be
effective upon receipt or in the case of fax or e-mail,
upon confirmation of receipt.

12.3　*No Assignment.* Neither party may assign, whether
in writing or orally, or encumber its rights or obligations
under this Agreement or permit the same to be transferred,
assigned or encumbered by operation of law or otherwise,
without the prior written consent of the other party.

12.4　*Force Majeure.* Designer shall not be deemed in
breach of this Agreement if Designer is unable to complete
the Services or any portion thereof by reason of fire, earth-
quake, labor dispute, act of God or public enemy, death,
illness or incapacity of Designer or any local, state, federal,
national or international law, governmental order or
regulation or any other event beyond Designer's control
(collectively, "Force Majeure Event"). Upon occurrence of
any Force Majeure Event, Designer shall give notice to
Client of its inability to perform or of delay in completing
the Services and shall propose revisions to the schedule
for completion of the Services.

12.5 *Governing Law and Dispute Resolution.* The forma-
tion, construction, performance and enforcement of this
Agreement shall be in accordance with the laws of the
United States and the state of without regard
to its conflict of law provisions or the conflict of law provi-
sions of any other jurisdiction. In the event of a dispute
arising out of this Agreement, the parties agree to attempt
to resolve any dispute by negotiation between the parties.
If they are unable to resolve the dispute, either party may
commence mediation and/or binding arbitration through
the American Arbitration Association, or other forum mutu-
ally agreed to by the parties. The prevailing party in any
dispute resolved by binding arbitration or litigation shall
be entitled to recover its attorneys' fees and costs. In all
other circumstances, the parties specifically consent to
the local, state and federal courts located in the state of
........................... The parties hereby waive any jurisdictional
or venue defenses available to them and further consent
to service of process by mail. Client acknowledges that
Designer will have no adequate remedy at law in the event
Client uses the deliverables in any way not permitted here-
under, and hereby agrees that Designer shall be entitled to
equitable relief by way of temporary and permanent injunc-
tion, and such other and further relief at law or equity as
any arbitrator or court of competent jurisdiction may deem
just and proper, in addition to any and all other remedies
provided for herein.

12.6 *Severability.* Whenever possible, each provision of
this Agreement shall be interpreted in such manner as to be
effective and valid under applicable law, but if any provi-
sion of this Agreement is held invalid or unenforceable, the
remainder of this Agreement shall nevertheless remain in
full force and effect and the invalid or unenforceable provi-
sion shall be replaced by a valid or enforceable provision.

12.7 _Headings._ The numbering and captions of the various sections are solely for convenience and reference only and shall not affect the scope, meaning, intent or interpretation of the provisions of this Agreement nor shall such headings otherwise be given any legal effect.

12.8 _Integration._ This Agreement comprises the entire understanding of the parties hereto on the subject matter herein contained, and supersedes and merges all prior and contemporaneous agreements, understandings and discussions between the parties relating to the subject matter of this Agreement. In the event of a conflict between the Proposal and any other Agreement documents, the terms of the Proposal shall control. This Agreement comprises this Basic Terms and Conditions document, the Proposal, Schedule A, and the following documents as indicated by the parties' initials:

Supplement 1: _Print-Specific Terms and Conditions_

......................

Supplement 2: _Interactive-Specific Terms and Conditions_

......................

Supplement 3: _Environmental-Specific Terms and Conditions_

......................

By their execution below, the parties hereto have agreed to all of the terms and conditions of this Agreement effective as of the last date of signature below, and each signatory represents that it has the full authority to enter into this Agreement and to bind her/his respective party to all of the terms and conditions herein.

Designer:

Authorized signature ...

Print name and title ...

Date ...

Address ...

Client:

Authorized signature ...

Print name and title ...

Date ...

Address ...

SCHEDULE A: INTELLECTUAL PROPERTY PROVISIONS

IP 1. Rights to Deliverables other than Final Art.

IP 1.1 *Client Content.* Client Content, including all pre-existing Trademarks, shall remain the sole property of Client or its respective suppliers, and Client or its suppliers shall be the sole owner of all rights in connection therewith. Client hereby grants to Designer a nonexclusive, nontransferable license to use, reproduce, modify, display and publish the Client Content solely in connection with Designer's performance of the Services and limited promotional uses of the Deliverables as authorized in this Agreement.

IP 1.2 *Third Party Materials.* All Third Party Materials are the exclusive property of their respective owners. Designer shall inform Client of all Third Party Materials that may be required to perform the Services or otherwise integrated into the Final Art. Under such circumstances Designer shall inform Client of any need to license, at Client's expense, and unless otherwise provided for by Client, Client shall obtain the license(s) necessary to permit Client's use of the Third Party Materials consistent with the usage rights granted herein. In the event Client fails to properly secure or otherwise arrange for any necessary licenses or instructs the use of Third Party Materials, Client hereby indemnifies, saves and holds harmless Designer from any and all damages, liabilities, costs, losses or expenses arising out of any claim, demand, or action by a third party arising out of Client's failure to obtain copyright, trademark, publicity, privacy, defamation or other releases or permissions with respect to materials included in the Final Art.

IP 1.3 *Preliminary Works.* Designer retains all rights in and to all Preliminary Works. Client shall return all Preliminary Works to Designer within thirty (30) days of completion of the Services and all rights in and to any Preliminary Works shall remain the exclusive property of Designer.

IP 1.4 *Original Artwork.* Designer retains all right and title in and to any original artwork comprising Final Art, including all rights to display or sell such artwork. Client shall return all original artwork to Designer within thirty (30) days of completion of the Services.

IP 1.5 *Trademarks.* Upon completion of the Services and expressly conditioned upon full payment of all fees, costs and out-of-pocket expenses due, Designer assigns to Client all ownership rights, including any copyrights, in and to any artworks or designs comprising the works created by Designer for use by Client as a Trademark. Designer shall cooperate with Client and shall execute any additional documents reasonably requested by Client to evidence such assignment. Client shall have sole responsibility for ensuring that any proposed trademarks or Final Deliverables intended to be a Trademark are available for use in commerce and federal registration and do not otherwise infringe the rights of any third party. Client hereby indemnifies, saves and holds harmless Designer from any and all damages, liabilities, costs, losses or expenses arising out of any claim, demand, or action by any third party alleging any infringement arising out of Client's use and/or failure to obtain rights to use or use of the Trademark.

IP 1.6 *Designer Tools.* All Designer Tools are and shall remain the exclusive property of Designer. Designer hereby grants to Client a nonexclusive, nontransferable (other than the right to sublicense such uses to Client's Web hosting or Internet service providers), perpetual, worldwide license

to use the Designer Tools solely to the extent necessary with the Final Deliverables for the Project. Client may not directly or indirectly, in any form or manner, decompile, reverse engineer, create derivative works or otherwise disassemble or modify any Designer Tools comprising any software or technology of Designer.

IP 2. Rights to Final Art.

Final Art ownership options: choose A-License (either limited usage, exclusive license with no modification rights, or exclusive license with modification rights — all licenses include liquidation for unlicensed use) or B-Assignment. Be sure to delete or cross out alternates not chosen. Check appropriate media for each provision:

IP 2.A (1) (a) License for limited usage, no modification rights:

IP 2.1 *For print, online/interactive,*
........ three-dimensional media: Upon completion of the Services, and expressly subject to full payment of all fees, costs and out-of-pocket expenses due, Designer grants to Client the rights in the Final Art as set forth below. Any additional uses not identified herein require an additional license and may require an additional fee. All other rights are expressly reserved by Designer. The rights granted to Client are for the usage of the Final Art in its original form only. Client may not crop, distort, manipulate, reconfigure, mimic, animate, create derivative works or extract portions or in any other manner, alter the Final Art.
Category of use: ...
Medium of use: ..
Duration of use: ..
Geographic territory: ...
Initial press run: ...
With respect to such usage, Client shall have (check one)
........ Exclusive / Nonexclusive rights

OR

IP 2.A (1) (b) Exclusive license, no modification rights:

IP 2.2 For print, online/interactive,
........ three-dimensional media: Designer hereby grants to
Client the exclusive, perpetual and worldwide right and
license to use, reproduce and display the Final Art solely
in connection with the Project as defined in the Proposal
and in accordance with the various terms and conditions
of this Agreement. The rights granted to Client are for
usage of the Final Art in its original form only. Client may
not crop, distort, manipulate, reconfigure, mimic, animate,
create derivative works or extract portions or in any other
manner, alter the Final Art.

OR

IP 2.A (1) (c) Exclusive license, with modification rights:

IP 2.3 For print, online/interactive,
........ three-dimensional media: Designer hereby grants to
Client the exclusive, perpetual and worldwide right and
license to use, reproduce, adapt, modify and display the
Final Art solely in connection with the Project as defined
in the Proposal and in accordance with the terms and
conditions of this Agreement.

AND

IP 2.A (2) Liquidation for unlicensed use:

IP 2.4 Client's use of the Final Art shall be limited to the
usage rights granted herein for the Project only. Use of the
Final Art, Deliverables or any derivative works thereof by
Client at any other time or location, or for another project
or outside the scope of the rights granted herein require
an additional fee and Designer shall be entitled to further
compensation equal to percent (........%) of
the original Project fee unless otherwise agreed in writing
by both parties. In the event of non-payment, Designer shall
be entitled to pursue all remedies under law and equity.

OR

IP 2.B Assignment:

IP 2.5 Upon completion of the Services, and expressly subject to full payment of all fees, costs, and expenses due, Designer hereby assigns to Client all right, title and interest, including without limitation copyright and other intellectual property rights, in and to the Final Art. Designer agrees to reasonably cooperate with Client and shall execute any additional documents reasonably necessary to evidence such assignment.

SUPPLEMENT 1:
PRINT-SPECIFIC TERMS AND CONDITIONS

P 1. Samples.

Client shall provide Designer with (number) of samples of each printed or published form of the Final Deliverables, for use in Designer's portfolio and other self-promotional uses. Such samples shall be representative of the highest quality of the work produced.

P 2. Finished Work.

The printed work, and the arrangement or brokering of the print services by Designer, shall be deemed in compliance with this Agreement if the final printed product is within the acceptable variations as to kind, quantity, and price in accordance with current or standard trade practices identified by the supplier of the print and print-related services. Whenever commercially reasonable and if available, Designer shall provide copies of the current or standard trade practices to Client. Notwithstanding, Designer shall have no responsibility or obligation to negotiate changes or amendments to the current or standard trade practices.

SUPPLEMENT 2:
INTERACTIVE-SPECIFIC TERMS AND CONDITIONS

I 1. Support Services.

I 1.1 *Warranty Period.* "Support Services" means
commercially reasonable technical support and assistance
to maintain and update the Deliverables, including correct-
ing any errors or Deficiencies, but shall not include the
development of enhancements to the Project or other
services outside the scope of the Proposal. During the first
........................... (insert number) months following expiration
of this Agreement ("Warranty Period"), if any, Designer
shall provide up to (insert number) hours
of Support Services at no additional cost to Client. Additional
time shall be billed at Designer's regular hourly rate, then in
effect upon the date of the request for additional support.

I 1.2 *Maintenance Period.* Upon expiration of the
Warranty Period and at Client's option, Designer will
provide Support Services for the following
(insert number) months (the "Maintenance Period") for a
monthly fee of $........................... [or Designer's hourly fees
of $........ per hour]. The parties may extend the Maintenance
Period beyond one year upon mutual written agreement.

I 2. Enhancements.
During the Maintenance Period, Client may request that
Designer develop enhancements to the Deliverables, and
Designer shall exercise commercially reasonable efforts to
prioritize Designer's resources to create such enhancements.
The parties understand that preexisting obligations to third
parties existing on the date of the request for enhancements
may delay the immediate execution of any such requested
enhancements. Such enhancements shall be provided
on a time and materials basis at Designer's then in
effect price for such services.

I 3. Additional Warranties and Representations.

I 3.1 *Deficiencies.* Subject to the representations and
warranties of Client in connection with Client Content,
Designer represents and warrants that the Final Deliverables

will be free from Deficiencies. For the purposes of this Agreement, "Deficiency" shall mean a failure to comply with the specifications set forth in the Proposal in any material respect, but shall not include any problems caused by Client Content, modifications, alterations or changes made to Final Deliverables by Client or any third party after delivery by Designer, or the interaction of Final Deliverables with third party applications such as Web browsers other than those specified in the Proposal. The parties acknowledge that Client's sole remedy and Designer's sole liability for a breach of this Section is the obligation of Designer to correct any Deficiency identified within the Warranty Period. In the event that a Deficiency is caused by Third Party Materials provided or specified by Designer, Designers sole obligation shall be to substitute alternative Third Party Materials.

I 3.2 *Designer Tools.* Subject to the representations and warranties of the Client in connection with the materials supplied by Client, Designer represents and warrants that, to the best of Designer's knowledge, the Designer Tools do not knowingly infringe the rights of any third party, and use of same in connection with the Project will not knowingly violate the rights of any third parties except to the extent that such violations are caused by Client Content, or the modification of, or use of the Deliverables in combination with materials or equipment outside the scope of the applicable specifications, by Client or third parties.

I 4. Compliance with Laws.

Designer shall use commercially reasonable efforts to ensure that all Final Deliverables shall be designed to comply with the known relevant rules and regulations. Client, upon acceptance of the Deliverables, shall be responsible for conformance with all laws relating to the transfer of software and technology.

SUPPLEMENT 3:
ENVIRONMENTAL-SPECIFIC TERMS AND CONDITIONS

3D 1. Photographs of the Project.

Designer shall have the right to document, photograph or otherwise record, all completed designs or installations of the Project, and to reproduce, publish and display such documentation, photographs or records for Designer's promotional purposes in accordance with Section 6 of the Basic Terms and Conditions of this Agreement.

3D 2. Additional Client Responsibilities.

Client acknowledges that Client shall be responsible for performing the following in a reasonable and timely manner:
(a) Communication of administrative or operational decisions if they affect the design or production of Deliverables, and coordination of required public approvals and meetings;
(b) Provision of accurate and complete information and materials requested by Designer such as, by way of example, not limitation, site plans, building plans and elevations, utility locations, color/material samples and all applicable codes, rules, and regulation information;
(c) Provision of approved naming, nomenclature; securing approvals and correct copy from third parties such as, by way of example, not limitation, end users or donors as may be necessary;
(d) Final proofreading and written approval of all project documents including, by way of example, not limitation, artwork, message schedules, sign location plans and design drawings before their release for fabrication or installation. In the event that Client has approved work containing errors or omissions, such as, by way of example, not limitation, typographic errors or misspellings, Client shall incur the cost of correcting such errors;
(e) Arranging for the documentation, permissions, licensing and implementation of all electrical, structural or mechanical elements needed to support, house or power signage; coordination of sign manufacture and installation with other trades; and
(f) Bid solicitation and contract negotiation; sourcing, establishment of final pricing and contract terms directly with fabricators or vendors.

3D 3. Engineering.

The Services shall include the selection and specifications for materials and construction details as described in the Proposal. However, Client acknowledges and agrees that [Designer is not a licensed engineer or architect, and that] responsibility for the interpretation of design drawings and the design and engineering of all work performed under this Agreement ("Engineering") is the sole responsibility of Client and/or its architect, engineer, or fabricator.

3D 4. Implementation.

Client expressly acknowledges and agrees that the estimates provided in the Proposal, at any time during the project for implementation charges such as, including, but not limited to, fabrication or installation are for planning purposes only. Such estimates represent the best judgment of Designer or its consultants at the time of the Proposal, but shall not be considered a representation or guarantee that project bids or costs will not vary. Client shall contract and pay those parties directly responsible for implementation services such as fabrication or installation ("Implementation"). Designer shall not be responsible for the quality or timeliness of the third-party Implementation services, irrespective of whether Designer assists or advises Client in evaluating, selecting or monitoring the provider of such services.

3D 5. Compliance with Laws.

Designer shall use commercially reasonable efforts to ensure that all Final Deliverables shall be designed to comply with the applicable rules and regulations such as the Americans with Disabilities Act ("ADA"). However, Designer is not an expert and makes no representations or warranties in connection with compliance with such rules, codes or regulations. The compliance of the Final Deliverables with any such rule, codes or regulations shall be the responsibility of Client. Designer shall use commercially reasonable efforts to ensure the suitability and conformance of the Final Deliverables.

3D 6. Client insurance.

Client shall maintain, during the term of this Agreement, at its sole expense, construction and maintenance liability, product liability, general business liability, and advertising injury insurance from a recognized insurance carrier in the amount of at least million dollars ($........,000,000.00) per occurrence. Such insurance shall name Designer individually as an additional named insured. Client shall provide a copy of said insurance policy to Designer at Designer's request.

Chapter 21:
Ethics and social responsibility

In discussing ethics and design, there are at least three different levels for us to consider. The first has to do with professional behavior in daily business interactions. The next level deals with specific professional expertise needed in such areas as accessibility, usability, consumer safety, and environmental practices. This leads us to the third level, which is about overall professional values — a broader framework of moral principles and obligations in life.

Professional behavior

In your design career, how do you define ethical conduct, and where do you turn for guidance? Ethical guidelines are published by a number of design organizations in the U.S. and abroad. For example:

- AIGA, the professional association for design
 www.aiga.org
- Graphic Artists Guild
 www.graphicartistsguild.org
- Industrial Designers Society of America
 www.idsa.org
- Society of Graphic Designers of Canada
 www.gdc.net
- Australian Graphic Design Association
 www.agda.com.au

As you read through these various codes, you will see that some of them focus on specific ways to exhibit integrity and respect in your daily business interactions with clients, suppliers, and other designers, while others address much broader issues and present fundamental ethical principles. Guidelines for daily business interactions tend to include such things as:

- Showing respect toward other designers in fair and open competition
- Being honest in describing your professional experience and competencies
- Avoiding any type of conflict of interest
- Acquainting yourself with each client's business and providing honest and impartial advice
- Maintaining the confidentiality of all client information
- Eliminating any form of hidden compensation or kickback
- Maintaining commitment to the development of innovative work of the highest quality
- Rejecting all forms of plagiarism
- Making proper acknowledgment of authorship when others have collaborated with you in creating a design

These codes describe recommended behavior for association members. Typically, however, adherence is voluntary. Such guidelines can be helpful in avoiding misunderstandings and disputes between designers and clients, and they can be very useful in educating new designers who are just entering the profession. AIGA also publishes guidelines for ethical practices related to the purchase and use of fonts, software, illustrations, and photography. Pamphlets on these topics are included in the "Design Business and Ethics Series." They can be downloaded as PDF files from the AIGA site.

Professional expertise
Depending on your design discipline and the nature of your client's business, you may need to be aware of additional responsibilities and legal obligations in the following areas:

Universal design and accessibility
Places, products, and services should be universally accessible to people of all ages, abilities, and physical conditions. You'll want your creative work to reduce barriers and be welcoming to everyone. This means that your designs should facilitate mobility, communication, and participation in civic life. In fact, some aspects of these moral obligations to the public have been written into law in the United States and other countries such as Japan and the United Kingdom.

For example, if you are working in the U.S. and you are designing a physical space, your project may be subject to the Americans with Disabilities Act of 1990 (ADA), which is a civil rights act that affects private businesses as well as governmental organizations. ADA requirements are of particular importance to industrial designers, interior designers, and architects. They apply to new construction as well as to alterations.

- The U.S. Department of Justice has published a set of "ADA Standards for Accessible Design" on their site. *www.ada.gov/stdspdf.htm*

If you are designing electronic products or digital services in the U.S., you need to be aware of Section 508 of the Workforce Investment Act of 1998. It's of particular importance to user interface designers as well as software and hardware developers. This law requires electronic and information technology purchased by the U.S. government to

be accessible for people with disabilities. It sets accessibility and usability requirements for any Web sites, video equipment, kiosks, computers, copiers, fax machines, and the like that may be procured by the government, thereby affecting all such products in the American market.

- More information is available on the Section 508 site. *www.section508.gov*

Consumer product labeling
If you are involved in the design of certain types of consumer products or packages, you and your client need to be aware of any applicable labeling requirements. In the U.S., a number of federal and state laws have been enacted to protect consumers from unknowingly purchasing products that might be unsafe or unsanitary. Similar laws are in place in Canada, Japan, and the European Union. The laws cover a variety of product categories, including such things as food, pharmaceuticals, textiles, bedding, furniture, and toys. Specific formats vary, but the labeling requirements often include identification of contents and country of origin, as well as the inclusion of safety instructions and warnings. For example, here are two sites with information about food product labels:

- U.S. Food and Drug Administration *www.fda.gov*
- Food Product Design *www.foodproductdesign.com*

Ecology and sustainability
With each passing year, issues related to ecology and sustainability become more critical for the entire world. Designers can make a big difference — not only through responsible choices about materials and processes used in current projects but also by staying well-informed and providing expert guidance to clients about long-term plans and activities. Industrial designers in particular are faced with a dual challenge — the need to constantly re-create and improve products while at the same time avoiding the excesses of planned obsolescence and throwaway culture. Innovative thinking is needed to reduce consumption and waste, reduce the use of toxic materials, encourage reuse and recycling, increase energy efficiency, and encourage

the development and use of renewable energy sources. In many countries, ecological principles are being written into law. For example, Germany has taken the lead in establishing requirements for manufacturers regarding the use of recycled materials, the use of sustainable energy sources, and the reduction of waste. General reference information is available to designers from a number of sources, including several professional associations. Here are two places to start:

- The AIGA Center for Sustainable Design has a publication titled "Print Design and Environmental Responsibility" that can be downloaded from their site. *http://sustainability.aiga.org*
- The Ecodesign section of the IDSA site addresses issues of environmental responsibility, with practical guidelines and links to other informational sites. *www.idsa.org*

Professional values
Clearly, the universal design concerns and ecological responsibilities mentioned are part of a much broader system of moral values and obligations — not just how we do our work but what it is that we are doing in the first place and what impact it will have on the world. Although there is strong agreement about what constitutes professional behavior toward our immediate clients and peers, there is less consensus about the obligations of designers toward society in general and the role that we should play in finding solutions to complex global problems. Here we move beyond objective instructions on how to do something and into subjective decisions about what is right and good. It's quite possible to be a skilled designer and a successful businessperson without being a good global citizen. Here are just a few of the many interrelated social, economic, and political challenges that we are facing:

The expansion of consumer culture
Designers are involved in many different activities, but a significant portion of the work that we do promotes corporate commercialism. When serving commerce, we need to be aware of the influence and impact that our

work has on the public. Marketing and advertising shape consumer culture, including the self-image and personal values of buyers. Our involvement in materialism and conspicuous consumption may even extend to the creation of artificial needs and the promotion of unnecessary products through advertising and marketing messages that are manipulative or deceptive. These concerns are also present in the political realm, where the latest consumer marketing techniques are used to manufacture consent on political issues and to sell candidates to voters. Two very interesting commentaries are available online about the relationship between commercialism and design.

- The first is an article by Milton Glaser called "The Road to Hell." In it, he shares his thoughts about the moral shades of gray that designers encounter in client assignments. It was published in Metropolis Magazine in 2002.
 www.metropolismag.com/html/content_0802/ gla/index.html
- The second is a manifesto called "First Things First" by graphic designer Ken Garland. It was first written in 1964 and then updated and republished in 2000 with the signatures of thirty-three well-known international designers. It has stimulated a great deal of discussion within the design community and has been published in a number of magazines including *Adbusters*, *Émigré*, and *Eye*.
 www.emigre.com/Editorial.php?sect=1&id=14 www.eyemagazine.com/feature.php?id=18&fid=99

The increasing power of corporations
Most leading design firms work for large corporate clients, and it's no secret that good design sometimes supports bad companies. Private profit making is often at odds with public good. Designers function as advisors to corporate clients and as advocates for the end user. In this capacity, we can exert a positive influence on clients and inspire responsibility. To do this, we must dig deeper, ask questions, express doubts, and propose alternatives. We must actively work to resolve contradictions between business and societal needs. On each commissioned project, we must ask ourselves: Is the message truthful? Is the service beneficial? Is the product useful, well

made, and produced in a sustainable way? We also shape our careers through our choice of clients. Some designers consciously shift their activities away from for-profit clients and into the not-for-profit realm, into activism and cause-related marketing. Many designers have taken the leap to developing their own, non-commissioned projects. Design entrepreneurs working at a small scale have more latitude to explore new business models and practices.

The globalization of trade
Many designers work with multinational corporations — either as outside consultants or as in-house employees. In most global businesses, raw materials come from one part of the world, manufacturing happens in another place, and final sales are made somewhere else. Through their activities, multinationals spread capitalism. They influence governments and have significant impact on local cultures. Unfortunately, their activities can lead to economic imbalances. Additional concerns include labor conditions, human rights, and environmental practices, particularly in developing countries.

The designer's role
Design is a problem-solving process, and the world today has so many problems. Designers need to play a larger role — not just responding but initiating. We need to bring our personal beliefs and professional activities into alignment. Through our work, we have the opportunity and the responsibility to put our system of basic values into action — to model the behavior that we want to see in the world.

In tackling complex issues, we need to be aware of larger contexts and to reach out to other professionals. In many instances, the scale of the challenge will move us beyond our training. We need to partner with experts in many other disciplines — economists, anthropologists, biologists, political scientists, and sociologists, to name just a few. To these collaborations we bring humanist roots, historical perspective, cross-cultural awareness, critical thinking, project leadership, and a holistic approach.

We must also be actively involved in the political process to reshape institutions and reset priorities. Design is a powerful tool for shaping the world and how we live in it. Ethical design is our way to contribute to the betterment of all and to ensure abundance, diversity, and health to future generations.

For more information

There are many ongoing conversations taking place within the design community concerning ethics and social responsibility. As an introduction, you may want to pick up one of these paperbacks:

- Citizen Designer: Perspectives on Design Responsibility
 Forty essays about the role of designers in social and political change; edited by Steven Heller and Veronique Vienne; published in 2003 by Watson-Guptill.
- Design Issues: How Graphic Design Informs Society
 A collection of articles on many different topics; edited by DK Holland; co-published in 2002 by Communication Arts and Allworth Press.
- Looking Closer 4: Critical Writings on Graphic Design
 Essays on a wide range of issues related to social responsibility and design ethics; edited by Michael Bierut, William Drenttel, and Steven Heller; published in 2002 by Allworth Press.

You'll also want to spend time on these two Web sites:

- www.designersaccord.org
 Founded in 2007, the Designers Accord is a global coalition of designers, educators, and corporate leaders working together to create positive environmental and social impact. It's vision is to integrate the principles of sustainability into all aspects of design practice and manufacturing.

- www.livingprinciples.net
 The AIGA Center for Sustainable Design has compiled a set of guidelines for sustainability called The Living Principles. It is a framework that addresses four areas of concern: environmental protection, social equity, economic health, and cultural vitality.

Chapter 22:
Successful design teams

In the design profession, nearly all important projects are too large to be completed by just one person. Because of this, each creative firm strives to develop a culture that fosters effective teamwork.

In many other professions, teams can be rather hierarchical, inflexible, and slow. This is especially true for corporate teams that are together for a number of years. Over time, they often become inward-focused and bureaucratic. They suffer from turf battles and politics. Design teams, however, are quite different. They are brought together for a short period of time, usually just a few weeks or a few months, to complete a single project. No two projects are identical, so the size and composition of each team varies. A cookie-cutter approach will not work — most projects need different processes and tools. To accommodate this, design firms structure their resources like a network, making them scalable and flexible enough to allow multiple configurations.

Design teams have fewer rules and a greater flow of information, both of which are important for rapid innovation. Design teams are externally oriented and focused on client needs. Because of this, the organizational structure for the team tends to be decentralized and organic rather than hierarchical and rigid. Having fewer layers and rules allows the group to be more adaptive to the external environment. Design teams also have an egalitarian nature that encourages self-management and regular participation by all group members in decision making. Individuals who do well in this environment are those who are drawn to challenges and are strongly motivated by opportunities for personal and professional growth.

Getting the right mix of skills
When a new project is first being pitched, one of the most important aspects of advance planning is to determine the exact mix of skills that will be required for success. Smart planning includes lining up the appropriate resources and resolving any competing demands for their availability. Design of course is the magic ingredient in the mix, but other skills will be vitally important as well. The needs of a large project will span multiple disciplines. A complex problem will require a wide range of expertise — from research, strategy, and content development to technology, engineering, and project management. The ultimate success of the project will depend upon getting just the right mix of talent, technical skills, and industry experience.

The exact size of each team is determined by the number of separate skill sets required. On a large project, there will be a core team that is augmented by other players on an as-needed basis. Many organizational experts advise that the most effective size for a problem-solving group is between five and seven people. Because of this, core teams tend to be small. Other resources are called upon in a very targeted way. In design firms, the core team for a project will be composed primarily of employees. The firm makes an important business decision about which skills to have on staff. This defines its core competencies and enables it to meet the recurring needs within its category of services. Outside resources are used for temporary needs and to accommodate project variations. Keep in mind that key project skills can also be provided by the client organization. Good design firms work in close collaboration with clients, functioning more like a partner than a vendor.

When other professionals are brought into a project, they may be freelancers or separate creative firms brought in on a subcontract basis. Within each of the many possible skill sets, there will also be people at different levels of experience, from senior down to entry-level. Not everyone will be involved for the full duration of the project — some may be needed during one or two phases only. The full team must of course be large enough to accomplish the work — the project will be doomed if the overall team is too small to carry the load or if key skills are missing. However, as teams increase in size, they can suffer from less cohesion, more confusion, and escalating costs.

Clarifying each person's role
Each person is added to the team for the skills that they possess and then placed in a particular role. It's important to clarify at the start exactly which role each person is being asked to play and what their relationship will be to the others. An individual's role may vary significantly from project to project. Each role carries certain responsibilities and is assigned specific tasks — the daily activities required to move the project forward.

As you can see, quite an assortment of individuals can be involved on a big project. Once you have assembled the right mix of resources, how do you keep everything functioning

smoothly? Two roles are vital to hold this shifting cast together — a team leader and a project manager (see Figure 22.01).

Team leader

In design firms, a creative director usually fills the role of the leader, although a senior professional from another discipline might also serve in this capacity. In general, leaders of design teams do not take a top-down approach, acting like a boss and telling people precisely what to do. Rather, he or she serves more as a facilitator and a catalyst. The leader must motivate the team members, clarify difficult issues, and orchestrate everyone's efforts. This means exploring alternatives, pushing boundaries, keeping the whole team involved, and moving the group toward consensus. It means getting members to share and preventing the team from diverging into the silos of separate disciplines. It means pulling the entire team together at key milestones, conducting brainstorming sessions and critiques, and guiding the development of a unifying concept for the project that will unite the various disciplines and span different types of media.

The leader will have to make tough judgment calls when the group is faced with difficult trade-offs. The leader must guide the creative process in such a way that the finished work is strategically sound and of the highest possible quality. In a short period of time, good ideas must be developed and then executed flawlessly. The team leader serves as the primary client contact for strategic and creative issues. He or she is responsible for managing client expectations over the course of the project and may often have to push back and persuade.

The team leader must also be sensitive to the needs and goals of individual team members. A good team leader will serve as a mentor, encouraging others to stretch creatively and helping them to develop their potential. In the case of staff members, this includes nurturing their personal growth over the course of multiple projects. To be a mentor, the team leader must have credibility. He or she must bring to the position proven ability and relevant industry experience. Leaders must establish and maintain mutual respect.

Figure 22.01. Design teams draw upon diverse resources. They function best with guidance from an effective leader and support from an experienced project manager.

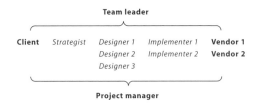

This requires honesty, trust, and a genuine and consistent emphasis on us/we/our. Effective design team leaders tend to have a decentralized approach to authority, allowing individuals to work independently on tasks, and then bring their work back to the group for evaluation and integration. This moves most projects forward through a cycle of rapid prototyping and incremental changes.

Lastly, the team leader must see to it that excitement and fun do not drain away from the work. Fun is a powerful motivator. It puts things into new contexts and leads to fresh ideas. Every design firm faces a paradox here. What is the right balance between freedom and discipline? True innovation requires creative risk. It involves experimentation and making mistakes. At the same time, however, design teams must be provided with just the right amount of structure. They must take a mature and responsible approach to budgets and schedules. In this latter respect, the team leader can be greatly assisted by a capable project manager.

Project manager
The role of the project manager is a very important one. Most design teams find it indispensable to have someone specifically charged with the coordination of logistics. This person must have a good understanding of the creative and production processes involved, but their role on the team is not that of a designer. When a project is first being pitched, the project manager may assist in developing estimates and timelines and identifying potential risks. Once a project is active, his or her primary responsibility is to support the team by taking care of a range of administrative tasks. Project management requires a special skill set that is not the same as design ability. In small firms, designers may be asked to take care of the logistics on their own projects, but these responsibilities may not

match their strongest skills or be the best use of their time. Having a project manager on the team frees up designers to spend more time actually designing. The project manager arranges any necessary meetings, distributes updated information, monitors budgets and deadlines, and documents the progress of each assignment.

The job title for this person may vary. On an interaction design team they may be called a "producer." On teams that do mostly print work, this person may be a "production manager" with special expertise related to print buying. On an advertising team, he or she may be the "traffic manager," making sure that the right materials are in the right place at the right time. Often the project manager serves as a filter to protect the productivity of other team members by shielding them from distractions. He or she may take incoming logistical information and requests and then route them to the appropriate team members. However, this is not at all the same as the account director role that exists in many advertising agencies. Design firms tend to regard account directors as middlemen or interpreters. Most design consultancies eliminate the account director role in order to have direct contact between the client and the creative team.

Dealing with people problems
The ideal situation for every team is to maintain positive interpersonal dynamics throughout the project. Realistically, though, a few personality clashes are almost inevitable when you have a variety of bright, ambitious people who are working together for the first time, particularly as deadlines approach and pressure mounts (see Figure 22.02). So what can you do to prevent or minimize people problems? Here are the secrets of successful teamwork:

Careful recruitment
Be selective when first assembling the team. In addition to creative and technical skills, look for personalities that will fit together well in a team environment. Look for professionalism, reliability, and a positive attitude. A collection of big egos will clash and work at cross-purposes. Individuals who are difficult or manipulative will undermine the success of the entire project.

Mutual respect
Various team members will come from different professional backgrounds. Each should be an expert in his or her respective field, and that expertise must be acknowledged and respected by the others. An "all-star" team is a collaboration of peers where all skills are equally necessary for success. In fact, the cross-pollination of different perspectives is one of the most powerful advantages of teams.

A larger commitment to the project
Everyone in the group will win or lose together. It's not possible for just one element of a project to succeed in isolation. The goals of the individuals involved must be in sync with the group's goals. Different intended outcomes will lead to failure.

A shared understanding of how the process will work
Design teams need a common framework and shared language for working together. Effective collaboration requires a commitment to shared methodology, terminology, and milestones. The process will include open critiques with all members participating — the goal is to identify and develop the very best ideas from all sources.

Open communication
Along the way, it's vital to maintain positive and effective communication and a commitment to rapid and fair conflict resolution. Projects benefit from creative tension but not personal conflicts. When differences arise, they must be acknowledged and addressed. This takes evenhanded intervention by the team leader, active facilitation by the project manager, and a strong group commitment to resolving problems. The team leader must keep critiques from becoming personal. All members should receive frequent feedback on task performance from the leader and other team members, and constructive suggestions whenever change is needed.

Monitoring progress daily and weekly
Most design projects involve a lot of information sharing and meetings. On big projects, it's typical to have a quick daily huddle to address pending deadlines or emergencies.

There will also be a more comprehensive weekly meeting that is organized by the project manager and guided by the team leader.

Even though digital technologies make it possible to collaborate remotely, on a fast-moving project there is no substitute for being in the same room and negotiating activities face-to-face. To respect everyone's schedule, keep it short and simple. In the meeting, state what has changed and what has been achieved. Be sure to recognize positive behaviors, results, and contributions. You should also include bad news, if there is any. This is a chance for the group to correct any miscommunications, clear the air if necessary, and refocus its energies. (However, the team leader will have to make a judgment call if a serious personal problem has come up with an individual team member. It may be best to remember the old adage about praising publicly and criticizing privately.) Input should be solicited from every team member, and each should have an opportunity to contribute. At the end of the meeting, summarize the decisions that have been made and the follow-up actions that are needed. For each action item, identify the person responsible and the date when it must be completed. There must be personal accountability for results.

Whenever possible, keep progress visible. Display the latest iterations of the creative work and any other important documentation such as research findings and brand strategy documents. Post charts that show the burn rate on budgets and updated schedules that remind everyone of important milestones and deadlines (for more information about burn rates, see Chapter 25). There should be one central repository for project information. It could be an intranet site, but it's more beneficial if the team has a shared physical space. Many industrial design firms set up a workroom where all of the materials related to a large project can be left spread out. All team meetings take place there. If the materials are confidential and must be protected when the team is away, the workroom will have a door that can be locked. Having a shared space enables the team to work in close physical proximity, which increases interaction and encourages camaraderie.

A job well done

At the end of a project, the team delivers the completed work to the client or hands it off to a third party such as a printing company for implementation. As soon as that happens, all team resources are reassigned. This raises a very important psychological issue. To stay in business, each design firm must line up a constant stream of assignments. The master schedule is kept very tight so that, as soon as one ends, everyone is immediately shifted to the next. However, it can be frustrating if there is never a moment's pause to savor what the team has accomplished together. This can damage staff morale and contribute to burnout. At the very least, the full team should have one final meeting to conduct a postpartum review of the completed project. This is an opportunity to evaluate the finished work in light of its success criteria. It's a chance to discuss what went well and what didn't and to learn from any failures. In a large firm, there should also be a way of sharing what you learn with the rest of the organization so that you are creating a culture of learning for the overall company (for more information about wrapping up large projects, see Chapter 25). For staff members, there should also be a way to include feedback on team play in their performance evaluations. This encourages personal and professional growth.

At the conclusion of a large or difficult project, it's also important to satisfy the very human needs for emotional closure and a sense of completion. There are many ways to recognize and reward the team: a small event or celebration, a team photograph, a personal memento, or perhaps a personal note of thanks from the team leader. All of these are effective ways of closing the loop and can have a big impact on morale. They mark the conclusion of a shared experience, send a clear message that the effort was worthwhile, and create positive motivation for future efforts.

INDIVIDUALLY

An individual team member can become distracted by a personal issue. It may be as a result of something that's happening in his or her private life, quite outside of work. This may lead to lower productivity, self-frustration, even quitting the team without completing assigned tasks.

BETWEEN TWO PEOPLE

There may be two team members who don't get along, which makes it awkward for them to collaborate effectively.

WITHIN A GROUP

Internal bickering or feuding can divide the team into rival factions. Divided allegiances damage team cohesion and can make it impossible to achieve and maintain consensus.

BETWEEN SEPARATE GROUPS

In a larger firm, tensions and rivalries may arise between separate teams or business units. The hostilities may be fueled by corporate politics, budget battles, or competition for resources.

Figure 22.02. Problems with people can crop up in several different ways.

Chapter 23:
Using student interns

Many creative teams include student interns. This is especially true in companies that are looking for ways to reduce expenses. In a design firm, payroll is always the largest expense by far. One popular strategy for reducing payroll costs is to seek out free labor in the form of student interns. However, design firm owners need to be aware that a number of federal and state laws apply to unpaid internship programs. If certain criteria are not met, then interns must be paid.

A complaint by an intern seeking compensation can trigger an audit by the Wage and Hour Division of the U.S. Department of Labor (DOL) or your own state's Division of Labor Standards. If a complaint is filed and an audit reveals a significant violation of the law, the penalties against your design firm can be severe. You may be on the hook for double the unpaid amount owed to that individual worker (and any other workers in the same situation) plus court costs and legal fees.

Because of these potential problems for employers, an intern program should not be launched or administered in a haphazard fashion. This chapter will help you understand the essential legal requirements that must be met.

Definitions
Let's start with some definitions. What do we mean by an internship? An intern is a professional in training. An intern does not yet have the knowledge and experience necessary to be fully useful in the studio. Internships provide supervised hands-on work experience within a student's field of interest. Internships are short-term (usually one semester), and the work schedule is typically part-time so that it does not interfere with class attendance.

An intern is not a volunteer. DOL regulations define a volunteer as an individual who provides services to a nonprofit organization or public agency for civic, charitable, or humanitarian reasons. An intern working at a for-profit company does not fit this definition.

It's also important to note that an intern is not a freelancer. The nature of the work relationship does not meet Internal Revenue Service guidelines for independent contractor status (for more information on this, see Chapter 03).

Setting up an unpaid internship can be great for your company's finances, but, at the same time, there is a downside for the student: no compensation for labor, no staff benefits such as paid vacation time, and no unemployment benefits after the internship has ended.

Lastly, an internship is not an opportunity to take advantage of anyone. In fact, federal and state laws are in place to protect workers from potential exploitation.

Federal requirements

The nature of your company's internship program must be primarily educational. If it's not, you run the risk of being found in violation of the Fair Labor Standards Act (FLSA), which applies to all companies with two or more employees and annual sales of at least $500K. If the program is not essentially educational, your unpaid interns will be classified as employees, meaning (among other things) they are entitled to the federal minimum wage. The FLSA establishes six requirements for unpaid internships:

1. Although an intern may be trained using equipment and procedures specific to your particular firm, the overall internship experience must be equivalent to what the student would be able to gain in a vocational school. In other words, the student could conceivably pay to receive very similar training elsewhere.

2. An intern cannot displace a regular employee. Instead, the intern must work under the close supervision of your regular staff members.

3. An internship cannot carry any guarantee of a future job. The intern is not necessarily entitled to become an employee at the conclusion of the training period.

4. The employer and the intern must both understand that the intern is not entitled to wages for the time spent in training.

5. Training should be primarily for the benefit of the intern.

6. The employer provides training but does not derive any immediate advantage from the activities of the intern. In fact, the training may actually impede normal operations on occasion.

TALENT IS NOT ENOUGH: BUSINESS SECRETS FOR DESIGNERS

Ideally, your unpaid internship program should meet all six of these criteria. In practice, however, the last requirement can be a bit of a challenge. For the experience to be educationally valid, an intern needs to participate actively in the work of the company. At what point does this constitute an "immediate advantage" for the firm? Several DOL rulings seem to suggest that as long as the internship is a prescribed part of an educational curriculum and is predominantly for the benefit of the student, the mere fact that the employer receives some benefit from the intern's services does not make the intern an employee for the purposes of wage and hour law. In short, an assessment will be made about the spirit of the internship program as a whole.

State requirements

In addition to the federal requirements we've been discussing, some individual states have imposed restrictions of their own. Two examples are California and New York. For details, you need to check with the Division of Labor Standards in the state where you are located. Some states require proof that the unpaid intern is receiving academic credit for the work. Some also specify that internships are subject to state workers' compensation insurance requirements.

Paid employees

If your internship program does not adequately meet federal and state requirements, then the intern will be a paid employee. The level of pay will, of course, be lower than that of more experienced staff members. However, the FLSA requires you to pay at least the federal minimum wage (currently $7.25). Don't forget that some states and cities have additional pay requirements (for example, the current minimum wage in California is $8.00 per hour, but in San Francisco the current minimum rate is $9.79).

Paid interns are also entitled to overtime pay when they work long hours. Interns do not qualify for the "Creative Professional" exemption that applies to more experienced designers. To be exempt, an employee must be involved in work requiring some degree of autonomy and self-direction. Fully trained professionals work without close supervision and consistently use independent judgment. This is not the case with any intern.

Mutual benefit
A well-thought-out internship program creates a relationship between the design firm and the student that is mutually beneficial.

For the student, an internship is a great way to learn by doing. It provides exposure to the work environment and the complex challenges of "real-world" design projects. It enhances the student's résumé and presents a valuable opportunity to gain references and network contacts. It also assists in the completion of a college degree by providing either pay or academic credit.

At the same time, design firms benefit greatly from being exposed to fresh ideas and new perspectives. And, yes, unpaid internships also help reduce payroll costs!

A final note: This chapter shares general information about legal requirements for internship programs. If you have specific questions about how state and federal statutes might apply to your particular situation, you will of course want to get expert guidance from an attorney who specializes in employment law.

For more information

For additional background information on these issues, you may want to spend some time on the following government Web sites.

U.S. Department of Labor
Employment Standards Administration
Wage and Hour Division

- *FLSA and minimum wage requirements:*
 www.dol.gov/whd/flsa/index.htm
 There are also links to state labor offices.

- *Federal overtime requirements:*
 www.dol.gov/whd/overtime_pay.htm
 Download fact sheet 17D for an explanation
 of the "Creative Professional" exemption.

U.S. Department of the Treasury
Internal Revenue Service

- *Independent contractor guidelines:*
 www.irs.gov
 Download publication 1779 "Independent
 Contractor or Employee."

Chapter 24:
Working with a sales rep

Most design firms are founded by someone who designs — that is to say, someone who is actively involved in producing the creative work being sold to clients. In addition, it's very common for that founder to be responsible for all marketing and sales during the early years of the business. The owner personally solicits new clients and then leads each project while the work is being done. This approach works very well as long as the company remains small.

However, if the firm grows, the founder's personal workload will gradually increase to the point where this broad mix of responsibilities must be sorted out. Some things will have to be delegated, or else the overall size of the company will be limited to the individual work capacity of the owner.

When the time comes to sort out the hats, the founder will have the luxury of deciding what to keep and what to delegate to other people. This involves making a choice between a role that is primarily internal (leading the creative process) and one that is primarily external (representing the firm to the business community). As designers, many founders choose to remain involved in the hands-on creative work. This means that someone else, often a new hire, will be charged with new business development. This is a fundamental change, and it brings with it a number of important challenges.

If a new employee is going to be given responsibility for marketing and sales, the transition must be planned very carefully. Advance preparation is necessary to set expectations and establish a structure that will meet the needs of the firm and enable the new person to succeed. Good planning will help to prevent confusion, make it easier to gauge performance, and reduce the possibility of disputes and disagreements. Here's what you should do to prepare:

Update your overall marketing strategy
Start by taking a look at your current mix of clients and services. Is there anything that you would like to change? Young firms tend to take shape in a reactive way, accepting any project that comes along, but established firms become much more proactive — aggressively pursuing certain types of work that might not come in the door otherwise. To become more proactive, you must first articulate your strategy. Is growth an objective, or do you want the size of your firm to remain the same? What are your plans for existing relationships? Usually these are referred to as "house accounts," and they have a certain amount of momentum carrying them forward. Requests for additional work on existing accounts usually come directly to the creative team. Chances are that your new marketing

person will not be involved in existing relationships but be specifically charged with finding new clients in certain categories. What do you want those categories to be and what credibility does your firm currently have in those new areas? (For some thoughts about potential growth, see Figure 24.01.)

Clarify the process that your firm uses for identifying and pursuing opportunities

Look at your current practices. How do you become aware of potential clients and convince them to consider you for new projects? In most design firms, this involves a great deal of personal networking, ongoing research in business journals, trade publications, and online, as well as maintaining visibility at client industry events. To keep tabs on all of this activity, your firm needs a database for contact tracking and customer relationship management. If you don't already have one, now is the time to put one in place — it's an essential tool for new business development. In addition, the person hired to manage all of these marketing activities will need an appropriate level of administrative support.

As more and more leads are identified and pursued, a clear set of selection criteria is needed for filtering and prioritizing them. The founder usually defines these criteria, and they can vary quite a bit from firm to firm. Your criteria might include some or all of the following: each new project must be a match to your services and technological capabilities, present a creative challenge, and be of interest to your design team; when completed, you may want the project to have a certain amount of visibility; the client organization should be within one of your target industries, be a reputable company, and offer some potential for the development of a long-term relationship; your primary contact there should be someone with sufficient authority; and finally, each project must have a realistic schedule and budget as well as the potential to produce a profit for your company. Some design firms give increased weight to certain items. Your criteria should be written out, preferably in a worksheet format so that they can be applied to all opportunities in a consistent way.

Set specific, realistic goals for new business development

Think about what you will be asking the new hire to accomplish. If your strategy is to maintain the firm at its current

size, what volume of work is required to do that? How much of your current volume is comprised of existing clients or services that you want to replace because they're not satisfying or profitable? Exactly what amount of new business is needed to take their place?

If your strategy is to grow, you must decide by how much. Set the new target for annual billings, and then break it down into client categories and project types. In each area, what amount is already in place, and what must come from new business development? When making these decisions, be realistic about how much growth is possible and how quickly your internal systems can expand. In most instances, an annual target for organic growth of 10 or 20% will represent a modest stretch, but a target above 50% could easily place too much strain on your staff and systems. Set goals that are high enough to motivate, but not so high that they can never be reached. Pressure to hit unattainable targets will quickly demoralize your team.

Figure 24.01. Growth often comes from adding new services to existing client relationships or selling existing services to new clients. There is much more risk involved in trying to sell new services to new clients.

Make sure your sales materials are current and complete
When meeting with potential clients, your new business development person will need a supply of great promotional materials. Make sure that you have an initial set of materials in place that will last at least six months. It will take that long for a new hire to come up to speed. Later, he or she will be able to assist in the development of new items.

Most creative firms have a modular system in place that includes a company backgrounder, an overview of services and clients, a series of specific case studies (by project type or client category), and reprints of recent press coverage. Any combination of these items can be slipped into a presentation folder or assembled using an in-house binding system. Many firms also design promotional mailers on a regular basis, often in the form of postcards. When hiring a new business development person, it would be great to have a printed mailer or an e-mail newsletter either in process or recently completed.

Write a detailed job description for the new position
Young design firms sometimes use outside salespeople on an independent contractor basis, similar to the way that photographers and illustrators work with agents. Established firms bring the responsibilities in-house,

allowing business development to happen in a more integrated and sustained way. Don't hesitate to give the staff position a very impressive-sounding job title. An executive title can help open doors at a senior level within client organizations. Next, write out a detailed job description that explains required duties and personal responsibilities. In a design firm, a new business development person usually:

- Conducts industry research
- Identifies and qualifies leads
- Initiates contact to make potential clients aware of services
- Follows up with all prospects through systematic mailings, phone calls, appointments, and correspondence
- Gives capabilities presentations
- Maintains a contact tracking database and produces periodic reports on activities and opportunities
- Reviews requests for proposals and collaborates with other team members to develop project schedules, budgets, and pricing
- Drafts proposals that clearly define each project's scope of work
- Obtains internal approval before releasing proposal documents
- Negotiates with clients to obtain signed acceptance
- Transitions new projects to the creative team
- Represents the design firm in the business community through business and civic organizations
- Writes press releases and manages ongoing public relations efforts
- When necessary, acts as an internal client, working with the founder and creative team to develop new marketing materials for the firm

Put your best efforts into the development of this job description, and be as specific as possible. It's important to present a very clear set of initial responsibilities. At the same time, you need to reserve the right to make future changes. Your firm is going to evolve, and you need to be able to redefine this position when necessary.

Decide on a sales compensation structure

Your new business development person should be considered a senior team member right from the start, and the overall compensation that you offer should reflect that status. As an initial reference, look at design compensation surveys such as the one published each year by AIGA, the professional association for design. When determining compensation levels in your firm, keep in mind that income for marketing and sales positions tends to be higher in large firms, in companies that have national client accounts, and in advertising agencies. Sales compensation might take several different forms: base salary only (prorated if the position is less than full-time), commission only (usually referred to as "straight commission"), or some combination of the two.

Some firms select a straight commission structure in order to reduce initial costs when a new business development position is created. However, it can lead to problems because it tends to encourage sales reps to go for quantity over quality. The easiest accounts to land might not be the ones you want. To preserve the go/no-go decision making authority of the founder or principals of the firm, the employment agreement for your sales rep should state that the determination of whether or not to accept assignments from a new client account will be made by the company at its sole discretion. (We'll come back to the topic of employment agreements for sales reps in just a moment.)

Employees on straight commission often negotiate to receive a draw, which is a set amount of money paid to the rep on a regular basis, regardless of how much commission is actually earned during that period. Reconciliations and adjustments are made at set intervals, such as every three months. Because a draw tends to function as an advance against commissions that have not been earned yet, it's not unusual for a dispute to arise over charge-backs if a rep happens to be overdrawn at the time of termination.

Other design firms avoid such problems by providing a salary only. This approach gives the firm complete freedom to pick and choose from the various opportunities identified by the rep, with no disputes over what is pitched and what is accepted because no sales commissions are being affected.

Figure 24.02. The mixture of base salary, sales target, and commission percentage can be adjusted to meet the needs of each firm. If you decide on a lower base salary, a higher commission percentage can produce the same overall compensation, provided that the sales target is reached.

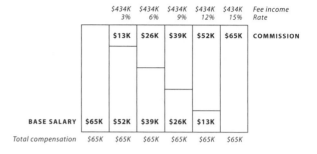

	$434K 3%	$434K 6%	$434K 9%	$434K 12%	$434K 15%	Fee income Rate
	$13K	$26K	$39K	$52K	$65K	COMMISSION
BASE SALARY	$65K	$52K	$39K	$26K	$13K	
Total compensation	$65K	$65K	$65K	$65K	$65K	$65K

Lastly, there are firms that combine the two: a base salary to provide the rep with some stability and a commission to serve as a performance incentive (see Figure 24.02). When the mix includes a high base salary, the commission percentage will be low (perhaps in the range of 2 to 8%). Conversely, a low base salary is usually paired with a higher commission percentage (perhaps from 8 to 15%). Just stating a percentage is not enough, however. You must be much more specific about how the system will work.

What is the commission based on?

- Marketing and sales executives line up new projects and get signatures on proposals that, of course, have healthy anticipated margins built into them. However, it's the responsibility of the creative team to successfully complete each project on budget and deliver the expected margin. For this reason, marketing and salespeople receive commissions based on the total professional fees generated on a project, whereas members of the creative team tend to be rewarded with discretionary bonuses only if a completed project actually produced a good margin. (In most instances, the success of a project can be attributed to factors that were within the control of the team. The gross margin that comes from each project is then used by the firm to cover other expenses. For this reason, discretionary bonuses for creative team members are not tied to net profits for the entire company. The company's bottom line is affected by many things that are outside of the team's control.)

- In most firms, the commission calculation is based on professional fees only. Project income related to materials, outside services, and reimbursable costs is specifically excluded.

Is there more than one rate?
- The commission structure that you develop might have several different layers or categories. However, the overall structure must still be easy to understand — don't make it any more complicated than it needs to be.
- An external sales representative whose primary task is to initiate new relationships may be offered a much higher commission on companies or project categories that have been specifically targeted by the principals of the firm. The target list must be updated according to an agreed-upon schedule.
- A smaller commission might be paid on projects outside of the desired companies, industries, or categories, or on the reactivation of past accounts that have been dormant.
- Usually, no commissions are paid on client accounts that are active at the time of hire. These are considered to be "house accounts." A list of them should be provided to the rep on the first day of work.
- New, commission-only reps sometimes bring pre-existing client relationships with them. When this happens, you must check to make sure that there are no conflicts of interest with any previous agencies. The rep may ask for 20 to 25% of the fee income from the first project on each of those accounts. You'll have to decide whether or not you feel comfortable with such an arrangement. The second project, however, should drop down to whatever standard rate has been agreed upon.
- In general, design firms discourage sales reps from hanging onto new accounts and gradually morphing into project managers. This is done by gradually reducing the commission paid on each new account until, at the end of the second or third year, it becomes a house account. (For example, your firm might offer something like a 7.5% commission on the first project with a new client, a 5% commission on subsequent projects during the first two years of the relationship, and no commission on the account thereafter.)

When is it earned?

- The word "earned" carries special significance here. You must identify the moment in time when a rep becomes entitled to a commission. That moment should not be when the proposal is signed. It should not be when a purchase order is received, and it should not be when services are billed. A commission should only be earned when payment for services rendered is received from the client.
- On a large project, you don't need to wait until the entire project is complete. A commission can be calculated as each progress payment arrives from the client.
- However, you should not generate commissions when advance deposits or retainers are received from clients. This is because no services have been performed yet. You might have to return the deposit or retainer to the client if the project is cancelled. Wait until services have actually been performed, then generate an internal invoice to cover the work, and then pay that invoice by applying funds from the deposit or retainer. That internal payment will trigger the commission calculation.

When is it paid?

- It's important to establish a regular schedule for summarizing commission activity and reporting it to the rep. Most firms do this monthly, after the in-house financial statements have been finalized. Be clear about where the numbers come from. You need to maintain an audit trail from cash receipts data to identification of activity by sales rep and through the commission calculation itself.
- When you've prepared the monthly commission report, you might then write a manual check to attach to it. However, it's more common to produce a commission check as part of the next regular payroll. That way, it can be printed by your payroll service. Sales commissions are taxable personal income, so all standard taxes and withholding amounts apply.

- Whenever a sales rep resigns or is discharged, you need to prepare a final payment for all wages due at the time of termination, including salary, accrued vacation pay, and earned commissions. In most states, final payment must be made within three days.
- Once a commission has been earned, it cannot legally be forfeited.
- Also, your company cannot reduce the amount of any final payment by making deductions for projects that were not profitable or attempting to recoup other business expenses such as lost or damaged laptops or mobile phones.

It will take you a while to develop the commission system that makes the most sense for your firm. Each time that you adjust the variables described here, measure the potential impact by running some sample calculations. Start with a "best case" scenario that reflects a series of positive assumptions about new business volume. Then, calculate a "worst case" scenario based on negative assumptions about activity, perhaps even including a client who fails to pay. Scenario planning will help you understand the range of financial results that could be produced by the new system. You'll quickly see that if goals are high and the new business development person hits them, he or she could become the highest paid individual in the company. This is not an unusual situation, and the founder or principals of the firm must be comfortable with the idea.

When planning your overall annual budget for new business development, be sure to remember that, in addition to employee compensation, benefits, and taxes, the firm must also pay for marketing materials, business cards, association memberships, business travel, customer entertainment, a laptop computer, a mobile phone, and the like. These additional business expenses are often equivalent to one-third of annual compensation or more.

Give yourself enough time to find and hire the best candidate

The sales rep will occupy an important senior position within your company. Don't be surprised if it takes a while to find someone who's a good fit, both in terms of skills and personality.

The strongest candidates will have solid experience in new business development for a design firm. In addition to that, many firms seek candidates who also have some client-side marketing experience — firsthand involvement in client strategy development and brand management can be a very valuable asset when it comes to selling strategic services. All candidates must have a good understanding of the creative process as well as the detailed advance planning that's required for complex projects. You're looking for an individual who has superior verbal and written communication skills and who is organized and proactive. In terms of personality, you're looking for someone with a positive, upbeat attitude; excellent interpersonal dynamics; and the special ability to be gently persistent when necessary.

To get the word out about the job opening, it's best to start in a targeted way. Contrary to popular wisdom, you should avoid advertising the position in your city's daily newspaper or on a big, generic employment site because that could easily trigger an avalanche of responses from individuals who are completely unqualified. It's smarter to start in a more focused way and then gradually expand the search process only as necessary.

The best way to start is with active personal networking by the founder and senior staff members. Describe the job opening to people you know within the design community, including your suppliers.

You might also get the word out discretely to your client contacts. Some of them may be excellent candidates — marketing professionals with a deep understanding of one of your target industries plus personal experience as a buyer of design services. However, if a client contact does express interest in moving over to the agency side of the relationship, think through the implications carefully. If you recruit

this particular person away from your client, is there a chance that you could lose the account? Or is there a chance that the hire could actually strengthen the relationship?

If you find that personal networking is not producing results, you should gradually expand the search by posting the position on your company's Web site, listing it with appropriate professional associations that maintain job banks, and perhaps placing recruitment ads in targeted trade publications that are relevant to your type of business. You also have the option of engaging a headhunting firm. This will increase your costs, but it will also bring many benefits. Established design recruitment firms know lots of people. You'll gain access to qualified candidates nationwide who may not be actively looking but who might be interested if personally approached by a recruiter.

When you do identify a number of strong candidates, review their sales backgrounds carefully. Your estimate of their future performance within your firm must be based on their actual performance at past firms. Look at the duration of each past sales position. If candidates have been job hopping every year or so, it may be an indication that past employers carried them through an initial orientation period, only to have them jump ship when pressure mounted to bring in new accounts.

When you find someone that you're interested in hiring, write a formal employment agreement. This is especially important for commissioned sales positions because the agreement will include a detailed compensation plan. Spell out exactly how and when commissions will be earned and paid, both during employment and in the event of termination. In the document, define all key terms so that there will be no confusion over language.

Commissions are a form of wages, so your firm must comply with all applicable wage and hour laws in the state where you are located. Labor laws vary considerably from state to state, so you need expert guidance. Draft the employment agreement with assistance from a labor attorney. A small investment now in legal fees could save you a lot of grief

later on. An agreement that is poorly written could easily lead to disputes and, in some instances, legal penalties for you as an employer.

As you work with your attorney to finalize the text of the agreement, ask for advice about competitive restrictions that might need to be included. The rep that you hire will gain specialized knowledge that is unique to your company. This information might include such things as customer contacts, pricing methods, and other trade secrets. At some point in the future, it's conceivable that the rep might leave your firm and go to work for a competitor. A noncompetition clause (also called a "covenant not to compete") may be necessary to protect your company. The purpose is not to prevent the rep from earning a living or to impede future career advancement but simply to protect your firm against unfair competition. The rep would be prohibited from doing two things: divulging proprietary and sensitive information to anyone outside your firm without proper authorization, and soliciting your clients for any business that competes with you. These narrow restrictions would apply during employment and for a reasonable period of time after termination, such as one year.

Take the new hire through a formal orientation period
The rep that you hire will not be productive immediately. Some time will be needed for him or her to come up to speed as an employee and begin establishing relationships with potential clients. Be prepared for an orientation process that may last six months or longer. During this time, you must provide guidance and supervision. You will be reviewing proposals and occasionally helping to close deals. The rep must become very familiar with your portfolio and case studies and learn to clearly articulate your offer before he or she can speak for the firm, representing it to the outside world. This process of acculturation includes learning the firm's criteria for evaluating opportunities. The rep must be able to determine how closely each poten-tial project fits the firm's abilities and strategic objectives.

If it becomes clear at any point during this orientation process that the new hire is just not working out, don't hesitate to make a tough judgment call and terminate his or her employment. New business development is vital to the ongoing success of your firm. Don't leave it in the hands of someone who is not good at it. It's wiser to make a clean break so that you can search for a more capable replacement.

On the other hand, if the new hire is working out well and becoming increasingly productive, continue to provide whatever guidance and mentoring might be necessary. In addition to daily, impromptu interactions, you should also schedule meetings at regular intervals to discuss performance in a more formal way. Have these discussions on the three-month, six-month, and twelve-month anniversaries of the date of hire. Reserve the right to adjust the responsibilities and activities of the position as needed. At the one-year anniversary, you should also reserve the right to fine-tune the commission structure if necessary. If you hired the right candidate and provided the right guidance, you'll be amazed at the results. Over time, the new business development person will become a trusted member of your senior management team and will contribute in very important ways to the evolution of the firm.

Chapter 25:
Large projects

As you move forward in your career, it's likely that you'll be working on projects of increasing size. There are important differences between small and large projects. Perhaps the most obvious difference is that projects of greater scope and complexity require a much broader range of resources. Because of this, more risk is involved. With more moving parts, there's simply more that can go wrong. As a result, large projects require a more formal approach to planning and management. This chapter is filled with real-world advice to help you meet these challenges.

Planning basics

It's not wise to rush into a big project without planning it out in a very detailed and logical way. Think of this advance planning as "phase zero" and give it the time and effort that it needs. Many basics of project planning were already discussed in Chapter 11. We'll start this new discussion by emphasizing these key issues:

- Understanding the client's situation
- Identifying the end user
- Defining the scope of work
- Identifying the final metrics that will be used to evaluate the completed work

Let's take a few moments to look at each of these in detail.

The client's situation

Start the planning process by quickly gathering as much advance information as you can about the client's company, their competitors, and their industry. It's essential to gain a basic understanding of the larger context of the assignment — the overall situation that has given rise to the specific needs you're being asked to address.

The end user

Next, identify the ultimate customers, audience, or beneficiaries of the service or product that your client provides. In the design process, you'll be serving as an advocate of the customer's needs. To put together an appropriate plan, an up-front orientation is necessary. You'll be digging much deeper within the initial phases of the project itself, so your advance planning must account for the time and resources you think will be necessary to gain new insights into the target audience and their interactions with your client and, ideally, to identify needs that are not currently being met.

The scope of work

Most design firms work with clients on a fixed-fee basis. That's why project planning is so important. The accuracy of your pricing will depend upon how clearly you identify the amount of work to be done. We've touched upon several key aspects of this in previous chapters:

- In Chapter 11, we discussed the need for fixed-fee agreements to be detailed and specific.
- In Chapter 12, we talked about the importance of change orders in documenting client requests that exceed the original scope.
- In Chapter 22, we discussed the size and composition of project teams.

Your project plan reflects your understanding of the scope of work. It reflects your assumptions about the skill sets that will be needed, the amount of time that will be necessary, and the costs that will be involved. Underlying this are assumptions about the level of quality that you and your team are striving for. Accordingly, the overall framework of the plan must reflect your own creative methodology — the process that will enable you to produce your best work.

At this point in our discussion, we must also note that more and more creative firms are becoming involved in research and development projects where the exact scope of work can't be known at the start. From a planning standpoint, what do you do when the final outcome cannot be anticipated? A project of this type is sometimes referred to as an "unframed challenge." If you're bidding on a large, exploratory project where the challenge is not routine or predictable, especially if you're going to be charging for your services on a fixed-fee basis, then the smartest move for you may be to take a sequential approach and bid on just one phase at a time.

Your first project plan should focus on the initial research necessary to develop a contextual framework for subsequent efforts. Essentially, the first proposal covers information gathering and discovery, which some firms describe as "immersion." The goal of the first assignment is problem definition. With that in place, you can move on to problem solving in later proposals. In this way, each round of work ends with specific recommendations for the subsequent round.

The final metrics
Whatever the service is that you're being asked to provide, or deliverable you're being asked to produce, you must clarify with the client how it will be evaluated. The final

evaluation must be based on objective measures that are not open to subjective interpretation — not "I like it" or "I don't like it," but "it works" or "it doesn't work." This is particularly true when it comes to evaluating the visual appearance of the work.

The larger the project, the more likely it is that multiple measures will be applied. Give careful consideration to all the significant factors that define success. Once the metrics have been defined, use them to assess the starting situation. This establishes a baseline so that you can later tell what has changed and by how much. Review this information carefully with the full team. To achieve success, everyone has to know how the finished work will be judged.

Planning on a larger scale
OK, now that we've reviewed some key issues that apply to design projects of all sizes, we're ready to explore a few additional planning activities and management techniques that are particularly useful when you're facing a very large project. To help you with the planning process, we'll discuss the following:

- Force-field analysis
- The importance of identifying sponsors and channels of influence
- Risk analysis
- The usefulness of breaking out subprojects
- Two different ways of visualizing the plan

Force-field analysis
This planning technique was developed in the 1930s by social psychologist Kurt Lewin. It involves identifying the key things that can help or hinder the project, both within the client organization and externally. You start the process by making a list of driving forces, such as pressure from customers, suppliers, and competitors — perhaps even management edicts. Be as specific as possible in listing everything that's exerting force toward the desired outcome of the project.

Next, identify the restraining forces that might limit what can actually be accomplished. If your client is a large organization, you'll need to pay special attention

Figure 25.01. When you take on a large project, force-field analysis is a very useful tool for identifying the key things that can help or hinder your efforts.

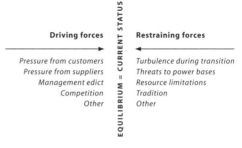

Driving forces	EQUILIBRIUM = CURRENT STATUS	Restraining forces
Pressure from customers		*Turbulence during transition*
Pressure from suppliers		*Threats to power bases*
Management edict		*Resource limitations*
Competition		*Tradition*
Other		*Other*

to political issues. There may be habits or attitudes, either on the part of individuals or within groups, that will make change difficult. Older client organizations, in particular, tend to have firmly entrenched customs. The new strategies or priorities that you represent might be perceived as threats to existing power bases. Depending on the nature of the project, there may also be concerns about lost productivity during any transition from old to new. On this list, include everything that's exerting force against the desired outcome of the project.

Now put the two lists side by side (see Figure 25.01). You'll find that the current situation is largely defined by the way in which the driving forces and restraining forces are arrayed in opposition to each other. In a sense, the current status represents equilibrium. The challenge for you and your client will be to shift the balance in the direction that you want it to go. If you're not able to do this, it's unlikely that your project will achieve its goals. Force-field analysis is a very useful planning tool for large projects because it helps clarify priorities and stimulates discussion about ways to diminish barriers and strengthen positive forces.

Sponsors and channels of influence
As you put your project plan together, gather information about the client's organizational structure. Your goal in this is to identify sponsors and channels of influence — that is, key people who will be involved in the project (whether directly or indirectly) and the extent of each person's power to impact the results. As you identify the key players, consider how your primary contact fits into the picture. To be successful, a large project needs

TALENT IS NOT ENOUGH: BUSINESS SECRETS FOR DESIGNERS

an effective champion on the client side of the relationship, preferably someone with real decision-making authority. It's vital for you to determine right at the start whether your contact is well positioned to serve as that champion.

As you identify the various individuals involved, be on the lookout for these key profiles:

- Recommender
 This may be the person who initially approached you. In a corporate setting, the recommender is often a staff member, such as an administrator or purchasing agent. The recommender researches the capabilities of potential service providers, performs some initial screening to narrow the field, and requests competitive bids. However, the recommender could also be an outside advisor or industry expert, such as an advertising search consultant. You need to convince the recommender that your services should be considered for the project at hand.

- Decider
 This individual has the legal and financial authority to engage you for the project and, ultimately, to accept or reject the work that you produce. Within large client organizations, the decider may be a busy executive who's not actually in the initial meetings with you. For the success of the project, it's vital for you to identify the ultimate decision maker, understand his or her concerns, and keep that person in the loop.

- Gatekeeper
 On a large project, many of your daily interactions could be with a middle manager or assistant who controls access to those with more authority. This gatekeeper is in a position to filter or block your information and requests, which can have a major impact on the progress of the project. Identify gatekeepers right at the start, and build effective working relationships with them.

- Third-party stakeholders
 All client organizations have key relationships with other businesses, such as suppliers, distributors, or value-added resellers. These business partners may have financial, legal, or ethical concerns that will impact the project

*in important ways, and they may exert considerable
influence on your client's decision-making process.
Their points of view must be taken into account.*

- Implementer
 *Often, the final work delivered by design firms
 must be implemented or maintained by people
 within the client organization (two common
 examples are identity systems and Web sites).
 Be sure that you know who these implementers
 are, understand their concerns, and provide
 them with whatever guidelines and tools might
 be necessary to successfully use the system
 that you've created.*

Risk analysis
The next issue for us to discuss is risk. Large projects
tend to involve greater risk than small projects. These
are not creative risks but potential threats to schedules,
logistics, and finances. The most common risks fall
into these general categories:

- People
 *For the project to be successful, your team members
 must have the right skills, be available at the right
 time, and make a strong personal commitment to
 the project. In addition, you must provide them
 with whatever critical information and resources
 are necessary for them to do their best work.*

- Politics
 *When working with large client organizations,
 you'll quickly find that corporate politics can be
 a problem. As we discussed, the best approach
 is to make sure that all key stakeholders have been
 identified and that there's sufficient agreement
 among them on the initial need for the project.
 Then, to keep everything on track, it's important to
 work closely with the internal champion of the project
 to document client approval at each key milestone.*

- Technology
 *There's always a competitive need to innovate.
 However, significant dangers are involved in going*

too far out on a limb with new technologies. This is particularly true of interactive projects. The technology you select must be proven, reliable, well understood, and available exactly when it's needed.

- Finances
Adequate client funding must be in place before a large project starts, and funds must remain available as work progresses. In many client organizations, financial control is a critical issue — it's not unusual for expected funds to be shifted elsewhere, bringing the project to a halt.

- Contracts
Many different legal issues can crop up on design projects. Because of this, you'll want to negotiate contract terms and conditions very carefully, particularly when it comes to legal liability in the event of failure of any project element. (For much more information about terms and conditions, please see Chapter 19.)

- Personal safety
Occasionally, physical risks might be involved on creative projects. Perhaps the most common dangers of this type are travel-related. In general, though, the risk of personal injury on graphic and interactive design projects is relatively low. In contrast, risk levels can be much higher for architectural and environmental design projects that involve the construction of physical spaces. Physical risks are also inherent to some entertainment projects such as filmmaking.

- Natural disasters
Lastly, nature may pose a risk to your project. You might face a simple inconvenience such as rain on the day of an outdoor event or a much more serious threat like a hurricane, flood, or earthquake. It's not possible to accurately predict severe weather or natural catastrophes, but it's wise to acknowledge that risk levels can be higher in certain geographic areas and at certain times of the year.

After reading through this long list, you might be asking yourself whether it's even safe to get out of bed in the morning! Fortunately, most design projects will face only

Figure 25.02. Every large project involves risks, but some risks require more caution and planning than others.

Improbable **HOW LIKELY?** Certain

Trivial **HOW SERIOUS?** Grave

a few of these many issues. Once you've identified the specific risks that are relevant to your particular project, the next step is to assess them (see Figure 25.02). A very useful approach is to rank each one to indicate how likely it is to occur (on a scale of 0 to 10) and then assign an additional rank to indicate how serious the impact would be (also from 0 to 10). Add the scores together and sort them from highest to lowest. After you've done this, you can concentrate your planning on those threats with the highest rankings. To counter a perceived threat, consider one of these strategies:

- Avoid it
 Identify the cause of the threat and avoid it, perhaps by eliminating the risky component of the project altogether.
- Deflect it
 Get others to take on or underwrite any component that you've identified as too risky. For the other responsibilities that you retain, be sure that you have appropriate insurance coverage in place.
- Have a contingency plan
 Your project plan should include an alternative or substitution for any risky component that could be implemented quickly if the need arises.

Breaking out subprojects
Large projects tend to have multiple deliverables. For this reason, it's smart to break up a large and complex project into a series of more manageable subprojects, each with its own schedule and resource needs. Over time, this approach to planning and tracking also allows you to accumulate a database of historical information about specific job types. If you've sorted things out properly, this detailed reference information can help make future budgets and schedules much more accurate.

In some creative fields such as architecture, this project/subproject approach is standard. Overall coordination

of several closely related projects is called "program management." A program is a set of projects with a common strategic goal. Often, there are many interdependencies as well. Even though the individual deliverables may be produced by separate teams, the broader effort benefits greatly from coordinated planning, prioritization, and management. This is particularly true if the program has an extended schedule, with work being executed over a period of months or years.

Visualizing the plan
The larger the project you're taking on, the more important it is for you to visualize the plan in some way. Preparing a project plan in the form of a chart or diagram allows you to see the "big picture" quite literally. There are several common visual formats for this. The two most often used by designers are Gantt charts and PERT diagrams. Here's an explanation of each one:

• Gantt charts
 As you may recall, we discussed Gantt charts very briefly in the chapter on proposals (Chapter 11). A Gantt chart is a particular type of bar graph that shows activities over a span of time. This specialized format for visualizing project plans was developed in 1917 by industrial engineer Henry Gantt. A project is divided into its component phases and steps, and each of these is presented as a horizontal bar. The length of each bar represents that task's duration. The relative positions of the bars show the time relationships between them. A Gantt chart indicates which tasks can be undertaken simultaneously and which must be done in sequence (although it doesn't usually show the details of any interdependencies between the tasks). A Gantt chart showing the original project plan can be expanded to include a comparison to actual activity. For each task in the project, a horizontal bar for actual performance can be placed immediately below the bar that represented the plan. Most project-management software includes the ability to create Gantt charts. Some stand-alone charting applications are also available. For a sample Gantt chart, please refer back to Figure 11.02. This topic of visualizing the actual hours or dollars expended on a large project is an important one, and we'll return to it in just a moment.

- PERT diagrams

 This is a completely different way of visualizing a project plan. PERT is an acronym for "program evaluation and review technique." This format was developed in the 1950s by the management consulting firm Booz Allen. It's a network diagram that shows key activities, the interdependencies between them, and the so-called critical path through the project. To prepare a PERT diagram, you have to make distinctions between tasks that have fixed durations and firm deadlines and those that have some scheduling flexibility (referred to as "float"). The critical path through these activities represents the minimum duration for the overall project. A large project must be kept on the critical path if it's going to be completed on time. Professional-level project-management software often includes the ability to create PERT diagrams. For a sample diagram, please see Figure 25.03.

Implementation

Obviously, preparing the plan is not the same as completing the project itself. Even though you've gone through a comprehensive advance planning process, you'll face many challenges after work has begun. For this reason, it's important to stay flexible — your plan may have to change as the situation evolves. This leads us to a major dilemma faced by design firms: from a creative standpoint, you must always remain open to change and discovery; however, as a smart businessperson, you also need to keep each project within its approved budget and schedule parameters. As every experienced design professional knows, keeping a large project on track is not easy to do!

Implementing the project plan requires collaborating very closely with all team members. It also requires monitoring progress at key checkpoints to see that objectives are being achieved. This process of monitoring performance requires you to prepare progress reports on at least a weekly basis. In general, big projects need much more documentation than small projects. It's essential for busy design firms handling large projects to have an efficient system in place for tracking the labor and expenses that are going

into each project. The system has to make it easy to generate work-to-date reports that are current and accurate.

Reports must also be produced with varying levels of detail. Those with the most detail are for you and your team. When a progress report is shared with a client, it should only be a summary — it's not a good idea to distract clients with too much detail. Reports are important tools for demonstrating progress and managing client expectations. Providing timely and reliable summaries to the client is an essential aspect of good account service.

Keep in mind that project summaries shared with clients should show gross amounts only. Most project-tracking software gives you the option of viewing financial information at net or at gross. Net is the internal cost to your

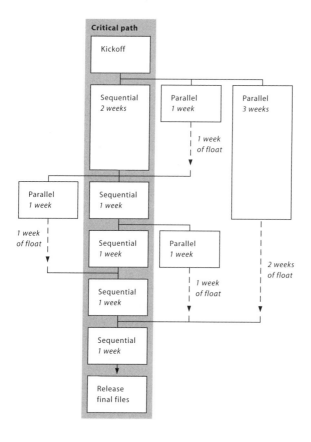

Figure 25.03. PERT diagrams are very useful for planning large projects because they require you to sort out task dependencies and durations.

studio (labor at payroll rates plus purchases at whatever amounts were paid to vendors). In contrast, gross is the external billing value — the total that will be shown on your invoice to the client (labor at full billing rates plus purchases to which a markup has been added).

Within the design team, an effective tracking system helps you stay within the approved scope of work and maintain the right priorities. To keep priorities straight, many people find the following concept quite useful.

Pareto principle
This concept is named after Vilfredo Pareto, an Italian economist and sociologist. Some people also refer to it as "the 80/20 rule." In 1906, Pareto published a study of the distribution of income in Italy. Not too surprisingly, the data indicated that most of the nation's income went to a small portion of its population. This observation of unequal distribution has led to a general management concept. It holds that, in most groups, the majority of items will have comparatively little importance, while the truly significant items will be in the minority. This is often the case with large design projects — just a few items are the most significant in terms of their effects or consequences. Because of this, it's vital for project managers to maintain clear priorities and concentrate the team's efforts on the most important elements. It's all too easy to lose focus and go off on tangents, squandering time and effort on insignificant items that won't have a noticeable impact on the ultimate success of the project.

Watching the budget
Now we need to expand upon a topic mentioned briefly a few moments ago: visualizing the actual time and materials being expended. On a large project, it's essential to track the speed at which the budget is being used. Most small projects have tight schedules. Although they're stressful, tight schedules are beneficial in that they force you to stay focused. In contrast, large projects tend to have extended schedules, which make it much easier for the team to slowly creep over budget without even being aware of it.

One technique for watching how quickly the budget is being used is to expand your Gantt chart, as we noted earlier. This involves adding a second set of bars to show current budget status. Gantt charts are quite specialized — they were specifically developed for planning and tracking projects. However, there are two more ways to visualize the total amount of time or money being expended: standard bar graphs and line charts.

- Bar graphs
 An ordinary bar graph is a great way to display the differences between groups of data. Typically, information is presented chronologically as a series of horizontal bars or vertical columns. The lengths of the bars are in proportion to the values of the data they represent. Bar graphs can show resource usage in specific weeks, such as dollars spent or hours worked. They are easily produced with any common spreadsheet application.
- Line charts
 These are commonly used to show increases or decreases in activity from period to period. The line connecting the series of data points tends to jog up and down, leading many people to call these "fever charts" like those seen in hospitals. For design projects, however, line charts are most useful for showing cumulative totals, which means that the connecting line will only move upward. A line chart of cumulative performance reflects the steady accumulation of costs over the lifetime of the project. A second line can be placed on this chart to visually compare the estimated cost of work scheduled to the actual cost of work performed. These line charts can be produced using any standard spreadsheet program.

Both bar graphs and line charts can help you keep an eye on your project's burn rate. "Burn rate" is an investment term for how quickly a limited amount of cash is being spent. Managers in start-up companies calculate their burn rate in order to understand how much time they have before they need to achieve positive cash flow from operations or obtain additional funding. In project management, the term is used to describe the rate at which the overall budget is being used. If you're working under a fixed-fee contract, all work must be completed before the budget runs out or else you'll begin to erode your planned profit.

To stay on top of a fast-moving project, many design firms maintain a chart of running totals and post it in the workplace for the team to see how quickly the budget is being used. The chart might show week-by-week totals, cumulative totals, or both (see Figure 25.04). Sometimes it's helpful to simplify how the original plan is presented so that it can be plotted as a straight line. This is done by taking the total budget and dividing it by the total number of weeks in the schedule. This would seem to imply that the level of activity is expected to be the same in all weeks. We know, of course, this won't be the case, but showing the budget as a straight line makes the chart much easier to read when actual performance data is added. The uneven line representing actual work will move around in marked contrast to the straight-line budget.

This charting process requires easy access to current data from your company's project-tracking system. The raw numbers available to you from the database can be either weekly or cumulative — it's a simple matter to calculate one as long as you have the other. If you're producing a weekly bar graph of dollar totals, another level of detail can be shown by building each bar in layers representing the subtotals for staff, freelancers, and materials.

Each time you prepare an update, you're watching to see whether actual totals have begun to exceed the plan. Sometimes an accelerated burn rate is not a problem — it could indicate that the project is ahead of schedule and all work will be completed early. If a project stays significantly ahead of schedule, you might even be able to reallocate unused money and resources.

Most of the time, however, running ahead of budget is a bad sign. It usually indicates one or more of these classic problems:

- Early estimates of the time and money required to do the work were inadequate.
- Project requirements were not defined accurately enough at the start.

TALENT IS NOT ENOUGH: BUSINESS SECRETS FOR DESIGNERS

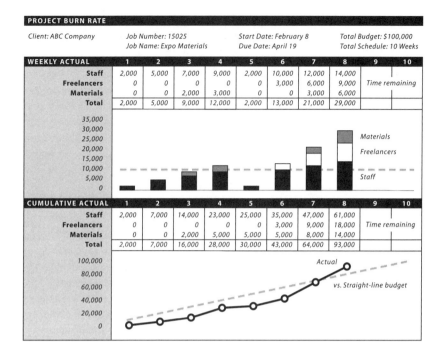

PROJECT BURN RATE

Client: ABC Company Job Number: 15025 Start Date: February 8 Total Budget: $100,000
Job Name: Expo Materials Due Date: April 19 Total Schedule: 10 Weeks

WEEKLY ACTUAL	1	2	3	4	5	6	7	8	9	10
Staff	2,000	5,000	7,000	9,000	2,000	10,000	12,000	14,000	Time remaining	
Freelancers	0	0	0	0	0	3,000	6,000	9,000		
Materials	0	0	2,000	3,000	0	0	3,000	6,000		
Total	2,000	5,000	9,000	12,000	2,000	13,000	21,000	29,000		

CUMULATIVE ACTUAL	1	2	3	4	5	6	7	8	9	10
Staff	2,000	7,000	14,000	23,000	25,000	35,000	47,000	61,000	Time remaining	
Freelancers	0	0	0	0	0	3,000	9,000	18,000		
Materials	0	0	2,000	5,000	5,000	5,000	8,000	14,000		
Total	2,000	7,000	16,000	28,000	30,000	43,000	64,000	93,000		

- Work has expanded beyond the agreed-upon scope.
- Design flaws, production difficulties, or technical challenges have emerged.
- A problem has developed with a key vendor.

If you see that actual expenses are beginning to exceed the budget, you must intervene to reduce the burn rate. In design firms, several tactics are common:

- Coaching the team for improved efficiency
- Narrowing down the number of alternative creative directions being pursued, if the project is still in the early phases
- Reducing the size of the team if there are individuals who are not being fully utilized
- Being more diligent about generating change orders

This last point is an important one. It's not unusual for design projects to fall behind schedule because of additional client requests. Anything that's outside the original scope of work should trigger a change order (as we discussed

Figure 25.04. On a large project, weekly activity will vary. For this reason, it's usually easier to track the overall burn rate by charting cumulative totals.

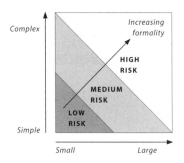

Figure 25.05. The amount of planning and analysis you do should be scaled to match the size and complexity of the project.

in Chapter 12). This gives you a chance to increase the budget and possibly renegotiate deadlines.

If overruns are not due to client changes, however, it's unlikely that additional funding will become available. If you negotiated a fixed-fee contract and now you're running out of money before the agreed-upon work is complete, it might simply mean that you under-budgeted. In such a case, you may have no option but to carry the project through to completion without additional compensation. As a businessperson, of course, you must be very cautious about this — accepting a reduced profit margin on too many projects will jeopardize your firm's long-term viability.

Earned value management
The amount of analysis you do and the formality of the reports you produce should, of course, be scaled to match the size and complexity of the project at hand (see Figure 25.05). At the upper end of this scale is something called "earned value management." It's an approach for measuring forward progress that's used by many engineering firms and software developers. Earned value is defined as the value of the useful work completed up to any given point in the project. Analysis of earned value is based on three different metrics: schedule performance, cost performance, and technical performance. Let's look briefly at each one (based on our earlier discussions, you'll notice that the first two are already quite familiar):

• Schedule performance
 This is management of the time budget. Detailed Gantt charts are used for tracking labor hours and

*keeping an eye on variances. The goal is to know
whether the project is behind or ahead of schedule
and whether it will be finished on time.*

- Cost performance
*This is management of the financial budget. Detailed line
charts are used for planning and tracking the monetary
aspects of the work. Usually there are two sets to show both
net cost and gross billing value. This data is continually
updated and analyzed to determine whether the project
is over or under budget and to calculate the size of any
variance. On an ongoing basis, you need to know whether
there's enough money left to complete the work.*

- Technical performance
*This third metric moves us into a new area that we
haven't discussed before. Technical performance means
measuring the volume of work accomplished — the
physical percentage of completion at a given moment.
This represents a significant challenge for design firms
because progress on creative problems is very difficult to
quantify. When asked how much progress has been made
on the scope of work, most design teams will respond
in a purely subjective way — a number will be pulled out
of the air, such as "concept development is 50% complete."
In contrast, earned value management attempts to
measure progress objectively. This requires you to quantify
the scope of work by breaking the project down into
a series of specific milestones and then assigning a
numeric value to each one, either in dollars or in
percentage of completion. Some milestones might have
much higher values than others. Each time you prepare
a progress report, the furthest milestone that has been
reached will determine the percentage of work completed
as of that status date. Once you have an accurate measure
of how far behind or ahead the team is on scope, you
can compare that to the cumulative totals for schedule
and cost. (One note of caution: since tracking technical
performance requires you to quantify the project
plan and assign predetermined values to milestones,
it's not always a good match for research and discovery
projects where the work itself will take you in new
directions that cannot be foreseen.)*

With these three metrics as a foundation, earned value analysis goes on to calculate an "estimate at completion" (also called a "forecast at completion"). This is a projection forward of the expected total cost and expected total schedule, based on actual performance as of the status date. This allows you to estimate what the variance will be at completion — the final difference between plan and actual.

This real-time trending gives you early warning of performance problems on large projects while there's still time for corrective action. The earlier a discrepancy is identified, the sooner you can act to remedy the problem. However, these midcourse corrections cannot be accomplished by the project manager alone — they require the involvement and commitment of the whole team. For that reason, earned value metrics are often used as a scoreboard for the team. Variances are shown as percentages or ratios, and any areas of concern are highlighted.

In a large studio with multiple teams, these metrics are also shared with the principals of the firm. Having current information on all active assignments allows company-wide managers to focus their attention on projects encountering difficulties and provide assistance as needed in the form of added support or mentorship.

What about quality?

We've talked a lot about managing time, money, and the quantity of work accomplished. At this point, you may be asking yourself, "What about quality?" It's important to note that quality control is a separate challenge. Project-tracking systems have no provision to measure quality, and good numbers from a database are no guarantee of creative success. Good design requires a strong creative leader. This leader must bring the right people into the team, inspire performance, maintain high standards, and effectively guide the group through an iterative problem-solving process. (For a much more detailed discussion of design team roles and dynamics, please see Chapter 20.)

Wrapping up

OK, you took on a large project and kept it on track. Now the end of work is drawing near. Here are a few quick tips for wrapping things up successfully:

Handover to client

As you near the conclusion of a large project, take time to prepare both the team and the client for a successful handover of the finished work. Especially on projects such as Web sites and corporate identities, it's important to formalize the process of transferring responsibility. The client may need preparation and training to use the solution that you've developed.

When you've delivered the last portions of your work, conduct a wrap-up meeting with your client to assess satisfaction. It's a final opportunity for the client to identify any defects and ask for corrections. It's also a golden opportunity for you to discuss additional needs that have emerged and to propose follow-up projects. Closing the loop in this way can help you convert a successful one-off project into an ongoing relationship. (The process of closing the loop with the client was discussed in Chapter 10.)

Final internal review

After client satisfaction has been assessed, it's smart to conduct an internal evaluation of the project with your team. Some firms refer to this as a "postmortem" because it takes place after the project's completion. However, a more optimistic term is "postpartum."

Hold this final discussion as soon as possible, while everyone is still available and all of the details of the project are still fresh in everyone's mind. Review the process as well as the outcome. Get the full team to participate so that all phases of the project and all professional perspectives are represented. Be honest in examining both the good and the bad. However, if the project did have some problems, be careful not to let the discussion devolve into a finger-pointing

session. Handled properly, this is a valuable opportunity for the team to learn from any mistakes and agree upon improvements that will benefit future projects.

Most of the issues that come up in this discussion will relate to specific details of planning and managing this one project; however, company-wide issues might surface as well. Start the review with some questions about the project's process and logistics:

- What went well? Why?
- What did not go well? Why?
- What was missing or not foreseen?
- What should we change for the next project of this type?
- What project-related action items are now necessary? By whom and by when?

Next, expand the discussion to address any company-wide issues that have surfaced:

- Based on what we've just learned, should any changes be considered to our company's vision and business plan?
- Are any improvements needed to our overall systems and processes?
- What future knowledge and skills will be needed to respond to emerging opportunities?
- What are the related staffing and training implications?
- What company-wide action items are necessary? By whom and by when?

Document the results of this final assessment, and follow up diligently on the action items that have been assigned. If the project was successful, you might also consider adding it to your design portfolio as a case study. As soon as that's done, you can archive the final creative files. Separately, be sure to save any client approvals and other key information that might be needed later to resolve any financial or legal disputes.

If your work on the project produced any new reference materials or forms that could be useful to other projects

in the future, store them in an easily accessible format and location. Many design firms maintain a binder of general procedures, a set of templates and forms for project planning and tracking, and reference files about vendor capabilities.

If you work in a large firm, you should also think about ways to publicize your project review findings internally. One of the best ways to disseminate the new knowledge is to present an end-of-the-day "show-and-tell" to the rest of your company's staff.

Conducting a final evaluation after each major project is essential for creating a culture of learning. Over time, it helps you improve your personal skills and evolve best practices that will contribute significantly to the success of your firm.

Chapter 26:
Financial management

This chapter reviews the essentials of financial management for a graphic design firm. When the design business is first established, the basic accounting system should be set up by a CPA, preferably one who has experience working with clients in the design profession. If the firm remains small, it will continue to rely upon an outside accountant or bookkeeping service for the preparation and analysis of financial information. However, if the firm has the opportunity to grow and decides to do so, it's a good idea to gradually bring more of this financial expertise in-house.

The benefits will be significant — financial information will be more current and complete, providing a better foundation for good decision making. This chapter discusses the process of preparing and using basic financial reports, and it explains additional key issues of particular importance to design firms. Tips are included for setting targets and benchmarking performance, along with a few suggestions to help keep everything on track.

Effectively tracking and managing financial performance involves looking at different levels of detail and understanding clearly how all of the pieces are interrelated. Design firms prepare a variety of reports at different intervals — primarily weekly and monthly. Together, these different perspectives combine to give a holistic view of the business.

Weekly reports

In a busy studio, it's important to look at individual project reports at least once a week (for more information about project management, see Chapters 12 and 25). It's also important to look at an overall cash flow projection every week — a summary of cash coming in from clients and cash going out to pay vendors, rent, taxes, salaries, and so on. (Please see Chapter 14 for a more detailed discussion of cash flow.)

Monthly reports

At the end of the month, when you have sent out the last of your client invoices, follow up by preparing and sending a statement of account to each active client to recap open items. (Usually this client statement is in the form of an aging report.)

For yourself, it's important to prepare complete monthly financial statements including a profit and loss statement (P&L) and a balance sheet. These should be prepared as soon as possible after the month has ended. If someone else prepares the financial statements, it's vital for you as a businessperson to spend time reading and analyzing the information. Get comfortable with the formats. Know where all of the numbers come from and how they have been calculated. In this way, you'll be able to use the statements as the basis for sound business decisions.

The P&L (also called an "income statement") is an operational view of your business over a span of time, such as a month, a quarter, or a year. Within that specific time period, it shows how income compared to expenses and whether or not a net profit was produced.

The balance sheet, in contrast, does not represent a span of time. It shows the strength of the company at one particular moment. It is an itemized statement of assets and liabilities in order to show the net worth of the business at that one moment. It's called a balance sheet because it is based on the "accounting equation," a mathematical expression that describes the relationship of the items included. The formula is this: assets = (liabilities + owner's equity). Looked at in another way, the total assets of the business minus its total liabilities will equal owners' equity, which can also be called the net worth or book value of the company.

It's preferable for your in-house financial statements to be accrual-based. In accrual-based accounting, all income is counted when it is earned, and all expenses are counted when they are incurred, regardless of when the actual cash is received or paid. This means that on your financial statements, you will be recognizing project activity In the month where the work itself took place. Your invoices to clients are recorded as sales and then tracked as open accounts receivable. Your purchases from vendors are recorded as expenses and then tracked as open accounts payable. This is in contrast to cash-basis accounting, where income and expenses are not counted until the actual cash changes hands. Cash payments tend to happen long after the fact, which can distort your view of monthly activity and indicate ups and downs that are quite misleading. For this reason, accrual-based financial statements present a more accurate picture.

Also in an accrual-based accounting system, adjusting entries are made when the books are closed at the end of each month in order to update your accounts for items such as depreciation that have not been recorded as part of your normal daily transactions. (More about depreciation in a moment.)

The P&L and balance sheet are interrelated. At the end of each year, the final net profit (or loss) shown on the P&L

is moved into the retained earnings account on the balance sheet. This allows the P&L to start again at zero for the following year.

For your reference, here are typical formats for a design firm's balance sheet and P&L. Sample percentages are shown to indicate the relative size of each category. Dollar amounts will of course vary based on the size of each firm.

Balance sheet format for design

Current assets
- Cash 16%
- Accounts receivable 45%
- Allowance for doubtful accounts 0%
- Work in process 10%
- Other 4%
- Sub-total current assets 75%

Long-term assets
- Furniture/fixtures/equipment 20%
- Computers 20%
- Autos 1%
- Leasehold improvements 7%
- Less: accumulated depreciation -28%
- Other 5%
- Sub-total long-term assets 25%

Total assets 100%

Current liabilities
- Accounts payable 11%
- Credit lines/short-term loans 9%
- Accruals 10%
- Client deposits 9%
- Other 7%
- Sub-total current liabilities 46%

Long-term liabilities
- Leases/long-term loans/other 11%

Owners equity

• Stock	5%
• Retained earnings	38%
• Sub-total owners equity	43%

Total liabilities and equity	100%

To help you become familiar with the format of the balance sheet, here are some simple explanations of the key categories and terms (your CPA will of course be able to provide you with much more detailed information):

Assets
Assets include anything of value owned by the firm. They are listed on the balance sheet in the order of their liquidity, which means how close they are to cash.

Current assets
These include cash and other items such as short-term investments that are expected to convert to cash within the next twelve months. How much cash should you have on hand? The general rule of thumb for a design firm is to accumulate an amount equal to three months of payroll and overhead. If something bad happens to your firm, such as the loss of several top clients, this cash reserve would give you some breathing room for making adjustments and recovering.

Accounts receivable
This is the total of all outstanding invoices that have been sent to, but not yet paid by, your clients. For most design firms, it is the largest current asset.

Allowance for doubtful accounts
Occasionally you might find yourself in a billing dispute with a client. As a result, you may not receive full payment on some invoice or other that you have submitted. When finalizing the balance sheet at the end of each month, the conservative approach is to prepare an adjusting entry to factor back the accounts receivable total by a few percentage points in order to allow for potential bad debts. The amount of the allowance will depend on your own history, but it is usually small. If you have been careful in selecting

credit-worthy clients, getting signatures on detailed proposals, and providing excellent customer service, you should have few disputes.

Work in process

The amount of work that you have put into active projects but not yet invoiced to clients is a valuable asset. In larger firms especially, a great deal of care is taken at the end of each month to calculate the value of the work in process that will be shown on the financial statements. There are two options for preparing this adjusting entry — one is to value the work at your net cost, and the other is to value the work at gross billing rates. Using the first method, unbilled project expenses that have already been posted to the cost of sales section of the P&L can be temporarily moved to the balance sheet and set up (at cost) as a type of inventory. In the second method, the unbilled project costs can be left on the P&L and an entry made to accrue the unbilled revenue (at contract billing rates) that relates to them.

Long-term assets

These include such items as computers, equipment, office furniture, and vehicles. When you purchase an item that costs more than $100 and has a useful life of at least three years, you will capitalize it (book it as an asset on the balance sheet) rather than expense it (post it directly to the P&L). The goal of this is to avoid distorting current profitability with the full impact of a large purchase. Also, a major purchase is usually financed, which allows you to match the long-term asset with a long-term liability (the loan payable), rather than depleting current cash.

Depreciation

Assets such as equipment and furniture will not last forever. Based on the useful life of each item (depending on the type of asset, this can be as short as three years or as long as twenty), an appropriate percentage of the purchase price will be expensed each year in an adjusting entry. There are various ways to calculate depreciation, but the simplest method is "straight line," which means that an equal portion will be expensed each year (see Figure 22.01). By the time the item is worn out, its book value as an asset will have been reduced to zero. Long-term assets also include real

Figure 26.01. In straight-line depreciation, the purchase price of an asset is divided by the number of years in its useful life. An equal amount is recorded as depreciation expense in each of those years.

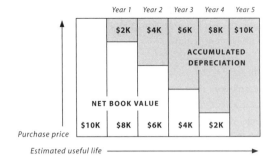

	Year 1	Year 2	Year 3	Year 4	Year 5
	$2K	$4K	$6K	$8K	$10K
			ACCUMULATED DEPRECIATION		
NET BOOK VALUE					
	$10K	$8K	$6K	$4K	$2K

Purchase price

Estimated useful life ⟶

estate. Business buildings can be depreciated, but land cannot. Many design firms do not own the buildings where they are located. If you are leasing a space and you make improvements to it (such as upgrading the wiring or remodeling), you can depreciate the cost of those leasehold improvements. The depreciation period will normally be the number of years remaining on the lease. (Your CPA will be able to answer any specific questions that you may have about depreciation.)

Liabilities
Liabilities are debts or other obligations that your business must pay at some point. They are categorized as either current or long-term.

Current liabilities
This includes anything that must be paid within the next twelve months. For example, bills from your suppliers (accounts payable) must usually be paid within thirty days. Client deposits are also included here because it's possible that some or all of the amount deposited would have to be returned if a project were cancelled. Bank lines of credit are also included here because they are intended for short-term use only.

Long-term liabilities
These are debts or other obligations that will be paid beyond the next twelve months. If you have taken out a business loan that will be repaid over a number of years, it will appear on your balance sheet in two separate pieces — the current portion and the long-term portion.

Owner's equity

This section of the balance sheet includes the original investment made by the founder(s) of the firm plus any profits that have accumulated over the life of the business. If the assets of the company were to be liquidated, it represents the portion of the proceeds that would come to the owner(s) after all debts had been paid. In a sense, it is the portion of the overall business that is currently owned free and clear.

Retained earnings

These are accumulated net profits that have been kept within the business. On financial statements, they are usually split into the subcategories of "current year" and "prior years." These retained earnings are held for future needs or for future distribution to the owner(s) of the firm.

Now let's turn our attention to the format of the P&L. Again, typical percentages are shown.

Profit and loss statement format for design

Income
- Labor billings 71%
- Billings for outside services and materials 29%
- Total income 100%

Cost of sales
- Direct labor costs 25%
- Independent contractors 5%
- Cost of outside services and materials 26%
- Total cost of sales 56%

Gross margin 44%

Overhead
- Indirect labor costs 11%
- Other operating expenses 22%
- Total overhead 33%

- Net profit before incentives 11%
- Incentives 6%

Net profit before taxes 5%

In these sample numbers, you can see that direct labor costs of 25% plus indirect labor costs of 11% mean that total payroll costs are equal to 36% of total income.

Here are some simple explanations of the other key terms and concepts involved in the P&L:

Income
This section includes all revenue of any type. For creative firms, most revenue comes from sales to clients, which should be split into two major categories: labor billings and billings for outside services and materials.

Labor billings
These are fees charged to clients for professional services provided by your staff.

Billings for outside services and materials
These include all third-party items that you have billed to your clients, usually at marked-up amounts.

Cost of sales
In order to produce billable work, you incur various costs directly related to active client projects.

Direct labor costs
Direct labor is the time that you and your team have spent working on active client projects. You should track those hours and use them to break out the billable portion of your payroll. Under normal circumstances, billable labor will represent roughly two-thirds of your total payroll. The remaining, non-billable portion of your payroll will be posted to the overhead section of the P&L (see Figure 26.02).

Independent contractor costs
Some creative firms rely heavily on freelancers. Others do not. When freelancers are involved, design firms track the expense separately but typically do not break it out as a separate line item when invoicing the client. If it is folded into the billings for professional services, this usually means that the work is being billed to the client at rates that would have been charged for staff labor. This is a different approach than simply marking up the freelance expense by a small percentage, as you would do with other outside costs.

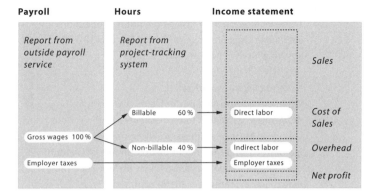

Payroll	Hours	Income statement

Report from outside payroll service

Report from project-tracking system

Sales

Billable 60% → Direct labor → Cost of Sales

Gross wages 100%

Non-billable 40% → Indirect labor → Overhead

Employer taxes → Employer taxes

Net profit

Cost of outside services and materials
These are amounts that the design firm has paid to third parties, usually for project supplies, materials, or outside services such as printing. They are recorded here at the amount that was on the vendor's invoice to the design firm. These project costs plus the markups added by the design firm will equal the total billings to clients for outside services and materials (discussed in the income section earlier).

Gross margin
This is a standard calculation that is used for businesses in nearly every industry except for advertising (more about that in a moment). Your sales to clients minus the direct costs of those sales (primarily labor and materials) equals the gross margin. After projects have covered their own costs, the gross margin is the additional amount that they have made available to the firm to be used for other purposes.

Overhead
This section of the P&L includes all general operating expenses that are not directly related to any particular client project.

Indirect labor costs
In each period, this is the portion of your payroll expense that was not directly matched to hours spent on active client projects. It includes marketing time, sick and vacation time, paid holidays, staff meetings, and secretarial or administrative activities. Typically this works out to roughly one-third of the payroll.

Other operating expenses
These include such things as rent, utilities, telephone, insurance, employer taxes and benefits, as well as the cost of your own marketing materials.

Net profit before incentives
When design firms are profitable, it's common for bonuses or incentive payments to be distributed to the various team members. Most often these are discretionary rather than guaranteed, and they might be determined on a monthly, quarterly, or annual basis. They may include such things as matching payments to a 401(k) plan, some type of general profit sharing, or perhaps individual bonuses to those personally responsible for successful projects or accounts.

Net profit before taxes
After any bonuses or incentive payments have been posted as expenses, this is the remaining profit that will be reported for business tax purposes.

Percentages
It's useful to look at each line item on the P&L as a percentage of total business income. Most financial software does this automatically. In design firms, it's also common to analyze each category of expense as a percentage of labor billings only. For the most part, graphic design firms concentrate on selling their own services, so it's typical for labor billings to be the major source of income. Material billings tend to be much smaller because many design firms do not want to take on the potential legal liabilities of brokering large amounts of printing or other third-party services. If something goes wrong with a third-party service such as printing, it's much safer for the designer if the client made the purchase directly.

So far, our discussion has focused specifically on graphic design firms. However, a few creative organizations are hybrids. They take on traditional graphic design assignments and, at the same time, create and manage advertising campaigns. This creates a challenge in the area of financial reporting. For comparison purposes, let's look at the standard P&L format that is used by advertising agencies.

Profit and loss statement format for advertising

Income

• Labor billings	16%
• Resale of media	55%
• Resale of outside services and materials	29%
• Total income	100%

Pass-throughs

• Cost of media placement	46%
• Cost of outside services and materials	24%
• Other project expenses	2%
• Total pass-throughs	72%

Agency gross income (AGI)	28%

Operating expenses	*of total*	*of AGI*
• All labor costs (direct and indirect)	15%	53%
• Other operating expenses	8%	28%
• Total operating expenses	23%	81%

Net profit before incentives and taxes	5%	19%

As you can see from this sample, advertising agencies use a P&L format that is quite different from the one used by graphic design firms. A standard gross margin is not being calculated. This is because a very large portion of advertising agency billings have traditionally been for the resale of media and third-party services, rather than for staff labor. Large outside purchases such as media placement are often referred to as "above the line" costs or "pass-throughs." This category also includes printing costs on any projects where the agency acts in the role of a print broker. The client is billed a list price — a marked-up amount that is higher than what the agency paid to the third party. When the costs of these large pass-throughs are subtracted from total billings, the amount remaining reflects the agency commission that was earned and the amount of any fee billings for labor.

Total billings minus all pass-throughs equals the "agency gross income" (AGI). The AGI must be large enough to cover all "below the line" costs (including all payroll and overhead

expenses) and still leave a net profit. For this reason, each "below the line" line item on an advertising agency's P&L can be analyzed in two different ways: as a percentage of the firm's total billings and as a percentage of AGI. If your firm does not do advertising, you should not use the AGI format.

Additional financial issues for design firms

In addition to fundamental business challenges such as developing effective pricing and cost controls, maintaining adequate cash, and managing debt, two additional issues are important specifically for design firms: maintaining balanced staffing and maintaining a healthy ratio of billable to non-billable hours.

Balanced staffing

As a design-centered organization, your business will consist of project teams supported by appropriate infrastructure. Overall headcount must be tied to workload as closely as possible. This means hiring very cautiously, particularly when it comes to support positions. As an example, let's say that your firm has a total staff of ten people. At least seven out of those ten employees must have the potential of being highly billable. That includes creative direction, design, pro-duction, and project coordination. No more than three out of the ten employees should be in support positions that do not have the potential of being highly billable, such as marketing and sales, finance, network administration/IT, reception, or secretarial. However, don't make the mistake of providing too little support. Your office will not run smoothly if no one is answering the phone and no one is balancing the books. The right level of support frees up the design staff to concentrate on client assignments.

Next, you must make sure that your new business devel-opment activities keep your office at or near your billable capacity. Initial hiring decisions will determine the billable potential of the firm, but once the staff is in place, you can only achieve that potential if new business development brings in a constant stream of appropriate new assignments. Strong billings will be the outcome of a healthy workload and good time management.

Individual billable potential

Designer		Hours	Percentage
Full-time schedule	52 wks x 40 hrs	2,080	100%
Less:			
Vacation	3 wks x 40 hrs	120	6%
Sick time	8 days x 8 hrs	64	3%
Public holidays	10 days x 8 hrs	80	4%
Admin, staff mtgs, etc.	45 wks x 5 hrs	225	11%
Marketing	0	0	0%
Total		**1,591**	**76%**

Figure 26.03. The billable target for a staff designer is often in the range of 75% to 80%.

Billable and non-billable hours for the individual
What is the highest billable potential for an individual staff position? To calculate this, start with the total of regularly scheduled hours, and then subtract all applicable vacation time, sick time, paid holidays, staff meetings, administrative time, and marketing activities. The hours remaining will be the maximum amount of regularly scheduled time that person has available to devote to client projects.

For example, the target for a staff design or production position might look something like Figure 26.03.

Many design firms state the billable target for each staff position in the initial hiring letter or employment agreement. Others negotiate targets at the beginning of each year. As a point of comparison, some law firms and accounting offices determine compensation on a scale, depending on how many billable hours the individual agrees to produce. This works well for a law partner who brings in his or her own accounts and bills on a time-and-materials basis, but it is less appropriate for design teams billing clients on a fixed-fee basis.

Billable and non-billable hours for the firm
The actual billable percentage achieved by the entire firm will be a combination of all the individuals involved. This statistic is also called "utilization" or "productivity." If you have the right staff mix to begin with and then maintain a good workload of client assignments, total utilization for a graphic design firm should be in the range of 60% to 65% (see Figure 26.04). Below this range, the firm will not be producing enough billable hours to sustain itself over the long haul. A low billable percentage usually indicates that

Figure 26.04. The total billable hours that can be produced by the company will depend on how many people you have in each role.

Company-wide billable potential

Staff type	Head count	Full-time	Total hrs	Billable	Target
Design	5	2,080	10,400	76%	7,904
Production	3	2,080	6,240	76%	4,742
Project mgmt	3	2,080	6,240	70%	4,368
New business dev	2	2,080	4,160	40%	1,664
Admin/finance	3	2.080	6,240	20%	1,248
Total	**16**		**33,280**	**60%**	**19,926**

there are too many non-billable people on the payroll and/or the billable staff members have not been given enough client work to do. At the other extreme, a long-term billable percentage above 65% can indicate that the workload is too heavy. This brings the risk of burnout for the team members producing the majority of the billable client hours.

In analyzing the time spent on client projects, keep in mind that there is a big difference between "billable" and "collectible." Even though someone reports extra project time, it might not result in any additional money coming in from clients. If an individual team member is falling short of his or her personal target, it might be tempting to pad a timesheet or two with additional "billable" hours. On a fixed-fee project, those hours would just sink the budget without changing any invoice totals. In a time-and-materials relationship, they would lead to very serious problems. Honest and accurate time reporting is an absolute requirement.

A note about marketing staff: the company-wide example given above shows a target of 40% for the new business development employees. This is explained in more detail in Figure 26.05. However, the real billable target for a marketing position will depend on how that role is structured in your particular firm. If the role is defined primarily as an external sales rep, then the billable percentage will be low. However, if your new business development person also spends time participating in active client projects as an account manager or a project manager, then the billable percentage will be higher. You will have to decide what mix of responsibilities is best in your own particular situation.

In each pay period, track the actual billable percentage for the full team, and use it to split your total payroll dollars

Individual billable potential

New business manager		Hours	Percentage
Full-time schedule	52 wks x 40 hrs	2,080	100%
Less:			
Vacation	3 wks x 40 hrs	120	6%
Sick time	8 days x 8 hrs	64	3%
Public holidays	10 days x 8 hrs	80	4%
Admin, staff mtgs, etc.	45 wks x 5 hrs	225	11%
Marketing	45 wks x 16.5 hrs	743	36%
Total		**848**	**40%**

Figure 26.05. The billable target for marketing managers is often in the range of 30% to 40%.

into the two categories discussed earlier: direct labor (project time that's included in the cost of sales) and indirect labor (non-project time that's included in overhead).

Benchmarks

Over time, you'll develop a sense of what the normal levels of activity seem to be within your own firm, but you need to use external references as well. Each month, compare your firm's performance to a basic set of industry norms. Key financial indicators fall into four categories: solvency, efficiency, profitability, and labor. Some of these are expressed as percentages while others are expressed as multipliers or ratios. Each ratio is the result of dividing one balance sheet or P&L item by another, so it is focused on a specific financial relationship. In each instance, the normal range varies quite a bit from industry to industry.

For your reference, here are explanations of key indicators in the four main categories, along with standard benchmarks for graphic design firms.

Solvency

Solvency is your company's long-term ability to meet all of its financial obligations. This is analyzed by comparing liabilities to assets. There are several different variations of this debt to assets comparison. You can look at just the current amounts, just the long-term amounts, or the combined totals. When analyzing solvency, assets other than cash can be taken into consideration because it may be possible to liquidate them to serve as an additional cushion against losses. It's advisable for design firms to be very cautious about taking on debt. Although debt is not necessarily "bad," it does require timely payments of interest and principal. The higher the level of debt that you take on, the

more important it is for your company to produce consistent profits and steady cash flow. This can be difficult if work comes to you primarily on a project-by-project basis and you have few, if any, longer-term client contracts.

Current ratio
Formula: current assets/current liabilities
Typical range: 1.6 to 2.2
Explanation: This is a measure of short-run solvency — that is to say the immediate ability of the firm to pay off short-term debts as they come due (as well as to cover any unforeseen cash needs in an unpredictable business environment). If you are thinking of borrowing money or applying for credit from major suppliers, those potential creditors will use this ratio as an indicator of how likely it is that you will be able to make required payments in a timely fashion. The 1.6 number stated above is not unusual for design firms, but it is actually too low for comfort. It is much better to have a current ratio of 2.1 or higher, indicating that for every dollar of debt coming due within the next twelve months, your firm has two dollars of cash (or assets that will convert to cash in that period) available to meet the obligation.

Quick ratio
Formula: (cash + accounts receivable)/total current liabilities
Typical range: 1.4 to 1.7
Explanation: This is sometimes called the "acid test" ratio because it's a more rigorous test of short-run solvency. It considers only cash, marketable securities (cash equivalents), and accounts receivable, because they are your most liquid assets. A quick ratio below the indicated range would not be considered healthy because it would imply that you are dependent upon assets that are less liquid to cover short-term debt.

Total liabilities/equity
Formula: (current liabilities + long-term liabilities)/equity
Typical range: 1.1 or less
Explanation: Another way to look at solvency is to compare a company's liabilities to its equity. This comparison is sometimes called the "debt to worth" or "debt to equity" ratio. It is a standard measure used by banks to determine the health of your firm. A debt to equity ratio lower than two to one is considered to be reasonable and safe for most

businesses, but the preferred limit for design firms is one to one. A high debt to equity ratio is a signal to creditors that a firm might be a credit risk because it is too dependent on debt to finance operations. A firm in this situation is described as highly leveraged, meaning that the amount of debt is quite high in relation to the owners' equity.

Efficiency
In general terms, efficiency is the ratio of the output of any system to the input. For design firms, this means how tightly you run your business. It includes such useful measurements as how quickly you collect money from clients, how heavily you rely on vendors, and how effectively you use your business assets.

Collection period in days
Formula: accounts receivable/(annual sales/365 days)
Typical range: 58 to 68
Explanation: This is the average length of time it takes to convert your sales into cash. There is a direct relationship between accounts receivable and cash flow. A longer average collection period means that more of your money is tied up in accounts receivable, and less cash is available for various other uses, such as paying bills. As you can see from the typical range listed here, many designers have difficulty enforcing the "net 30" terms printed on their invoices to clients.

Assets to annual sales
Formula: assets/annual sales
Typical range: 32% to 44%
Explanation: This is a general measure of your firm's ability to generate sales in relation to your total business assets. As you can guess, the best situation is to produce a high level of sales with only a modest investment in assets.

Accounts payable to annual sales
Formula: accounts payable/annual sales
Typical range: 2.4 to 4.2
Explanation: This measures the relative speed with which your company pays suppliers. If your numbers are higher than the typical range listed here, it is an indication that you are using vendors' assets (the cash that you owe to them) to fund your own operations.

Profitability

This is a very important category of financial comparison with other firms in your industry. There are four measures here that you will want to examine closely.

Gross margin
Formula: (annual sales — annual cost of sales)/annual sales
Typical range: 42% to 53%
Explanation: As explained in the P&L definitions earlier, the gross margin is the amount of money that projects, after they have covered their own direct labor and material costs, have made available to the firm for other purposes. If the gross margin is below the range indicated here, you should look at cutting project costs and/or increasing your prices (and maybe even reconsidering the mix of services that you are offering).

Pre-incentive margin
Formula: net profit before incentives/annual sales
Typical range: 8% to 11%
Explanation: Targets in some creative firms may range as high as 20%, but most graphic design firms are happy if they achieve an actual net profit of 10% for the year. Out of this profit, you will have to decide how much money, if any, can be awarded to team members as discretionary bonuses, profit sharing payments, or 401(k) matching contributions.

Pre-tax margin
Formula: net profit before taxes/annual sales
Typical range: 2% to 6%
Explanation: After discretionary incentives and bonuses have been recorded, this is the amount of profit that would be reported for business tax purposes.

Return on assets
Formula: net profit before taxes/total assets
Typical range: 6% to 14%
Explanation: This compares the pre-tax earnings to total business assets. The higher the number, the greater the return on assets. However, the desire to produce greater profits using fewer assets has to be balanced against other important considerations such as risk, sustainability, and necessary reinvestment in the business.

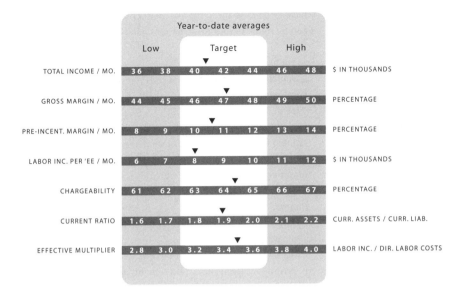

Year-to-date averages										
	Low			Target ▼			High			
TOTAL INCOME / MO.	36	38	40	42	44	46	48	$ IN THOUSANDS		
GROSS MARGIN / MO.	44	45	46	47	48	49	50	PERCENTAGE		
PRE-INCENT. MARGIN / MO.	8	9	10	11	12	13	14	PERCENTAGE		
LABOR INC. PER 'EE / MO.	6	7	8	9	10	11	12	$ IN THOUSANDS		
CHARGEABILITY	61	62	63	64	65	66	67	PERCENTAGE		
CURRENT RATIO	1.6	1.7	1.8	1.9	2.0	2.1	2.2	CURR. ASSETS / CURR. LIAB.		
EFFECTIVE MULTIPLIER	2.8	3.0	3.2	3.4	3.6	3.8	4.0	LABOR INC. / DIR. LABOR COSTS		

Labor

In a design firm, labor is the most important resource. It is the largest single expense, and it generates the majority of income. To be successful, you need to monitor the following labor indicators very closely. (Three of these are included in Figure 26.06, along with other key indicators.)

Effective multiplier
Formula: labor billings/direct labor costs
Typical range: 2.8 to 4.0
Explanation: This is sometimes called the "net effective multiplier" or the "direct labor multiplier." It is an important comparison of your project labor expense to the related client fees that are being generated. As a multiplier, it indicates that each $1.00 of direct labor expense typically generates about $3.50 in fee billings. Needless to say, a multiplier of 4.5 or 5.0 would be even better.

Total income per employee
Formula: total annual sales/average number of employees during that year
Typical range: $150K to $200K
Explanation: This can vary greatly, based on how you choose to do business. If you broker a lot of third-party services or

Figure 26.06. Track key indicators for your firm on a monthly basis. Select the indicators that are most meaningful and relevant to your activities. For each one, establish an acceptable range based on industry benchmarks. When your own performance strays outside of that range, it should trigger corrective actions to address the underlying causes.

have large pass-throughs like media placement, this number can be much higher than the range indicated here.

Labor billings per employee
Formula: annual labor billings only/average number of employees during that year
Typical range: $100K to $125K
Explanation: For most graphic design firms, this is a more reliable indicator of labor efficiency than total income per employee because it is not distorted by large billings for materials, printing, or other outside services.

Chargeability
Formula: direct labor costs/total base salaries
Typical range: 59% to 69%
Explanation: As explained in the P&L definitions earlier, this is your direct labor utilization rate. In each pay period, this identifies the portion of total staff labor that related to active client projects. Over the long haul, most graphic design firms seek to maintain a chargeability rate of around 65%.

Break-even multiplier
Formula: (direct labor costs + operating expenses)/direct labor costs
Typical range: 2.5 to 3.0
Explanation: This includes indirect labor and all other general and administrative costs (payroll taxes, benefits, utilities, rent, etc.) but not incentives or business taxes. As a multiplier, this means that for every $1.00 of direct payroll spent on projects, the typical design firm incurs an additional $2.75 of indirect operating expenses.

Overhead multiplier
Formula: (operating expenses + other expenses + interest expense)/direct labor costs
Typical range: 1.6 to 2.3
Explanation: Here, overhead expenses are calculated more broadly to include such things as the interest paid on loans, but it still does not include incentives or business taxes. The overhead multiplier tends to decrease when the firm

TALENT IS NOT ENOUGH: BUSINESS SECRETS FOR DESIGNERS

is busy. Lower is better. In good times, workloads increase and project schedules are tighter, which causes more of the payroll to be recorded as direct labor and less to be absorbed as overhead.

Some suggestions for staying on track
There are many things that you can do to maintain good financial health. For starters, make sure that you calculate a reliable budget for every project and build a reasonable profit into your client pricing. Then, strive to complete each project on budget.

Even when you are busy with active projects, keep an eye on your backlog (some firms call it the "pipeline"), which is the amount of client work that you have committed to do in the coming months. An increase or decrease in that backlog is a strong indicator of future sales and, by extension, an indicator of future profits or losses. Stay on top of this by maintaining a detailed projection of your firm's expected workload and billings. It should include current projects that are winding down, newly signed contracts that are ramping up, and potential projects that you are just now pitching. The value of the latter must of course be factored back to reflect your probability of landing them. The goal of the projection is to see how much of your firm's capacity is booked in each of the coming periods so that you can fine-tune your sales efforts and make any necessary adjustments to headcount. (For more information about forecasting, see Chapter 27.)

It's also wise to set some specific goals for the firm at the start of each business year. Goals should be aggressive enough that you and your team have to stretch to reach them, but never so wildly optimistic or unrealistic that they cannot be achieved.

Consider setting targets for each type of work that you do:

• Total revenue by project category
 This indicates how you want your portfolio to grow.

- Gross margin by project type
 Some types of work may be more profitable than others. Over time, a successful businessperson will seek to expand the services that are profitable and rethink the ones that are not.

Also consider setting targets that are client-related:

- Total revenue by client category
 The best way to insulate yourself against industry cycles is to seek out clients who are engaged in different types of businesses.
- No single client should represent more than 25% of your annual billings
 It's much safer to have several mid-sized accounts than to become dependent on a single large one.
- On a regular basis, compare client billings to client profits
 The most active accounts are not necessarily the most profitable. You may need to periodically adjust pricing or levels of service so that each individual account produces an acceptable margin.

Staying on track involves setting internal goals that are attainable and verifiable, capturing and measuring your actual activity completely and consistently, and benchmarking your firm's performance against that of your professional peers. Being successful also requires that you constantly look for and adjust to trends in your clients' industries and in the general economy.

Chapter 27:
Forecasting

In most design firms, the overall workload is uneven from month to month. This makes it difficult to have the right resources in place when they are needed. If you don't have a reliable method of forecasting the workload, you could easily find yourself overstaffed (and unprofitable) or understaffed (and having difficulty delivering on client commitments). In this chapter, we'll discuss two different types of forecasting for design firms: the first is a short-term projection of the workload based on specific projects and client accounts; the second is a longer-term projection of overall financial activity based on past performance, adjusted for new assumptions about market conditions.

Of course, trying to predict anything is a guessing game. However, if you come to the process with enough relevant information, you can in fact get useful results. The crystal ball needs to clear up just enough to give you an indication of whether your company will be at or near its productive capacity. As soon as you know this, you can make any necessary adjustments — such as accelerating (or perhaps delaying) the start of any large new projects or arranging for more (or fewer) resources. In particular, a reliable projection of the workload can help you determine whether any changes might be needed to your company's head count.

Prerequisites

Before you can begin to predict tomorrow's workload and finances, you need to know exactly where you stand today. This essential business information needs to be coming to you already:

- Daily project balances
- Weekly summaries of new business activities
- Monthly financial statements

Let's take a quick look at each of these individually.

Daily project balances

It's vital to track the time and materials going into open projects. You need easy access to real-time totals of labor and outside costs, which means that daily posting of timesheets and vendor invoices is required. Many different project-tracking systems are available. Among other capabilities, the system you select must compare estimates to actuals and calculate the remaining balances on projects. These numbers are necessary for the workload projection that we'll be discussing in this chapter. Also, keeping a close eye on the time and materials remaining is an essential part of tracking the burn rate on large projects, as we discussed in Chapter 25.

Weekly summaries of new business activities

Your weekly recap of all new business development efforts should include rough estimates of the schedules and expected billings for pending projects. Quantify each opportunity as best you can. Also, make sure you're capturing all marketing activities. In many studios,

several people are involved in soliciting new projects. Preparing and discussing a weekly recap allows the group to exchange information, develop shared priorities, and coordinate efforts.

Monthly financial statements
Your monthly financial statements (balance sheet and P&L) must be timely and accurate. As discussed in Chapter 26, you need to track key financial indicators and watch for trends. To help with this, it's a great idea to maintain a set of monthly charts to visualize the data. (We'll come back to the topic of charts in a moment.)

If you have all of these prerequisites in place, you're ready to move forward to the process of preparing projections. Our discussion will focus on two formats. First let's examine a short-term approach.

Short term
This type of forecast can be described as a "bottom up" projection because it's built up from specific details about active projects and client accounts. It's quite realistic because it's firmly anchored in today's information. The general concept for this is visualized in Figure 27.01.

In preparing this projection, you'll be bringing together two sets of current numbers — actual projects that are winding down plus new business that you expect to be ramping up. Figure 27.02 contains some sample data in this format. As you can see, the upper portion of the worksheet shows active projects. The columns show the approved total for each project, minus the amount already billed, leaving you with the amount remaining. This remaining balance is then spread across the number of months left in the schedule.

Please note that we're looking at dollars rather than hours. This means we're making an important assumption that the two are still largely in sync. However, this might not be the case if you're working on a fixed-fee project that has turned out to be much more labor-intensive than you originally anticipated. The real work might extend beyond the end of the negotiated billings. As you read down this list of open projects, you'll see that some have just begun, while others

are almost finished. When each project does come to an end, the individuals or teams involved will become available for new assignments.

Now let's move to the middle section of this worksheet. It shows potential new projects that will be ramping up. Each new business opportunity has been assigned an estimated schedule and a total billing value. To be conservative, these estimated billings must then be factored back to reflect the probability of you landing the assignment. This probability factor is a judgment call. If a potential project is add-on work for an existing client, it's an initiative that the client is definitely committed to and you know for certain that no other studios are being approached, then you'll assign a high probability. In contrast, if you're in a competitive bidding situation to land a new client and you know they're talking to three or four different firms, you'll assign a lower probability. Your chances may be one in three (33%) or one in four (25%).

Compiling this new business data every week is an ongoing challenge. To quantify each opportunity, you need to be far enough along in your conversations with the client to have sufficient information for your assumptions to be reliable. Any preliminary conversations that are still too vague for you to quantify should only be listed here with zeros.

Regarding schedules: the upper portion of this projection should guide you in setting potential start dates for future work. Obviously, you can't promise to start a big new project tomorrow if you already know that the essential resources for it are still tied up with a previous assignment.

The next step in preparing this short-term projection is to combine the two pieces we've been discussing: project tracking data plus new business information equals a rough projection of the total workload. Based on this projected workload, we can now estimate the total head count that will be needed. At the bottom of Figure 27.02, the monthly number shown for "head count required" is a very loose estimate — it should be calculated using your own firm's history of average billings per person. This is not an exact

Figure 27.01. The projected workload includes current projects winding down and new projects ramping up. Ideally, the combined total is close to your firm's productive capacity.

science. It's just a very quick and simplistic comparison of total employees to total revenue. The number includes all staff, not just those doing hands-on creative work. Billings per person can vary quite a bit from firm to firm, depending on the nature of the work being produced by your employees and the amount of third-party services being purchased. For example, a media placement firm could have very high billings but a low head count.

As we discussed in Chapter 26, design firms often expect annual labor billings to average somewhere between $100K and $125K per person. This represents a monthly average of approximately $8K to $10K. For discussion purposes, if your projected monthly billings for the entire company are about $200K and your past billings per employee have averaged $10K per month, then you would need approximately 20 people to support the projected workload.

Once you've calculated the head count required, compare it to the actual size of your staff. The two totals will never be an exact match because capacity and demand are never entirely in sync. However, if the discrepancy between the

Figure 27.02. This short-term projection shows the workload in terms of anticipated monthly billings. From this, we can develop a rough idea of the head count necessary to produce the work.

PROJECTED BILLINGS / WORKLOAD						OCT	NOV	DEC	JAN	LATER
Client	Project	Approved total	Already billed	Amount remaining		**JOBS CURRENTLY ACTIVE**				
Alpha	identity	95,000	50,000	45,000		45,000	0	0	0	0
Alpha	brochure	25,000	15,000	10,000		10,000	0	0	0	0
Bravo	prospectus	20,000	10,000	10,000		5,000	5,000	0	0	0
Bravo	b/w ads	15,000	6,500	8,500		4,250	4,250	0	0	0
Golf	research	40,000	10,000	30,000		10,000	10,000	10,000	0	0
Sierra	packaging	60,000	10,000	50,000		12,500	12,500	12,500	12,500	0
Tango	signage	50,000	0	50,000		0	16,667	16,667	16,667	0

Prospect	Project	Possible total	Probability factor	Probable total		**POTENTIAL NEW JOBS**				
Alpha	templates	30,000	100%	30,000		0	10,000	10,000	10,000	0
Bravo	site update	90,000	90%	81,000		0	20,250	20,250	20,250	20,250
Foxtrot	trade show	85,000	80%	68,000		0	0	22,667	22,667	22,667
Golf	branding	80,000	50%	40,000		0	0	13,333	13,333	13,333
Hotel	banner ads	40,000	33%	13,200		0	0	4,400	4,400	4,400
Zulu	identity	95,000	25%	23,750		0	0	0	7,917	15,833
Zulu	guidelines	65,000	25%	16,250		0	0	0	0	16,250

All amounts as of:
October 1

COMBINED TOTAL				
86,750	78,667	109,817	107,733	92,733

HEAD COUNT REQUIRED				
8	8	11	10	9

two is large, you should consider making some changes
to your resources.

If the projection indicates that you're going to need more
people than you currently have, you now have some lead
time for booking freelancers or making new hires. In many
industries, managers think it's desirable to have demand that
is slightly beyond regular capacity because it puts pressure
on the company to become more organized and efficient.
In manufacturing, a short-term spike in demand temporar-
ily takes the company into overtime capacity. If workers are
being paid on an hourly basis, overtime scheduling results in
increased costs. Analysis is done to make sure the additional
costs are more than offset by increased sales.

In contrast, design firms usually pay creative team members
a fixed salary. This means that temporary spikes in the work-
load can result in additional billings without any change to
labor costs. (Some design managers refer to this short-term
dynamic as "compression.") However, if such a situation con-
tinues for too long, it has the very real potential of lowering
morale, which negatively impacts the quality of work being
performed. It also leads to employee burnout.

The opposite situation would be a design firm operating
below its regular capacity. If there are not enough client
projects to go around, a portion of the workforce will be
idle. Typically, design firms have limited financial reserves,
and they cannot afford to carry labor costs that do not
contribute in some way to client billings. If your short-term
projection indicates a workload that is too light to support
the number of people on the payroll, you might consider
several management options:

- Step up marketing efforts to bring in more
 project opportunities
- Move up the start dates on new projects that
 have already been approved
- Temporarily round out the workload with in-house
 projects, such as updating your Web site
- Encourage employees who are between assignments
 to begin using accumulated vacation time
- Consider whether or not the overall staff size needs
 to be reduced

Obviously, staffing and payroll issues are very important to your company and to the individual people involved. You won't make such decisions lightly. Fine-tune the format of your short-term projection to fit your own company's situation more closely, and make sure all of the numbers are as current and reliable as you can make them. Run this projection at least twice over the course of a month before making any decision about resources.

In the field of personnel management, issues related to projected staffing levels are often referred to as "workforce planning." Every business faces the challenge of having the right workers with the right skills at the right time. Head count is only one aspect of this. You must also consider skill sets.

The supply and demand equation for specific creative skills is different in each city. As a design firm owner or manager, you are of course on the demand side of this equation. Keep in mind that the requirements of your organization today may be different from tomorrow. You may need to make gradual changes to the mix of skills if your firm is evolving away from one design discipline and toward another. New project types will require different design and implementation capabilities. On an even larger scale, you might be contemplating a shift in your company's basic business model. If so, the staffing implications could be significant. For example, if you move toward more brokering of third-party services, it's likely that your company will need a much smaller core staff.

At this point in your planning process, you've determined whether different skills need to be brought into your organization. If the answer is yes, we need to shift our attention to the supply side. What are the conditions in your local labor pool? Is the available workforce supply a match to your company's needs? How many good designers are available in your particular discipline and how much competition is there for them? Recruitment of creative staff tends to be a slow and careful process. In the meantime, you might need some immediate

assistance in producing short-term projects. If so, it may be possible to bring in one or two freelancers on short notice. To keep this option open, you need to consciously maintain a broad professional network, with information about who is available, their specialties, and their billing rates.

To effectively manage long-term client relationships, however, you'll want to assign staff members to important accounts. If you've done a good job of forecasting, you should have enough lead time to go through a careful employee recruitment process. This can easily take a month or more.

One final note about the format of this short-term projection: when you prepare the worksheet for your own firm, the time frame may vary — that is to say, you might need more columns on the right side. Four or five months, as shown in our example, would be a typical horizon for many graphic design firms, which tend to have lots of small, fast projects. In contrast, six months or more would be typical for product development or environmental graphic design firms, where projects tend to be larger and have extended schedules.

Long term

Now we're ready to discuss a longer-term projection, meaning one that covers a year or more. This type of forecast can be described as "top down" because it's a forward projection of total financial activity based on your company's past performance. It is not built up project by project. In accounting, this is called a "pro forma projection," from the Latin meaning "according to form" or "as a matter of form." This term is used to identify financial statements that have one or more assumptions or hypothetical conditions built into the data. (For example, our focus is on regular business operations, so we're assuming there won't be any extraordinary charges or expenses such as those related to a merger or acquisition.) Our projection will show the world on an "as if" basis — that is to say, its accuracy depends on whether the underlying assumptions hold true.

ACTUAL	J	F	M	A	M	J	J	A	S	O	N	D	J	F	M	A	M
Sales	170	315	356	270	318	263	273	242	198	299	331	343	373	419	428	358	408
Cost of sales	85	158	178	135	159	132	137	121	99	150	166	172	187	210	214	179	204
Overhead	152	112	98	110	90	107	110	115	150	108	108	104	100	90	87	118	92
Profit	-67	45	80	25	69	24	26	6	-51	41	57	67	86	119	127	61	112

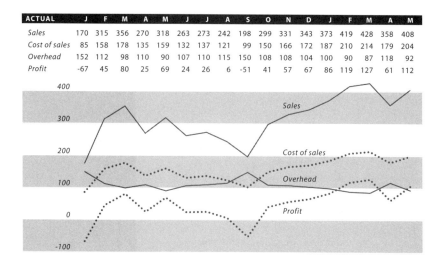

Figure 27.03. A long-term chart of actual monthly totals from the P&L will help you recognize seasonal patterns and identify your break-even point. (In this example, the firm tends to lose money when monthly sales fall below $250K.)

For creative firms, this long-term projection is primarily sales-driven. Expenses are planned in relation to expected revenue. We're taking last year's actual numbers for monthly sales, expenses, and net profits, and we're projecting them forward in a conservative way, adjusting specific amounts as necessary to reflect anticipated changes in client relationships as well as any new assumptions we have about overall market conditions.

One of the big benefits of this extended time frame is that it allows us to analyze whether past activity has followed a seasonal or annual cycle. In many companies, history shows recurring fluctuations in the demand for particular services. For example, if you design annual reports or if you produce marketing materials for retail stores, you'll see that certain months have always been much busier (or quieter) than others.

The first step in developing your long-term projection is to prepare a spreadsheet with actual income and expense data for the past twelve months. If you use a common spreadsheet application such as Excel, you might not have to format everything from scratch — lots of preformatted templates are available that have all the mathematical formulas already in place (one free online source is

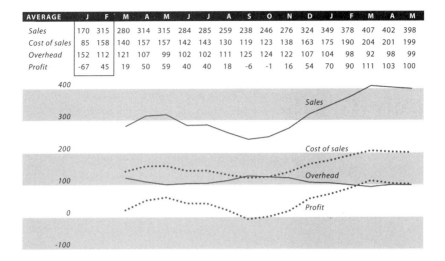

AVERAGE	J	F	M	A	M	J	J	A	S	O	N	D	J	F	M	A	M
Sales	170	315	280	314	315	284	285	259	238	246	276	324	349	378	407	402	398
Cost of sales	85	158	140	157	157	142	143	130	119	123	138	163	175	190	204	201	199
Overhead	152	112	121	107	99	102	102	111	125	124	122	107	104	98	92	98	99
Profit	-67	45	19	50	59	40	40	18	-6	-1	16	54	70	90	111	103	100

http://exceltemplates.net). As soon as you've entered your historical data, start a companion worksheet in the same format and plan out your expectations for the future twelve months.

The next step is to visualize your data by preparing two charts. Even if you tracked down a preformatted spreadsheet, you'll probably want to create your own chart format. As a reference, Figure 27.03 shows a sample. As you can see, four separate lines are being plotted, showing monthly totals for sales, cost of sales, overhead, and net profits (or losses). Your goal in this is to have side-by-side charts that allow you to visually compare the recent past with the anticipated future.

I must add one quick note regarding the line that represents your monthly cost of sales: as we discussed in Chapter 26, payroll expenses should be split based on the actual billable/non-billable hours reported in each pay period. Billable labor is part of your cost of sales, while non-billable labor is part of overhead. This means that when your sales go down, the line for cost of sales will also go down if you're doing a good job of matching project expenses to project billings within each period, but overhead will go up because of the increased non-billable time being reported.

Figure 27.04. A three-month moving average smooths out monthly volatility and makes it easier to see overall trends. This is a good basis for making forward projections.

For comparison purposes, you may want to chart your performance against industry benchmarks for cost of sales, overhead, and net profit. The best way to do this is to prepare three small supplemental charts, each with just two lines: one for your actual monthly activity (which will be jagged) and another for the industry average (which will be a straight horizontal line). Benchmarks vary from one creative discipline to another. You'll have to do some research to find numbers relevant to your specialty. As an example, here are typical P&L percentages for graphic design firms:

Sales	100%
Cost of sales	56%
Overhead expenses	33%
Net profit before incentives and taxes	11%

Chart variations
Some firms take a slightly different approach to long-term projections by calculating a "moving average." In statistics, a moving average (also called a "rolling average" or "running average") is used to smooth out brief fluctuations and highlight longer-term trends or cycles. Each new month's numbers are added to the average, and the oldest month is dropped. This is how the average moves forward in time. In general, the shorter the time frame used, the more volatile the activity will appear. For our purposes, a three-month average works well. Figure 27.04 shows an example.

If you've calculated a moving average as the basis of your revenue trend, you might also want to add a "head count required" calculation, just as we did with our earlier short-term forecast. The moving average has given you a steadier base for head count planning than actual monthly sales numbers, because it shows fewer sudden changes.

Another variation for charting revenue is to split your sales history into layers representing your major client categories. This allows you to visualize which ones have been gradually expanding or contracting. Then you can project those layers forward to reflect what you know about industry conditions plus any changes you plan to make in your marketing focus.

Best guess

Ultimately, this long-term projection is your best guess of what will happen, based on the information available to you on the date the projection was prepared. As noted earlier, it's also based on a series of underlying assumptions. Perhaps the most basic of these is that your company is a "going concern." This is a term used by accountants; it refers to a company that is in solid financial shape and can continue operating for the foreseeable future. For this to happen, your company must have several important attributes:

- An active base of regular clients
- Employees who know the business and have strong working relationships with clients and suppliers
- Equipment, furniture, fixtures, and similar assets that are in good condition and still being depreciated (meaning that they are still within their expected useful life)
- Verifiable profits over several years (as evidenced by tax records)
- Positive cash flow (enabling the company to cover ongoing operational expenses)
- The ability to pay off any long-term debts within a reasonable time frame

If your design firm is indeed a going concern, then you have some momentum carrying you forward. A certain base level of activity can be predicted with some confidence. On top of this, you may also be planning for growth. If so, you have to decide how optimistic and how flexible your plan will be. One approach is to define a range for acceptable performance. This involves projecting a conservative trend line that is as realistic as you can make it and then allowing for variations of plus or minus 5%, creating a range of acceptable performance that is ten percentage points wide. One of the benefits of this approach is that it allows you to manage by exception — corrective action will be triggered if and when actual monthly performance strays outside of the allowed range.

Reaping the benefits

Both short-term and long-term forecasts take a lot of work to put together, but the process of preparing them will generate significant benefits for your creative firm:

- You'll keep a closer eye on current balances for active projects.
- You'll quantify all new business expectations.
- You'll link your firm's staffing level more closely to the workload.
- You'll set specific targets for future financial activity.
- You'll track and respond to trends more quickly.
- You'll have fewer bad surprises.

Just remember that for this "distant early warning" system to be as effective as possible, you need to update your forecasts with fresh data on a regular schedule.

Chapter 28:
Business planning

Conventional wisdom is that a business plan must be written before a company is launched, especially if outside financing is needed. So why is this chapter on business planning closer to the end of the book than to the beginning? Frankly, it's because many design firms do not have a business plan. If they do, there's a good chance that it was written several years after the business started. Many of us ease into business based on project opportunities that come our way. A few big projects and a few loyal clients can enable a freelance career to gradually expand into a successful small office. Often there's no outside pressure to produce a business plan.

If you've been freelancing for a while, you might already own most of the equipment and software required for the company, and start-up capital needed for other purposes may be minimal. So, if your design firm is already operating successfully, why would you want to write a business plan after the fact? The answer is that the document itself is part of a larger strategic planning process.

Planning process

Writing a business plan involves asking yourself a series of hard questions about the work that you're doing and the direction in which you're heading. Young firms tend to take shape in a reactive way, accepting any project that comes along. Eventually, though, you'll decide that it's time to become more proactive and exercise greater control over the evolution of your firm. The business planning process is an opportunity to evaluate your situation, think through every aspect of your operations in a thorough and systematic way, and bring everything into alignment. You'll analyze recent trends and then project them forward in order to set realistic goals for the next three years. Most importantly, writing a business plan is not a one-time effort. It's just one part of an ongoing strategic planning process that can help your firm reach its full potential.

Business plan contents

The structure of the business plan document reflects the logical sequence of issues that need to be considered. It starts with a very broad-brush description of the company, gradually becomes more specific, and ends with detailed projections of financial activity. The exact details of the document vary somewhat from industry to industry. For creative firms, the outline usually looks like this:

- Executive summary
- Values statement
- Vision statement
- Mission statement
- Goals
- Description of services
- Business environment and market trends
- Client profile
- Evaluation of your competition
- Sustainable advantage

- Marketing plan
- Operations plan
- Human resources plan
- Technology and physical facilities plan
- Financial plan for the next three years

Let's look at each of these sections individually and discuss the content that you need to prepare.

Executive summary

Even though this is the first section in the document, it's actually written last. It summarizes the most important information from each of the other sections and shows how all of the pieces are working together toward the same goals. It identifies the critical success factors for your type of firm. The executive summary should not be more than one or two pages long. It provides an overview of the firm for any reader who's not already familiar with the company, such as a loan officer at a bank or a potential investor.

Values statement

A lot of books have been published about the process of writing a business plan. However, most of them make no mention of a values statement. That's because many entre-preneurs are simply looking for a market opportunity that will support a successful launch and produce a profit. For example, if research indicates that a particular neighborhood needs a dry cleaner or a car wash, that's the type of company that many entrepreneurs will be happy to launch — not because they're passionate about the nature of the business but because they recognize that it's in demand, will generate a profit if planned and managed efficiently, and can easily be sold to a new owner at a future date. There is no larger philosophical context.

The situation is different for designers. We're passionate about our profession and the positive impact that our work can have on society. For us, design is a problem-solving process, and we're painfully aware that the world is full of important problems crying out for solutions. Through the design of companies, products, services, environments, and systems, we have the opportunity to create value, increase understanding, and improve the quality of life.

This strong sense of purpose must be reflected in your business plan. A clear values statement will lay out the principles that guide your business activities. It should be concise, compelling, and sincere. These core values do not change over time. They will guide your decision making whenever you're faced with tough choices. For example, your values statement might emphasize:

• Using the power of design to

Vision statement

From a statement of values and philosophy we now turn to a statement of business objectives. Write a sentence or two describing the long-term objectives of your firm. This announces where your company wants to go — the ultimate level to which you aspire. Make it ambitious but attainable. Your business aims may be lofty, but they must still be within the realm of possibility. Here are some examples:

• Attaining a reputation for world-class
• Becoming the leading provider of
 in the region.
• Achieving a dominant market position in

It's important to have a solid understanding of your own intentions. You must define where you want to go so that you can chart a course. Like your values statement, the business vision will remain constant. You will be continually working toward these long-term objectives.

Mission statement

From a future-oriented statement, we now turn to a snapshot of where you are today. This is your "elevator speech" — a capsule description of your firm. It should only take a few moments to recite. It should not be vague. Make it specific and understandable to a layperson. Write a couple of sentences that state clearly:

• What kind of firm you are
 (Is your primary discipline graphic design, interaction design, product development, advertising, or something else?)
• What you sell
 (Name the two or three specific services that comprise most of your billings.)

- Who buys your services
 (These are your markets — the client categories where you have the most experience.)
- Your competitive advantages
 (Why do clients buy from you instead of someone else? What sets you apart from other firms that provide similar services?)

Your mission statement is your message to the marketplace. Keep it brief. You'll analyze your services, clients, and competitive advantages in much more detail in the remaining sections of the business plan.

Your company's mission statement must be updated periodically. Because it's a snapshot of the firm at a given moment in time, the contents must change to keep pace with the evolution of your business activities. You should also keep it visible to clients and employees. Many design firms post it on the home page of their Web site and feature it prominently in their marketing materials.

Goals

Business goals are short-term aims that are stated in numeric terms, such as the number of client accounts, total annual billings, size of staff, or number of offices. Goals should include time frames and deadlines. For example, one of your goals might be to reach one million dollars in annual sales by the end of the calendar year. Setting specific short-term goals is a way to motivate yourself and focus your energies. You define the successful end result and then determine the steps that will get you there. Each goal is accomplished through a series of next actions. In the remaining sections of the business plan, you'll explain exactly what you'll do to reach these goals.

Description of services

Chances are that your firm will be providing more than one type of creative service, but it's important to recognize that you can't be everything to everybody. To be successful, each firm needs a primary focus. As the founder, you get to decide what that focus will be. Make a choice that emphasizes your strengths and your professional experience.

What are you best at, and what do you enjoy the most? Take a look at your past work — what has been most successful and profitable for you? As a smart businessperson, you'll steer away from things that you don't enjoy, are not good at, or lose money on.

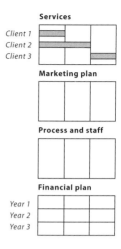

This section of your business plan describes your core competencies — the categories of work that you specialize in. For example, within the field of graphic design, the primary emphasis of a new firm might be on corporate identity, packaging systems, collateral materials, or other specialties. In interaction design, the primary focus could be on Web development, mobile application development, or another type of work. In product development, you might focus on industrial design, engineering, or perhaps a related service. In advertising, the initial creative focus of your firm could be on broadcast, print, online marketing, or a related specialty.

Figure 28.01. If you provide services that are not closely related, each category of service should have its own planning track. Many client relationships will not span the categories.

Many firms identify two or three primary categories that are closely related to one another. If your clients make other requests, you will, of course, accommodate them if you are able, but you can't effectively position yourself in the marketplace as a leading expert in ten different specialties. Trying to do so would stretch the resources of even the largest creative organization. It's a mistake to take a scattershot approach. Trying to be all things to all clients runs the risk of sending a negative message to the marketplace. Your firm could appear desperate — perhaps even a bit schizophrenic.

Select your areas of specialization carefully because much of your later planning will depend upon these decisions. If you select specialties that are not closely related, then your planning must be in two or three tracks to reflect the fact that different resources and processes will be involved and that different pricing and marketing strategies may be necessary (see Figure 28.01). Keep in mind that innovative services involving newer technologies tend to command premium prices and produce wider margins, but they also place continual pressure on you to stay one step ahead of the competition.

Business environment and market trends

In selecting your areas of specialization, it's important to focus on areas where there will be ongoing demand. For this part of your plan, ask yourself some tough questions: How much demand currently exists for the services that you want to provide? Will demand be increasing or decreasing over the next three years? Where are the greatest opportunities? Your answers need to be based on research, not personal opinion or wishful thinking.

Chances are that you're already aware of trends in the overall economy. Recurring cycles of expansion and recession have a great impact on consumer confidence, corporate spending, and the availability of financing. Beyond this, though, you need to analyze trends in your clients' industries. The opportunities for you will not be the same in all industries — some will stand out.

You'll be preparing an overview of each client industry that you're interested in. The goal is to describe the current trends and future prospects — are they shrinking, stable, or growing? In each industry, the current condition and the anticipated growth rate are important factors in determining the approach that companies will take to such matters as new product development, marketing initiatives, and advertising campaigns.

Many designers say that this is the most challenging section of the entire document to write. Your research will take time, and along the way, you should be prepared to spend some money if necessary for key bits of information. The following advice will help you through the research process.

To start your research, look up the industry codes for your major client categories. There are two sets of codes currently in use. The SIC (Standard Industrial Classification) system has been used by the U.S. government to track economic activity for many years. In fact, because of the age of the system, it doesn't track newer industries very effectively. Emerging industries tend to be lumped in with their

predecessors, even though data that mixes several different business activities together can be misleading. For this reason, the SIC system is gradually being replaced by a newer set of codes called NAICS (the North American Industry Classification System). To look up the SIC and NAICS codes for your clients' industries, use these online indexes:

- U.S. Department of Labor,
 Occupational Safety and Health Administration
 www.osha.gov/pls/imis/sicsearch.html
 (You can search SIC classifications by keyword.)

- Log Link / Logistics World
 www.loglink.com/sic.asp
 (You can search SIC and NAICS codes
 by category or keyword.)

These codes will come in handy for tracking down statistics and industry forecasts. While you're at it, be sure to get the codes that apply to your own type of business as well. (For example, graphic design is NAICS 54143 and SIC 7336, industrial design is NAICS 54142 and SIC 7389, and the codes for advertising are NAICS 54181 and SIC 7311.)

Lots of free information is available from the federal government in databases like the following:

- U.S. Census Bureau,
 Economic Programs
 www.census.gov/econ/www/index.html
 (The government conducts a census of U.S. businesses
 every five years and then publishes economic statistics
 by industry and by location.)

- U.S. Department of Commerce,
 Bureau of Economic Analysis
 www.bea.gov
 (This site has detailed statistical data on annual
 income and expenditures for more than
 sixty industries.)

- U.S. Department of Labor,
 Bureau of Labor Statistics
 www.bls.gov/oco/home.htm
 *(The BLS updates its Occupational Outlook Handbook
 every two years. Each type of business activity has
 a "job outlook" section with current employment
 information plus a ten-year projection.)*

- FEDSTATS
 www.fedstats.gov
 *(This is a gateway to additional government
 statistics from over 100 different agencies.)*

When looking at government information, keep in mind
that some of it may not be very current. For this reason,
your next task is to find non-governmental sources of data.
Fast-moving industries with new categories of products and
services are often profiled in general business publications
like *The Wall Street Journal* and *BusinessWeek*. You can use
search engines like Google and Yahoo! for industry outlook
articles. Be sure to visit:

- Yahoo! Finance
 Industry Center
 http://biz.yahoo.com/ic/
 *(This includes market summaries and a chronological
 listing of recent news stories by industry.)*

Next, identify trade magazines and specialized journals
for the industries you're interested in. They're great sources
for articles on trends. Often, subscribers are able to search
past articles online. You might also consider requesting
a media kit, which is a packet of information sent out to
advertisers with statistics on audience size, demographics,
and purchasing habits.

Every industry has its own trade associations. They
often conduct surveys and publish information about
current conditions and trends that are affecting their

members. Here's a good resource book that you can
find in most libraries:

- National Trade and Professional Associations Directory
 www.columbiabooks.com/ntpa.cfm
 (Published every year by Columbia Books, this
 directory lists national membership organizations
 by name, subject, location, and annual budget.)

Many trade groups produce annual conferences. Identify
the business events that are most important to your
clients. Here's a helpful site:

- Trade Show News Network / The Tarsus Group
 www.tsnn.com
 (This is an online trade show directory
 that you can search by industry.)

Many trade shows have Web sites that are kept online
after the event. Visit the sites of recent conferences to
learn about presentations and exhibitors. If possible, attend
upcoming events to conduct in-person research. This is
a great way to identify the major players, view the products,
pick up literature, and meet marketing representatives.
(It may also be possible for you to buy lists of attendees
that you can use for promotional mailings.)

Now that you've analyzed the industries, you're ready
to focus in on individual companies.

Visit the sites of key players. Research the companies
that caught your interest at trade shows. If a corporation
is publicly traded, you can request a free copy of their
most recent annual report. It will provide you with detailed
information about their business. Some companies place
a PDF version of the report on their Web site. Others make
copies available through independent services such as:

- AnnualReports.com / IR Solutions
 www.annualreports.com
 (They provide online annual reports to
 individual and institutional investors.)

- The Wall Street Journal Online
 Annual Reports Service
 http://wsjie.ar.wilink.com/v5/index.asp?cp_code=WSJ3&
 *(This is a central source for reports from a wide
 variety of companies.)*

There are many investment-oriented sites with profiles
and financial summaries of publicly traded companies.
Take a look at:

- Quote.Com / IDC
 www.quote.com
 *(They have company overviews, summaries
 of stock performance, and recent news.)*

- U.S. Securities and Exchange Commission
 www.sec.gov/edgar.shtml
 *(The EDGAR database contains registration statements
 and periodic reports by domestic and foreign companies.)*

At this point in your research, you'll have to make a judg-
ment call. If there are still gaps in the information that
you need for your business plan, you may want to use paid
information providers. It's possible to buy a wide range of
current information about industries and companies. Many
of these services provide basic information for free, but the
objective is to tempt you into buying more comprehensive
reports (and, in some instances, subscribing to ongoing
research services). Here are a few sources for you to consider,
along with some current pricing information:

- Dun & Bradstreet, D&B Small Business Solutions
 *http://smallbusiness.dnb.com/make-informed-business-
 decisions/12316286-1.html*
 *(Their $30 "Industry Report" provides an overview
 and analysis, with profiles of top companies.)*

- Hoovers
 www.hoovers.com
 *(Hoovers is owned by D&B. Their free information about
 companies and industries includes overviews and lists of
 key people. You can pay to build a custom list of companies
 that match criteria you define. You can also purchase
 a range of in-depth D&B reports.)*

- Goliath / The Gale Group
 http://goliath.ecnext.com
 *(For $29.95, you can request a "Company Profile" or
 an "Industry and Market Report" by SIC code. The site
 also has a "Business News" database of recent articles
 that can be searched by keyword. Payment is required
 to view the full text.)*

- Integra / MicroBilt
 *www.microbilt.com/financial-benchmarking.aspx
 (This market research company sells industry reports
 by SIC code. Their $70 "Industry Growth Outlook Report"
 recaps financial activity for the most recent five
 years and then projects five years into the future.
 More detailed information is available in the
 $180 "Industry Overview Report.")*

- IBIS World
 *www.ibisworld.com
 (You can order $595 "Industry Reports" for approximately
 700 different types of manufacturing, wholesale, retail,
 and service businesses. Each contains detailed information
 about key players, current conditions, and the outlook
 for the future.)*

Don't forget: while you're gathering information about
your target clients, you need to gather information about
their competitors as well. This will allow you to compare
their services, products, distribution channels, marketing
strategies, and customers. It's important to understand how
the companies differentiate themselves from each other.

Client profile

Now you need to answer some questions about how
your clients make purchasing decisions. If you've been
in business for a while, start with your current relationships,
and then add the new clients that you're targeting. Chances
are that you've already gathered information about key
executives during your industry research. Look at the
organizational structure, and pay attention to recent

changes. It's not unusual for a new president or marketing executive to be brought in with a mandate for change. Think about the following:

- What are the job titles of your primary contacts?
- How are they positioned in the hierarchy?
- What decision-making authority do they have?
- What do they buy?
- Why do they buy it?
- What are the key factors that drive their decision making?
- What is their buying process?
 (For example, in many large companies, you must first be added to the list of approved vendors before you can participate in competitive bidding for individual projects.)
- When are purchases made?
 (For example, are some projects tied to an annual business cycle? Do major product launches happen on a different schedule?)

Sometimes geography can be an important factor as well. Some clients prefer to work with firms that are nearby. If proximity is an issue, think of ways to deal with it. For example, it might be difficult for a design firm in Montana to service a major corporate account in Florida without having at least one team member physically located there. You might consider hiring a local account executive or even opening a local office, as ad agencies often do when they land major accounts.

Evaluation of your competition
For this part of your plan, identify and research each of your competitors carefully. What other services out there are similar to your own? When you pitch a project, who do you come up against? If you've targeted new clients, identify who they're buying from now. When you've identified eight to ten competitors, spend time on their Web sites and use search engines to find news articles about them. Research how your competitors have structured their firms, analyze how they promote and price their services, and identify their major accounts. (For more information about competition, positioning, and differentiation, please see Chapter 10.)

Keep in mind that you may face a different group of
competitors for each type of service that you provide.
It's also important to note that if you're launching a new
company and you're unable to identify any competitors
at all, it's possible that a market does not exist for the
service that you want to offer.

When you've gathered detailed information about your
competitors, evaluate their strengths and weaknesses and
compare them to your own. Be brutally honest. Your goal
is to be able to explain what's new or different about your
services. In what way are your services better than those
offered by the competition?

Sustainable advantage

When you've identified your key advantage, describe how
you'll be able to sustain it over time. Also think about ways
to defend it. Can you put up barriers of any kind to make
it harder for others to copy your success? For creative
firms, this could include the development and protection
of various types of intellectual property. For example,
interaction design firms might register utility patents for
software applications that they've developed. Another
strategy could be to negotiate exclusive relationships with
firms that provide services that are synergistic to your own.
It's smart to build defensibility into your business model
whenever possible.

Also, if you have competitive advantages that can be
maintained over time, they may lead to growth opportuni-
ties. Think about how your services might evolve. Could
they be augmented in some logical way? Could they be
expanded into a broader and more comprehensive offer
to your clients? If you're interested in increasing the size
of your company, that's a very important objective and
it must be clearly reflected in your planning.

Marketing plan

You've already thought about what you want your target
mix of clients and services to be. Now you need to determine
the combination of marketing and sales activities most likely
to bring in the work that you're hoping for. If you've been in
business for a while, you should have a number of loyal client
relationships. This means that a portion of your studio's

capacity will be filled with repeat business. Beyond that, you need to calculate the amount of new business that must be generated in order to reach your overall goals. Think about what can be accomplished through general promotional activities and what will require personal one-on-one selling. Plan out a promotions program that's as comprehensive as you can make it. This might include such activities as:

- Updating your capabilities materials to feature recent case studies in your target industries
- Redesigning your Web site to make it more useful and informative to potential clients
- Preparing a CD-ROM or DVD of recent interactive work and motion graphics
- Developing a mailing list and sending out direct mail pieces on a regular basis
- Placing ads in key trade publications
- Buying pages in annual creative directories
- Entering selected competitions to enhance your credentials
- Maintaining a presence at important trade shows and industry events
- Writing press releases and preparing reprints of positive press coverage
- Publishing articles and books that position you as an expert
- Networking through appropriate membership organizations
- Establishing alliances with synergistic businesses
- Actively seeking referrals from current and past clients

These potential components are discussed in more detail in Chapter 10. For each activity, plan a realistic budget and timeline. As a reference for budgeting: in public companies, it's common for 10% of total annual expenses to be related to marketing and sales. (For some thoughts about the difference between marketing and sales, see Figure 28.02.)

If your promotions program includes direct mail, you might consider buying mailing lists to identify new prospects. Industry associations often sell lists of their members. Trade publications sell lists of their subscribers. Product companies sometimes offer lists of customers who have

submitted warranty registration cards. There are also
research companies that sell lists for most industries,
based on SIC codes. Buying a list can be expensive, so make
sure that it's very targeted and the contact information
is as current as possible. One of the leading providers is:

- infoUSA
 www.infousa.com
 (You can select business prospects by industry, location,
 size of company, the contact's job title, or other criteria.)

For your marketing plan to be complete, it must address
every step in the new business development cycle:

- Ongoing trend research in your target industries
- Constant identification and qualification
 of new prospects
- Successful development of those prospects
 with the most potential
 (How do you approach them, what do you show,
 and how do you follow up? Your message must
 be targeted, relevant, and compelling.)
- A well-thought-out pricing strategy
 (Within different project categories, pricing and
 margins may be different. Consider this carefully.
 You may need to periodically adjust pricing in
 certain categories in order to stay competitive.)
- Effective negotiation
 (How do you overcome objections, close deals,
 and keep them closed?)
- Smooth transitioning of new projects from
 the sales rep to the design team
 (This issue was discussed in more detail
 in Chapter 24.)
- Ongoing relationship management
 (It's often said that you win new business on the
 strength of your portfolio, but you retain the business
 based on the quality of your relationship management.)

In the long run, you're building relationships rather than
just selling. People buy from companies that they like.
Clients will place more trust in you if you demonstrate a
solid understanding of their issues and an ability to partner
with them in a way that makes the most of their internal

*Figure 28.02. Many
people confuse the terms
"marketing" and "sales."
In fact, they represent
different sets of issues.*

capabilities. It's smart to view your company as a portfolio of customers. You want to be a proactive marketing partner, not simply a creative vendor. Clients must be able to rely on you for expert insights and brand stewardship, particularly when there is staff turnover on their side of the relationship.

The marketing portion of your business plan must end with a list of action items. For each activity, set a firm deadline, and assign personal responsibility to yourself or another member of your new business development team. If accountability is not established at the individual level, it's quite possible that no progress will be made. Beyond accountability for specific activities, you must also think about personal accountability for results. Develop metrics to judge marketing performance. These vary from company to company, so you need to define what's most important for your own firm. Your metrics might include such things as market share, account growth, and client loyalty.

Remember that your marketing plan is not carved in stone. On a regular basis, you need to fine-tune it to make sure that each action is helping to accomplish your overall goals. This means that you need to be able to monitor the impact of marketing expenditures on sales results. You need to apply quantitative and analytical skills to make sure that your marketing activities are effective and producing an acceptable return on the time and money being invested in them. Your project tracking and financial management system must give you the ability to match data on past marketing expenditures by creative service or client industry with the related sales and profit results. This lets you analyze the profitability of each component so that you can redirect spending toward opportunities with higher potential.

Operations plan

For this section of your plan, write a general description of your process for producing client work. That is to say, once you land new projects, how do you go about completing them, and what controls do you have in place for keeping them on track? There are two aspects to this — an ongoing quality control system for maintaining high creative standards, and a project management system to keep the work on schedule and on budget. Describe the

typical size, budget, and duration of projects. How many projects can be done simultaneously? Describe your system for coordinating company-wide workflow and traffic.

If you use a lot of outside resources, explain what you outsource and why. This is a critical issue because it indicates how dependent your success will be on others. Most design firms draw upon a large network of outside services. The quality and reliability of the relationships that you have with freelancers and vendors will shape your business. You must be able to effectively collaborate with synergistic firms and seamlessly tap into their services on an as-needed basis.

Human resources plan
Describe the size and structure of your company's staff. List the key skill sets needed for your firm to be successful and the number of people that you currently have in each role. Include a management profile of yourself. Describe your primary role and the relevant skills and qualifications that you bring to it.

Staff recruitment, retention, and advancement are critical issues for your firm. Design is a people business, and the quality of your staff is vital to your success. Low skill levels and high turnover would make it hard for your firm to produce good work and provide continuity to client accounts. How will your firm attract the best and brightest and provide an environment where they can realize their potential?

Think about how the firm's staffing needs will change over time as your services evolve. If your plan is for the overall size of the firm to increase, what opportunities will there be for internal advancement? Which future positions are most likely to be filled though outside recruitment? List the sequence of hires and the anticipated salaries. As creative firms grow, it's common for design and production staff to be sorted eventually into teams that provide different services or work with clients in different industries. This expanding staff structure will require effective leaders. Senior employees who grow into leadership roles might even have potential to become the next generation of ownership. It may seem odd to think of this in the early years, but every business owner needs to have

a clear exit strategy. (For more information about exit strategies, see Chapter 29.)

One final note about increased staff size: your human resources plan might include the eventual hire of a new business development person. This raises important issues about incentive compensation, the delegation of key responsibilities, and the changing role of the founder. (For a more extended discussion of this transition, please see Chapter 24.)

Technology and physical facilities plan
Think about the physical space, equipment, and software needed to produce your work. Describe the size and configuration of the space that your company occupies. Start with the spaces needed for design and production, and then factor in conference rooms, a reception area, a kitchen, adequate storage, restrooms, and so on. Best case, the space that you occupy should be easy to expand or contract in response to changing business needs. For design firms, another important issue is whether or not the location and condition of the premises project the right image. Do they communicate the right message about your brand and the quality of the services that you provide? (For more guidance on facilities-related issues, please see Chapter 16.)

Now describe the equipment and software that the company needs for hands-on design and production and to facilitate collaboration and knowledge sharing. Don't forget the information systems that are needed for overall business and financial management.

Financial plan for the next three years
The final section of your business plan will consist of detailed projections of income and expenses for the next three years. These must reflect all of the assumptions and decisions that you've made in the preceding pages. If your company is a start-up, begin with a detailed budget for your ramp-up expenses. Then, once you're open for business, estimate how much time will pass before the company begins to produce a profit. Together, these indicate how much start-up capital will be needed. Don't underestimate. The standard advice for an entrepreneur is that launching a new company

will take longer than expected and will require twice
as much capital as anticipated. Make sure that every
planned expenditure is closely integrated with strategy.

Your financial plan needs to cover three years of operations.
If you're already in business, your forward projection should
be based on past trends, adjusted to reflect your assump-
tions of what will change. Prepare detailed projections of
sales, costs of sales, overhead, and anticipated net profits.
To organize all of these numbers, prepare a spreadsheet
that follows the standard format for profit and loss reports
as shown in Chapter 26. In many business plans, the projec-
tions are on a quarterly basis. However, they're more useful
if they're presented as monthly numbers because that's
how the actual activity will eventually be tracked.

Be specific about your monthly sales projections. Don't just
drop in arbitrary totals. Develop those totals in a logical way
by estimating how many projects of each type will be active
in each period. Be specific about labor as well. Since payroll
is the largest expense for most design firms, you need to
estimate how much of your labor will be project-related
and lead to client billings. Under normal circumstances,
billable labor will represent roughly two-thirds of the total
payroll. The remaining, non-billable portion of your payroll
will be absorbed as overhead. (This issue is discussed in
more detail in Chapter 26.)

Revisions and refinements
OK, now you have a first draft of your plan. Writing a busi-
ness plan is always an iterative process. The document will
go through several rounds of revisions and refinements. To
help with this process, seek out people with more experience
to review your draft and provide you with feedback. Develop
an informal "business advisory board" that includes your
accountant and attorney, and perhaps your banker, insur-
ance agent, and an industry consultant as well.

If you've been in business for a while, you might also want
to consider assembling an informal "client advisory board."
You probably won't share the full document with any of
them (especially your projections of costs and profits), but
it's smart to speak to key clients individually to gain insights

into their needs. Discuss possible ways to tailor your services and resources to better meet those needs.

Small business resources

For additional advice on business planning, take a look at the information available from the following sources:

- U.S. Chamber of Commerce
 www.uschamber.org
 (This is a membership organization that provides free online resources for entrepreneurs, including small business toolkits and advice on business planning for start-ups.)

- U.S. Small Business Administration
 www.sba.gov
 (The SBA is a government organization dedicated to helping entrepreneurs. It has offices in every state. Its Web site has free online courses and articles about preparing and implementing a business plan.)

- Service Corps of Retired Executives
 www.score.org
 (SCORE is a nonprofit association with local offices across the country. It's a resource partner with the SBA, providing workshops, seminars, and online advice for both start-ups and established businesses. Their site has free business plan templates that can be downloaded in Word or PDF format, plus Excel spreadsheets for financial projections.)

- Nolo Press
 www.nolo.com
 (Nolo is a publishing company that specializes in legal and business information. They sell do-it-yourself books, forms, and software. Their site has lots of free advice for entrepreneurs.)

The business planning cycle

Writing a business plan document has been the first step in the planning cycle (see Figure 28.03). You've defined your company's vision and mission. You've identified goals and

determined the best methods for achieving them. Now you need to implement the wonderful plan that you've developed. Great execution is what makes companies succeed.

Along the way, monitor and measure your progress and update the plan as needed. It's at this step in the process that many firms fall down. It's all too easy to be overwhelmed by daily details and gradually lose sight of the big picture. Revisit the information and assumptions in your plan at least once a year. Make revisions to take advantage of new opportunities and to adjust for changes in your situation. Use and maintain your business plan as a living document.

Figure 28.03. The business planning cycle is an ongoing strategic process.

Chapter 29:
Exit strategies

After establishing a successful design firm and managing it profitably for a number of years, you may begin to think about moving on to the next step in your career or to the next big thing in your life. This chapter discusses a number of exit strategies for owners and describes the overall process of valuing and selling a design firm.

If you own a design studio, there are three primary ways for you to eventually leave the business. The first and most unfortunate way would be to die in the saddle. By that I mean, don't do any planning at all and just work until you drop. If you were to die suddenly, you would leave quite a tangle for your heirs. Chances are they're not designers and have not been involved in the business. They will not know the market for creative services and will not know how to manage the operations of the firm. Because of this, they may not be able to extract much value from what you have left behind.

The second option for you would be to simply shut the business down. In the past, this was probably the most common exit for design firm founders. In a small firm where your name is on the door, the work being produced is an extension of your own interests, abilities, and personal relationships. It's typical to extract all profits as you go along, leaving very little of value within the firm itself. When you want to move on or retire, the process is simple: you stop taking new assignments, sell off the furniture and equipment, and then just lock the door. There is no financial payoff for you at the end of this process — you've already gotten whatever you're going to receive.

The third and best option for you would be to sell the business to a new owner. A well-established firm that has produced good work and consistent profits over the years is what an accountant would call a "going concern." If you have built up value within the firm and maintained a roster of stable client accounts, there's no reason at all to shut the business down. It's likely that you will be able to find willing buyers.

Reasons to sell
There are many valid reasons why you might be interested in selling your company:

- You may feel restless and want to seek out new creative challenges. Perhaps you're a serial entrepreneur who loves launching new enterprises, but not necessarily managing them on a daily basis over the long haul.

- An unexpected strategic opportunity to sell or merge may come along that you feel is just too good to pass up.
- You may have developed some health problems and need to sell because of them.
- You may be going through a divorce that is causing a forced division of assets.
- Your decision to sell may be triggered by personal financial planning and the need to diversify assets.
- You may be thinking about retirement, that is to say you're nearing an age where you simply want to stop working so hard.

Potential buyers

If you're thinking about selling your business, who are the most likely buyers? There are several different categories of buyers for you to consider. Depending on your circumstances, you might be able to sell your firm to a co-owner, to a strategic buyer (meaning a supplier, customer, or competitor), to your employees, or to the public. Here are some thoughts about each of these categories:

Co-owner

Selling to a co-owner (such as a co-founder or partner) may be the easiest option, provided that you do, in fact, have a co-owner. If you do, a buy-sell provision was probably included in your original partnership setup or company formation. This specifies in advance a mutually agreed-upon method for you to give notice of your intention to leave, for valuing your portion of the business, and the exact method and time frame for you to be paid. A common approach is for the departing co-owner to receive a down payment of 25% or 30% of the buyout price, followed by monthly installment payments (including a reasonable rate of interest) over the course of three to five years.

Supplier

A supplier may be interested in buying the firm because you offer services that are in some way complementary to theirs. The combination would create synergy, bringing various components together in a way that makes the whole greater than the sum of the parts. The acquiring company may be seeking vertical integration — control over the flow of services and products from origination all the way to the end-user. Depending on the industry that they are in, it may make sense for them to assemble some combination of

resources in design, manufacturing, distribution, and perhaps even wholesale or retail sales. Your company may be the next logical step in a larger process for them. Examples of this would include the acquisition of both the Palo Alto Design Group and frog design by global electronics manufacturer Flextronics. Other examples might include the purchase of a packaging design business by a printing company or the purchase of a fashion design studio by a clothing manufacturer.

Customer
Less commonly, you may have the option of selling some or all of the business to a customer. A customer may be interested if they have an ongoing internal need for the creative services being provided. An investment would allow them to lock in availability and reduce cost. One example of this would be the investment that Steelcase, the large office equipment company, made in the industrial design firm IDEO.

Competitor
Finally, a strategic buyer for your firm may be a competitor. Large firms often grow through acquisitions, rather than through internal, "organic" growth. Acquiring another company is a fast way to expand into new markets or to add innovative services. Large organizations may also be seeking economies of scale. Economies of scale are the reductions in per unit costs for producing and marketing a product or service that occur as the overall quantity increases. Acquisitions by competitors have been very common in the field of interaction design. The acquisition of interactive agency SBI/Razorfish by the large digital marketing company aQuantive was just one example of this.

Growth through acquisitions has always been standard operating procedure in the advertising world. It has resulted in the industry being dominated by holding companies like Omnicom, WPP, and Interpublic Group. For new advertising agencies just getting started, reaching critical mass rather quickly is often necessary in order to compete successfully with the global holding companies for major clients. When an advertising network seeks to grow through acquisitions, the challenge of course is to acquire the best companies without paying inflated prices. If a company is purchased at the top of an economic cycle and a downturn follows

shortly thereafter, the acquirer may have difficulty generating enough revenue to service the debt that it has taken on. Periodically, a shakeout takes place in the advertising industry. During an economic downturn, the closing, consolidation, or acquisition of small and midsized advertising shops is common.

Employees
Selling your design firm to your employees is also a possibility. However, it's usually a stretch for the employees to be able to afford it. The purchase may be done as a management buyout (MBO), where senior members of the management team arrange the financing based on their own personal assets (and the likelihood of continued strong performance of the company). If the buyers do not have a lot of personal assets, a leveraged buyout (LBO) may be a possibility. In an LBO, they may be able to use the assets of the business itself to secure an acquisition loan and then use the cash generated by ongoing business operations to gradually repay the loan.

If you are the owner of a large company, you may be able to undertake the more complex task of structuring an employee stock option plan (ESOP). This allows employees to use payroll contributions to purchase shares as part of a company-wide retirement plan that invests almost exclusively in the company's own stock. Employees become vested over a specific period of time, such as five or seven years. There are many legal restrictions for ESOPs. The setup requires a good deal of expertise from CPAs and attorneys, and the ongoing reporting requirements are extensive. Lastly, because of the long vesting period for the new owners, an ESOP is definitely not a quick exit strategy for the founder.

Public
Your final option might be to sell the business to the public in an initial public offering (IPO). This is not common for graphic design firms. However, selling stock to the public is sometimes possible in a strong economy, provided that your firm is providing innovative services that are in great demand. If your firm has the potential for rapid growth,

investors may want to participate in that growth. This was the case in the late 1990s for Web development firms due to the explosive growth of the Internet.

If the conditions are right, an IPO can be a way to raise large amounts of capital to fund the growth of the firm and to provide liquidity. The overall process typically starts when a firm with significant potential accepts a private equity investment from a venture capital firm. Later, a large underwriting firm will be brought in to manage the public offering. Because equity is being offered to the public, the entire process is subject to stringent governmental requirements. Also, an IPO does not provide an immediate exit for the original owners because the venture capitalists and underwriters will usually want management continuity. The post-IPO success of the publicly traded company would be jeopardized by the departure of the individuals who made the company a success in the first place.

Manage with exit in mind
Even though you may not sell your firm until several years from now, you must begin to manage with that eventual exit in mind. A good way to start is to analyze the current strengths and weaknesses of the business. For example, would a change in legal structure now (say, from a sole proprietorship to a partnership or a corporation) make it easier to sell later on? Have you been cautious about debt and long-term leases? A new owner might not want to be saddled with such obligations unless they are on very favorable terms.

Make sure that your books are complete and that the business has no unrecorded liabilities. For example, have you booked adequate reserves for such things as potential bad debt, the possible refund of client deposits, or the value of paid vacation time that is due to employees? Do you have adequate insurance coverage? Depending on the creative services that you provide, this might include coverage for errors and omissions, professional liability, media liability, or product liability.

Make sure that your financial statements are prepared on an accrual basis so that they provide an accurate picture of month-to-month activity. It's even better if your financial statements are periodically reviewed or audited by a CPA. If you've never had that done, you should give it serious consideration now.

Build value

On a daily basis, manage your firm in such a way that you are making it a more attractive target for a potential buyer. This means consciously building value within the firm. There are many different aspects to this:

- Client base
 This includes the longevity of accounts and the average collection rate, the client categories that you specialize in, and the long-term trends in those client industries.
- Services
 Are you focused on services for which there will continue to be strong demand?
- Key personnel
 Have you put together a team with the right mix of skills and personalities? What is the strength of their commitment to the ongoing success of the firm?
- Marketing and sales
 How do you promote your services and maintain a healthy workload? This involves good positioning and differentiation, as well as an effective marketing and sales process so that you are constantly identifying new opportunities and lining up new commitments.
- Contracts
 What types of written contracts, leases, and agreements have you signed? Are the terms and conditions favorable to your business? It's especially attractive to have long-term commitments from clients.
- Pricing
 Are your prices competitive, and have you factored in an adequate profit margin?

- Work methodology

 Have you developed an appropriate process that enables you to produce great work? At the same time, is the process efficient and productive? Does it keep projects on schedule and on budget, and does it prevent serious problems?

- Financial systems

 Do you have reliable systems and procedures in place that provide accurate and timely information? Do you have controls in place to effectively manage costs?

- Benchmarks

 Does your performance compare favorably to that of your peers on key indicators such as profitability and utilization?

- Cash flow

 Does the business produce consistent, positive cash flow from operations, with no dramatic peaks or valleys?

- Equipment and technology

 Do you have in place the full range of resources needed to produce great client work? In each category, do you have the newest and best? Do you have licensed copies of all software?

- Facilities

 Are the physical facilities in a good location and in good condition? Do they create a positive impression on clients and project the right image for your firm?

- Intellectual property

 Have you developed and retained ownership of any valuable intellectual property? This might include copyrights (such as illustrators and photographers who retain ownership of images), trademarks (especially for your own firm's name and visual identity), and perhaps design patents or utility patents (such as proprietary processes or custom coding developed by interactive design firms).

- Culture

 Is the general mood in the workplace positive and creative? Is staff morale high? Do team members look forward to coming to work each day? Is the company a place where the best and brightest want to work?

Advisors

As you come closer to selling your firm, you will need help and guidance from a number of professional advisors. It's important to find the best that you can. Do some research and ask for recommendations. These advisors will include:

- A business accountant
 Use a certified public accountant to review or audit your financial statements and to provide advice on tax issues. Your CPA should have experience with other firms in your industry.
- A transactional attorney
 An attorney will be required for preparation of contracts and for ongoing guidance. He or she must have specific experience in the buying and selling of businesses and in the negotiation of mergers and acquisitions (often referred to as "M&A").
- A business broker
 Your broker must be a specialist in your industry. When you list with a broker, you may need to pay a retainer. The relationship may be either exclusive or non-exclusive. Most brokers receive a contingent fee that is scaled to the size of the transaction (often calculated in layers, such as 5% of the first million, 4% of the second, 3% of the third, 2% of the fourth, and 1% of the balance).
- An industry appraiser
 Professional appraisers are industry-specific. Most charge a flat fee.
- A personal financial planner
 You should use a private financial advisor to help you plan the best use of the proceeds from the sale.
- A lender
 Eventually, there will also be a lender in the mix to provide financing for the buyer.

Valuation

You will be guided through the valuation process by a professional appraiser. Usually he or she will calculate the value of the firm using several different methods, get a range of results, and then determine a final value that is somewhere in the middle of the range.

Here are some of the most common approaches (your CPA can provide you with more detailed explanations of the calculations involved):

- Net asset value and future revenue stream (ROI)
 This focuses on the buyer's potential return on investment, adjusted for market demand as well as for operational and management factors.
- Capital asset pricing model (CAPM)
 This approach values the firm by relating risk and expected return. Buyers will require additional expected return (called a risk premium) if they feel that additional risk is involved.
- Discounted cash-flow analysis (DCF)
 This is a method of evaluating an investment by estimating the future cash flows that will be produced. (A variation of this method is called "capitalization of earnings.") The calculation takes into consideration the time value of money (the idea that a dollar today is worth more than a dollar in the future, because the dollar received today can earn interest up until the time the future dollar is received).

The valuation process will include a comparison of your firm to others that provide the same kind of services, using several standard performance indicators. The market value of your firm may be stated as a multiple of one of these indicators:

- Earnings before interest and taxes (EBIT)
- Earnings before interest, taxes, depreciation, and amortization (EBITDA)
- Adjusted profit (net profit + add-back amounts for any excess salaries and perks)

Each indicator will be calculated as a weighted average of the past three years. (As one example of this: in a strong economy, PR firms in hot categories have been known to sell for up to six times their average adjusted EBIT.)

Depending on the type of firm you have, there may also be a multiplier or rule of thumb that is based on annual sales, gross margin (or agency gross income, if you're involved in advertising), annual percentage growth in fee billings, or

cash flow. Whenever a business is offered for sale, a search is done to identify any recent transactions that are in some way comparable. (For example, you may own an industrial design firm, and your research may indicate that firms similar to yours in size have recently sold for between 1.0 and 1.4 times their annual revenue, or perhaps for between 4.3 and 5.0 times their annual profit.) Your valuation will of course be adjusted to reflect the specifics of your own situation.

An aspect of valuation that will vary quite a bit from firm to firm is business goodwill. Goodwill includes any intangible assets that provide your firm with a competitive advantage. These might be a strong brand, an excellent reputation, or high employee morale. These do not appear on the balance sheet of the firm being sold, but they will be included in the purchase price. After completion of the purchase, goodwill appears on the balance sheet of the acquirer as the amount by which the price paid exceeded the net tangible assets of the acquired company.

Selling prospectus

When you're ready, the next step in the process is to prepare a selling prospectus that will be given to business brokers and to qualified buyers. In scope, it's rather like a business plan, but it emphasizes the strength and quality of what's in place today. You need to put into writing everything that makes the firm successful. The contents will include:

- An overview of the company
 (your history and reputation)
- A description of your services
- An overall market assessment
- An overview of your sales and marketing process
- Descriptions of any special assets, processes, or agreements
- Profiles of key management personnel
- A summary of financial performance for the past three years
 (this should be a top-level recap with enough information to show trends, but not complete details — they will be shared later in the process)

- A three-year projection of future financial performance *(project your current financial trends forward as realistically as possible)*
- The company's ownership structure *(partnership, corporation, et cetera)*
- Your asking price and preferred financing

Special issues for professional services

Selling a firm that provides professional services is very different from selling a company involved in manufacturing or retailing. To start with, there is a limited pool of buyers because they must have relevant professional experience. For a design firm, this means a proven ability to market creative services, produce excellent work, and manage the creative process efficiently. Another difference is the fact that the long-term success of a professional services firm is very dependent on client loyalty. This involves maintaining a high level of trust, an excellent reputation, strong referrals, and personal bonds. Because of this emphasis on personal relationships, any change of ownership brings with it the potential for degradation of the practice. Great care must be taken with the planning and completion of a successful transition period from the founder to the new owner.

Timing

The timing of your sale will have a big impact on the selling price and the terms of the deal. The overall health of the economy is a factor: the level of optimism in the country will affect the availability of financing. Trends and cycles within your industry are important: if the industry is expanding, the perceived risk for potential buyers will be lower. Individual businesses go through cycles as well, so the current condition of your firm is important: are you expanding, or have you recently been forced to cut back? If several different acquisition targets are available to a buyer, why would your company be the best choice at this particular moment in time?

If you find yourself in the midst of an economic downturn, it's not a good time for you to sell. Buyers with cash will be looking for bargains. It's much smarter for you to use a downturn to make changes and improvements: fine-tune your internal systems, rethink your services and resources, or perhaps even reposition or restructure your firm entirely.

By doing this, you'll be prepared to benefit when economic conditions improve. Sellers tend to get the best deals early in an upswing.

Negotiating the deal

When you have your advisors in place, your business valuation completed, and your selling prospectus prepared, you're ready to start talking with potential buyers. Have each one sign a confidentiality agreement. You'll be revealing competitive information about your operations, and you need to protect that information. Don't set any deadlines for yourself or expect things to move forward too quickly. The process of identifying a buyer and negotiating a deal often takes six months to a year. The exact structure of the deal will emerge from the negotiations and will reflect the advice that you receive from your professional advisors. Here are some of the basic options:

- A taxable purchase of assets
 The deal may be structured as a taxable purchase of assets for cash and/or other valuable consideration. The price paid by the buyer will be allocated over the various assets purchased, and those assets will be stepped up to fair market value.
- A taxable purchase of stock
 The acquirer will make a taxable purchase of stock in your company for cash and/or other consideration.
- A tax-deferred exchange of assets for stock
 This involves acquisition of the seller's assets in a tax-deferred exchange for stock in the buyer's company.
- A tax-deferred exchange of stock for stock
 This involves acquisition of the company in a tax-deferred exchange of your stock for their stock. This pooling of interest merges the two business entities into one. All assets and liabilities will transfer to the buying company at book value.

Many variables

Along the way, the deal will be fleshed out with many variables, including the amount of any down payment. If you negotiate a taxable purchase, the deal might consist of a mixture of some cash and some stock. You will need to receive enough cash to pay the taxes that will be assessed. For stock, you will face restrictions on the amount, timing,

and method of selling any shares that you receive. Details about the financing lined up by the buyer will also vary.

Occasionally, discussions may touch upon the option of seller financing. I recommend against this because it offers less of a clean exit for the seller. However if you do take this route, it involves negotiating an interest rate and the length of the payment schedule. A promissory note must be prepared and signed, and you may want to require additional security to be given by the buyer.

All through the negotiating process, work closely with your CPA to manage the timing and amount of any tax liability. Sellers will usually want most of the deal taxed at a capital gain rate rather than a personal rate. Your CPA will also advise on different rules for "S" corporations and "C" corporations.

Several other variables could come up in your discussions. One of them might be the ownership of accounts receivable and work-in-process inventory. This is because they relate to work done by the departing owner. When client payments eventually come in for that past work, the buyer may be willing to pass the money through to the seller. However, it would also be logical to discuss responsibility for any open accounts payable that relate to those same projects. If the seller is entitled to receive the client payments, he or she should also be responsible for paying the vendors who were involved.

Real estate is sometimes an issue. Most design firms lease space. If a building was purchased at some point in the company's history, more often than not it was purchased separately by the owner of the firm, not by the design business itself. This means that if the business is later sold, the building will not be included in the deal. The previous owner of the business will remain in the picture as a landlord.

As you go through the negotiation process, it's important to identify and manage risks, both for the buyer and for the seller. Discuss what could go wrong and plan how to cope with each possibility. For example, what would happen if the deal fell through — who would be responsible for paying

the advisors? Another example would be the major risk to the buyer of potential degradation of the practice after the purchase is complete. To mitigate this, the buyer will often negotiate an employment agreement with the seller to keep him or her on the payroll through a reasonable transition period, often three to five years.

The agreement will include a good salary and an impressive job title. Beyond that, the buyer will want to motivate the seller to work hard to make the transition a big success. This is done by offering future incentives and contingent payments (often called "earn-outs"). Each deal will be different, but it's not unusual for 70 or 80% of the total value of the deal to be paid up front, with the balance structured as earn-outs. Both parties will agree on the goals in advance. Your agreement must define precisely what the payments will be based on and how they will be calculated. This is important because the accounting system for the business may change after the acquisition, and the format and terminology of reports may be different. Specific goals can be both annual and cumulative. You might also want to negotiate for higher payments to be made if the goals are exceeded.

One final negotiating point might be the name of firm. Will it retain the original name during the transition period? When will it change, and what will the new name be?

Closing the deal

The process of finalizing the commitment starts with a letter of intent (sometimes called a "term sheet"). This is a non-binding summary from the buyer to the seller of all the major deal points that have been decided. Signing the letter of intent will initiate a period of "due diligence." This is a pre-determined amount of time, usually several weeks, during which the potential buyer will have access to all of the company's books, records, and files. They will investigate the information given to them so far to ensure that it's true and accurate. The potential buyer will exercise care in evaluating the company's operations, its solvency, and the trustworthiness of management. As part of the process, they will interview employees and perhaps customers. During the due diligence period, it is mandatory for the

seller to make any material disclosures, such as pending lawsuits. Material information includes anything that would influence or change the judgment of a reasonable person about the deal.

During this time, the potential buyer will review complete financial data for the past three to five years. They will use this information to prepare new projections of future activity that factor in any new savings or costs. For example, if the company will be run as a subsidiary or a division of the acquiring firm, it's possible that a monthly management fee will have to be paid to the parent company. This will be added into the projection of overhead expenses.

At the same time, however, the seller should conduct a reasonable investigation of the potential buyer. Verify the accuracy of the information that they have given to you, and ask for any additional data that might help you to reach a sound business decision. If the buyer has purchased any other firms in the past, it's a very good idea for you to speak directly with those other acquisitions.

At the end of the due diligence period, it's time to sign the full purchase contract and complete the closing process. The full contract will include a covenant not to compete. The purpose of this is to prevent you from immediately setting up a new firm in direct competition with your old one. To emphasize the importance of the covenant not to compete, it will usually be allocated a portion of the purchase price. However, you will not want unreasonable restrictions placed on the future direction of your career. Because of this, the covenant not to compete must be very specific in activity, place, and time.

In some industries, buyers will sometimes make one final request before signing the purchase contract. They may ask for an interim "management agreement." This is essentially a test-drive. It allows the potential purchaser to manage the company for a while before actually buying it. This would be unusual for a design firm, and you should definitely say no. There is too much potential for damage to the business. The purchase could later fall through, and you would be left to pick up the pieces.

Successful transition

OK, the deal is done. Now you must make sure that the transition period is successful. Many inhibitors of change might come into play, so you should expect some turbulence. Chances are that your staff will feel insecure. They may be resistant to new procedures, even worried about the future of their own jobs. It's smart for the new owner to motivate the staff, particularly key managers, with financial incentives tied to important business goals. In mergers and acquisitions that involve large firms, some common threats to success include lack of clarity about the desired outcome, culture clashes between the two organizations, conflicting interests, and the emergence of competing factions.

You must work hard to transfer customer loyalty to the new owner. Meet individually with clients to emphasize the benefits of the change. Maintain as much continuity as possible within individual account teams, and continue to provide outstanding customer service.

You should also plan and execute a comprehensive public relations campaign. A typical time span for the campaign would be eight to ten months. It's especially important to explain the change and communicate a positive message to the market if the business now has a different name — you don't want people to think that the company simply went out of business.

Finally, for the seller, there may be emotional issues related to letting go of the old and embracing the new. It's not unusual for the founder of a firm to experience "seller's remorse" when he or she moves on. This is particularly true if your self-identity has been very tied up with the firm. Directing projects has put you in control, given you access to important people, and won accolades. It may be hard to step out of the spotlight or to give up authority and perhaps even the sense of being needed. All of this will be psychologically much easier for you if you've used the business transition period to define yourself apart from the office and to prepare for your next personal move.

Chapter 30:
Special challenges for in-house departments

In addition to producing high-quality creative work, in-house design managers face many political and operational challenges. Chief among these is the need to understand the evolving needs of the larger organization and the optimal mix of internal and external resources required to meet those needs.

Once the right skill sets and creative methodology are in place, the design manager must also provide excellent customer service. This customer orientation includes ongoing internal marketing efforts as well as effective negotiation of new project budgets and schedules. Active projects can be produced more efficiently through the implementation of an appropriate project management system, which can also be a great tool for analyzing and benchmarking the activities of the department. Finally, an in-house design manager must continually justify the existence of the department by quantifying and communicating the ultimate value to the organization of the great work being produced.

Working in-house

Many designers work inside corporations rather than for independent consultancies. While the creative challenges may be similar for both, other aspects of the job tend to be quite different. Perhaps the largest difference is that design teams within a large organization face many operational issues that have a political dimension. The name and emphasis of the in-house department may vary, from Creative Services to Marketing Communications or Corporate Communications, but regardless of the particular focus, it's important for the group to clearly see how they fit into the overall design and communications needs of the enterprise.

The big picture

Depending on the particular company and industry, these needs might include such things as identity development, marketing materials, advertising campaigns, product development, and Web and interactive design. Each need comes up with varying frequency. For example, basic identities are not redesigned very often, whereas other needs such as advertising, marketing materials, and publications come up on a continuing basis. The in-house design manager must have a good understanding of the full scope of needs as well as the relative volume and priorities.

Next comes the question of how those various needs are met. In some corporations, the in-house team is limited to producing just one category of creative work, and all other projects pass it by. In other corporations, the in-house design department occupies a central role — managing all creative activity, including the work of

outside firms. This management role positions the department at a higher organizational level. It is more involved in strategy and can generate much higher value for the company by keeping all design and communication initiatives "on brand."

Skill sets

Comprehensive and consistent branding requires a very wide range of skill sets. If you are going to do certain types of creative work in-house, what is it that you are best equipped to handle? Conduct an honest self-assessment of your current capabilities. What skill sets do you have now? Are they a match to the assignments that currently come to you? What experience and skills are not represented in your department? For now, projects requiring such skills must be outsourced. However, you might want to handle them differently in the future. Identify the additional expertise that would be needed if a different mix of projects were to be handled in-house. Of those additional capabilities, assess which ones could be developed through extra training for existing employees and which ones would require new hires. Then think about the best way to approach the political challenges involved in making changes. Any redefinition of your role or negotiation for expanded resources will require careful consideration of the company's core and non-core activities and assets, and each change must be evaluated in terms of potential trade-offs between quality, cost, and schedule.

Resource planning

Make a list of your firm's recurring project types. To the right of the list, add several columns – one for each core skill set needed to complete the projects successfully. Then check off which skills are used on which projects (see the sample in Figure 30.01). Use this completed matrix as a guide to your optimal staff mix. The skill sets that are needed most frequently should be staff positions to give you greater control, faster turnaround, and lower costs. Other skills that are needed only occasionally should be purchased from freelancers or outside firms.

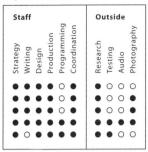

Required skill sets

Recurring project types	Staff						Outside			
	Strategy	Writing	Design	Production	Programming	Coordination	Research	Testing	Audio	Photography
Identity	●	●	●	●	○	●	●	○	○	○
Marketing	●	●	●	●	○	●	●	○	○	●
Advertising	●	●	●	●	○	●	●	○	○	●
Interactive	●	●	●	●	●	●	●	●	●	●
Industrial	●	○	●	●	●	●	●	●	○	○

Figure 30.01. Analyze the specific skills needed for the bulk of your company's projects in order to determine which resources should be brought in-house.

Our sample matrix indicates two possible changes that could be made. First, custom computer programming seems to be needed so infrequently that it could easily be outsourced. Second, a particular type of research is needed frequently enough that it should be brought in-house.

Your own matrix will be different. Keep it close at hand, and revisit the mix on a regular basis. Project requirements shift, and company needs evolve. Constantly reevaluate your resources and update them as necessary. For outside services, make sure that your list of contacts is up-to-date. Always have more than one source in each category so that you have options for price, availability, and the best match to project needs.

Internal marketing

This is an area where almost every in-house creative group can make dramatic improvements. Ask yourself some hard questions: How do you communicate the capabilities of your department to the rest of the company? Do people know what should come to you and what should not? How is your work generally perceived in terms of quality, cost, and turnaround? Some of your in-house clients may have other options for creative services. Be aware of your competition — both internal and external. Use this information to guide your internal marketing activities. Promote your services and their value by conducting orientations for new managers from other departments and by sending newsletters and promotional information on a regular basis. Fine-tune your efforts by conducting an annual satisfaction survey of your clients.

Your process

Another important challenge for in-house departments is communicating to internal clients the fact that design is a problem-solving discipline and that the essential activities at the start of each project are information gathering and analysis. Clients who are not familiar with design often try to short-circuit the process by bringing you into a project too late and asking you to jump directly to form-giving. To avoid this, think about the ideal process that you would like your projects to follow — the phases, steps, and milestones that are most appropriate. Then describe this process in a written document. Diagram it, and use the diagram as a tool in your internal marketing and client education efforts. This preferred process should be your framework for planning, tracking, and managing all projects.

Project planning and agreements

Start each project with a basic requisition, preferably in the form of a questionnaire, and then use this initial information as the basis for a personal conversation with the requestor to clarify the context and objectives of the project. Following this conversation, you'll have enough information to write a detailed creative brief that states the scope of work required and the specific objectives to be accomplished. With this in hand, you're ready to draft a budget and schedule. The best method is to use an internal planning worksheet that has your own standard process and default rates built into it. The worksheet will give you suggested totals for the project, which you can then adjust as needed.

At this point, independent consultancies go on to write a separate proposal document for the client to review and sign. As an in-house department, you probably won't be preparing formal proposals, but it's still a very good idea to have your clients sign some form of written agreement to indicate their acceptance of the schedule and budget. A signed agreement formalizes your understanding, leads to better management internally, and projects a stronger image of professionalism to your clients.

Customer service

Now the agreed-upon project begins. You're ready to do the very best creative work possible. At the same time, you must do a great job of taking care of the customer. Inside a large company, it's often easy for this client focus to fall by the wayside. Don't let that happen — apply the same diligence and consideration to client service that an outside supplier would. Excellent customer service involves these essentials:

- Over the course of each project, you must be proactive in providing updates to the client, both verbal and written. Find the format and the frequency that is best for your organization.
- You should always be accessible. Clients need to know who the key team members on their projects are. Identify your team lead and how he or she can be reached — even outside of regular office hours.
- When those inquiries come in, respond promptly. Even on weekends and in the evening, check your messages regularly, and acknowledge to the client that you have received them.

All of these are important aspects of professionalism. By providing both great design and great customer service, you will earn the confidence and respect of each of your in-house clients. Strive to convert one-off projects into ongoing relationships by always closing the loop and assessing client satisfaction at the end of a project. Your goal is to become recognized as an important ally and trusted advisor. Ultimately, your involvement should be sought out to the extent that clients wouldn't dream of starting an important project without you.

Team issues

When making decisions about the overall structure and composition of your internal team, pay special attention to the role of project and program management. Most teams find it indispensable to have someone specifically charged with the coordination of logistics. This person must have a good understanding of the creative process, but their team role is not as a designer. Their primary responsibility is to support the team by taking care

of a range of administrative tasks. On a day-to-day basis, they often serve as the primary contact for client inquiries. They arrange any necessary meetings, distribute updated information, document the progress of each assignment, and monitor budgets and deadlines.

The usual job title for this role is Project Manager. However, on an interaction design team they may be called a Producer. On teams that do mostly print work, this person may be a Production Manager with special expertise related to print buying. On an advertising team, he or she will be the Traffic Manager, making sure that the right materials are in the right place at the right time. This key skill set is sometimes absent from corporate staffing plans. If you haven't already done so, consider adding a Project Manager to your team. This will free up your designers to spend more time actually designing.

An additional team issue is utilization, which is the comparison of project hours to non-project hours. In an independent consultancy, this is the distinction between billable time and non-billable time. Every team member should be given a target number of project hours. In a corporate environment, the word "billable" may be misleading. Different corporations take very different approaches when it comes to internal budgets and billings — some generate invoices, others have charge-back systems, and others have nothing at all. However, billable time is an important management metric. You should track it even if you are not billing for it.

Selecting appropriate tools
No doubt you already have the latest design software. You also need the most appropriate tools for planning and managing your workflow. Start with a basic contact tracking system — this will help you manage your internal marketing efforts so that you can gain greater control over what comes to you. Use your contact tracking system to maintain information about existing clients, potential clients, informational campaigns, orientation sessions, and other activities. Next comes the selection and implementation of an appropriate project-tracking system. You need one that is specifically for project-based work, with phases, tasks, scheduling,

resource management, time tracking, and built-in comparisons of project estimates versus actuals. Within this system, the time-tracking function must distinguish between billable hours and non-billable hours.

In a large enterprise, you will have to negotiate your software needs with an information technology (IT) department that is managed independently and has its own priorities. It's vital for the IT decision makers to understand that the project-tracking needs of your team are quite different from those of the other corporate departments they support. IT might initially expect you to get by with just a spreadsheet application. At the other extreme, IT might become overly ambitious and attempt to develop a custom solution for you from scratch. However, there is no need to reinvent the wheel. There are a number of good, design-specific project-management systems already available.

Project tracking leads us to the issue of financial management. In-house creative departments often face challenges related to corporate financial reporting. Too often the information flow is strictly one-way — you hand in time sheets and approved vendor invoices, but no project reporting ever comes back to you. It's better for you to capture important information within your department first, then export any necessary detail to corporate accounting. Good project-tracking systems can handle this without a problem. Good systems are also scalable — choose one that can grow with you. You don't want the frustration and disruption of having to replace it every time your department expands.

Until you have a good system in place, you will be primarily in reactive mode — fighting fires and scrambling to get completed work out the door. This chaotic, seat-of-the-pants approach can easily lead to burnout unless you gradually evolve an appropriate management system for your department. Choosing and implementing the right procedures and tools will make your life a lot easier and facilitate the development of norms and benchmarks. Your ultimate goal should be to become proactive — projecting future activity, anticipating resource needs, setting targets, and recognizing trends.

Benchmarking

Here are some thoughts about how you might benchmark your activities and begin to measure your impact on the overall organization. The recent economic downturn and general trend toward outsourcing has put increased pressure on in-house teams to justify their existence. Smart corporate decisions about your department and its role need to be based on complete and accurate information. If you are the best source of that information, you will have a better shot at occupying a seat at the decision-making table.

The prerequisite for analysis and benchmarking is that you must track everything and capture it in real time. Make information gathering automatic, which is easy if you have selected and implemented the right project management system. Central to this is the fact that you need good timekeeping, whether or not your labor is actually being charged back to clients. Next, make sure that every project has a staff labor budget and a schedule. Then, on a regular basis, recap your completed projects in order to compare the original estimates to the final actuals. This will help you identify trends.

Here are some specific suggestions for benchmarks that you should consider. They are grouped into four general categories: projects, resources, profitability, and return on investment (ROI).

Projects

- Number of completed projects per year
 The total volume of work produced by your department within the annual budgeting cycle.
- Number of projects per month
 This will help you recognize and plan for seasonal cycles.
- Number of projects per client
 Identify the most active, least active (and why), average project size, and project turnaround; this is also an indicator of the success of your past PR efforts and a guide to how you need to promote your services in the future.

- Number of projects per category

 This will allow you to develop the average cost, schedule, and turnaround for each recurring job type, and to develop project-management templates for each one.

Resources
- Track productivity

 Compare project time to non-project time as a percentage of the total hours reported; in a consultancy, this is the split between billable and non-billable time.
- Set productivity targets

 For each individual and department — again, this means that you need to track actual hours, even if team members are receiving fixed salaries.
- Analyze outsourcing

 Look at the categories, amounts, and reasons for outside purchases — constantly reevaluate your mix of in-house and outside services.

Profitability
- Direct cost

 Calculate your project labor at payroll rates and your project materials at cost.
- Comparable outside rate

 Calculate what a vendor would charge for the same work using their standard hourly billing rates and their standard markups.
- Transfer rate

 If you charge back your work to clients at an in-house rate, it is often calculated to be somewhere in between your direct cost and the comparable outside rate.
- Difference between these rates

 An analysis of the margins between each of the rates just mentioned can be an important indicator of the cost efficiencies that you are creating for the organization.

Value / return on investment
After your creative services have been performed, the final challenge is to describe the client benefits that you delivered and to quantify those benefits in some way. They must be

objective rather than subjective. They must be based on reliable data, and you must make a persuasive case that there is a direct, logical relationship between your work and the measurable business results. Some possible ROI indicators might include:

- Reduced time to market for new products and services
- Creation of new and valuable intellectual property
- Competitive advantages of strategic alignment and consistent branding
- Increased market share and awareness within target segments
- Improvements to the bottom line through increased revenue and/or reduced costs

At the conclusion of each major project, write and distribute a case study that utilizes some or all of these indicators in order to show the real impact of your work on the enterprise.

Index

80/20 rule, 340

A

about this book, 14–17
accessible design, 292–293
accountants, 89, 165, 169, 418
 See also CPAs
accounting
 accrual-based, 167, 352
 cash-based, 167, 352
 definition of, 165
 workshops on, 155
 See also bookkeeping
accounting equation, 352
accounts payable, 157, 171
accounts receivable, 156, 171, 354
accreditation, 244–245
accrual-based accounting, 167, 352
acid test ratio, 366
ACM SIGCHI, 39
ACM SIGGRAPH, 39
actual damages, 232
Ad Age Career Center, 42
addendum to agreements, 260
advertising
 promoting business through, 125
 See also marketing
advisors, 89
Adweek Classifieds, 42
Adweek Directory, 45
Agency Compile, 44
agency gross income (AGI), 361–362
agreements
 design services, 238–262
 employment, 54, 325–326
 independent contractor, 62–63,
 67–75
 partnership, 91–92
 written vs. oral, 108
AIGA, 38
 design services agreement,
 238–262, 264–289
 ethical guidelines, 291, 292
 national job bank, 42
 salary/benefits survey, 50, 83
 sustainable design info, 294, 297
 AIGA Standard Form of Agreement for
 Design Services, 238–262,
 264–289
 basic terms and conditions,
 240–251, 265–278
 intellectual property provisions,
 251–254, 279–283
 supplements, 254–256, 285–289
 See also terms and conditions

alliances, 127
allowance for doubtful accounts,
 354–355
American Advertising Federation,
 39, 43
American Association of Advertising
 Agencies, 39
American Society of Media
 Photographers, 39
Americans with Disabilities Act
 (ADA), 256, 288, 292
annual reports, 397–398
Aquent, 46
arbitration, 250–251, 276
Art Directors Club, 39
article publishing, 126
artist's reps, 20
assets, 159, 354, 355
Association of Professional Design
 Firms, 50
Association of Registered Graphic
 Designers of Ontario, 50
at will employment, 54
attorneys, 89, 251, 261–262, 418
 See also legal issues
audit trail, 156
auditing the books, 169
Australian Graphic Design
 Association, 291
automobile insurance, 190–191

B

background checks, 49, 52–53, 168
backlog, 371
backup procedure, 145
bake-off, 106
balance sheet, 351, 352–357
 explanation of categories on,
 354–357
 format for design firms, 353–354
bank accounts
 opening for small business, 61
 reconciling statements for,
 157–158
bankers, 89
banking relationship, 163
bar graphs, 341
benchmarks, 365–371, 436–438
benefit statement, 122
Berne Convention for the Protection
 of Literary and Artistic Works,
 224–225

bids, 108
billable hours, 84–85, 144, 363–365
billing cycles, 161
billing rates
 design firm, 110–119
 freelancer, 82–86
 See also rates
blended rates, 111–113
book publishing, 126
bookkeeping, 154–169
 double-entry, 165–166
 importance of, 155
 information resources on,
 155–156
 internal controls for, 168–169
 procedures and systems for,
 161–167
 records maintained for, 156–161
borrowing money, 173
bottom line, 167
bottom-up projections, 376
break-even multiplier, 370
break-even rate, 85
Broadcast Designers' Association, 39
brokerage fee, 182
Brunsten, Don, 239
budgets
 developing, 117–118
 tracking, 340–344
build-out allowance, 203–204
Bureau of Economic Analysis (BEA),
 395
Bureau of Labor Statistics (BLS), 50,
 52, 396
burn rate, 148, 341, 343
business cards, 31
business development
 setting goals for, 316–317
 weekly summaries of, 375–376
business envelopes, 31
business environment, 394–399
business expenses
 estimated taxes and, 77–78
 freelance rates and, 83–84
business file, 143
business insurance, 186–199
 basic and additional, 186–194
 design-firm specific, 194–198
 providing proof of, 199
business interruption insurance, 190
business owner's policy (BOP), 188
business permits, 100

U

umbrella liability insurance, 190
unemployment insurance, 62, 192
unfair competition, 220–221
unique selling point, 122
universal design, 292–293
University and College Designers
 Association, 39
up-front deposit, 174
Usability Professionals' Association,
 39
use-based pricing, 104–105
utilitarian works, 211
utility patents, 222

V

vacations, 62
valuation process, 418–420
values, professional, 294–296
values statement, 390–391
vendor invoices, 156–157
vendor relationships, 163
vision statement, 391
Visual Artists Rights Act (VARA), 224
visualizing plans, 337–338
Volunteer Lawyers for the Arts, 261

W

W-2 form, 164
W-4 form, 164
W-9 form, 64
Wall Street Journal Online, 398
warranties, 247, 248, 271–272
Web sites
 domain names for, 99
 intellectual property on, 225
 promoting business through, 124
 putting portfolios on, 36
 See also information resources
weekly reports, 351
Wert & Company, 46
whole life policies, 185
work in process, 353, 355
workers' compensation insurance, 62,
 101, 191–192

Workforce Investment Act (1998),
 255, 292–293
workforce planning, 380
work-for-hire, 63, 210, 245–246
World Intellectual Property
 Organization, 226
World Trade Organization, 226
wrapping-up projects, 347–349

Y

Yahoo! Finance, 396
Yahoo! HotJobs, 44

Z

zoning issues, 100

Acknowledgments

In producing the second edition of this book, I've had expert guidance from a great team at New Riders and Peachpit Press including Michael Nolan and Valerie Witte. I'm also eternally grateful to alumni Chris Nelson, Steve Weiss, and Cheryl England for their assistance with the first edition. Many thanks to all of them.

The content of the book reflects the experiences that I've had in my professional career. I want to express my sincere thanks to the many wonderful colleagues and clients with whom I've had the honor of collaborating over the years.

Thanks also to my graduate students, who enable me to see so many issues related to professional practices through new eyes each semester.

Last but not least, I'm deeply grateful for the loving support of friends and family — most especially that of my wife Karin, *animae dimidium meae.*

About the author

Shel Perkins is a graphic designer, management consultant, and educator with more than twenty years of experience in managing the operations of leading design firms in the U.S. and the U.K. He currently provides management consulting services to a range of creative firms in both traditional and new media, and he serves as chairman of the AIGA Center for Practice Management.

He has written the *Professional Practice* column for *STEP* magazine, the *Design Firm Management* column for Graphics.com, and the *Design Business* newsletter for AIGA. He has given presentations and workshops for many organizations, including IDSA, SEGD, HOW, ACD, Dynamic Graphics, STEP, Seybold, APDF, PromaxBDA, InSource, RGD Ontario, and the Graphic Artists Guild.

Shel teaches courses in professional practices at the California College of the Arts, the Academy of Art in San Francisco, and the University of California. He has served on the national boards of AIGA and the Association of Professional Design Firms. He has also been honored as an AIGA Fellow "in recognition of significant personal and professional contributions to raising the standards of excellence within the design community."

WATCH
READ
CREATE

Meet Creative Edge.

A new resource of unlimited books, videos and tutorials for creatives from the world's leading experts.

Creative Edge is your one stop for inspiration, answers to technical questions and ways to stay at the top of your game so you can focus on what you do best—being creative.

All for only $24.99 per month for access—any day any time you need it.